THE MONSTER BOOK OF MANGA

MANGA

THE MONSTER BOOK OF MANGA

Edited by Estudio Joso

COLLINS | DESIGN

An Imprint of HarperCollins*Publishers*

THE MONSTER BOOK OF MANGA
Copyright © 2005 by COLLINS DESIGN and Loft Publications

HarperCollins books may be purchased for educational, business, or sales promotional use.
For information, please write: Special Markets Department, HarperCollins Publishers,
10 East 53rd Street, New York, NY 10022.

First Edition published in 2005 by:
Loft Publications
Via Laietana 32, 4º Of. 92
08003 Barcelona. Spain
Tel.: +34 932 688 088
Fax: +34 932 687 073
loft@loftpublications.com
www.loftpublications.com

English language edition first published in 2005 by:
Collins Design
An Imprint of HarperCollins Publishers
10 East 53rd Street
New York, NY 10022
Tel.: (212) 207-7000
Fax: (212) 207-7654
collinsdesign@harpercollins.com
www.harpercollins.com

Distributed throughout the world by:
HarperCollins Publishers
10 East 53rd Street
New York, NY 10022
Fax: (212) 207-7654

Publisher:
Paco Asensio

Editor:
Aurora Cuito

Texts and Illustrations:
Robert Garcia and Fernando Casaus/ Estudio Joso

Art Director:
Mireia Casanovas Soley

Layout:
Cris Tarradas Dulcet

Library of Congress Cataloging-in-Publication Data

The monster book of manga : draw like the experts / Estudio Joso.-- 1st
ed.
 p. cm.
 ISBN 0-06-082993-1 (pbk.)
 1. Comic books, strips, etc.--Japan--Technique. 2. Comic strip
characters--Japan. 3. Drawing--Technique. I. Estudio Joso.
 NC1764.5.J3M66 2005
 741.5--dc22
 2005021800

Printed in Spain

Fifth Printing, 2006

MANGA

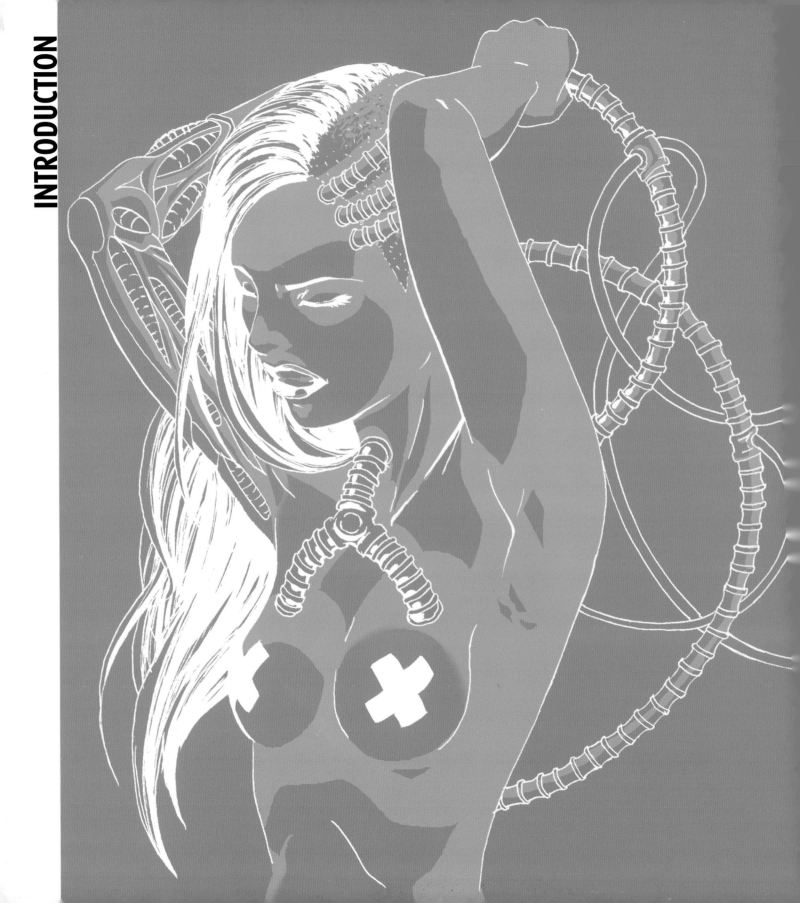

Today, Manga or Japanese comics are highly popular in many countries outside of Japan, and the consumers are not just adolescents. Manga is reaching all types of people and spans a great number of genres. As a commercial and cultural product, it has many features that set it apart from other comic genres. One of them is the presence of female characters, which are more frequent than in Western comics and they play a more leading role. Among the many and varied subgenres of Manga, Shojo Manga and Shonen Manga stand out most, aimed commercially and aesthetically at male and female readers, respectively, although both sexes read one as much as the other. In Shojo Manga, girls are often the main characters and as the plots unwind their personalities are studied in depth. Great care is taken over the aesthetics of the characters, and their faces stand out, with enormous, expressive eyes, and complexions belonging to prepubescents. Shonen Manga, however, often shows women who have a more eye-catching physique with ages ranging from adolescents to thirty-somethings.

Likewise knights, dwarfs, elves, goblins (evil creatures; astute and scheming), and other fantasy creatures have flooded the pages of Manga and are the stars of stories in which the forces of good and evil wage fierce combat.

The appearance of monsters is common in Manga, a large number coming from Western literature (vampires, mummies, werewolves, etc.), and others based on Japan's own mythology. They offer an enormous richness with a multitude of tales and legends about spirits and ghosts. The monsters are often evil characters that appear in horror or adventure Mangas, but can also be kind, likable creatures aimed at a young readership.

Also in Manga, current music trends are reflected as characters are identified with such varying styles as hip-hop, rock, pop, etc. This often does not just imply a particular aesthetic, but a way of living and thinking. They are more like urban stories, most of which take place in the present.

Other characters that are common to Manga are the samurai, members of Japan's old feudal society, of a class below the nobility made up of soldiers that served the feudal lords or the emperor. The stories they appear in focus on their extraordinary abilities or narrate an episode from Japanese history, which requires rigorous historical documentation. Drawing these types of characters also requires knowledge of different types of metal weaponry such as daggers, spears, swords, knives, and above all the characteristic katana.

Science fiction is a genre that is very rich and offers infinite possibilities, putting the illustrator's imagination to the test. The stories are set in the future or in other galaxies, and some characters combine human features with technological characteristics. Within science fiction there are various subgenres, such as Mecha Manga, whose design has gained great importance in the production of Anime and Manga. The term refers to machinery, robots, and so on, and the main characters of these stories are Robotech or Evangelion-style giant robots. The cyberpunk Mangas, on the other hand, are set in a highly technologically advanced world and combine elements from the present and the future in some sort of confrontation between man and machine. Another subgenre is the space opera; these plots are based on an interstellar conflict used as a backdrop to space battles and romantic adventures. The main element in all of these is advanced technology (high-tech), and this type of drawing requires the skills for the futuristic design of vehicles, objects, sceneries, etc. and demands a command of perspective.

Finally, we ought to point out the enormous evolution in the creative process of Japanese comics thanks to the incorporation of computers. One of the main advantages that they offer is the application and manipulation of color and, in general, the command that the artist has over all of the creative process. Thanks to advanced design programs, drawings can be digitalized so they can later be retouched, colored, and have dazzling effects added to them.

By following the explanations step by step, you can gain the practical knowledge needed to create drawings from preliminary sketches, find the most suitable posture for a character, and design the clothing, the details, and the color finish using the technique that best suits the illustrator: color pencil, marker, watercolor, color from a computer, etcetera.

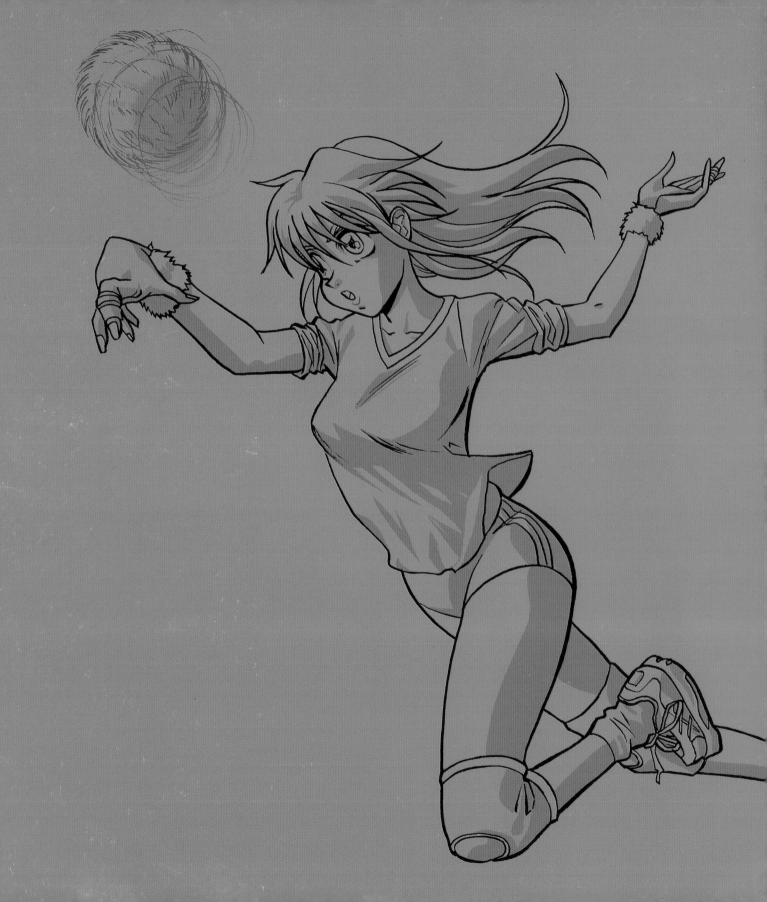

GIRLS

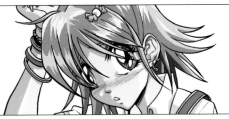

SHY SCHOOLGIRL

The life of a student is a reoccurring theme in Manga plots, and in the school environment the female characters often have defined characteristics.

The typical student is young, between 12 and 14 years old, and wears a school uniform, in this case, a shirt and a skirt. But the attire is not just the uniform; the girl also wears homemade accessories: bracelets, earrings, necklaces, hair clips, and the typical baggy socks, very similar to leg warmers. All these give the girl an air of "kogal." This term is used in Japan to refer to adolescents who are worried about their appearance and follow fashion.

Lastly, a touch of bashfulness gives her an air of innocence, which is typical of her age.

1. Shape

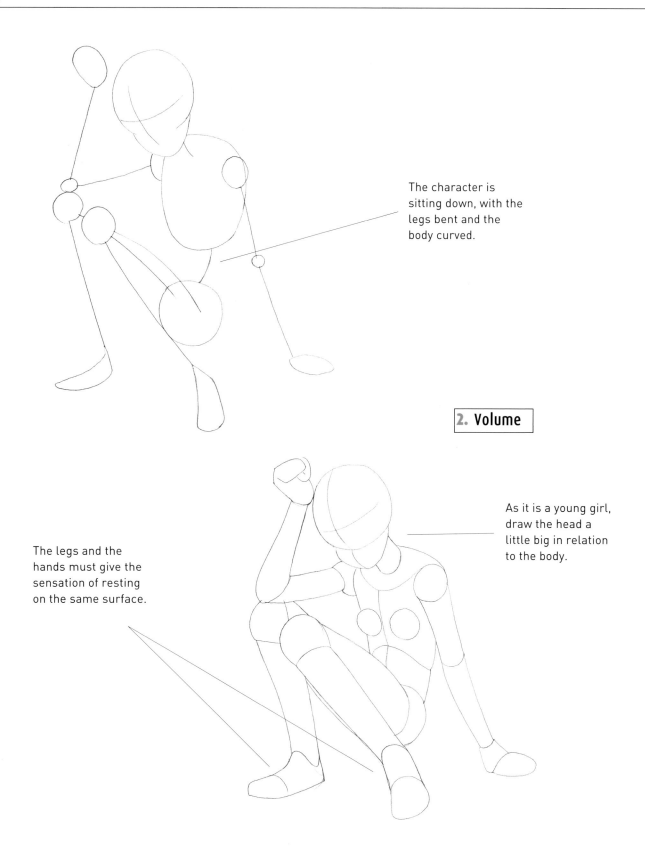

The character is sitting down, with the legs bent and the body curved.

2. Volume

The legs and the hands must give the sensation of resting on the same surface.

As it is a young girl, draw the head a little big in relation to the body.

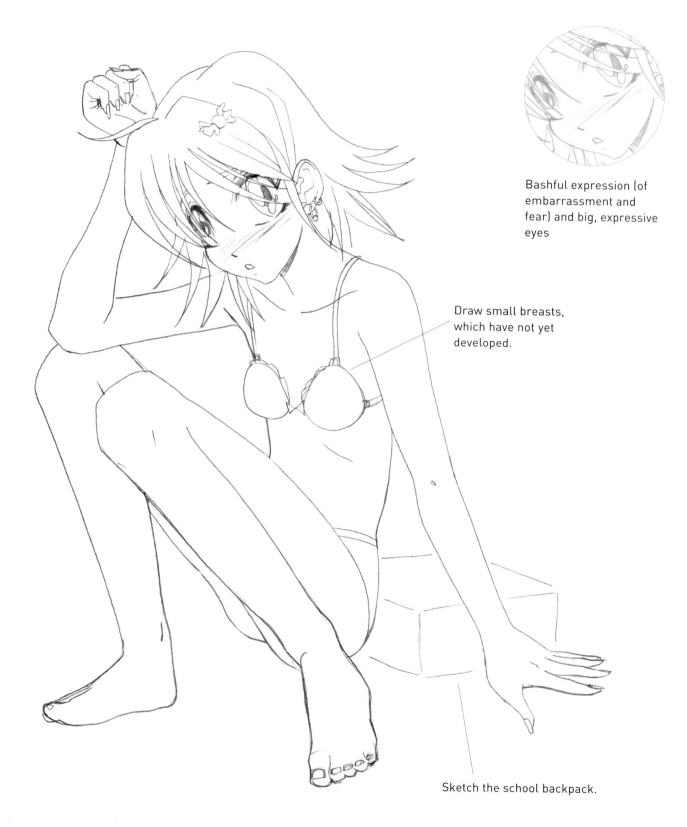

Bashful expression (of embarrassment and fear) and big, expressive eyes

Draw small breasts, which have not yet developed.

Sketch the school backpack.

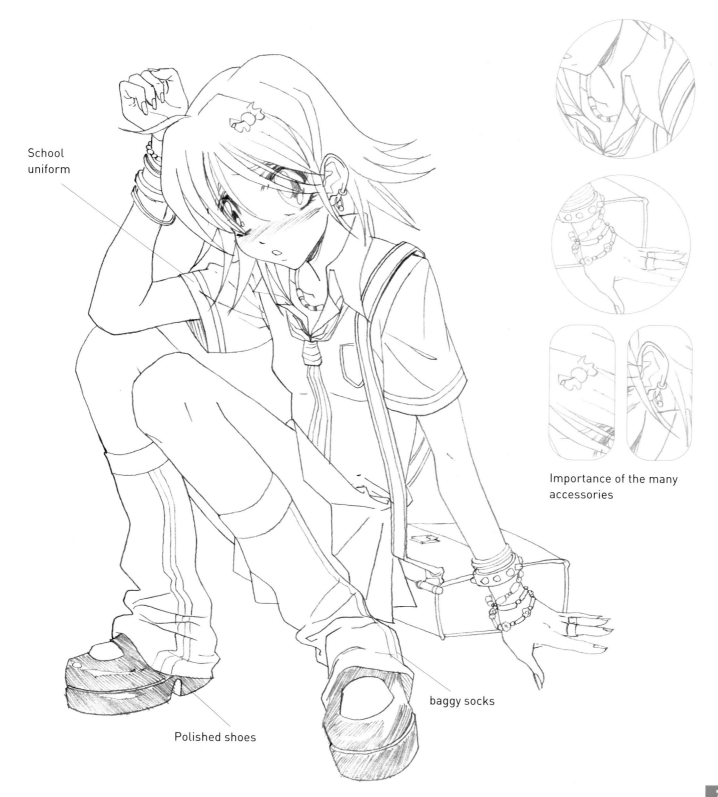

School
uniform

Importance of the many
accessories

baggy socks

Polished shoes

The shadows of the hair follow its shape

Source of light

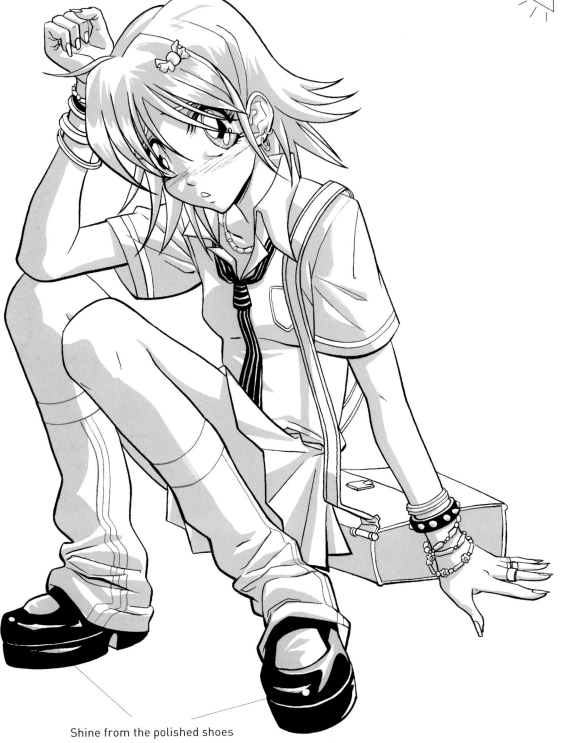

Shine from the polished shoes

The texture of the skirt is achieved by crossing vertical and horizontal straight lines as if it were a blanket.

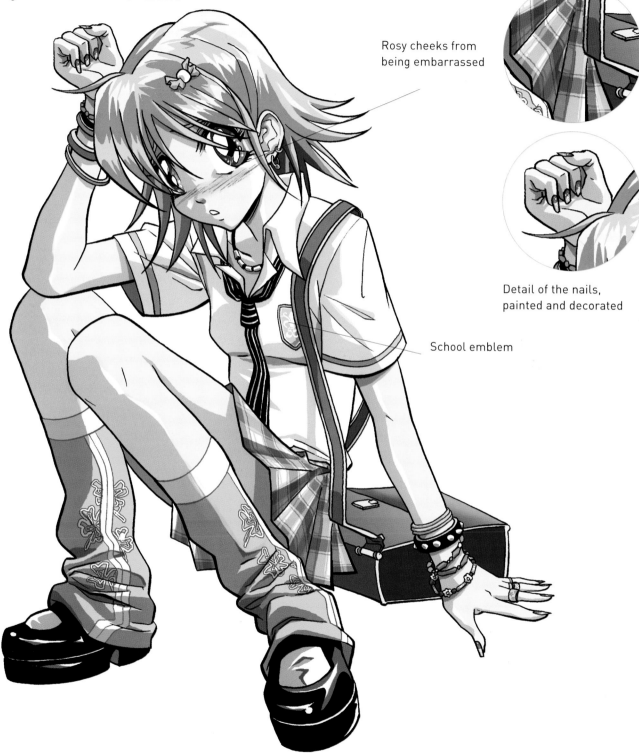

Rosy cheeks from being embarrassed

Detail of the nails, painted and decorated

School emblem

SPORTY

In Japan sport is very important at school. In order to encourage students to work and play as a team from childhood all schools have several athletic clubs.

In the following exercise, we will draw a female volleyball player in a very dynamic position, jumping through the air. Instead of representing the usual abruptness of quick movements, we will try to show a certain gracefulness and elegance in the posture, as if she were floating.

Lastly, to reinforce the effect of motion, instead of using kinetic lines, we will draw a trail that the character leaves behind her.

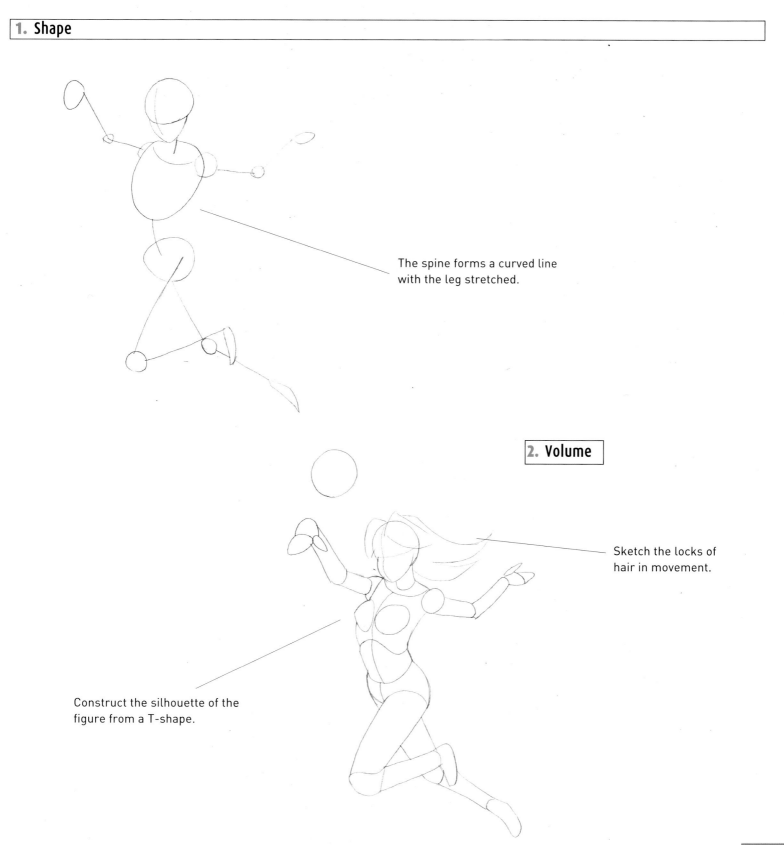

1. Shape

The spine forms a curved line with the leg stretched.

2. Volume

Sketch the locks of hair in movement.

Construct the silhouette of the figure from a T-shape.

11

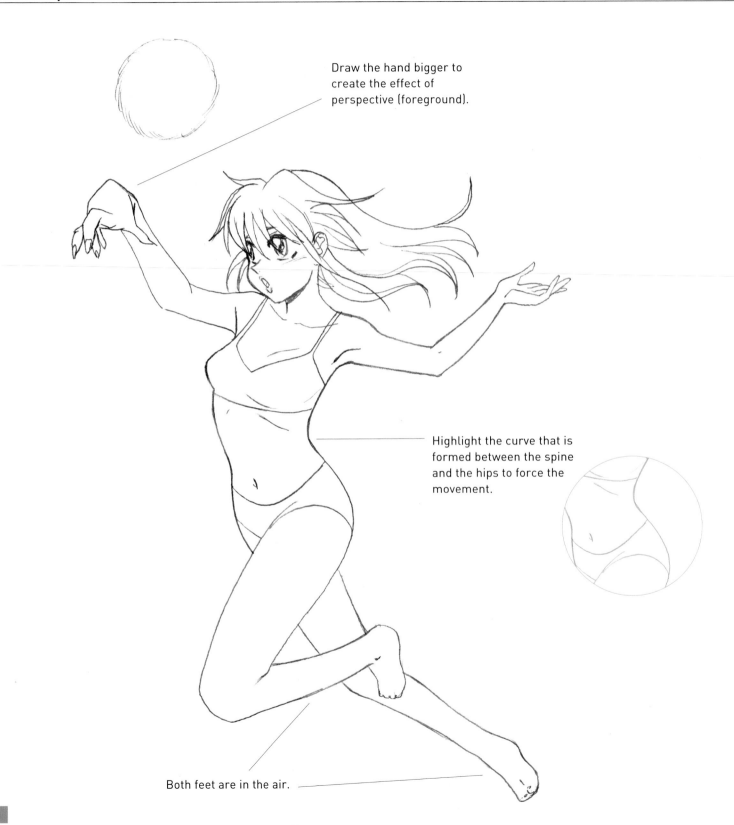

Draw the hand bigger to
create the effect of
perspective (foreground).

Highlight the curve that is
formed between the spine
and the hips to force the
movement.

Both feet are in the air.

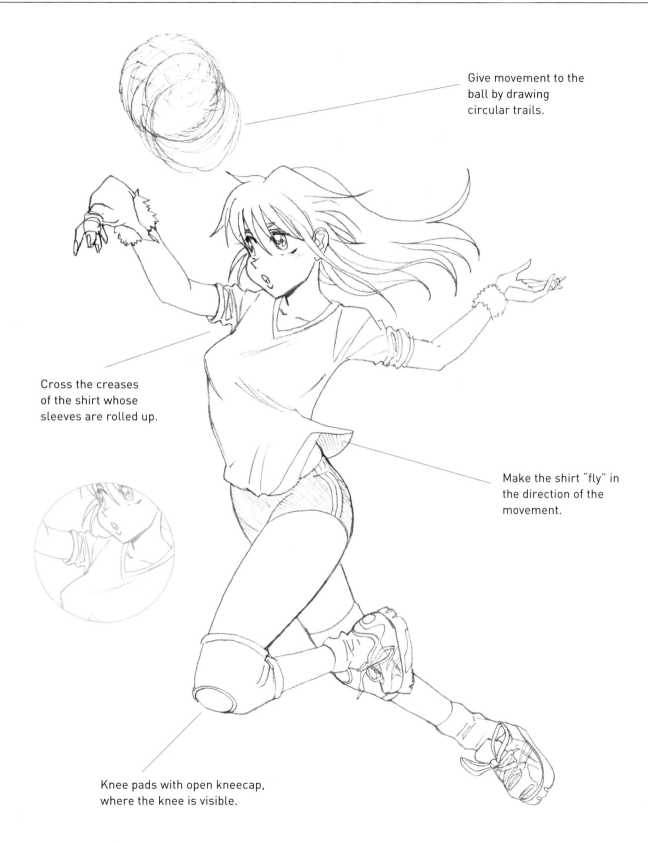

Give movement to the ball by drawing circular trails.

Cross the creases of the shirt whose sleeves are rolled up.

Make the shirt "fly" in the direction of the movement.

Knee pads with open kneecap, where the knee is visible.

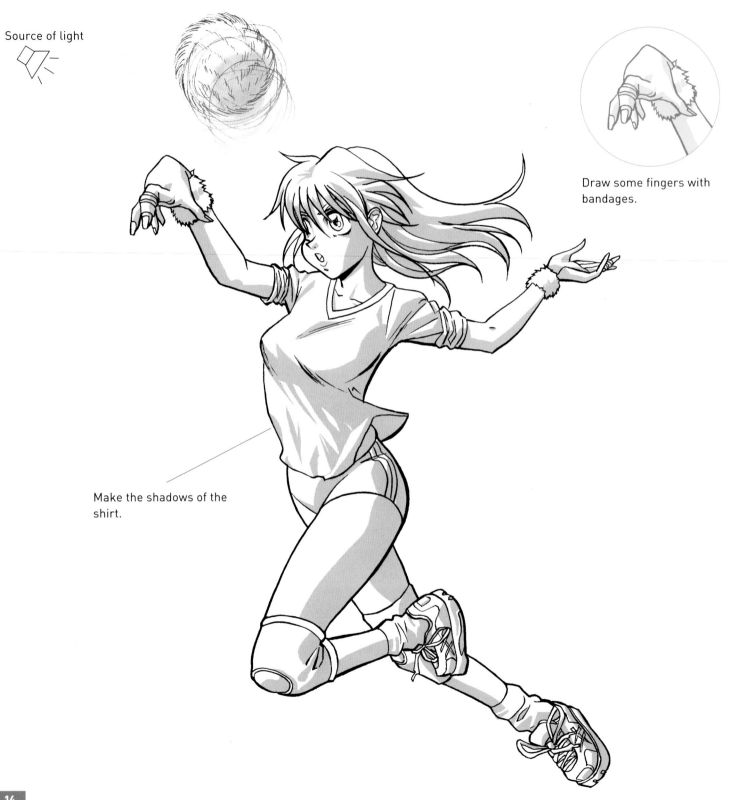

Source of light

Draw some fingers with bandages.

Make the shadows of the shirt.

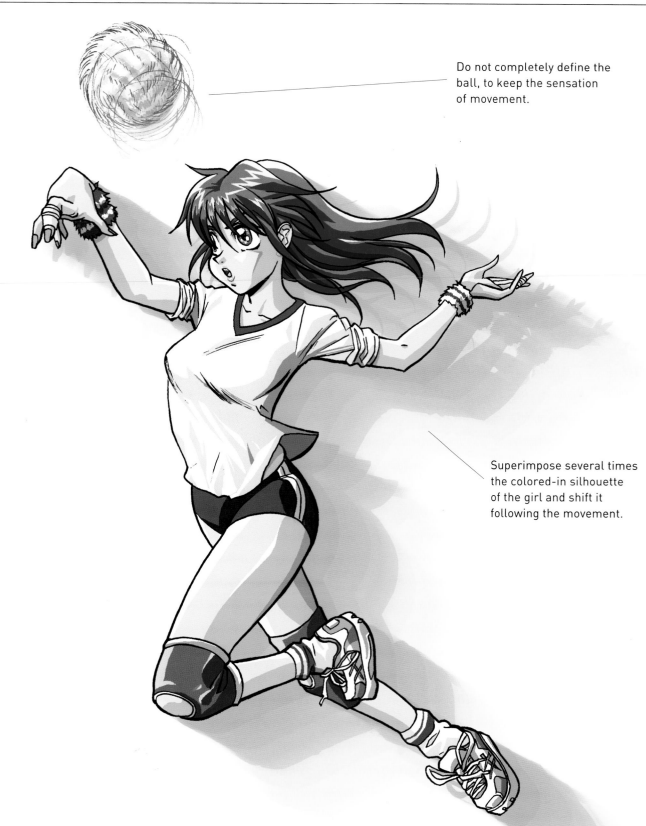

Do not completely define the ball, to keep the sensation of movement.

Superimpose several times the colored-in silhouette of the girl and shift it following the movement.

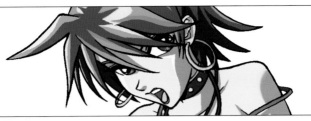

STATIC MOVEMENT

In the following exercise we will try to give the impression of energy and movement in the figure of a character without the feet being off the ground.

To achieve this effect, it is important to open the body's extremities and give the trunk an inclination, so that it does not look too stiff. So starting from a posture with the legs more or less open, the movement will be focused from the waist upwards.

It is advisable to draw with a stroke based on soft, curved lines. The use of accessories can help give the figure more motion, as drawing objects in movement emphasizes this sensation in the whole body.

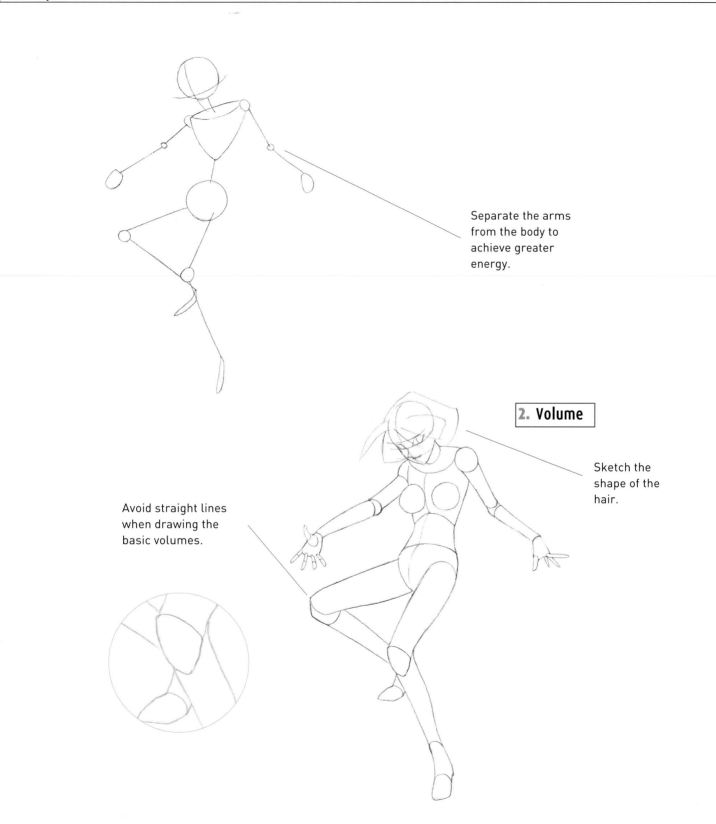

Separate the arms
from the body to
achieve greater
energy.

2. Volume

Sketch the
shape of the
hair.

Avoid straight lines
when drawing the
basic volumes.

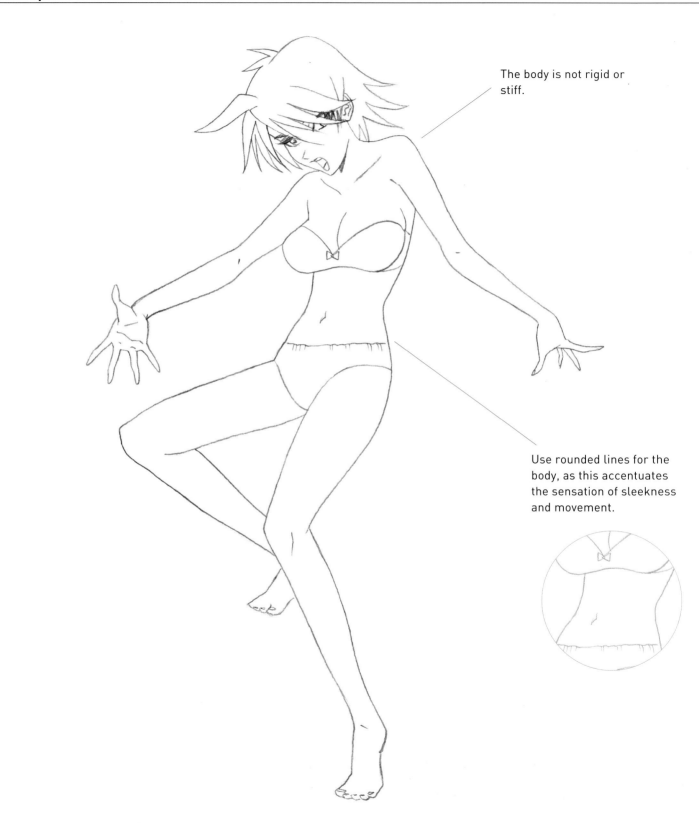

The body is not rigid or stiff.

Use rounded lines for the body, as this accentuates the sensation of sleekness and movement.

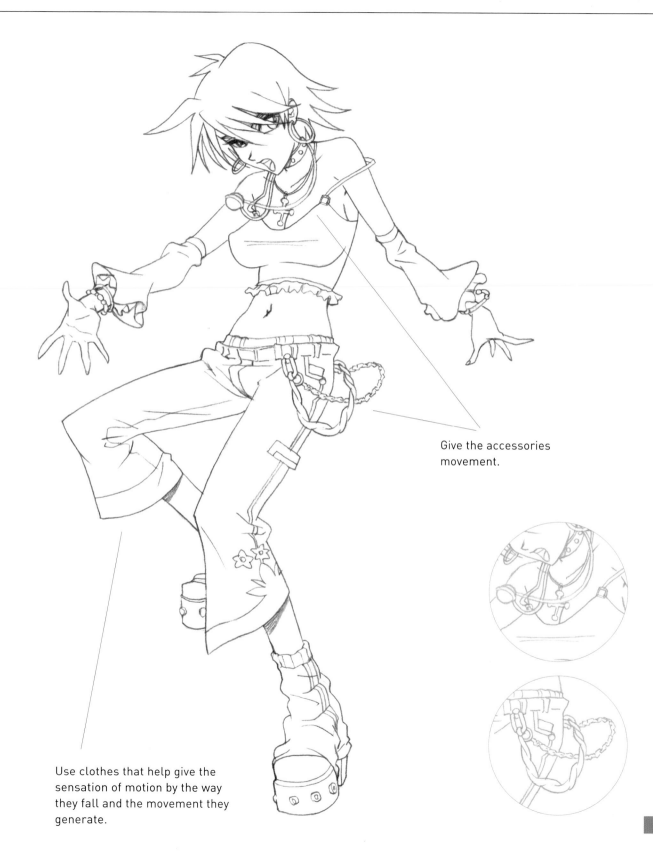

Give the accessories movement.

Use clothes that help give the sensation of motion by the way they fall and the movement they generate.

Source of light

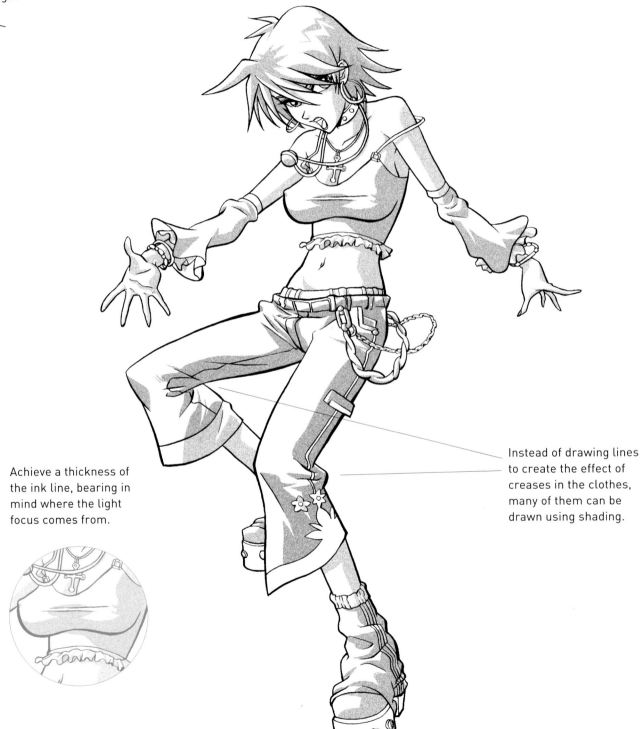

Achieve a thickness of
the ink line, bearing in
mind where the light
focus comes from.

Instead of drawing lines
to create the effect of
creases in the clothes,
many of them can be
drawn using shading.

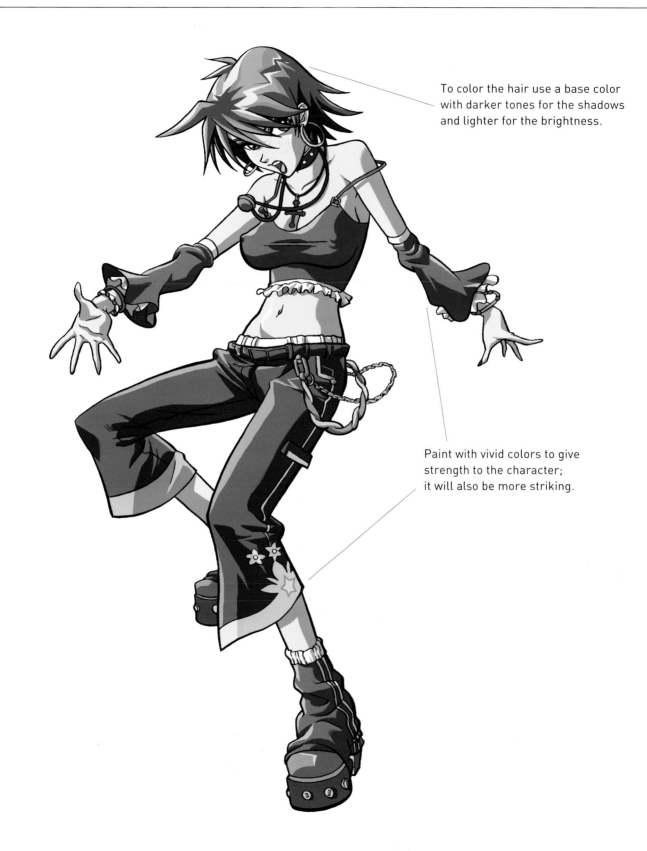

To color the hair use a base color with darker tones for the shadows and lighter for the brightness.

Paint with vivid colors to give strength to the character; it will also be more striking.

CAT GIRL

The concept of a cat woman is one of Japan's obsessions and, as such, is reflected in a large amount of Manga where some sort of reference is made to her.

In this exercise we will try to combine the attractiveness of women with that of cats, or other animals like tigers or panthers. So, we will accentuate the feline features in the face, such as wide and aggressive eyes, the triangular shape of the face, the sharp teeth, and, above all, cat ears. As for the body, since they are often aggressive, agile, and quick characters, they need a strong but light constitution. The posture has to be threatening, in such a way that it makes you fear her next move.

Clothes with a sexy cut are best for these characters, and can be complemented with accessories such as felt cat claws, a tail, or a big bell hung around the neck that reinforce the idea of being a hybrid, a mix of human and animal.

1. Shape

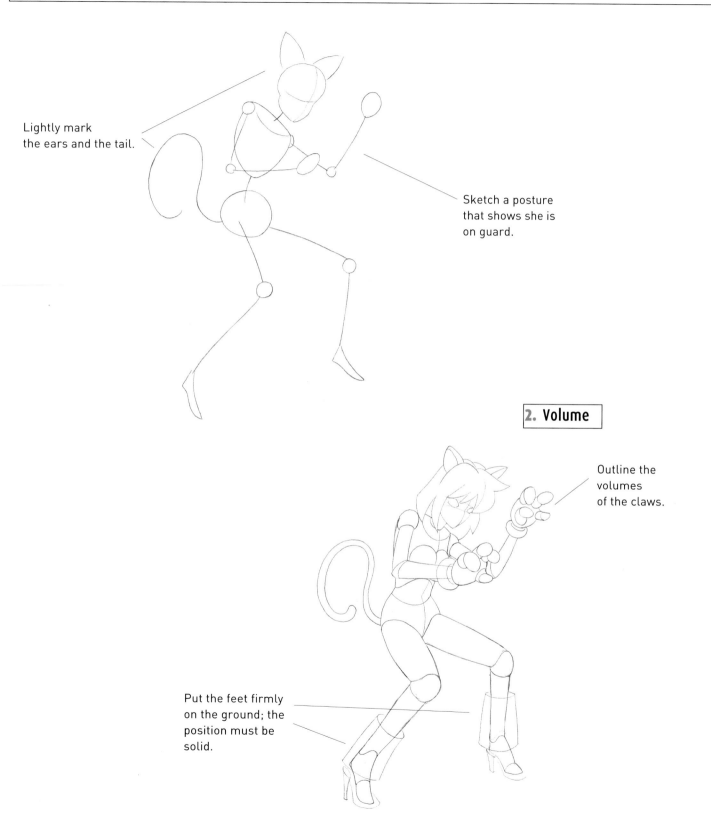

Lightly mark the ears and the tail.

Sketch a posture that shows she is on guard.

2. Volume

Outline the volumes of the claws.

Put the feet firmly on the ground; the position must be solid.

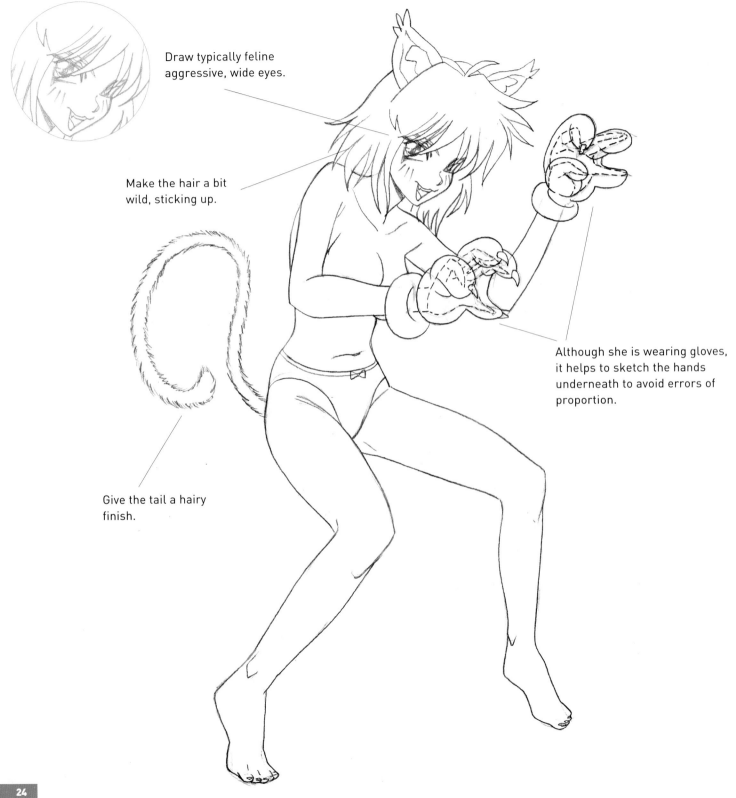

Draw typically feline aggressive, wide eyes.

Make the hair a bit wild, sticking up.

Although she is wearing gloves, it helps to sketch the hands underneath to avoid errors of proportion.

Give the tail a hairy finish.

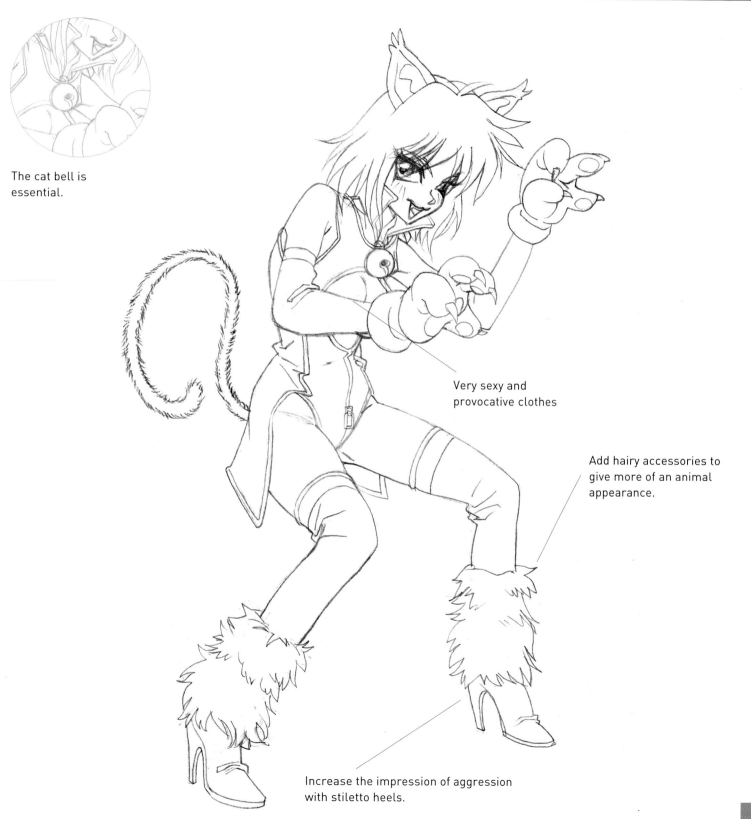

The cat bell is essential.

Very sexy and provocative clothes

Add hairy accessories to give more of an animal appearance.

Increase the impression of aggression with stiletto heels.

Give the eyes a dark outline.

Create the effect of whiskers by drawing stripes across the face.

Source of light

A thicker ink line highlights the silhouette of the claw and brings it into the foreground.

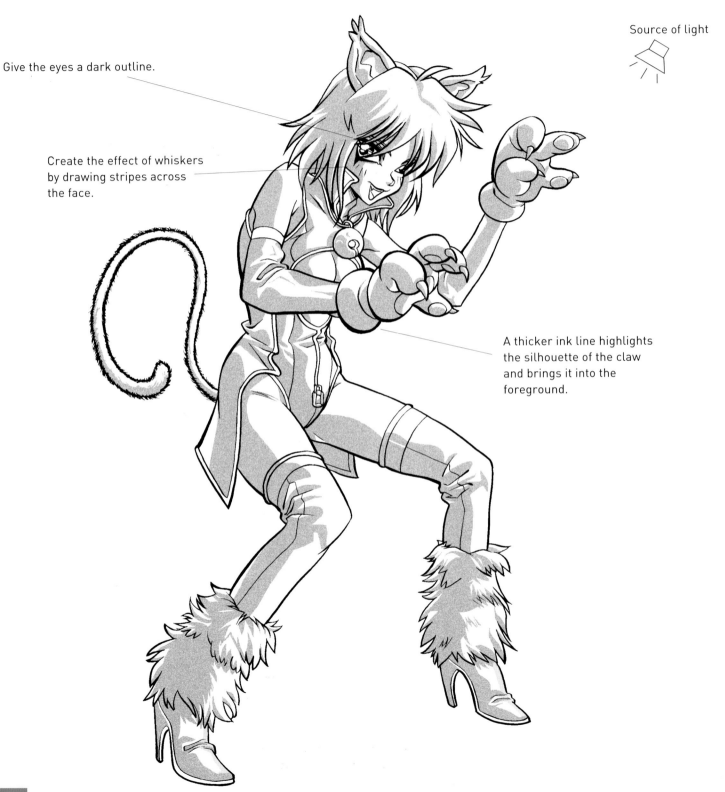

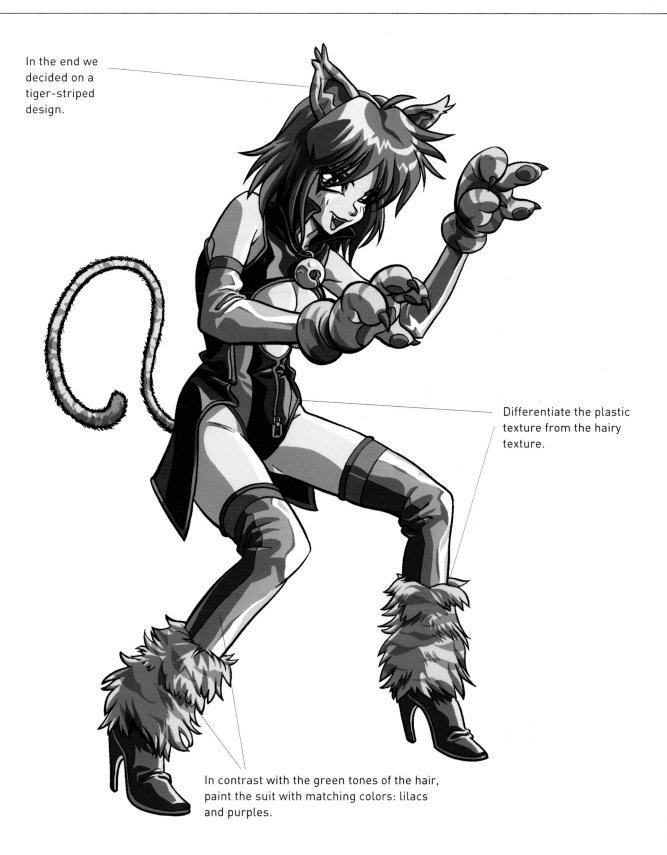

In the end we decided on a tiger-striped design.

Differentiate the plastic texture from the hairy texture.

In contrast with the green tones of the hair, paint the suit with matching colors: lilacs and purples.

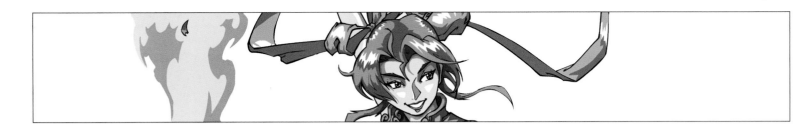

FIGHTER

This character has the three basic characteristics of a warrior, and they make her lethal in combat: strength, speed, and agility. So, she must be in excellent physical condition, well muscled, and we probably want the girl to be attractive. So, we could give her good thighs that heighten her beauty.

She has a dynamic posture that shows her speed and agility. The girl we have chosen for this exercise looks like a follower of one of the Eastern combat disciplines. In keeping with this, the clothes, the protection, the weapons, and the adornments, including the tattoo, correspond to the Eastern culture.

As in the static movement exercise, we can reinforce the idea of motion by giving movement to the clothes and accessories.

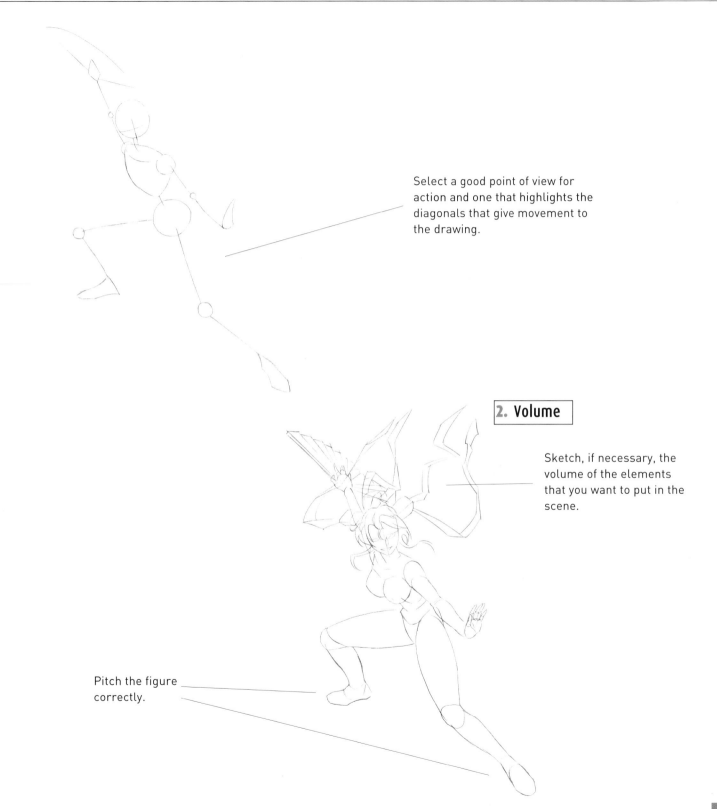

Select a good point of view for action and one that highlights the diagonals that give movement to the drawing.

2. Volume

Sketch, if necessary, the volume of the elements that you want to put in the scene.

Pitch the figure correctly.

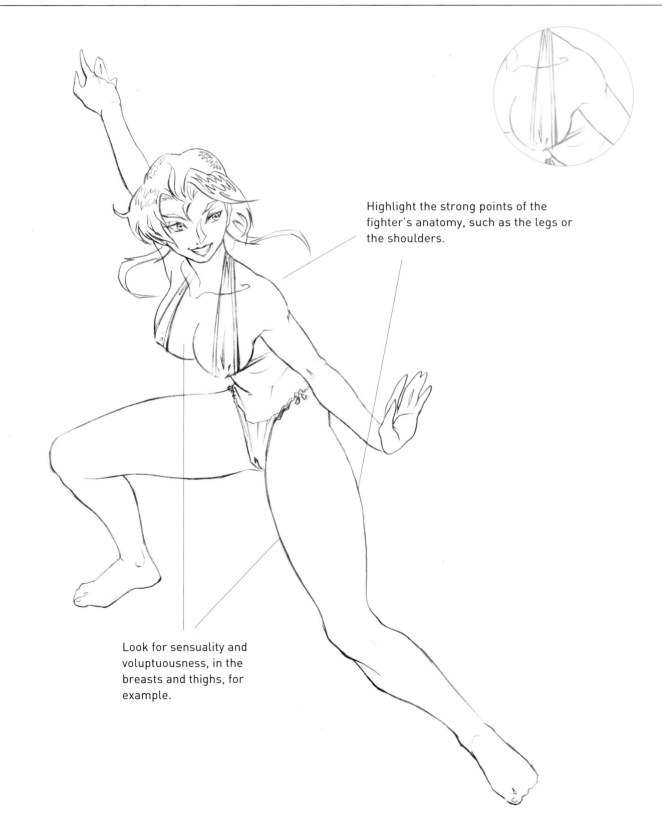

Highlight the strong points of the fighter's anatomy, such as the legs or the shoulders.

Look for sensuality and voluptuousness, in the breasts and thighs, for example.

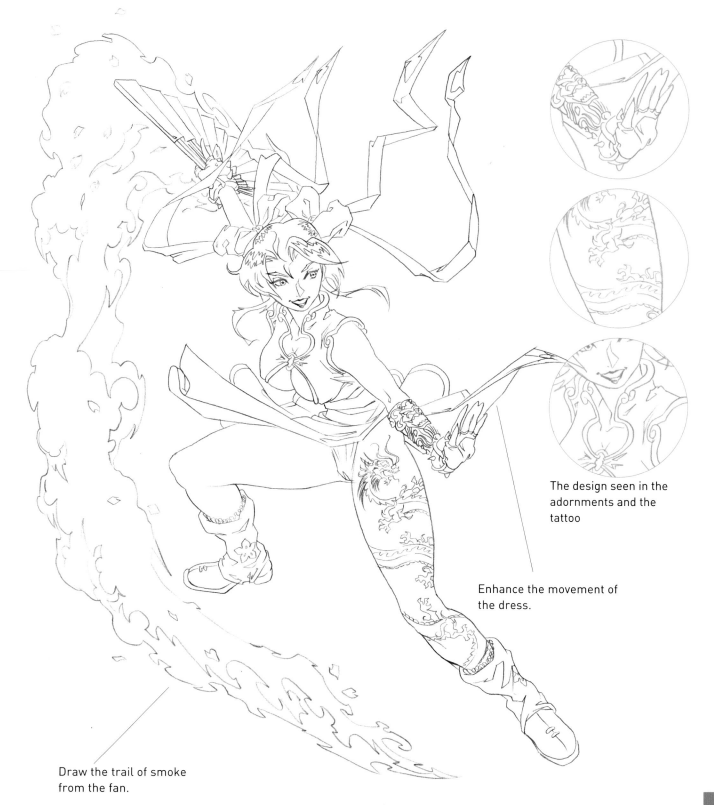

The design seen in the adornments and the tattoo

Enhance the movement of the dress.

Draw the trail of smoke from the fan.

Source of light

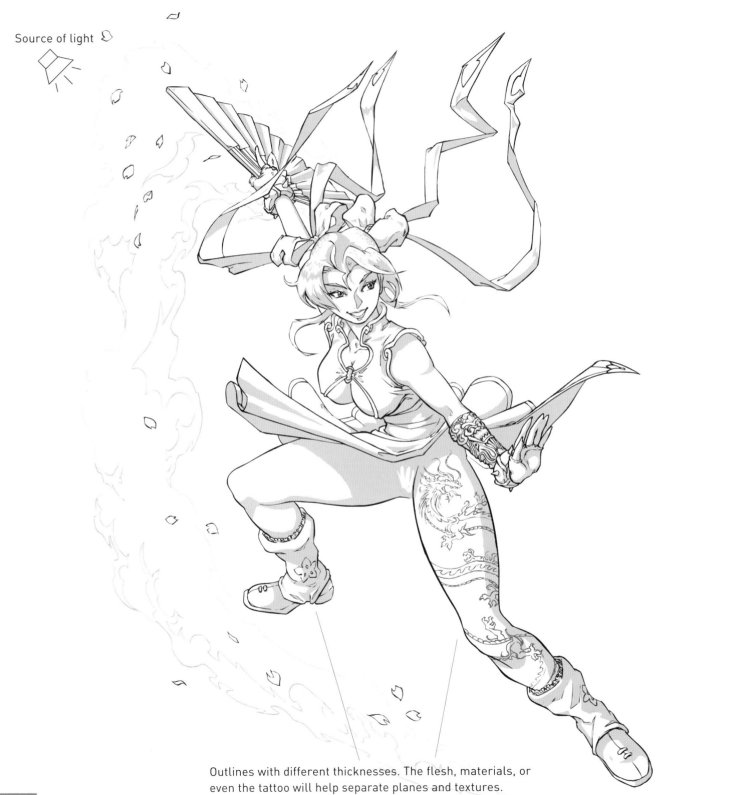

Outlines with different thicknesses. The flesh, materials, or even the tattoo will help separate planes and textures.

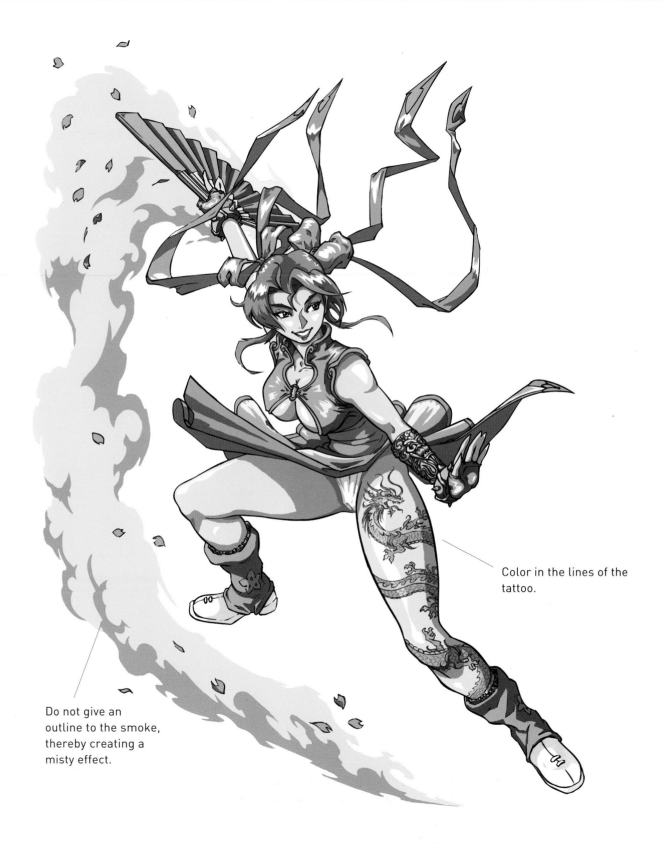

Color in the lines of the tattoo.

Do not give an outline to the smoke, thereby creating a misty effect.

GOTHIC LOLITA

Influenced by a dark Western culture of the 1980s, since the mid-1990s the "visual rock" has been very fashionable in Japan. This means a taste for anything sinister, dark, and gothic. For some people it has become a way of life. It can be seen in different artistic fields, such as music, where visual rock groups are constantly appearing and try to stand out in a saturated market. This is why they are very careful with their style, as if they were competing for the strangest look.

Within this aesthetic wave appears the figure of Gothic Lolita. With a fragile appearance, white complexion, overelaborate, dark, gothic-style dress, and hardly any facial expression, these disturbing girls are very attractive and do not lack mystery.

The girl from the following exercise follows this style, so we will respect this dark aesthetic and give her a light touch of punk and vampirism.

1. Shape

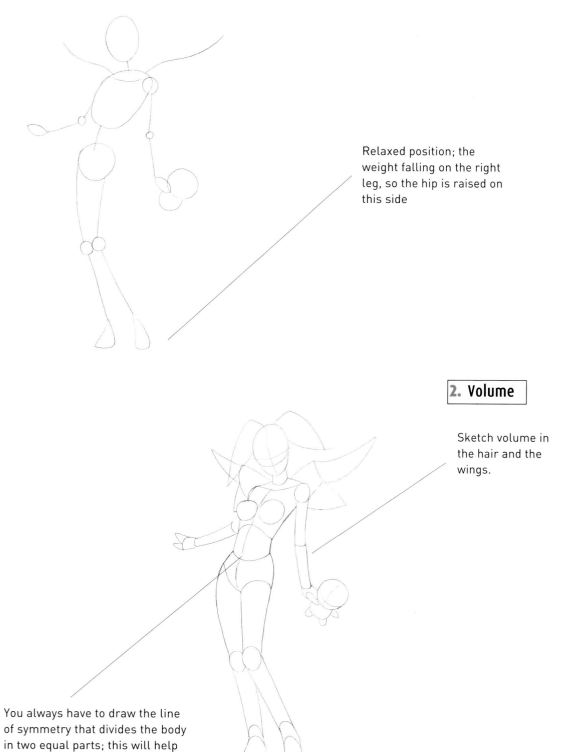

Relaxed position; the weight falling on the right leg, so the hip is raised on this side

2. Volume

Sketch volume in the hair and the wings.

You always have to draw the line of symmetry that divides the body in two equal parts; this will help as you advance in the drawing.

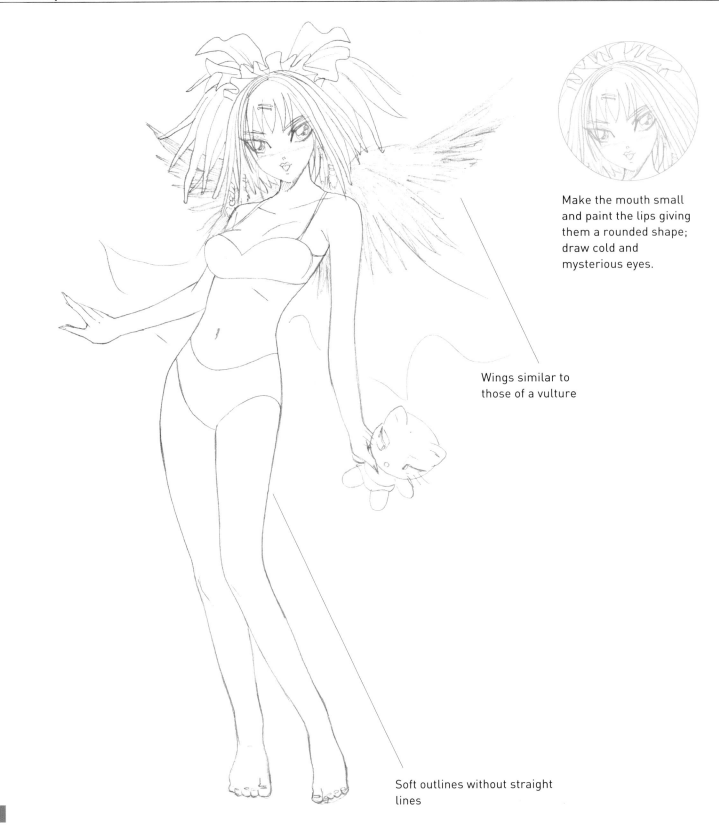

Make the mouth small and paint the lips giving them a rounded shape; draw cold and mysterious eyes.

Wings similar to those of a vulture

Soft outlines without straight lines

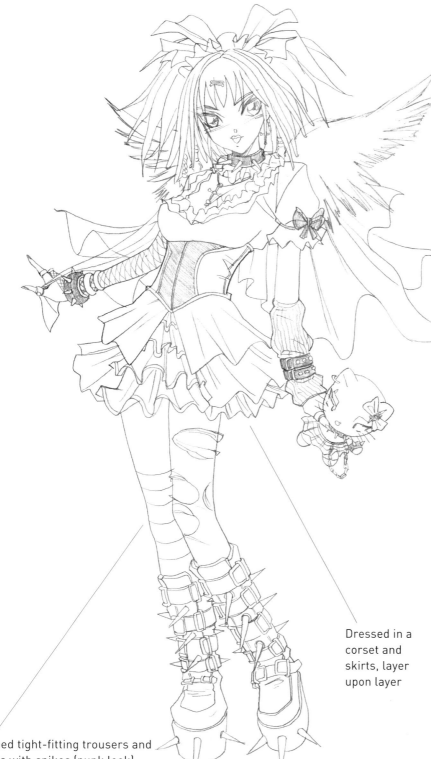

Add accessories based on leather and metal (crosses, spikes, chains, bracelets, etc.).

Dressed in a corset and skirts, layer upon layer

Ripped tight-fitting trousers and boots with spikes (punk look)

Source of light

Give the hair
dreadlocks.

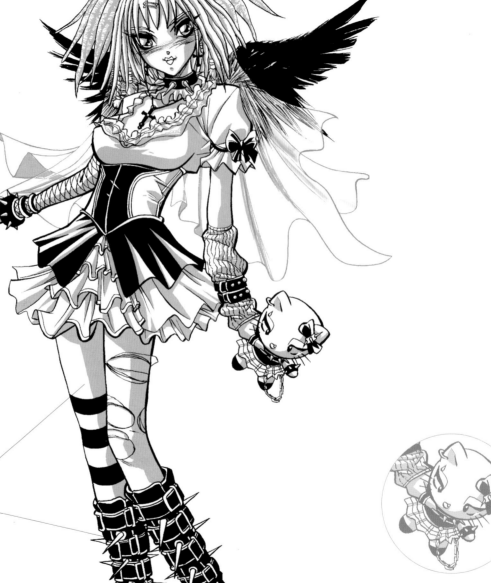

Use plenty of black tones
to give a more sinister
look.

Turn the teddy into a punk
doll adding accessories
like piercings, chains,
spikes, eye-catching
makeup, etc.

Give the skin shadow with cold tones (lilacs).

Reinforce the gothic appearance with some blood stains.

Paint the lighting misty and transparent.

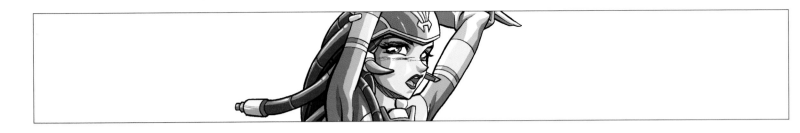

CYBERGIRL

The cyberpunk culture and science fiction inspire a genre firmly established in the world of Manga, set in futuristic scenes that are technologically advanced and populated with characters who are often halfway between human and machine.

The following exercise consists of drawing a human character but with artificial components integrated into her body.

The base of the construction of the figure is normal. At the end the artificial details are added, trying to combine the organic appearance of human skin with the coldness of materials like plastic or metal. The posture chosen is both rigid and sinuous.

1. Shape

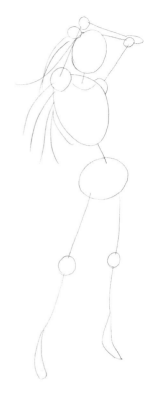

Simple position; back
arched and arms
crossed over the head

2. Volume

Draw the hips pushed
forward.

Draw the hair as long
flexible cylinders.

41

Give details to the cables that make up the hair.

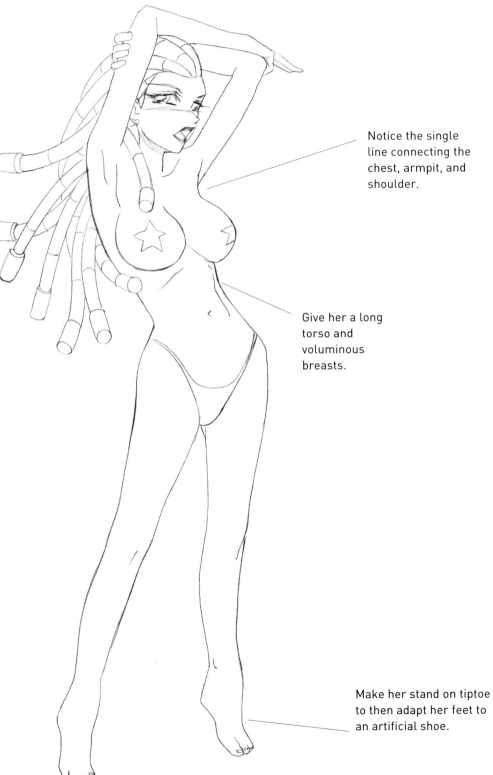

Notice the single line connecting the chest, armpit, and shoulder.

Give her a long torso and voluminous breasts.

Make her stand on tiptoe to then adapt her feet to an artificial shoe.

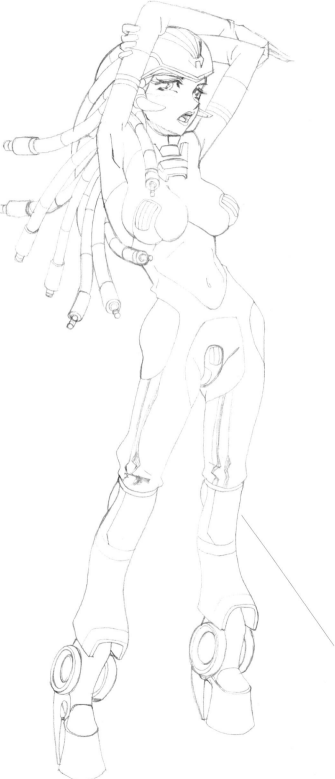

Add accessories that give her a more technological appearance.

You can give her boots or draw obviously robotic legs.

Source of light

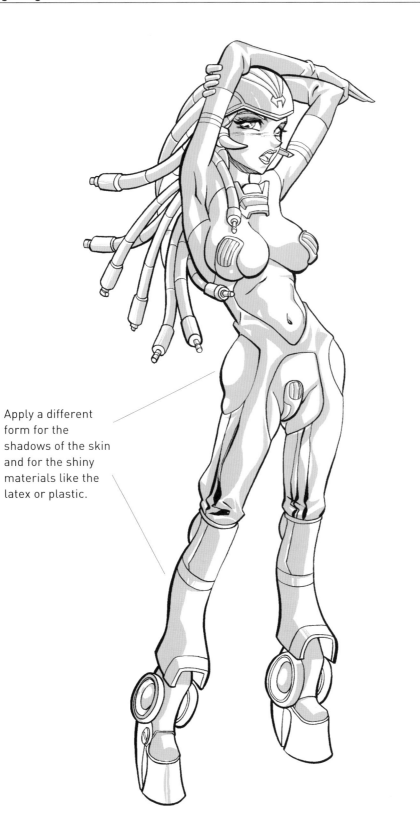

Apply a different form for the shadows of the skin and for the shiny materials like the latex or plastic.

When inking parts of machinery, make the outer lines thicker than the inner ones to reinforce the effect.

Apply a cold color base to the skin; in this case, lilac.

Give shine to the skin as if it were varnished.

Pull the clothes tight over the body, that way even the natural parts have a mechanical appearance.

Use cold colors to enhance the feeling of a mechanical woman.

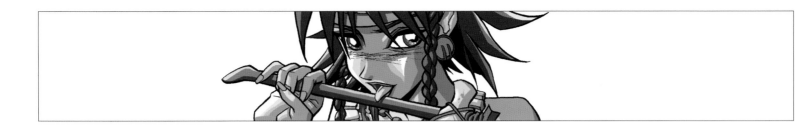

PINUP GIRL

The "pinup girls" style appeared at the time of the Second World War, when American soldiers decorated their vehicles with photos of pretty young ladies posing for the camera.

In the field of illustration, there are professionals who specialize in work of this kind, which should not be confused with pornographic illustration, as it consists of creating beautiful feminine images. In the world of Manga, where the woman plays an important part, some women follow this fashion, and there are mangakas (Manga artists) who develop it.

In this exercise we are going to draw a figure kneeling down on the floor, in quite a sensual posture, that radiates beauty and naughtiness. Since there often are not very many clothes in this type of drawing, it is a good chance to practice drawing the anatomy.

Because, we have chosen to represent an American Indian girl, ethnic designs will dominate the clothes and accessories.

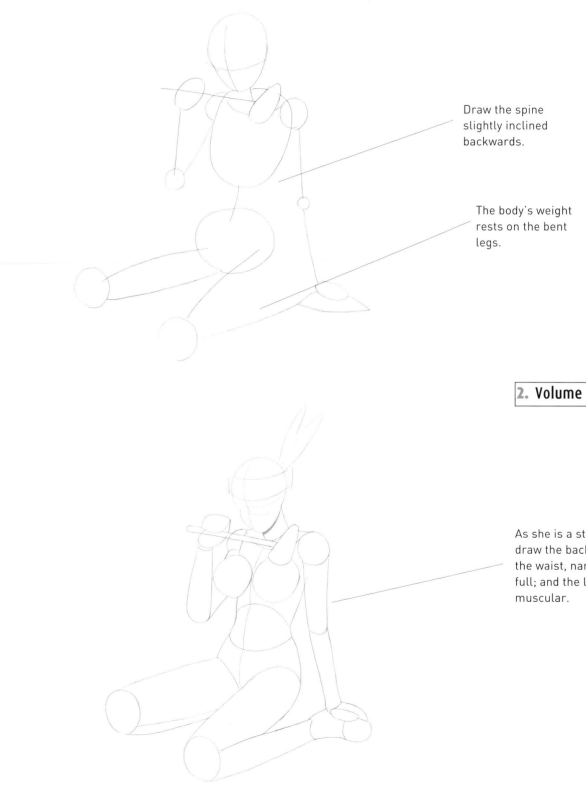

Draw the spine slightly inclined backwards.

The body's weight rests on the bent legs.

2. Volume

As she is a strong girl, draw the back quite wide; the waist, narrow; the hips, full; and the legs, muscular.

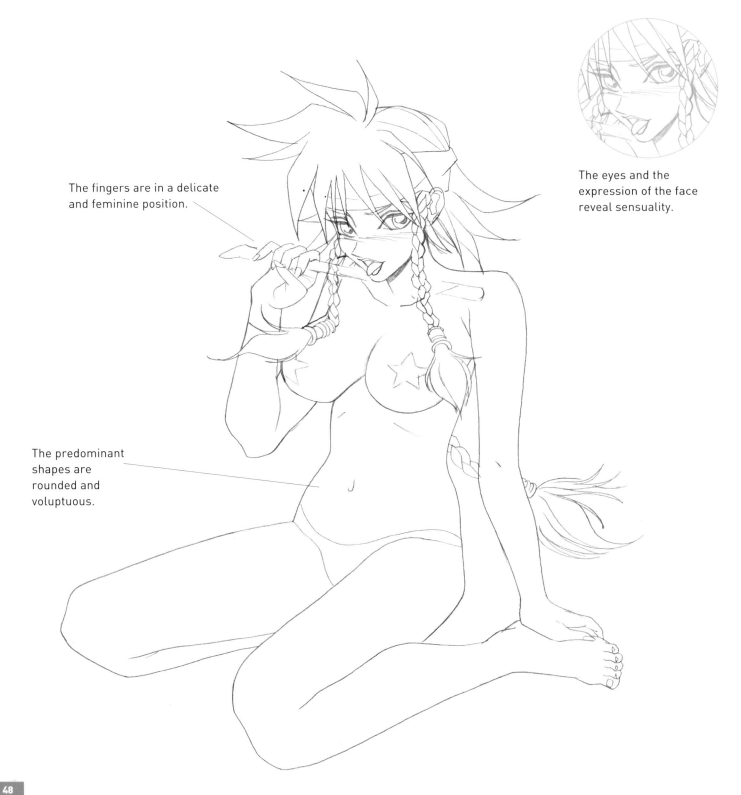

The fingers are in a delicate and feminine position.

The eyes and the expression of the face reveal sensuality.

The predominant shapes are rounded and voluptuous.

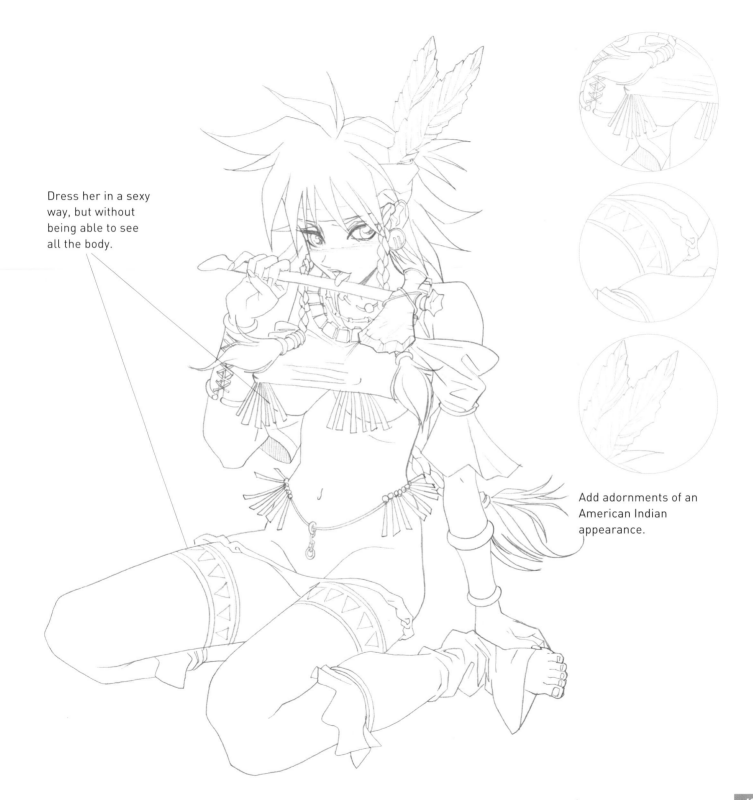

Dress her in a sexy way, but without being able to see all the body.

Add adornments of an American Indian appearance.

Source of light

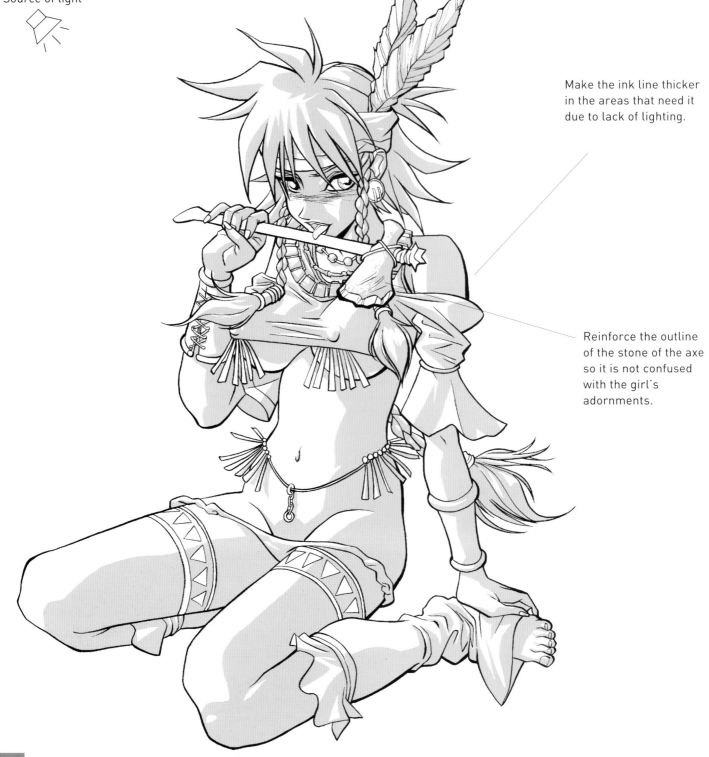

Make the ink line thicker in the areas that need it due to lack of lighting.

Reinforce the outline of the stone of the axe so it is not confused with the girl's adornments.

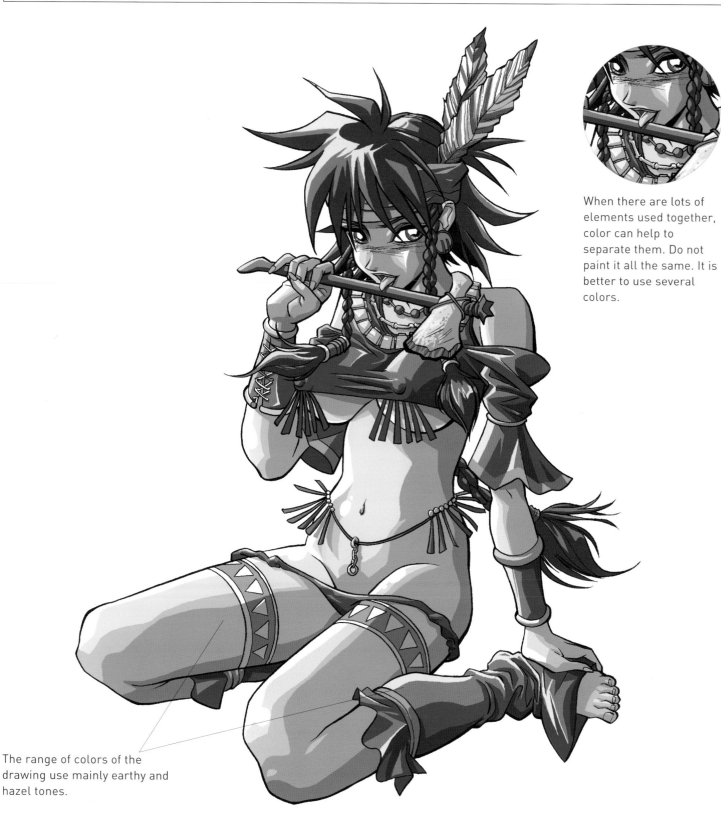

When there are lots of elements used together, color can help to separate them. Do not paint it all the same. It is better to use several colors.

The range of colors of the drawing use mainly earthy and hazel tones.

FRIENDS

In this section we are going to represent the contact between two people. Although this exercise is more complicated than just drawing a lone figure, it can be mastered with a few techniques that will be explained now, and through practice.

To achieve the feeling of close contact, we have to interlink some of the extremities or make the figures lean on each other. Once we have created a shape of the posture, now comes the crucial part, the collision of masses that will give realism to the contact. For this it is a good idea to use soft outlines, avoid constructing bodies based on rigid forms, and look for ways to add motion.

We will need clothes that reflect the effect created by the volume of the figures, allow us to control the intensity of the contact, and complete the work.

1. Shape

Interlink or join the extremities of both figures.

2. Volume

Create a point where the two characters support each other.

Make the volumes soft, not solid.

Draw the haircuts completely different.

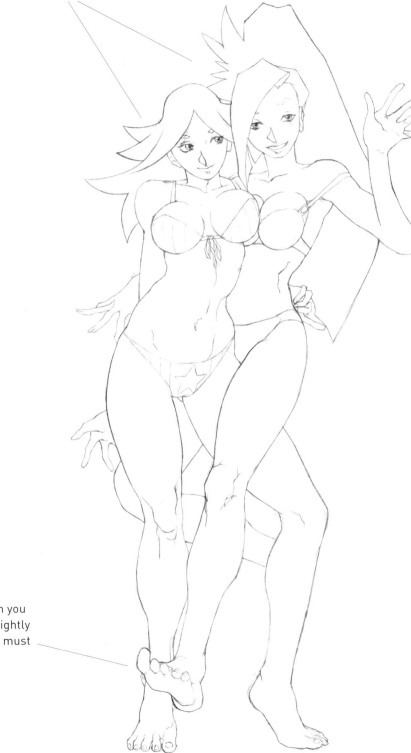

Since they are characters with muscular toning, you must define details of the body, such as the abdominal muscles.

Be careful when you draw the foot slightly raised: the sole must be visible.

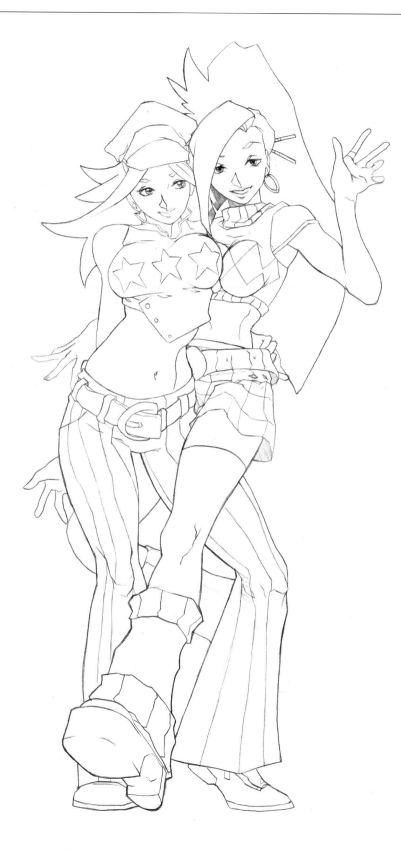

The way the clothes are used and the handling of their volume help to reinforce the effect of contact.

source of light

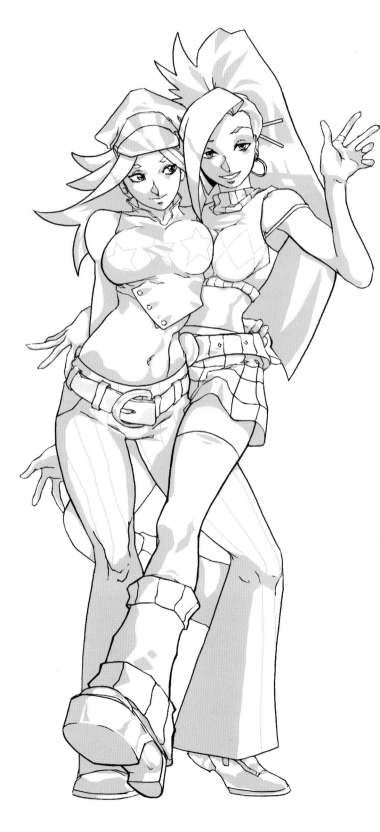

One body projects
shadow on the other.

Applying different skin
tones will help to
differentiate the
characters.

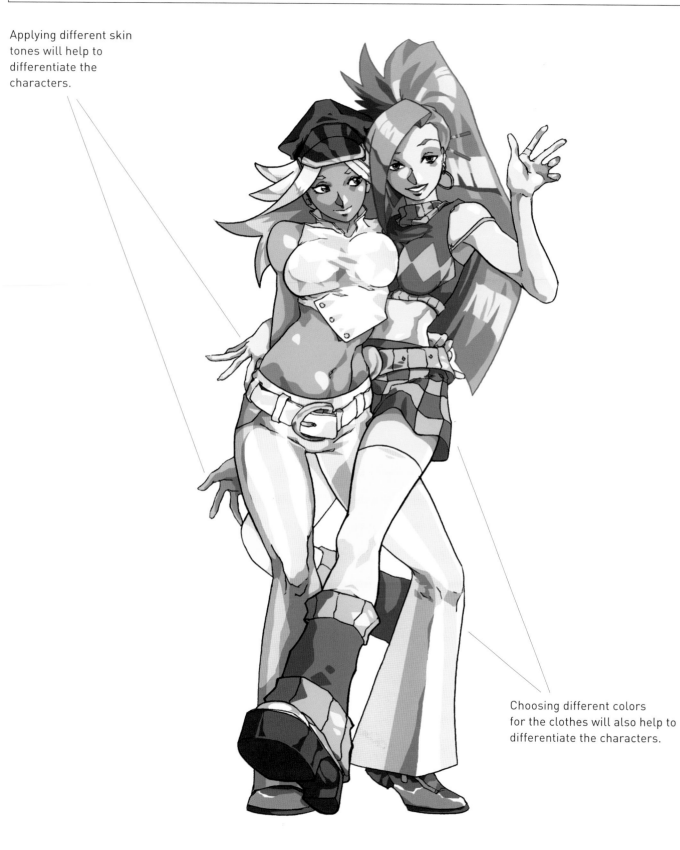

Choosing different colors
for the clothes will also help to
differentiate the characters.

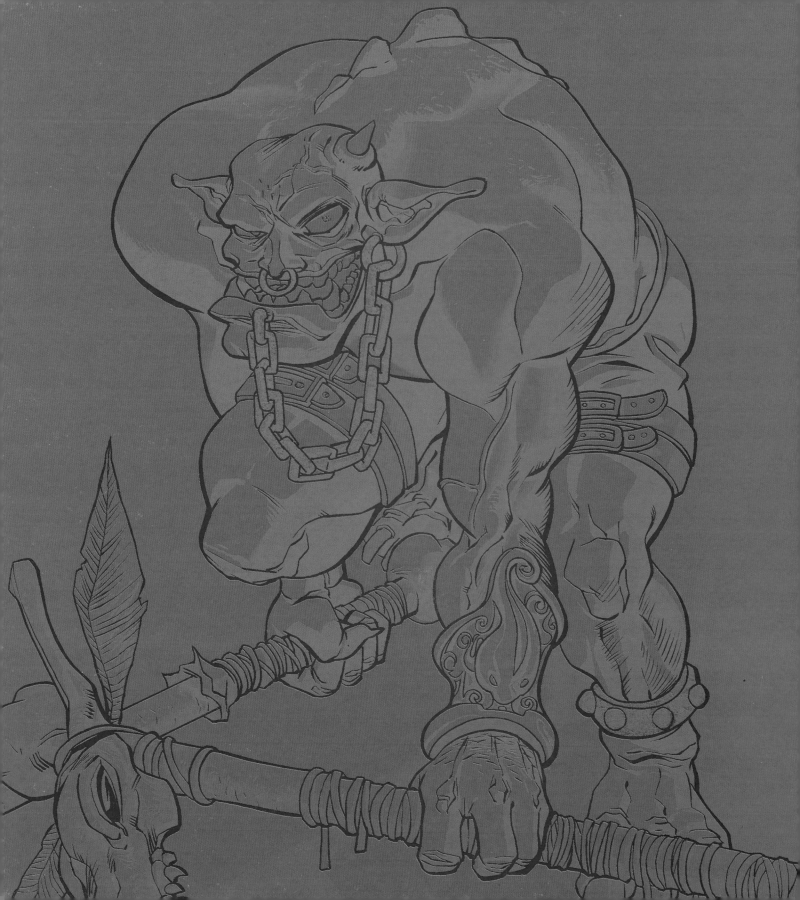

FANTASY

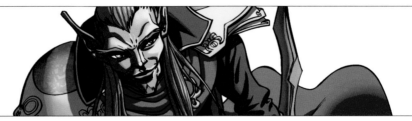

MALE ELF

Elves are fantastical creatures. They originated in Germanic mythology but have been made popular, partly thanks to the descriptions written by Tolkein. His influence has, of course, reached the Manga genre.

In this exercise we will draw an elf walking decisively with the look fixed ahead and an expression of total coldness on his face. We will also convey the sensation that the character is moving in slow motion.

It will be a good opportunity to practice coloring armour, whose effect produces shine and shimmer.

1. Shape

When walking and running, the arm opposite to the front leg is pushed forward.

2. Volume

The front leg seems bigger than the other for the effect of perspective (visual distortion).

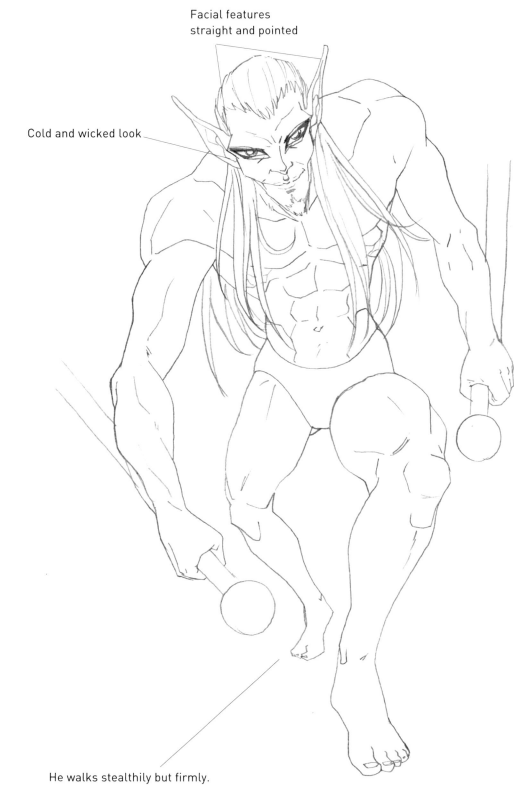

Facial features
straight and pointed

Cold and wicked look

Physical complexion:
large chest and back,
narrow waist, and veined
muscles

He walks stealthily but firmly.

Shoulder pads over the top (greater protection)

Give the cloak movement, as it flutters in the wind.

Fairly light armor, which gives greater energy and mobility

As he is a wicked character, he carries threatening weapons.

Source of light

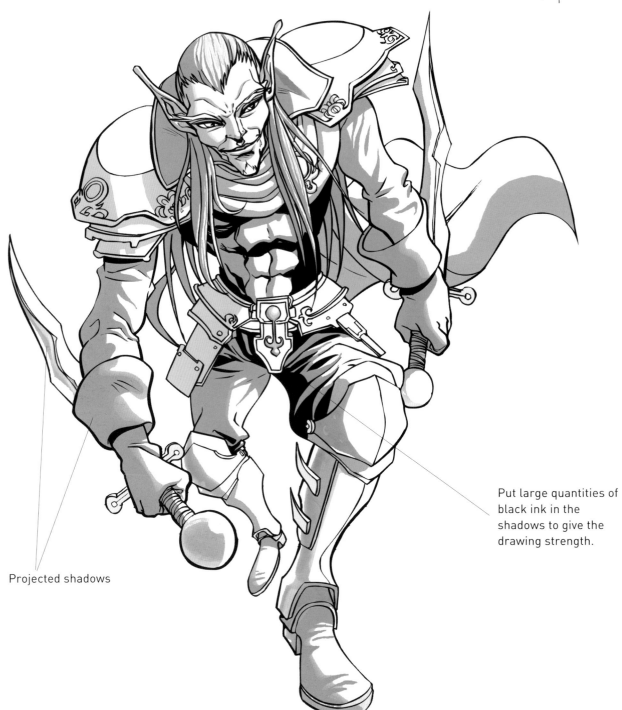

Put large quantities of black ink in the shadows to give the drawing strength.

Projected shadows

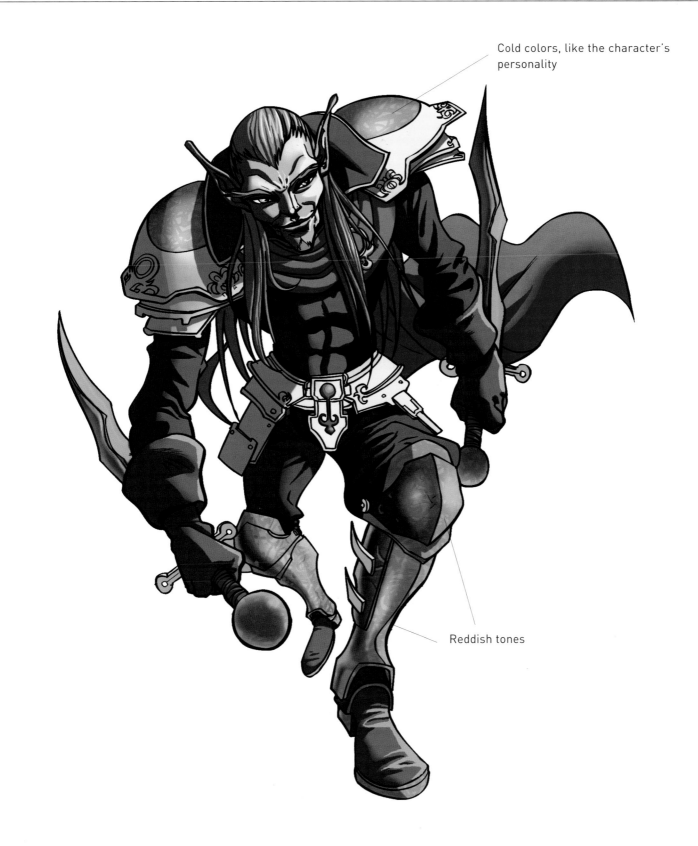

Cold colors, like the character's personality

Reddish tones

FEMALE ELF

We will draw our main female elf preparing herself to shoot an arrow, her knee on the ground and arms locked in position to shoot. We will try to convey that she is pulling the bow back softly.

To lend more strength to the drawing and make it more spectacular, we will point the arrow toward the front of the drawing and give it perspective.

Finally we will pay special attention to the folds of the clothes and the volume of the character's hair.

1. Shape

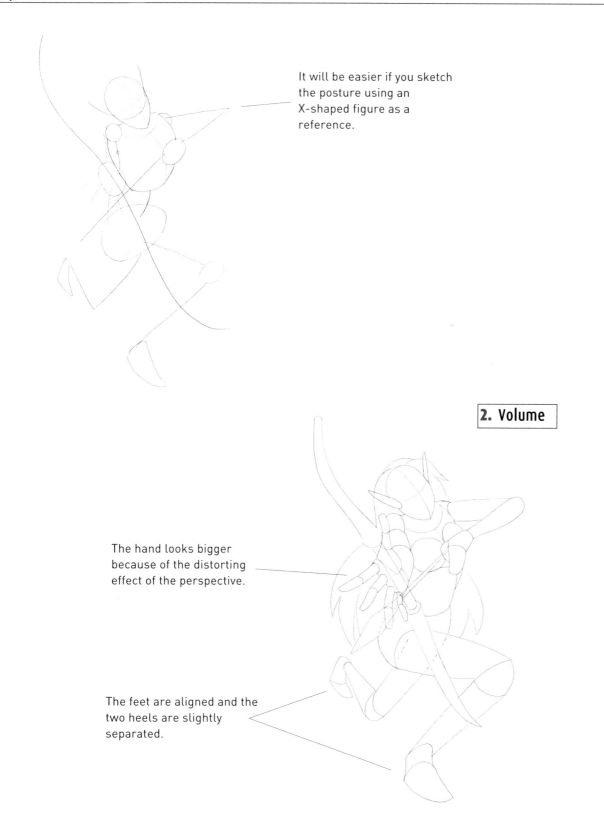

It will be easier if you sketch the posture using an X-shaped figure as a reference.

2. Volume

The hand looks bigger because of the distorting effect of the perspective.

The feet are aligned and the two heels are slightly separated.

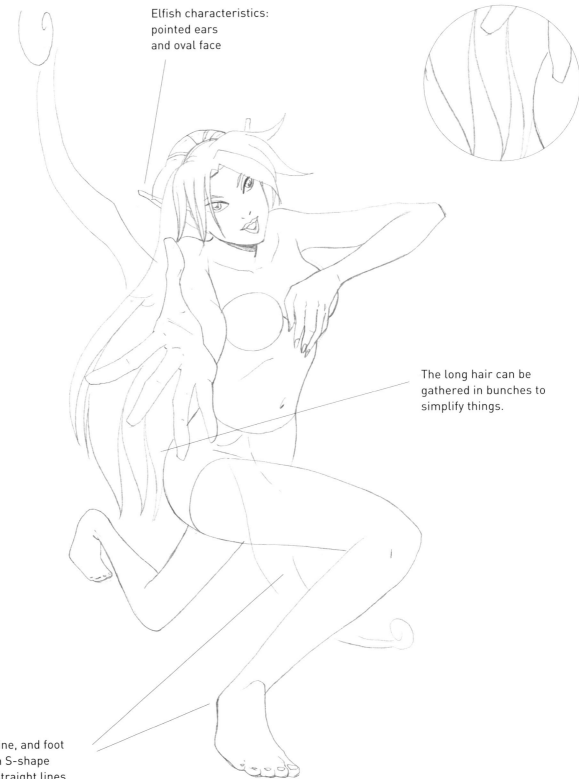

Elfish characteristics: pointed ears and oval face

The long hair can be gathered in bunches to simplify things.

Knee, spine, and foot create an S-shape without straight lines.

Draw nicks to
make the wood
older.

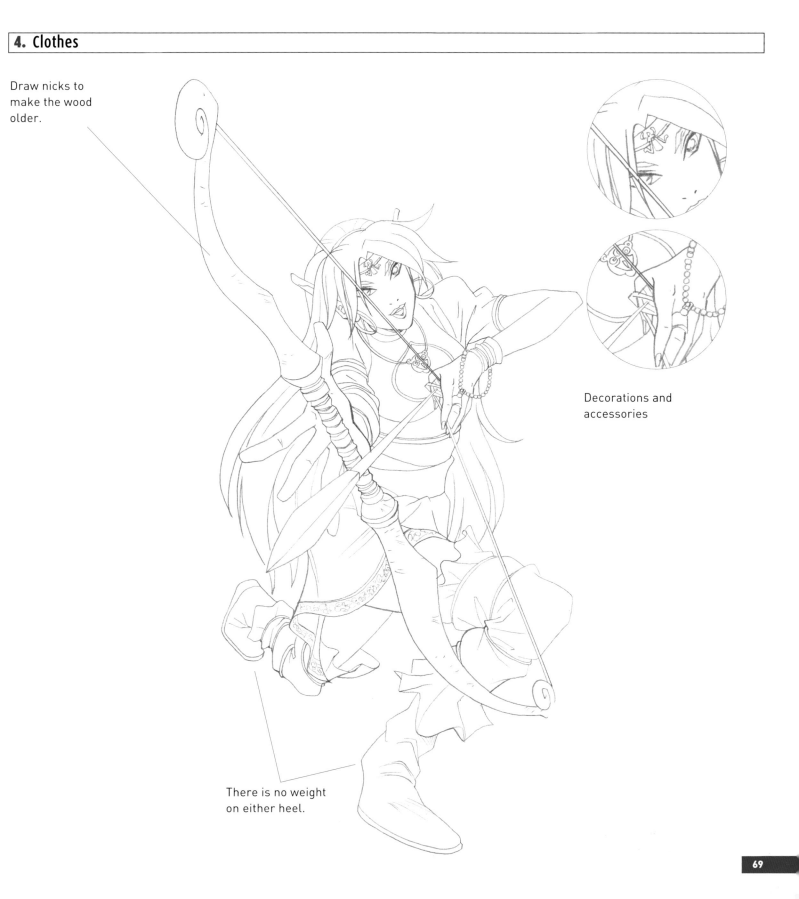

Decorations and
accessories

There is no weight
on either heel.

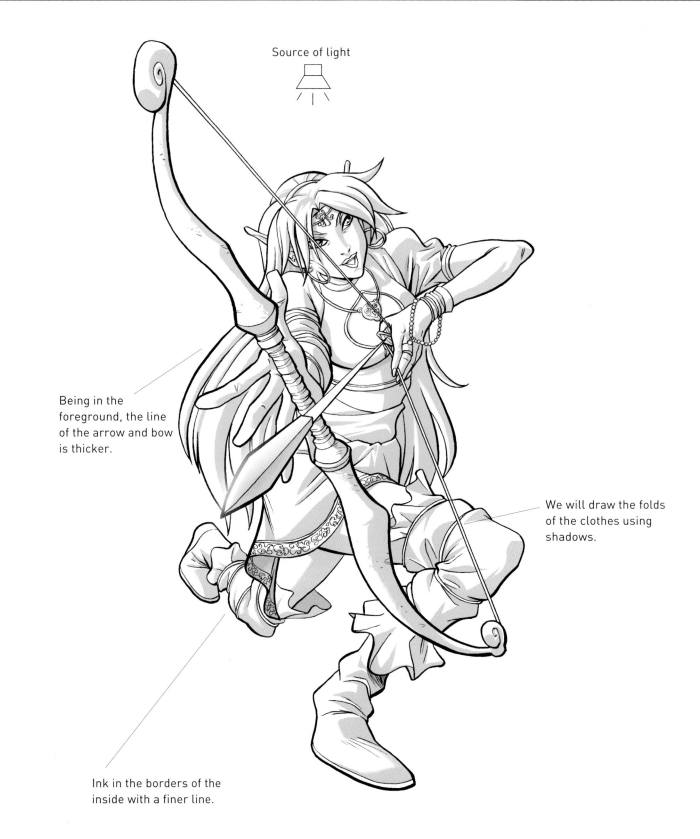

Source of light

Being in the
foreground, the line
of the arrow and bow
is thicker.

We will draw the folds
of the clothes using
shadows.

Ink in the borders of the
inside with a finer line.

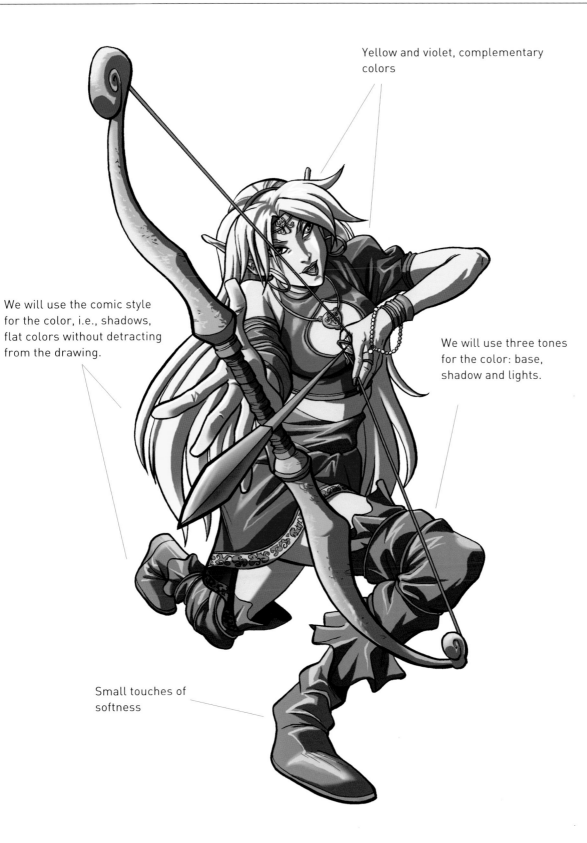

Yellow and violet, complementary colors

We will use the comic style for the color, i.e., shadows, flat colors without detracting from the drawing.

We will use three tones for the color: base, shadow and lights.

Small touches of softness

KNIGHT

The knight is a character always present in Manga's world of heroes and heroines. He is characterized by great bravery, so we will show him after having slain a dragon, which he has under his feet. But it looks as if a new threat is approaching and he is waiting for it. This is shown by using a movement of tension.

The knight must reflect, through his body and facial expression, the uncertainty and anxiety of the moment. So, the extremities are tense and his face looks worried.

Lastly, we will pay special attention to the folds in the clothes, since the materials are tough and form deep creases.

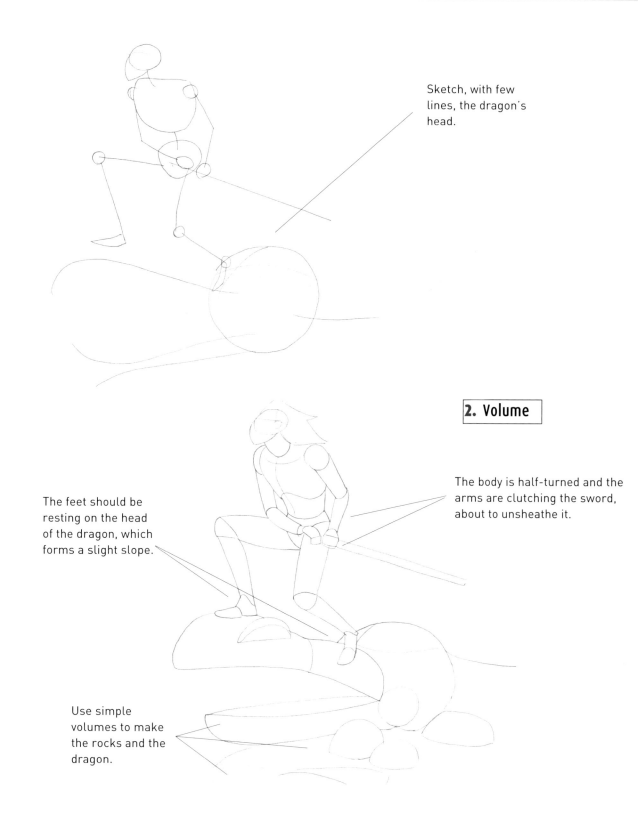

1. Shape

Sketch, with few lines, the dragon's head.

2. Volume

The body is half-turned and the arms are clutching the sword, about to unsheathe it.

The feet should be resting on the head of the dragon, which forms a slight slope.

Use simple volumes to make the rocks and the dragon.

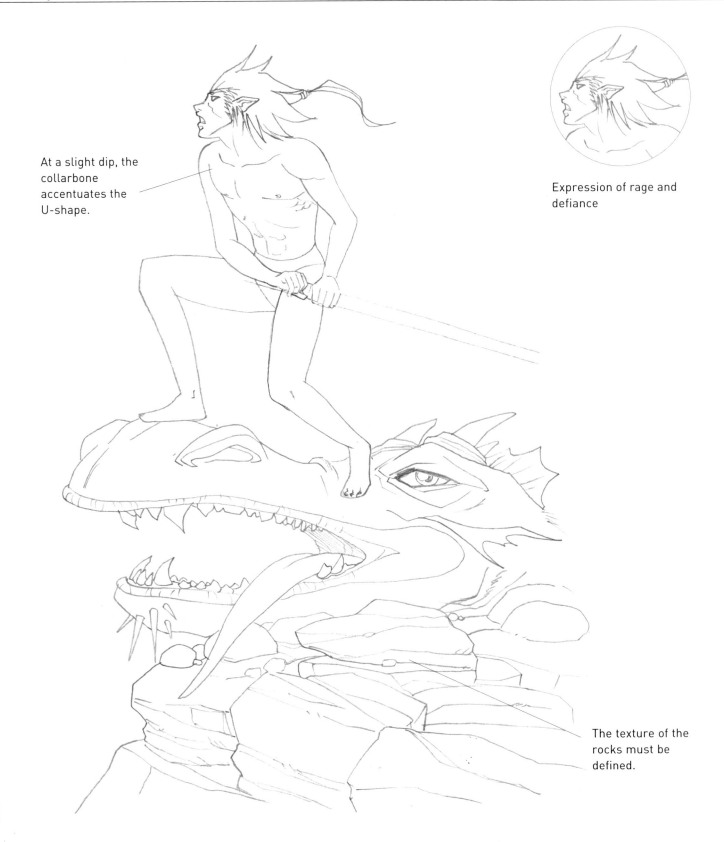

At a slight dip, the collarbone accentuates the U-shape.

Expression of rage and defiance

The texture of the rocks must be defined.

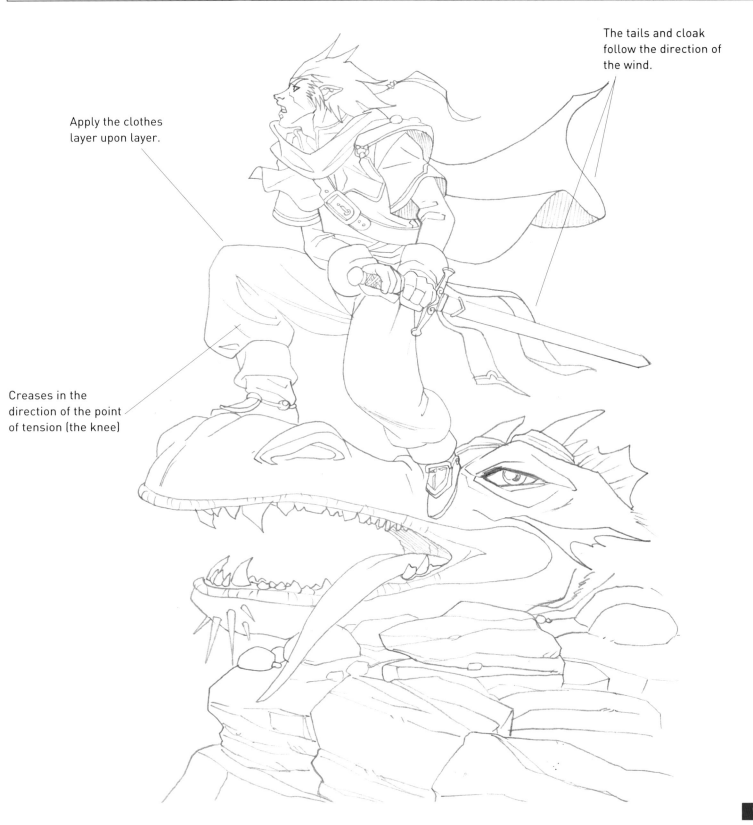

The tails and cloak follow the direction of the wind.

Apply the clothes layer upon layer.

Creases in the direction of the point of tension (the knee)

Source of light

We will draw the folds of the clothes and their shadows.

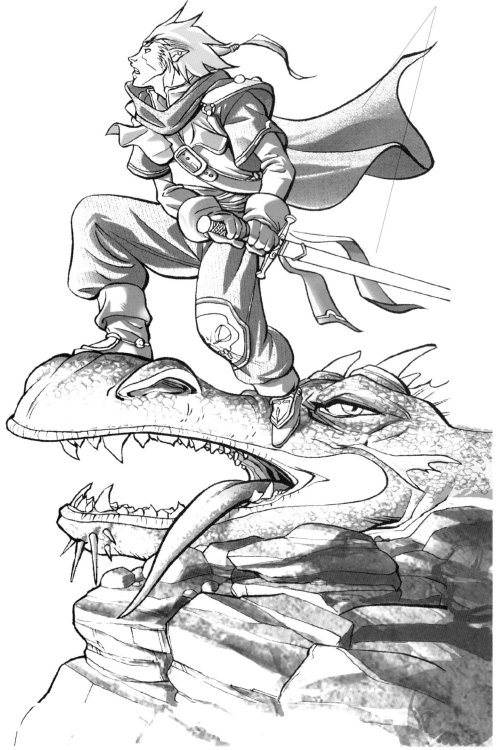

Lighting with two different light sources at the same time

source of light

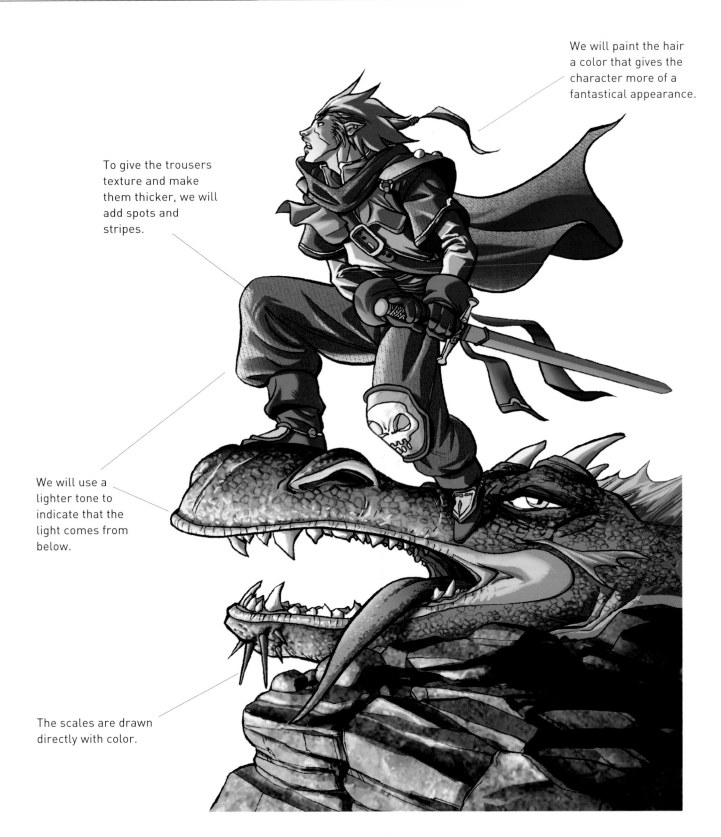

We will paint the hair a color that gives the character more of a fantastical appearance.

To give the trousers texture and make them thicker, we will add spots and stripes.

We will use a lighter tone to indicate that the light comes from below.

The scales are drawn directly with color.

EXPLORER

Here we will practice how to draw a character riding an animal. In this case the animal is a gigantic, hairy anteater.

The girl, wearing very tight, sexy clothing, is standing up on the animal with her body leaning forward staring into the horizon. It is quite a forced position, but natural at the same time, quite naïve and not at all aggressive.

It will be interesting to draw the explorer's accessories, as well as the anteater's fur coat and armour. We will also introduce a simple background: a mountainous landscape and an enormous rock next to the characters.

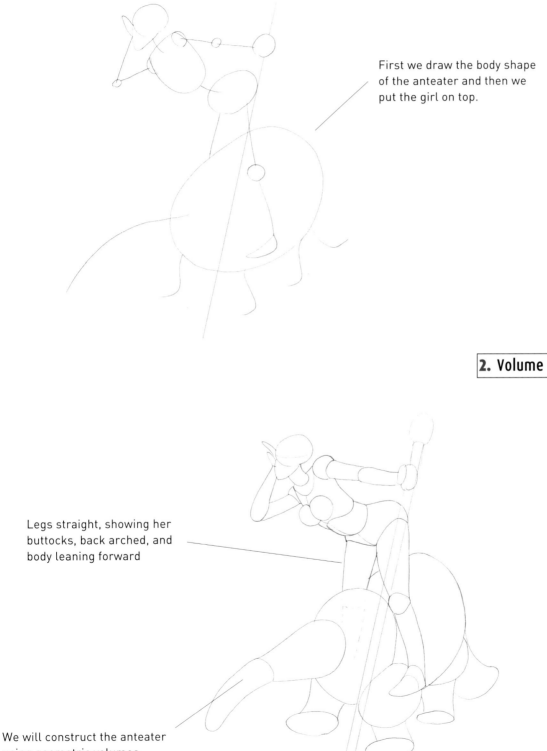

First we draw the body shape
of the anteater and then we
put the girl on top.

2. Volume

Legs straight, showing her
buttocks, back arched, and
body leaning forward

We will construct the anteater
using geometric volumes.

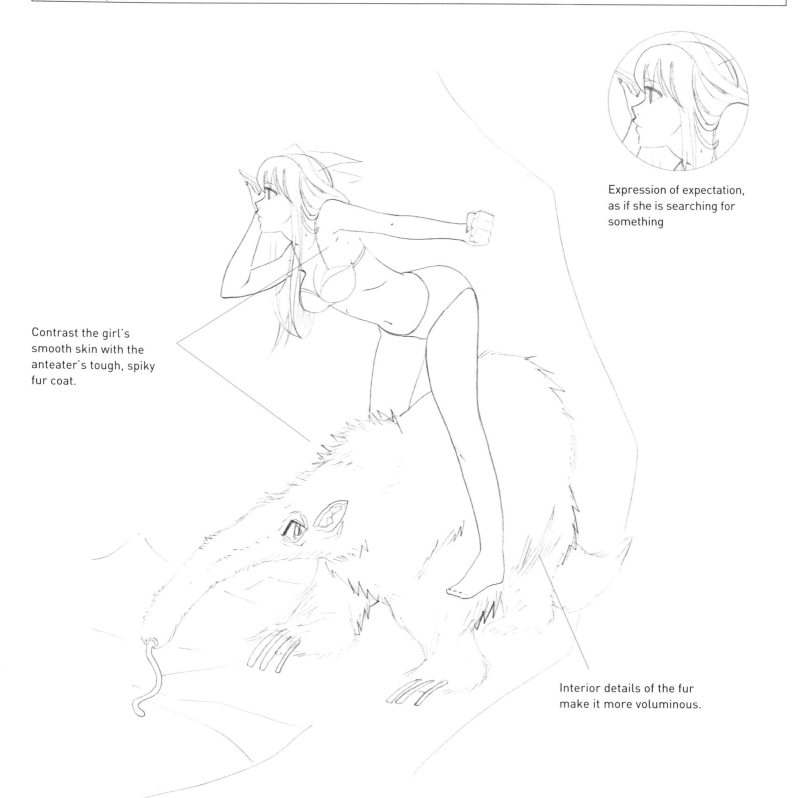

Expression of expectation, as if she is searching for something

Contrast the girl's smooth skin with the anteater's tough, spiky fur coat.

Interior details of the fur make it more voluminous.

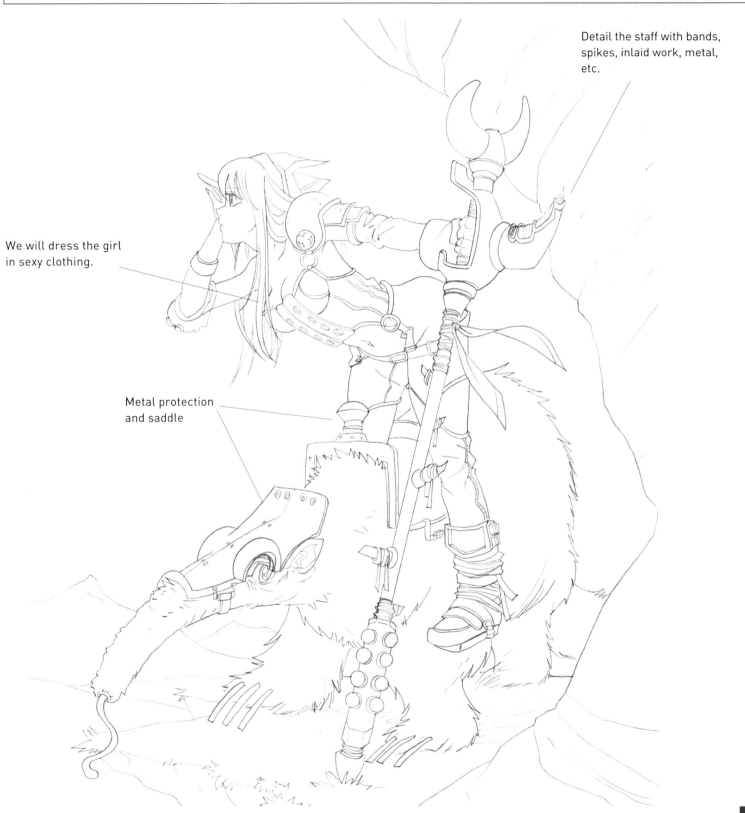

Detail the staff with bands, spikes, inlaid work, metal, etc.

We will dress the girl in sexy clothing.

Metal protection and saddle

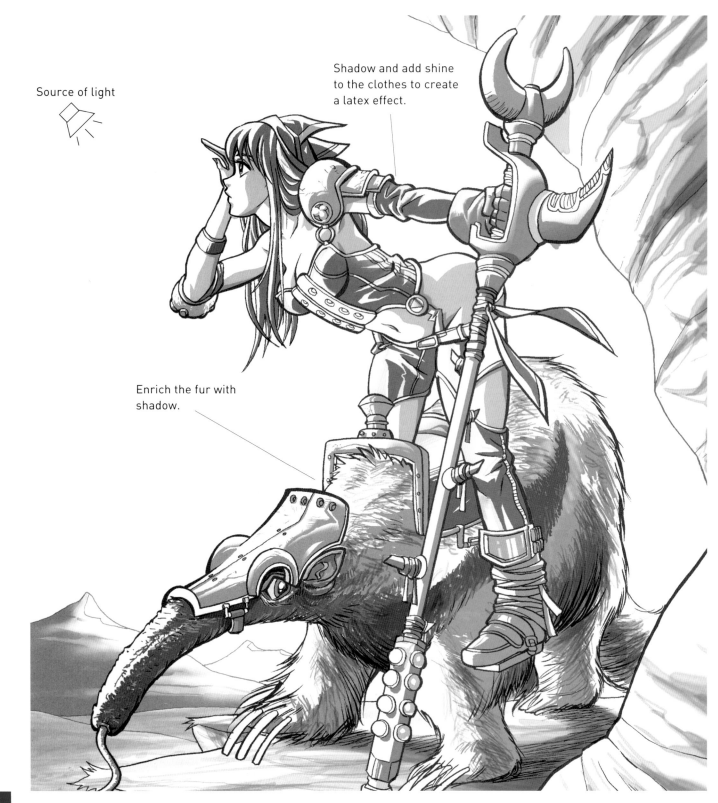

Source of light

Shadow and add shine to the clothes to create a latex effect.

Enrich the fur with shadow.

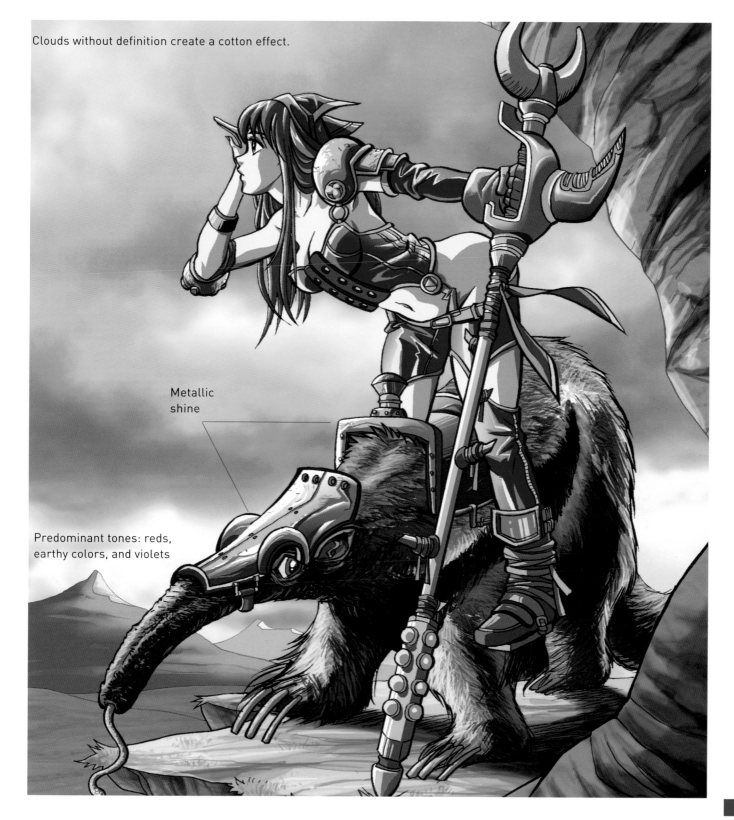

Clouds without definition create a cotton effect.

Metallic
shine

Predominant tones: reds,
earthy colors, and violets

ORC

This vile and inhuman race is not very attractive or intelligent. However, his muscular physique and crazed look make this character truly terrifying and unpredictable. The question, therefore, will be how to draw a character who would be terrifying to meet.

We will draw him in a natural environment, half crouching and about to throw himself after his prey.

Finally, remember the accessories, as they lend strength to his fiery, merciless appearance. The weapons that he uses are very rudimentary. Making them is hardly more than smelting down the metal.

1. Shape

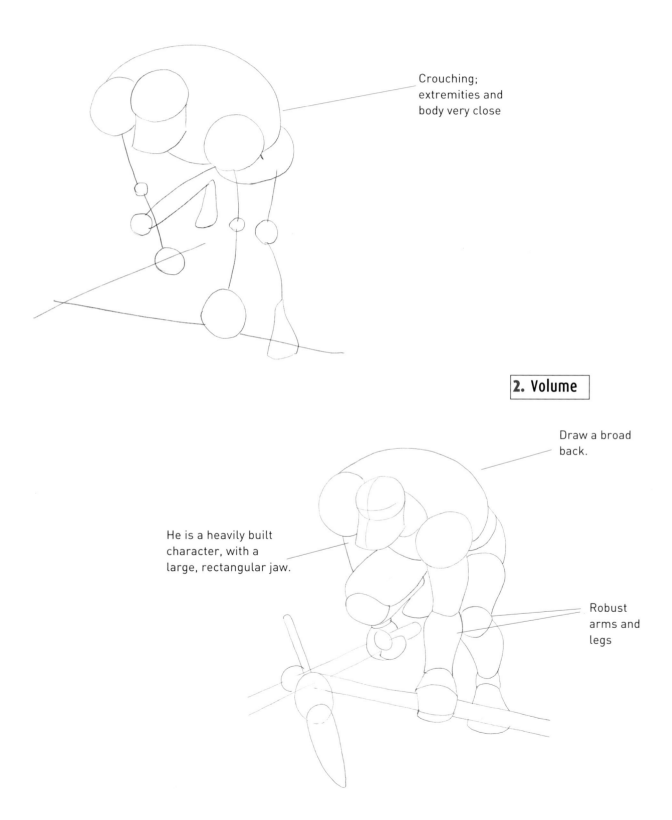

Crouching;
extremities and
body very close

2. Volume

Draw a broad
back.

He is a heavily built
character, with a
large, rectangular jaw.

Robust
arms and
legs

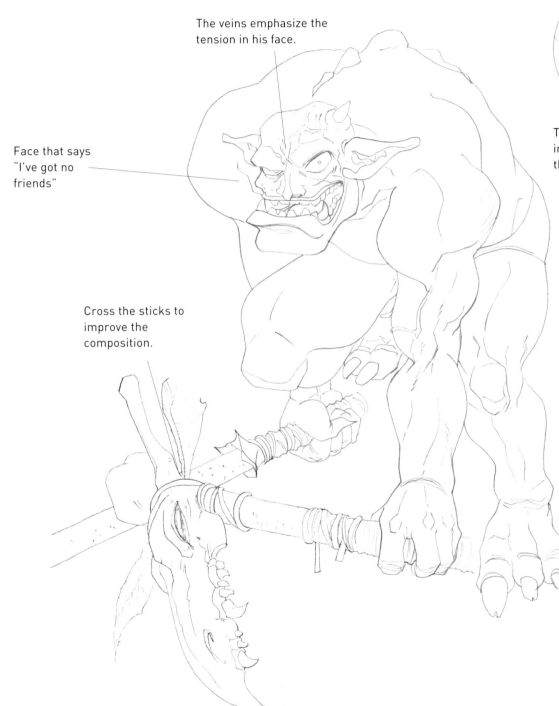

The veins emphasize the tension in his face.

The unequal eyes increase the craziness of the expression.

Face that says "I've got no friends"

Cross the sticks to improve the composition.

Spinal blades reinforce the punk style.

The chains and the piercings give the character a macabre appearance.

The leather straps and shackles make him look more evil.

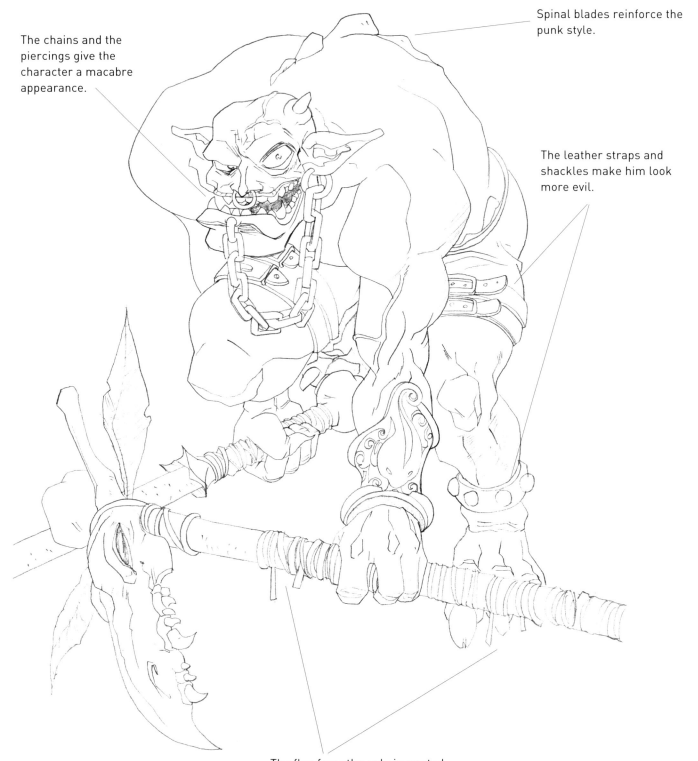

The flag from the pole is wasted away from so much use.

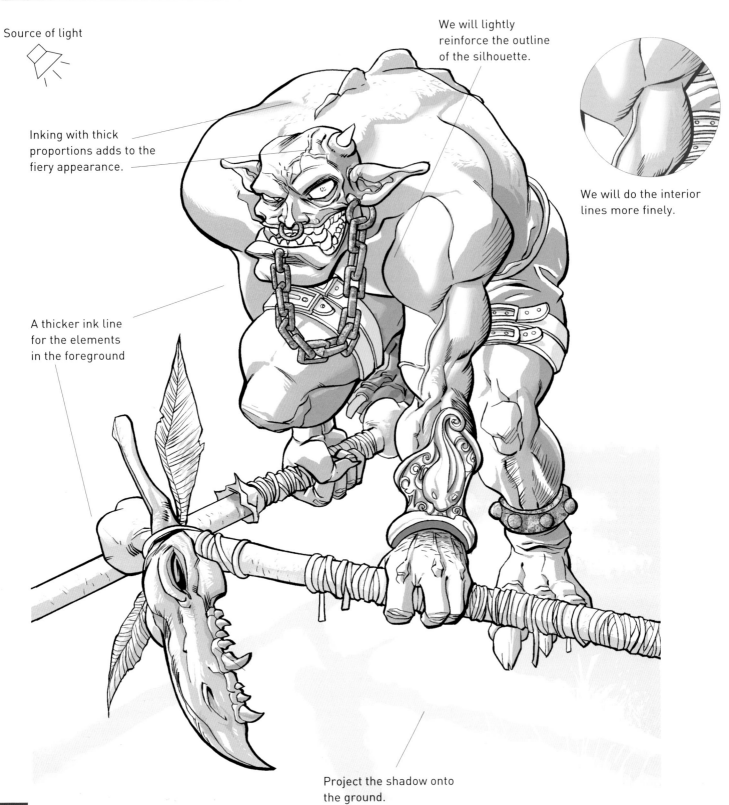

Source of light

We will lightly reinforce the outline of the silhouette.

Inking with thick proportions adds to the fiery appearance.

We will do the interior lines more finely.

A thicker ink line for the elements in the foreground

Project the shadow onto the ground.

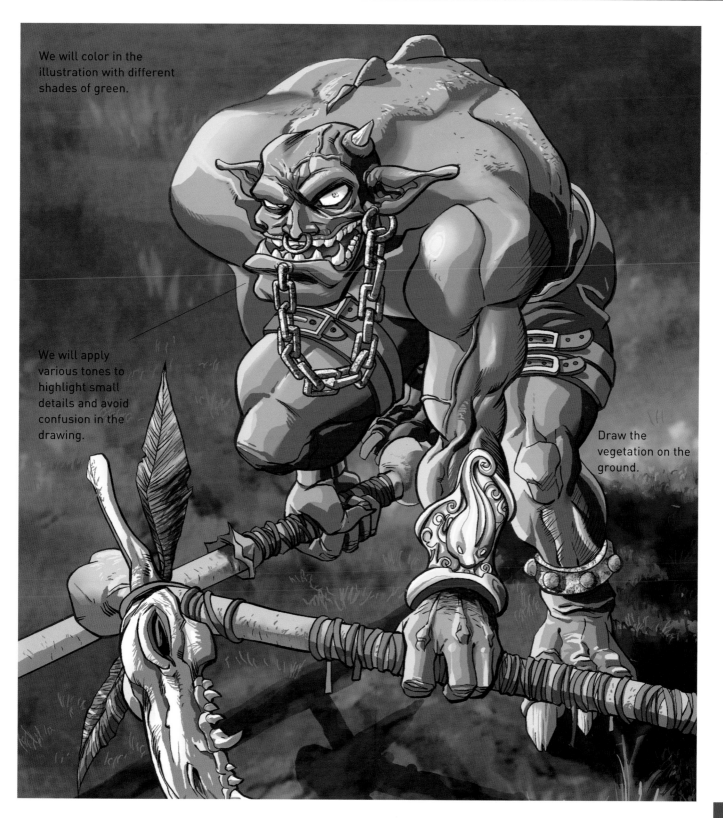

We will color in the illustration with different shades of green.

We will apply various tones to highlight small details and avoid confusion in the drawing.

Draw the vegetation on the ground.

DWARF

Everyone knows that dwarfs are a very proud race. Despite their small size, they are hardened creatures, brave and stubborn. So we will show our character as an arrogant braggart, resting his foot on an enormous axe.

His anatomy is of reduced proportions but robust. Remember that the drawing must give the sensation of being before a character, who is as hard as a rock, but at the same time good-natured.

Lastly, the clothing must be baggy, to allow him to move freely in battle, and tough. We will place our character on a rock, and we will try to give it a good finish so that it has the rough appearance of stone.

1. Shape

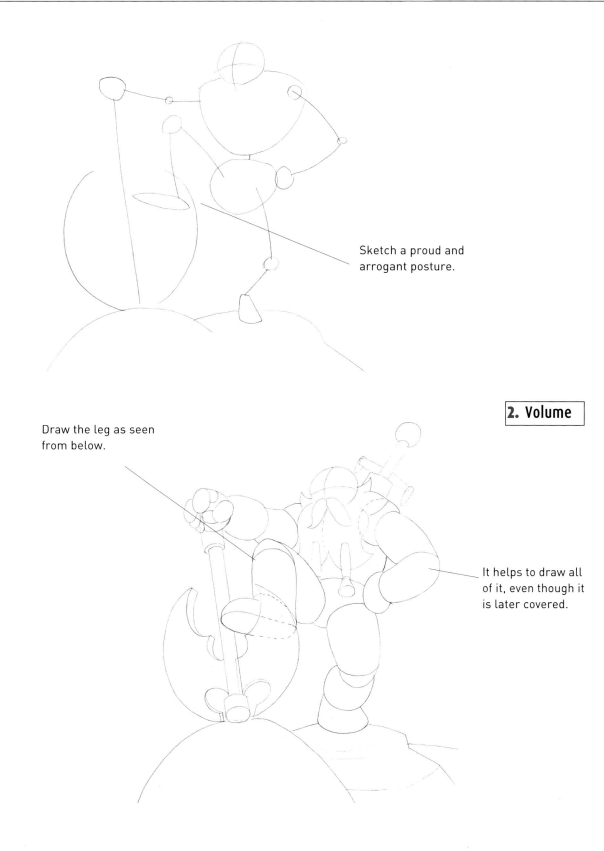

Sketch a proud and arrogant posture.

2. Volume

Draw the leg as seen from below.

It helps to draw all of it, even though it is later covered.

Although the helmet covers
it, we draw all the head.

Very developed muscles but
in a small and stocky body

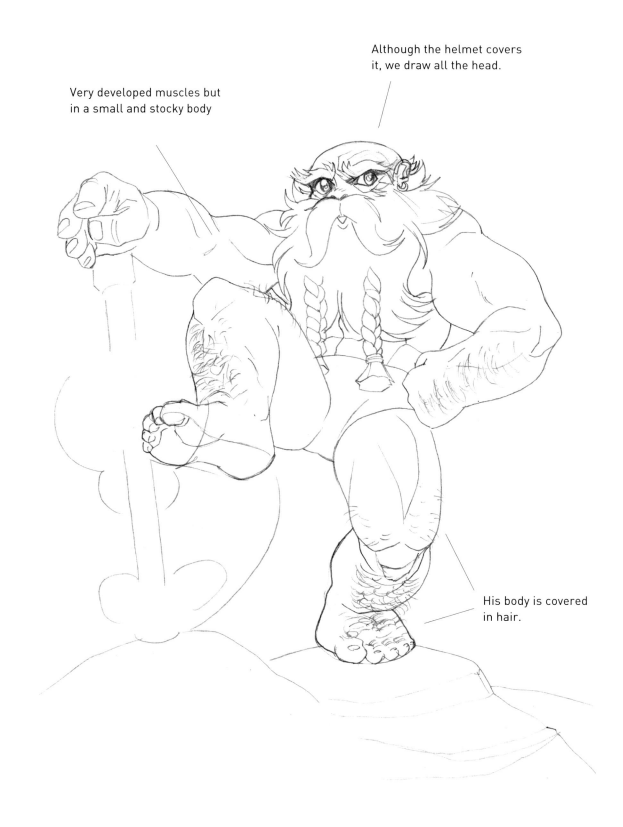

His body is covered
in hair.

Big gloves, which are not
tied to the arm

The elevation of the leg forms
creases in the cloak.

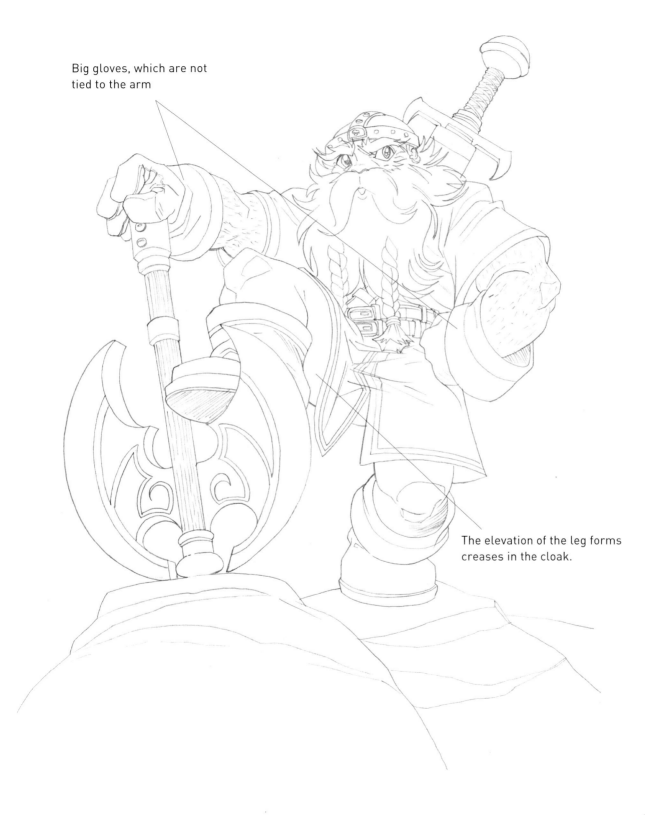

Source of light

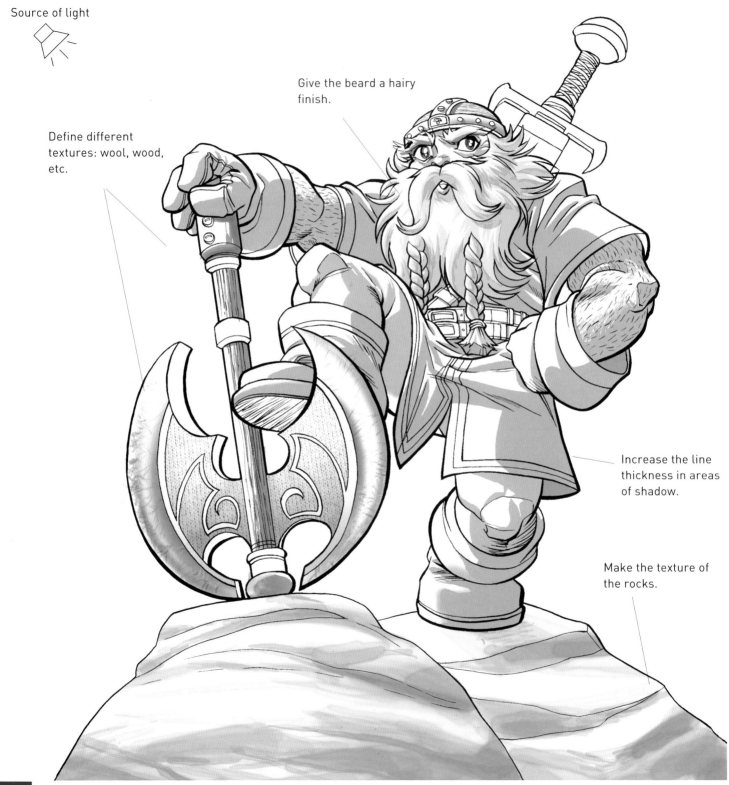

Give the beard a hairy finish.

Define different textures: wool, wood, etc.

Increase the line thickness in areas of shadow.

Make the texture of the rocks.

Not too striking, better to be a bit dull

Apply shine, scratches, and polish to the metal.

Light up some details of the wool to make it look more realistic.

Make the texture of the rock look old by combining spots of different colors.

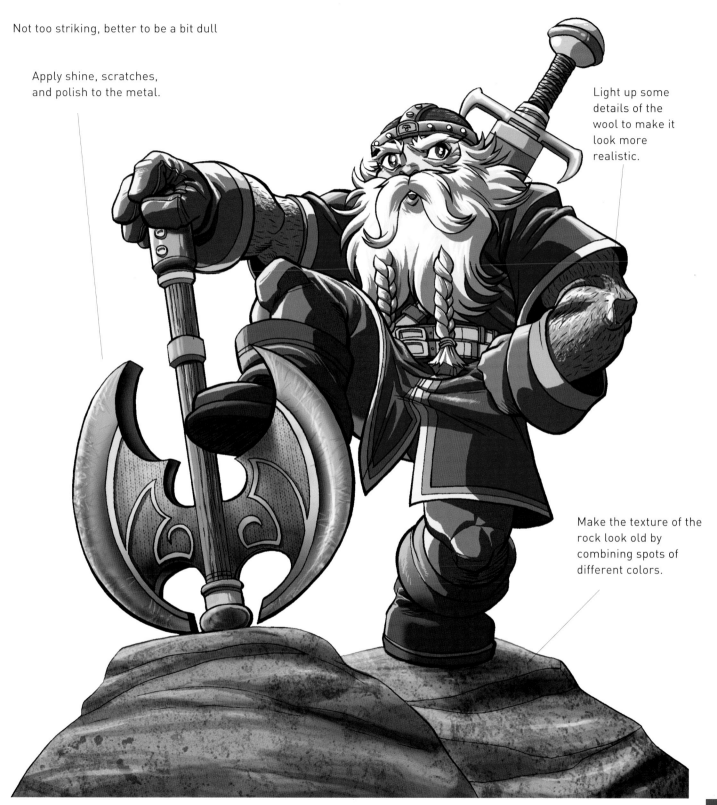

AMAZONS

An Amazon is a warrior woman, skilled in combat, in handling weapons from childhood, and extremely well prepared physically and mentally.

In the following exercise, we will draw two figures: a human and another animal. It is always attractive to combine humans with animals and especially in this case as we want to emphasize the warrior-like and ferocious character that they both share.

We will draw them apparently relaxed, when in fact they are ready for action. To convey tension, we will give the characters a calm but ready posture. This is shown by the Amazon who is holding the bow and arrow. We will also use this opportunity to practice sitting postures.

1. Shape

We can take the two figures as if they were one mass so that their silhouette looks more harmonious.

The character covers the animal, which is in the background.

2. Volume

Sketch some of the girl's accessories.

The animal figure can also be broken down into basic volumes of geometrical shapes.

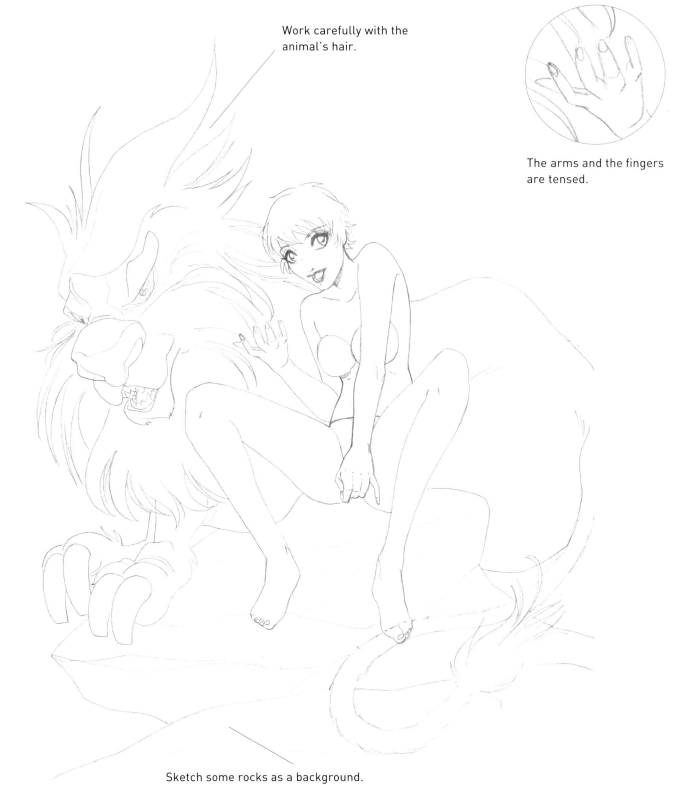

Work carefully with the animal's hair.

The arms and the fingers are tensed.

Sketch some rocks as a background.

The helmet must not cover the eyes, or detract from the expression of the Amazon.

Strengthen the 3D effect of the horns when giving detail to the pieces.

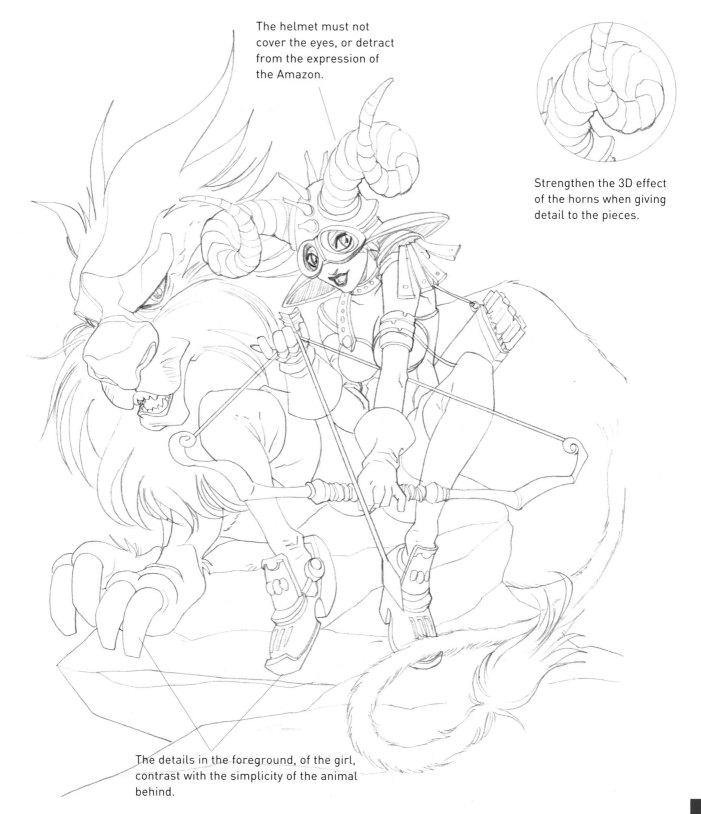

The details in the foreground, of the girl, contrast with the simplicity of the animal behind.

Source of light

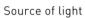

Be careful with the projected shadows.

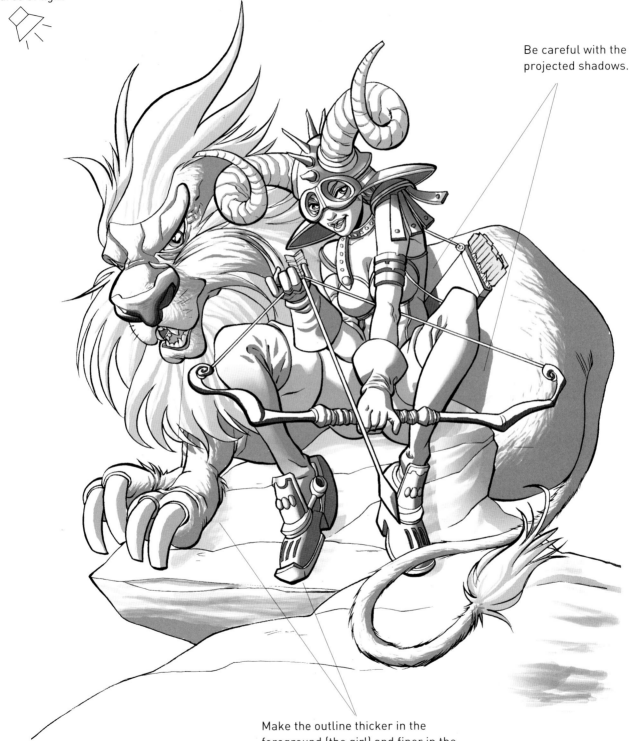

Make the outline thicker in the foreground (the girl) and finer in the background (the animal).

Give detail to the hair, following the directions of the strands.

Make the darkness of the sky contrast with the light colors of the character.

Nocturnal shadows in violet tones

Add texture to the rock, first giving an average tone for the shadow, then another darker one.

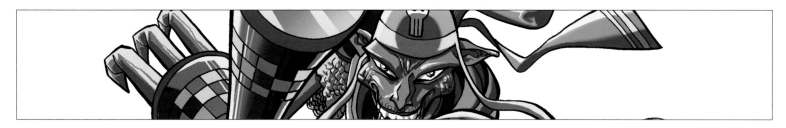

GOBLIN

Goblins are cunning, scheming creatures. They have a sharp nose, pointed ears, and like the elves, they are bald. They are all short and quite ugly. To show his treacherous, evil character, we will draw in a sinister smile.

We will give the goblin a typical posture for this character, with the back bent and the knees flexed in a menacing manner.

What is most noticeable in the drawing is, without a doubt, the huge claws that seem to come out of the paper toward us. This effect is achieved through perspective.

Therefore, the illustration must be spectacular and convey energy and a sensation of movement.

1. Shape

The body slightly curved and legs flexed

The outline must be quite dynamic.

2. Volume

Try to force the position of the legs. Don't worry, they won't break; he's a beast!

Notice how the torso goes inwards and the abdominal muscles stick out.

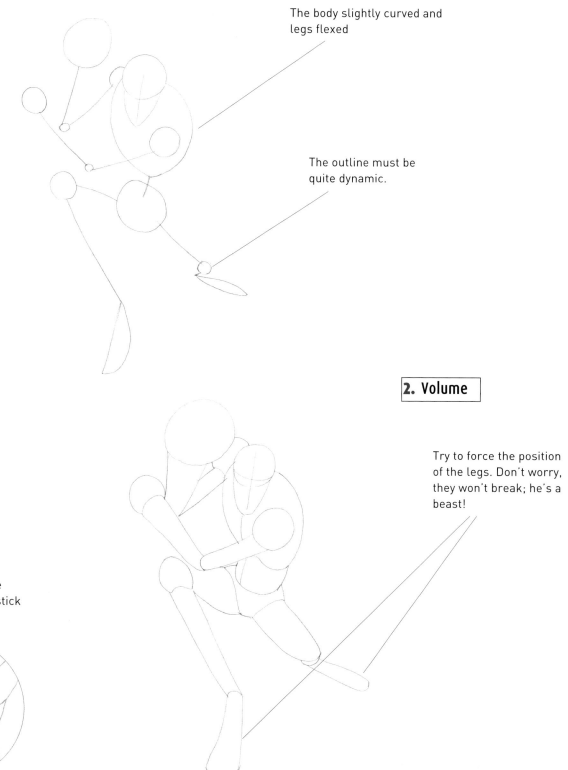

Fist forward and distorted by
the perspective

The big and pointed teeth
give the animal greater
ferocity.

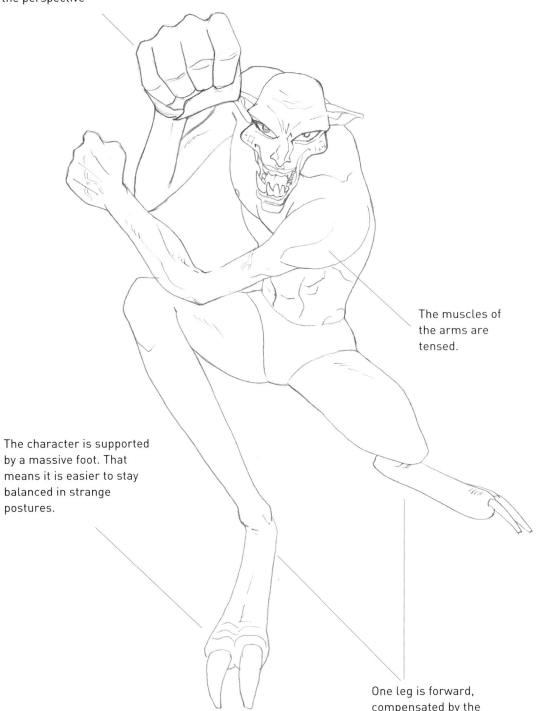

The muscles of
the arms are
tensed.

The character is supported
by a massive foot. That
means it is easier to stay
balanced in strange
postures.

One leg is forward,
compensated by the
other behind it.

The claws in the foreground create more of a spectacle.

The straps respond to the movements of the whole body.

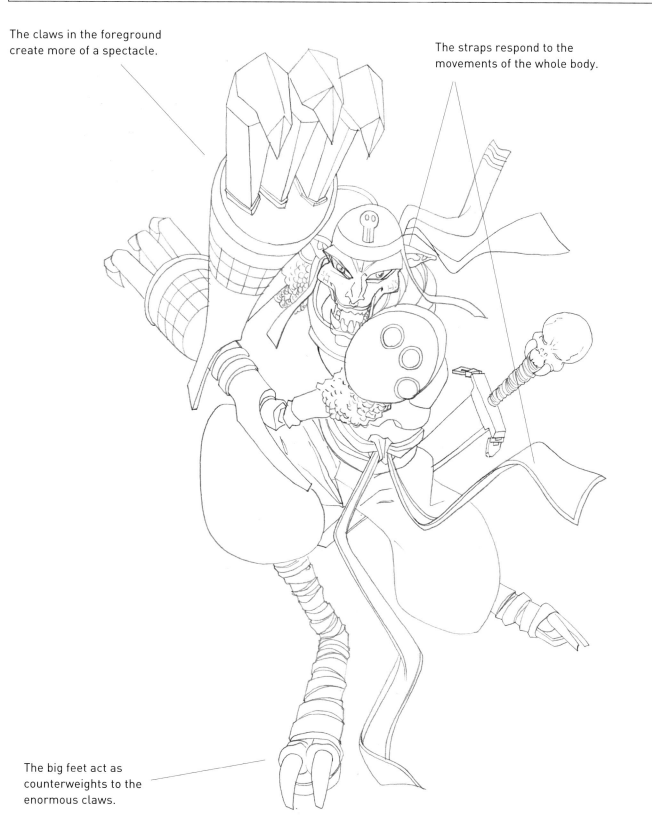

The big feet act as counterweights to the enormous claws.

Source of light

source of light

Gleam from the cold steel

The weight of the sword is necessary to balance that of the claws on the other side.

Reinforce the ink line which does not receive any light.

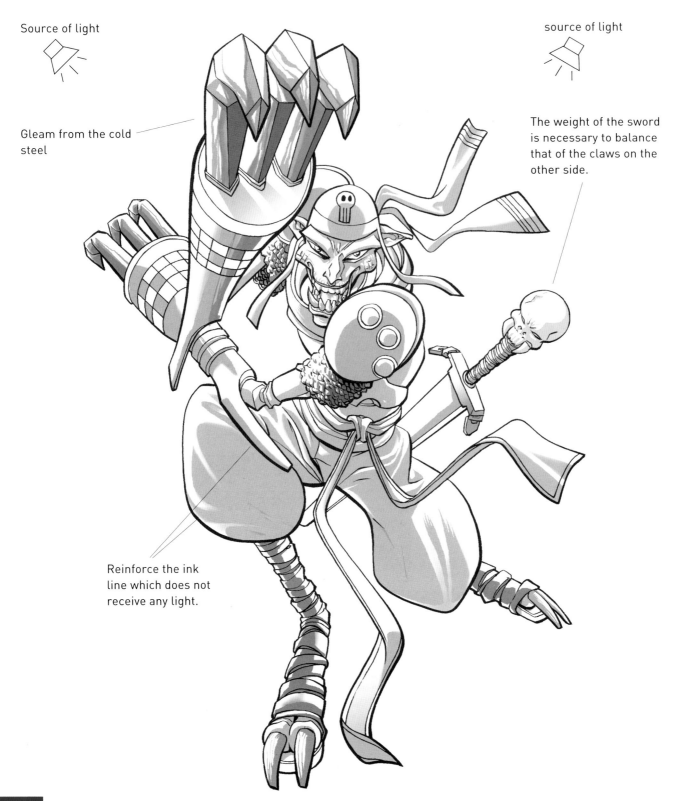

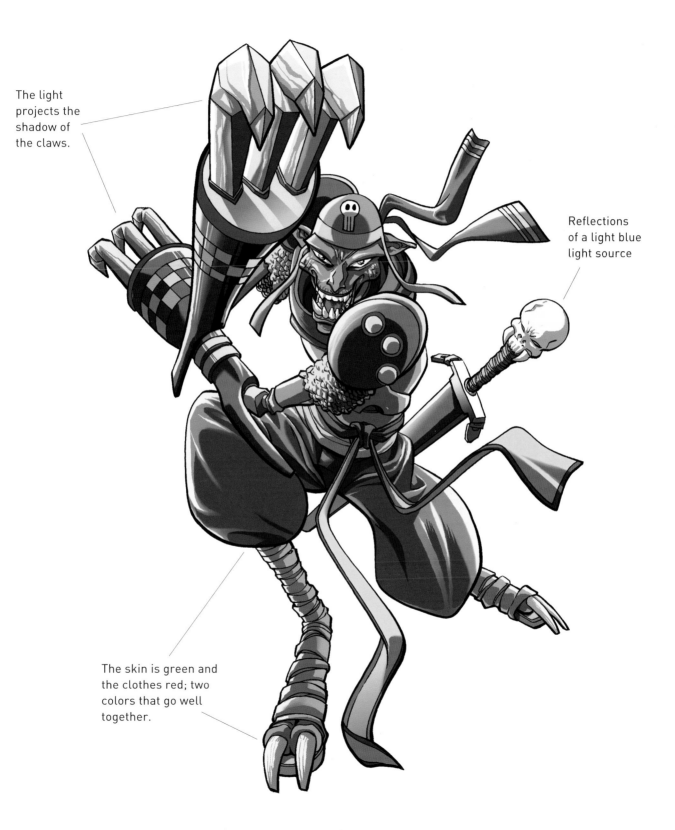

The light projects the shadow of the claws.

Reflections of a light blue light source

The skin is green and the clothes red; two colors that go well together.

DEVIL

These creatures are common in Manga, which often portrays the forces of good and evil. Devils are gigantic and horrible, and have big fangs and horns that come out from the body. These are used as lethal weapons.

Do not forget that this is the personification of evil, so the face must express all the evil that is possible. We will draw the look and accompany it with a sarcastic and evil laugh.

The character is sitting down, practically sideways, and the vertical composition is in an S-shape. This exercise without a doubt is a good opportunity to practice a half-human, half-supernatural anatomy.

1. Shape

Very curved spine,
almost in fetal
position

Composition is
S-shaped

The wings come
from both sides
of the back.

The figure is
sitting on skulls,
which we will
initially draw with
spheres.

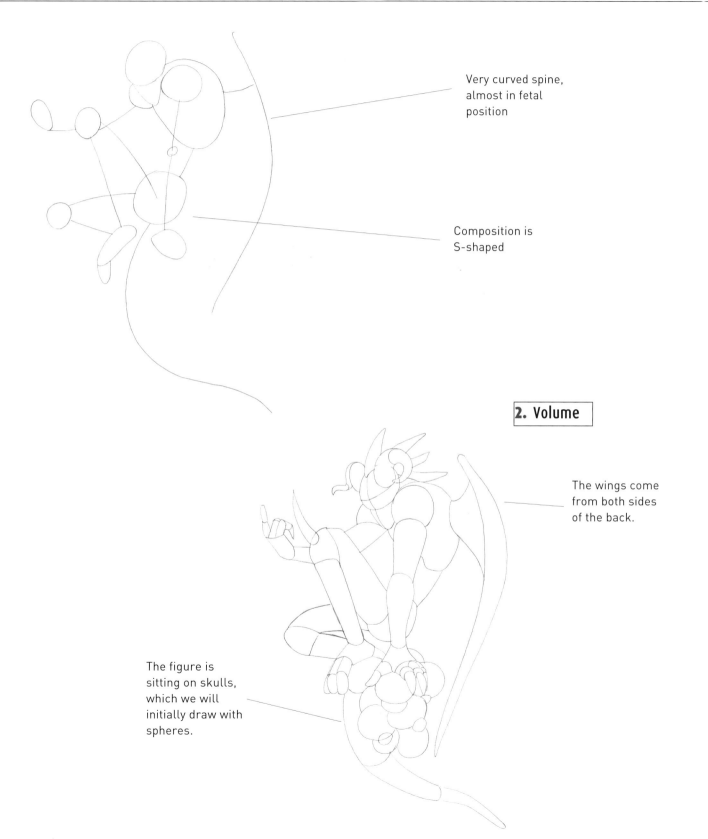

Muscles in general are similar to human muscles.

Bony horns and cartilage crest

Make the expression of evil with sharp teeth and wide eyes.

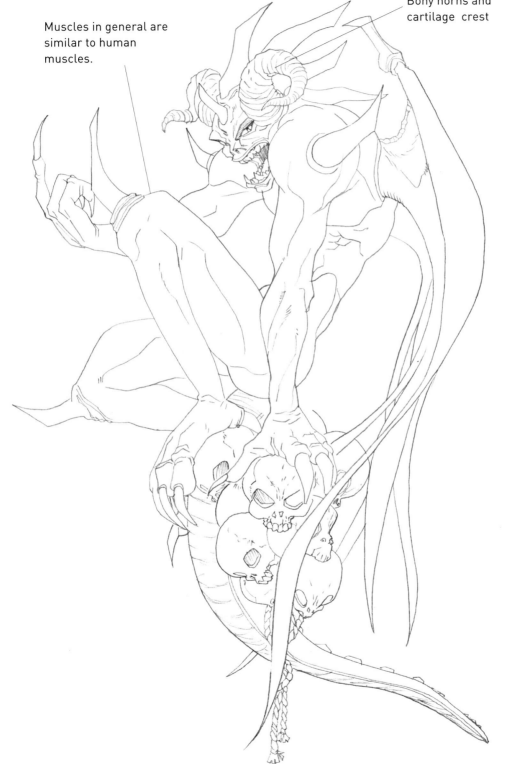

Clothes tight
around the body

Accessories
based on thorns
and horns

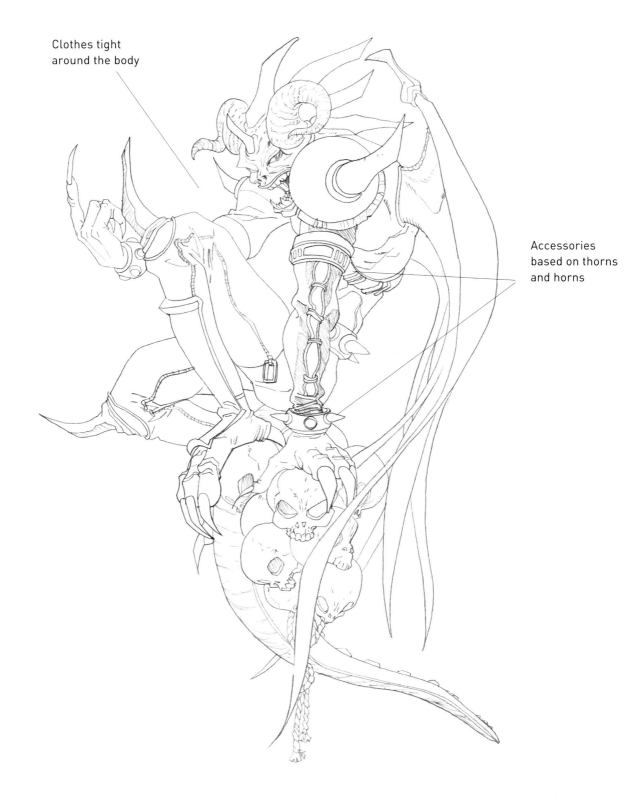

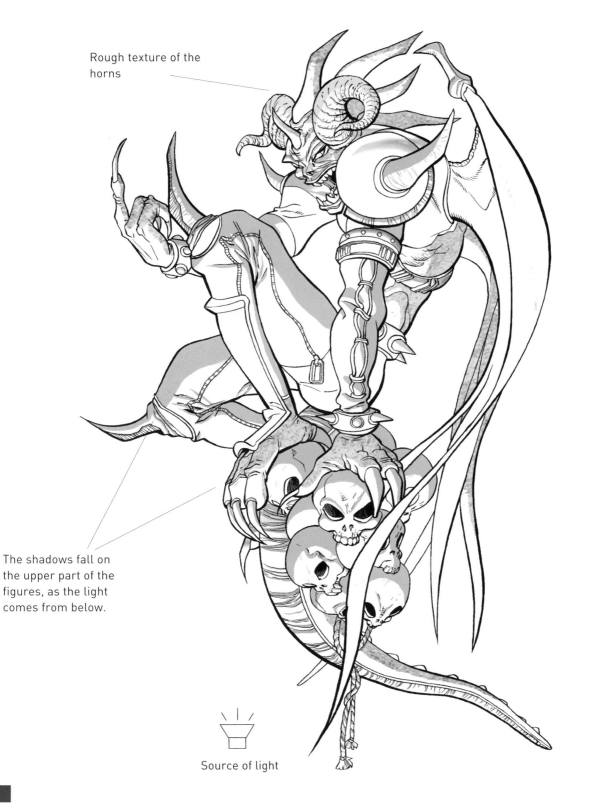

Rough texture of the horns

The shadows fall on the upper part of the figures, as the light comes from below.

Source of light

Red tones predominate as they create more of an infernal atmosphere.

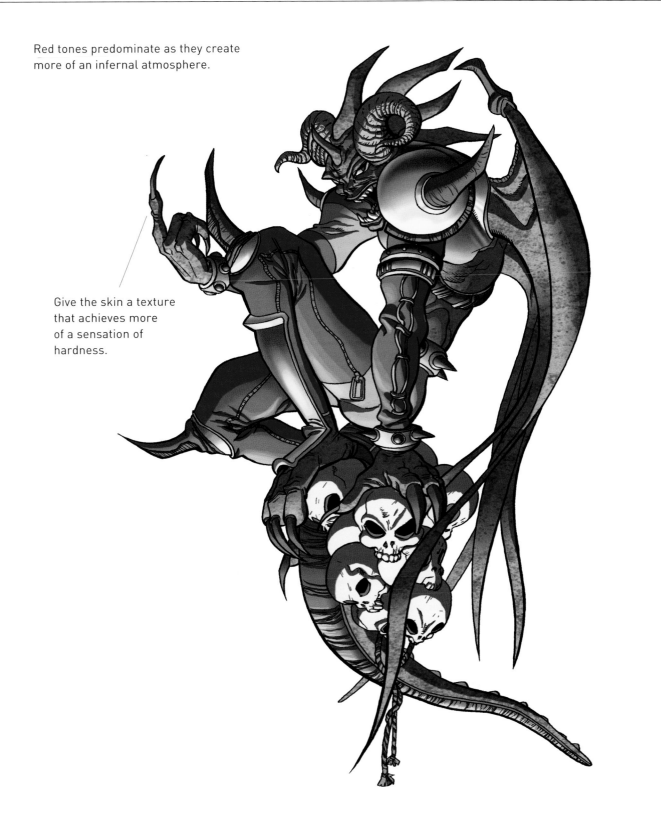

Give the skin a texture that achieves more of a sensation of hardness.

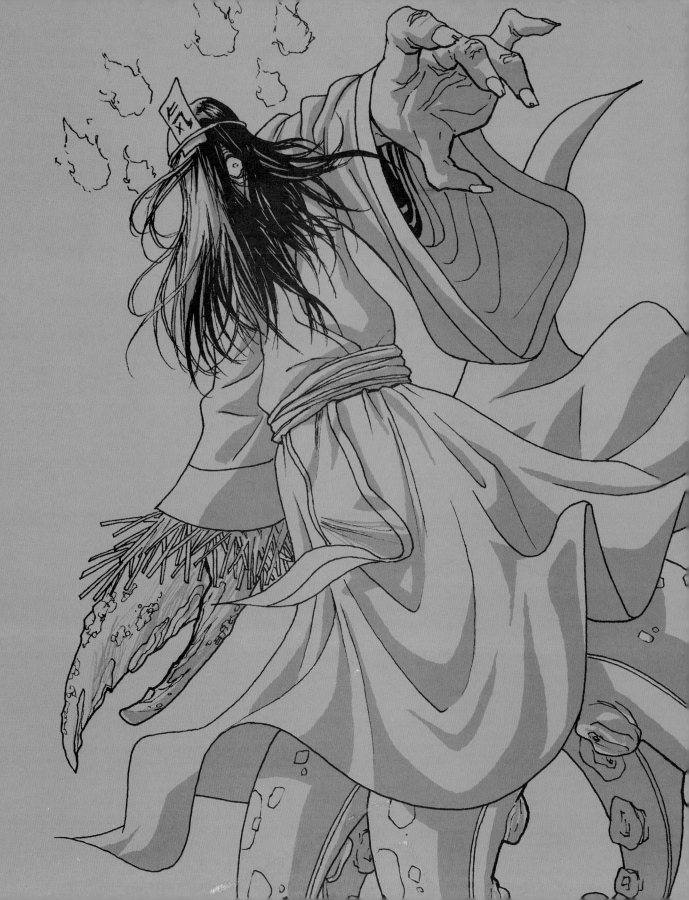

MONSTERS

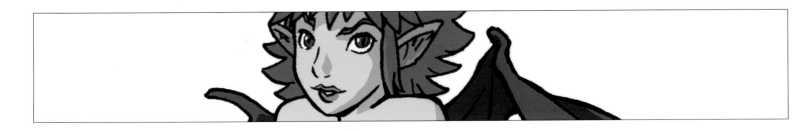

SUCCUBUS

The succubae are demons or spirits that take on the appearance of a woman. The she-devils and the feminine versions of demons have the reputation of being extremely provocative and aggressive. They spend their time seducing and manipulating mortals with their spells. So, the succubus is the personification of temptation, a very sexy woman, with voluptuous shapes and a sensual character.

This character does not really have a clearly defined appearance. You could draw an attractive girl and give her some evil features, like an angular face, wide eyes, and pointed ears. If we want to go further, we could give her horns and a tail. The bat wings are the element used most in Manga to represent the succubus; small wings that hardly stick out from the back or, the opposite, very visible wings with a powerful appearance. It's good to keep the slender shape and the sinuous curves of the female figure.

1. Shape

Select a posture that shows a provocative attitude.

2. Volume

Draw the wings as a single piece, flat and flexible; so you can imagine the shape they would fold into.

Be careful with the shape that the horns curve into.

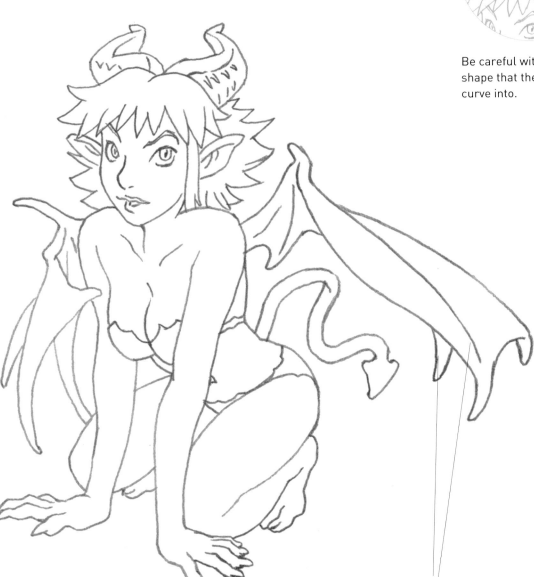

Give volume to the wings and differentiate between the thick, long bony parts and the flat shape of the membrane of the inner part of the wing.

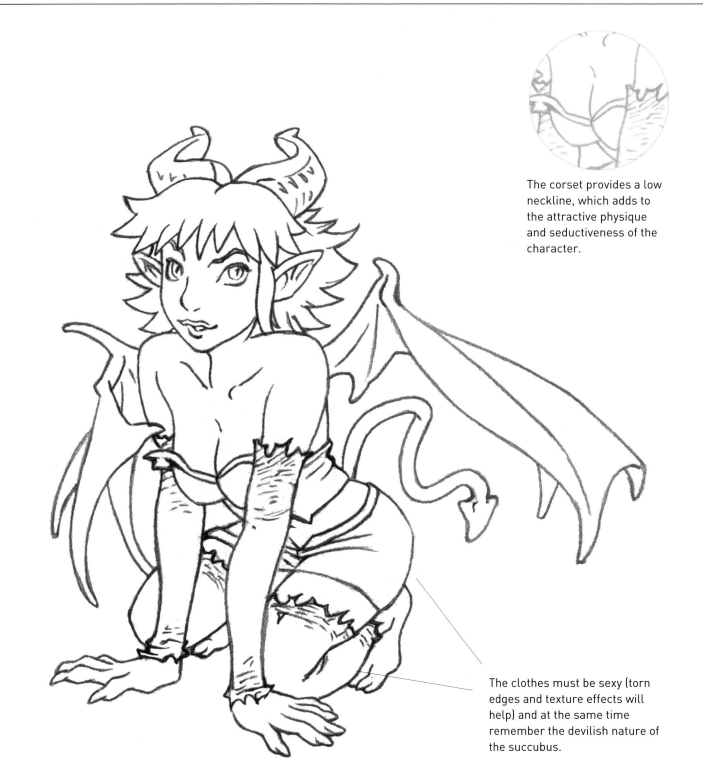

The corset provides a low neckline, which adds to the attractive physique and seductiveness of the character.

The clothes must be sexy (torn edges and texture effects will help) and at the same time remember the devilish nature of the succubus.

Source of light

Differentiate the inner part and the outer part of the wings with shadows.

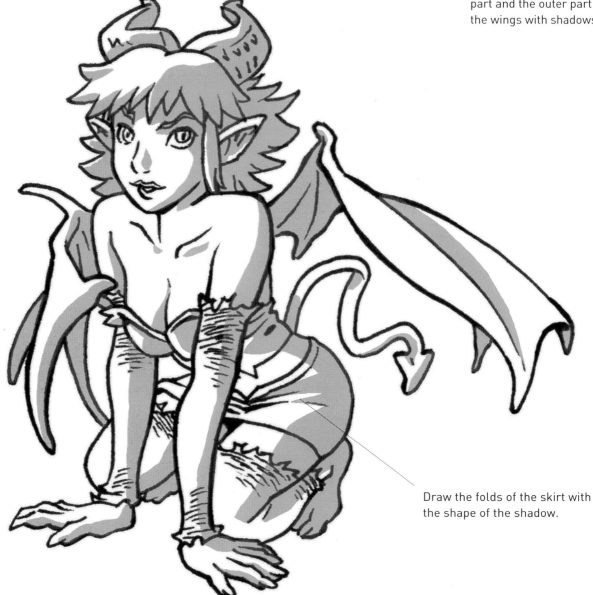

Draw the folds of the skirt with the shape of the shadow.

Give the hair a reddish color to represent her devilish nature, and shadow with a violet tone.

The flesh is a warmer color than the clothes, so use a pink tone that is stronger in the areas of shadow.

DRAGON

Dragons are fabulous animals, with heavily built snake shaped bodies, legs, and wings. They have a ferocious character and the capacity of breathing fire. These mythological beings appear as much in Western culture as in Eastern, although, of course, in each they have different characteristics. In Chinese and Japanese mythology dragons are very important beings, which is reflected in Manga.

In the following exercise we will combine two types of monsters: the dragon and the stone beast. The latter is very robust and resistant, which also means that it is slower and heavier. It is common to consider one of the four elements of nature when creating a monstrous creature with special and natural powers.

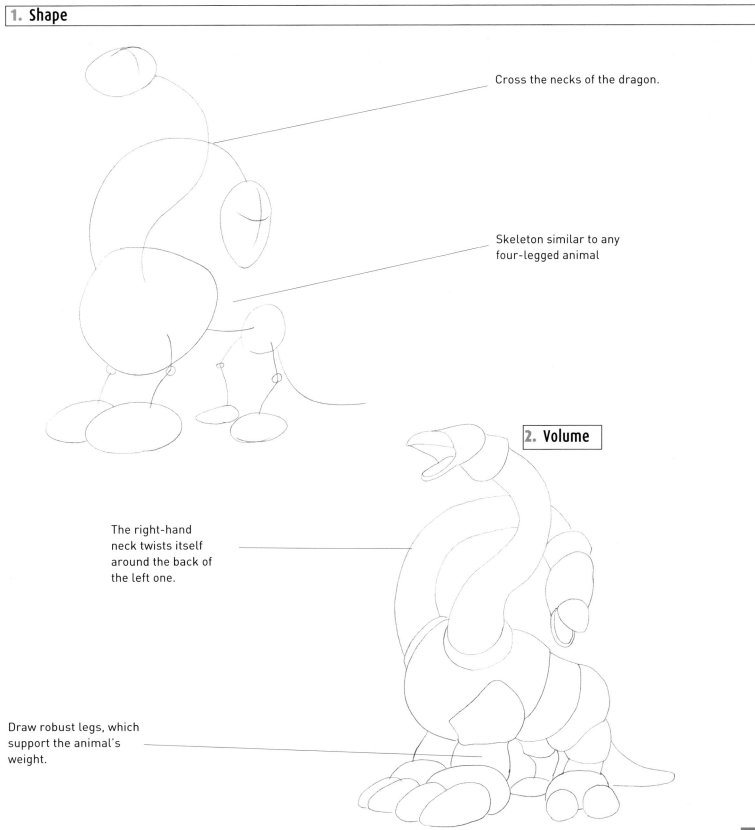

1. Shape

Cross the necks of the dragon.

Skeleton similar to any four-legged animal

2. Volume

The right-hand neck twists itself around the back of the left one.

Draw robust legs, which support the animal's weight.

An organic base to which we will apply a stone covering.

In this phase you must consider how you are going to apply the stone pieces afterwards.

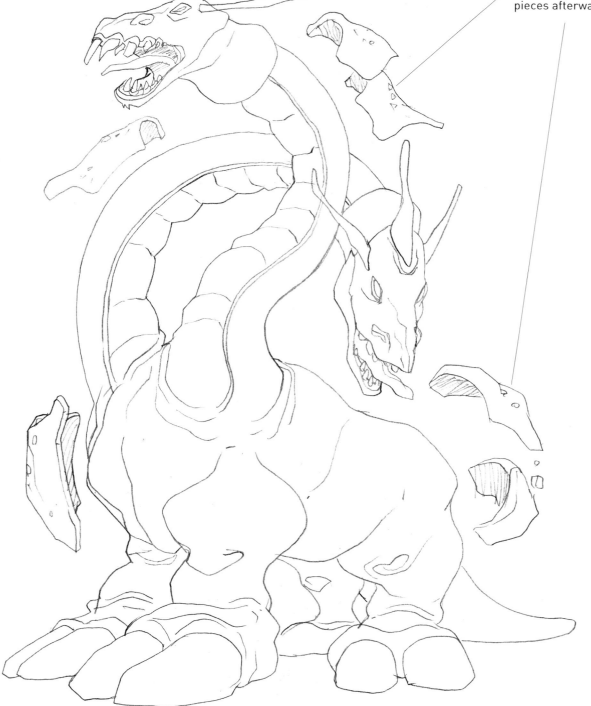

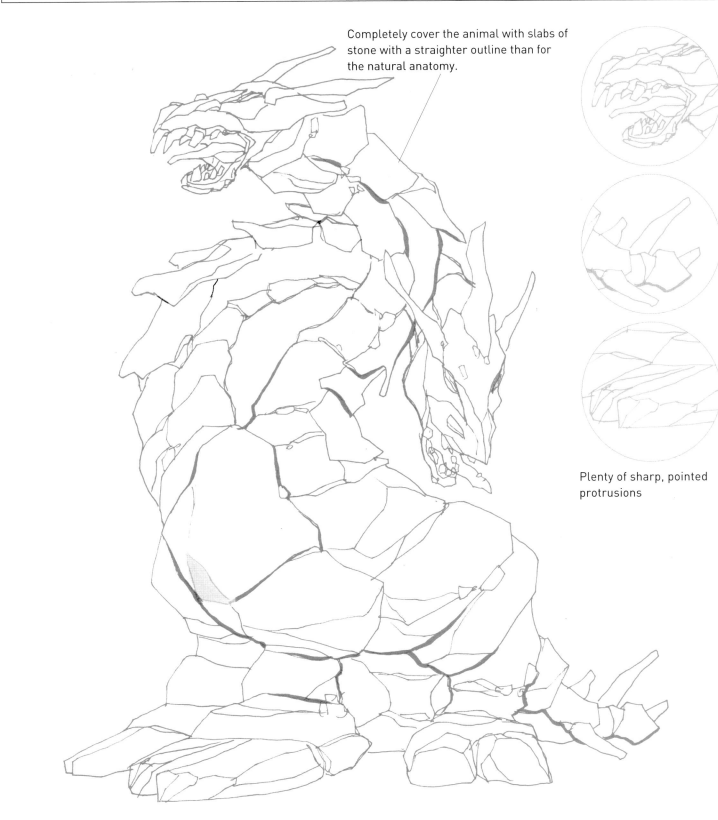

Completely cover the animal with slabs of stone with a straighter outline than for the natural anatomy.

Plenty of sharp, pointed protrusions

5. Lighting

The shadows as well as the lighting will be done with straight lines that adapt themselves to the stone.

Source of light

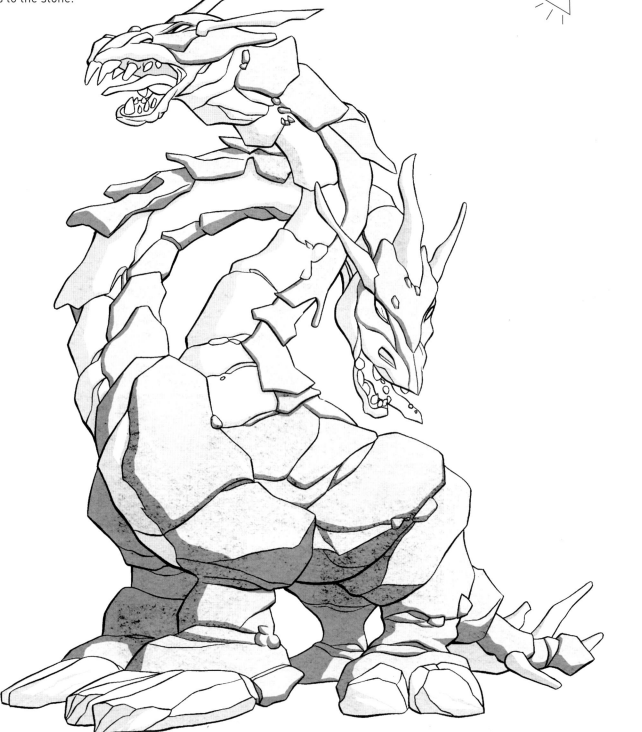

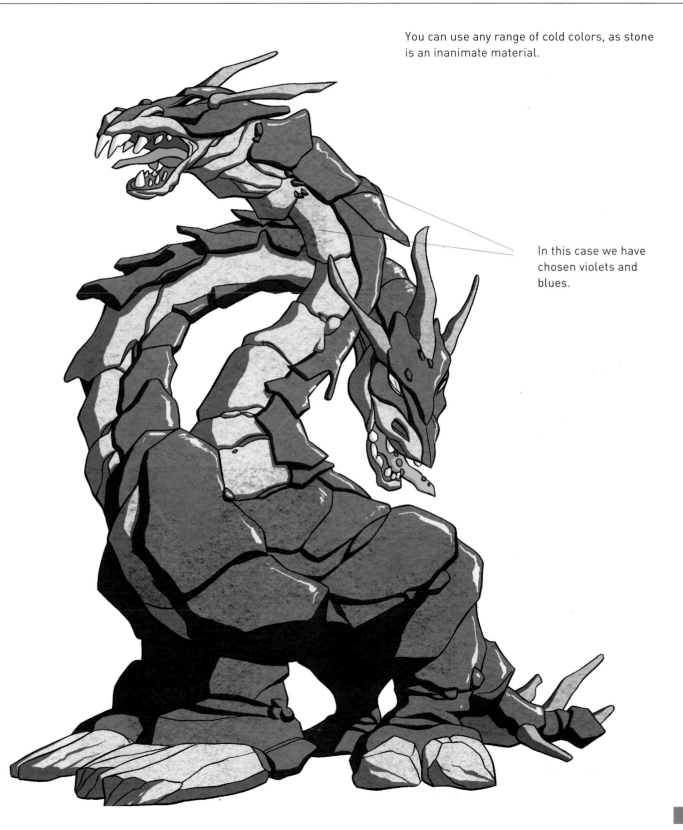

You can use any range of cold colors, as stone is an inanimate material.

In this case we have chosen violets and blues.

GHOST

Stories of ghosts and spirits are very common in Japanese folklore and tradition, and it is a subject as popular in the cinema as it is in literature and in Manga. The supernatural often makes the reader curious, and scriptwriters know it. So it would be very useful to practice drawing this type of monster. We will draw this character by mixing traditional Japanese elements with animal characteristics. Some animals have a strong connection with the supernatural, so they are used to make reference to these types of spectres and spirits. We will add tentacles and crab pincers, and dress him in a kimono. With this drawing we must depict the character as worried, startled, and slightly afraid; remember ghosts are surrounded by an aura of mysticism and messages from the other side.

1. Shape

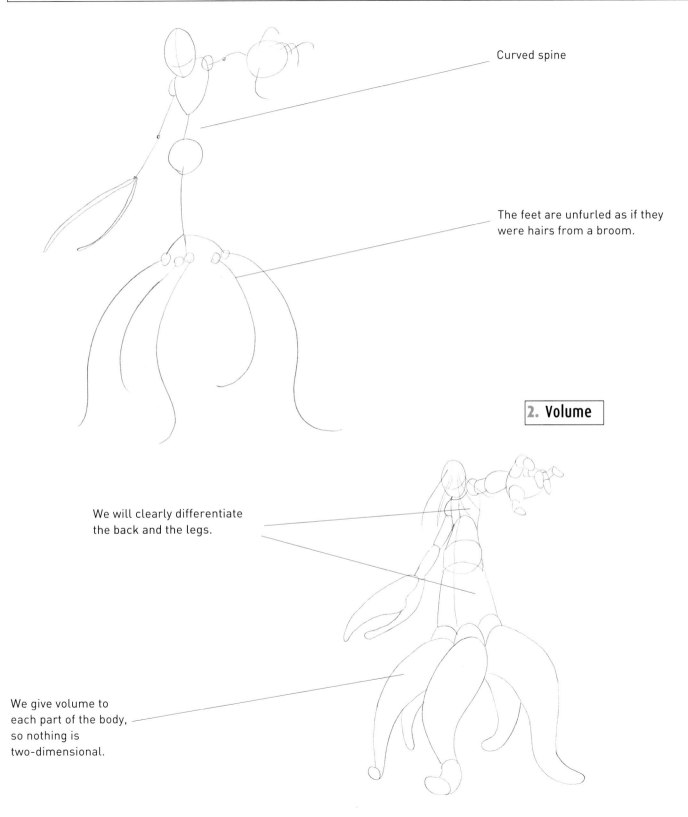

Curved spine

The feet are unfurled as if they were hairs from a broom.

2. Volume

We will clearly differentiate the back and the legs.

We give volume to each part of the body, so nothing is two-dimensional.

The hair hides the character's face (except an eye) to lend more of an air of mystery.

We will substitute the other hand for pincers of a crustacean.

To give him greater depth, we will draw the left hand bigger, in proportion with the rest of the body, since it is further forward.

The lower part of the hips will be an extension covered in coral, which will be the link with the tentacles.

The character's legs are tentacles

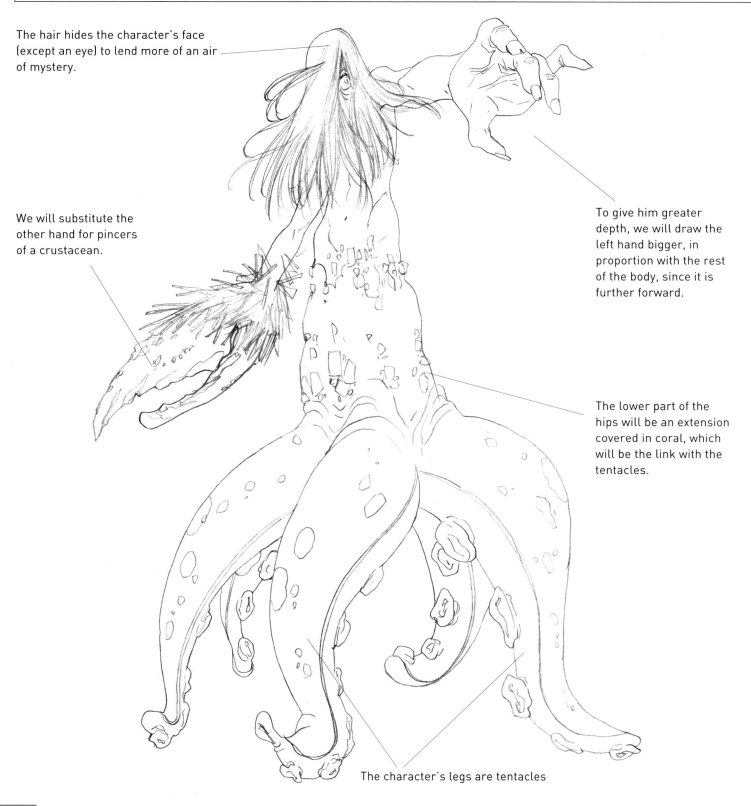

Draw small spectres of fire circling the round head of the ghost.

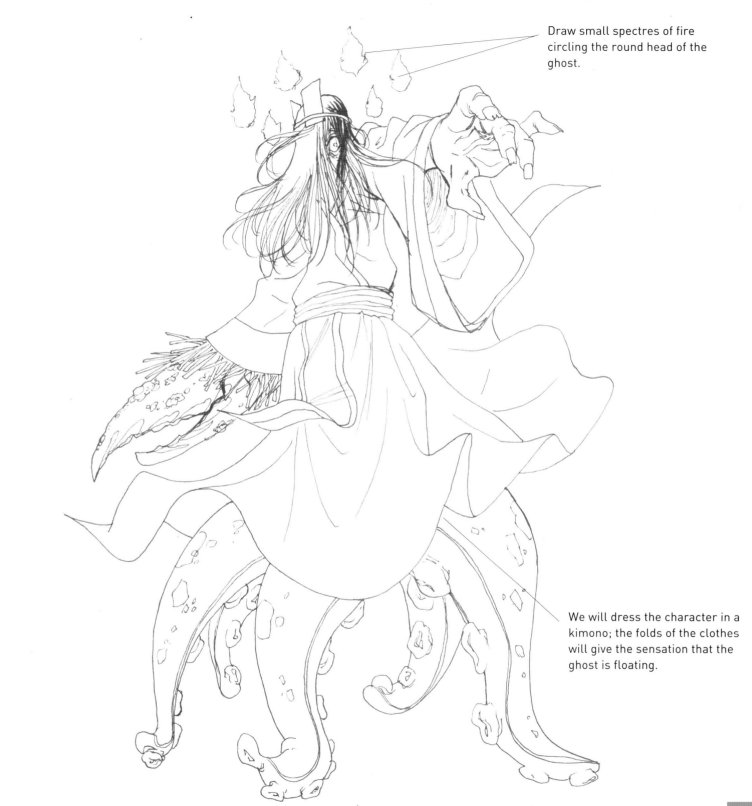

We will dress the character in a kimono; the folds of the clothes will give the sensation that the ghost is floating.

Source of light

Emphasize the quantity of black ink on the head, to make it more voluminous.

Do most of the folds in the clothes with shadows, without just falling back on the ink lines.

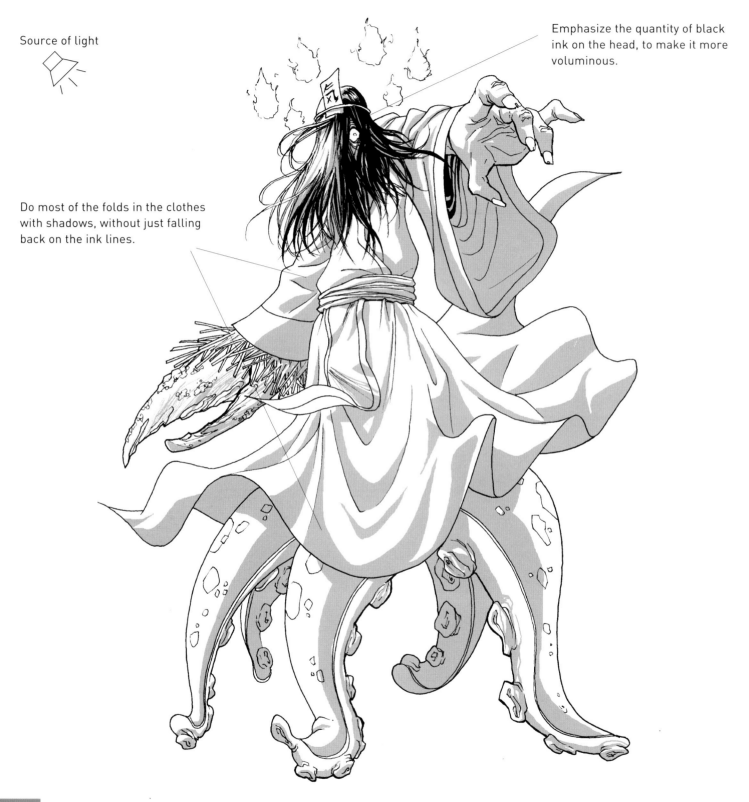

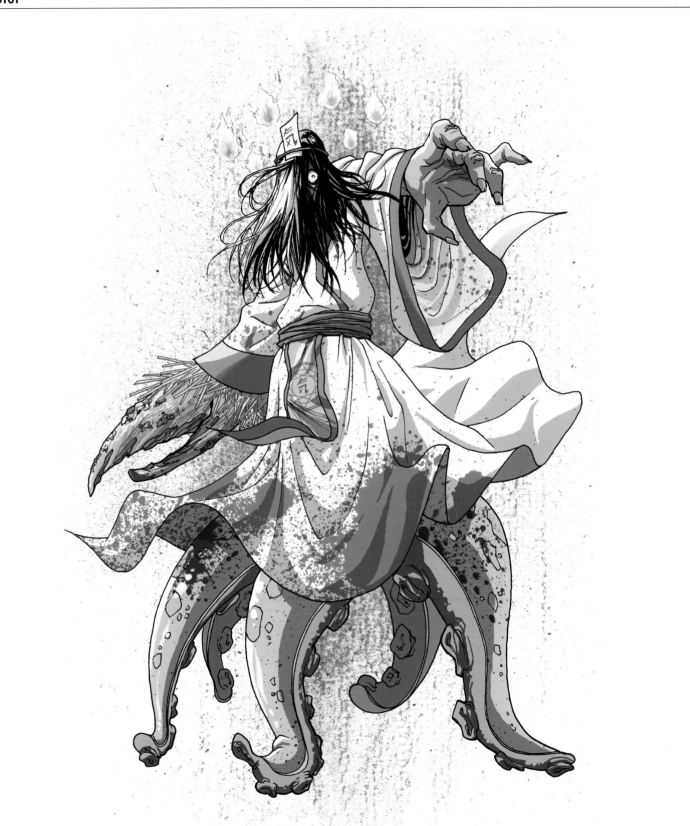

WORM

This worm looks overall quite unpleasant, but we will give him an original and personal touch by drawing features that give him a friendlier appearance: big, friendly, and expressive eyes. We will also add elements from other animals, although keeping the basic characteristics of the worm, which means a long, cylindrical, soft body without a skeleton or extremities, which moves by contracting and stretching its body.

It may seem inoffensive at first sight, but if we give it a considerable size it could change into a fearsome and powerful monster.

1. Shape

We will sketch the figure in the shape of an S, with two spheres in each extreme, which will be the tail and head.

2. Volume

We will give a tubular form to the structure of the invertebrate.

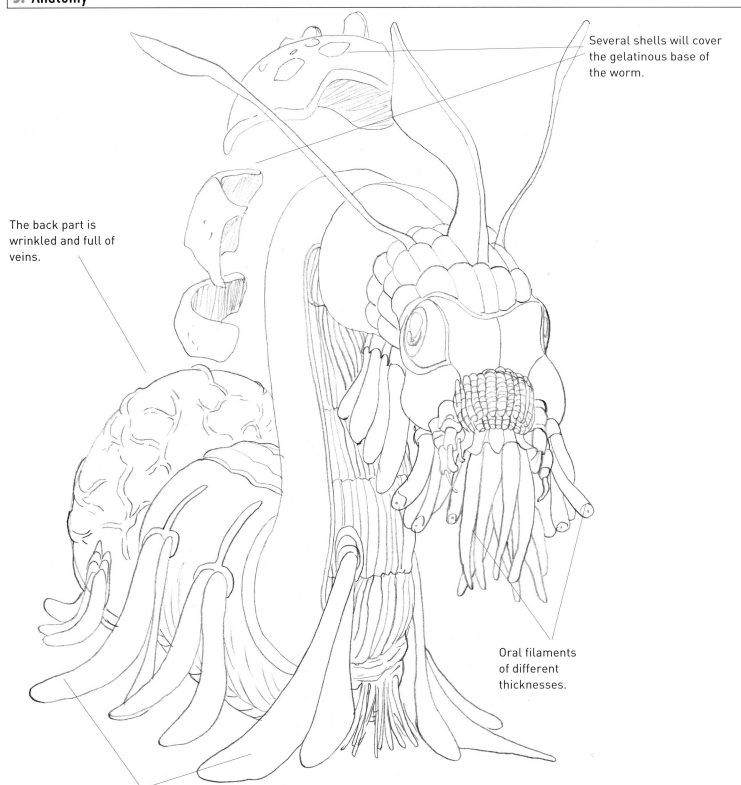

Several shells will cover the gelatinous base of the worm.

The back part is wrinkled and full of veins.

Oral filaments of different thicknesses.

Some lateral fins, which help him to move along the floor

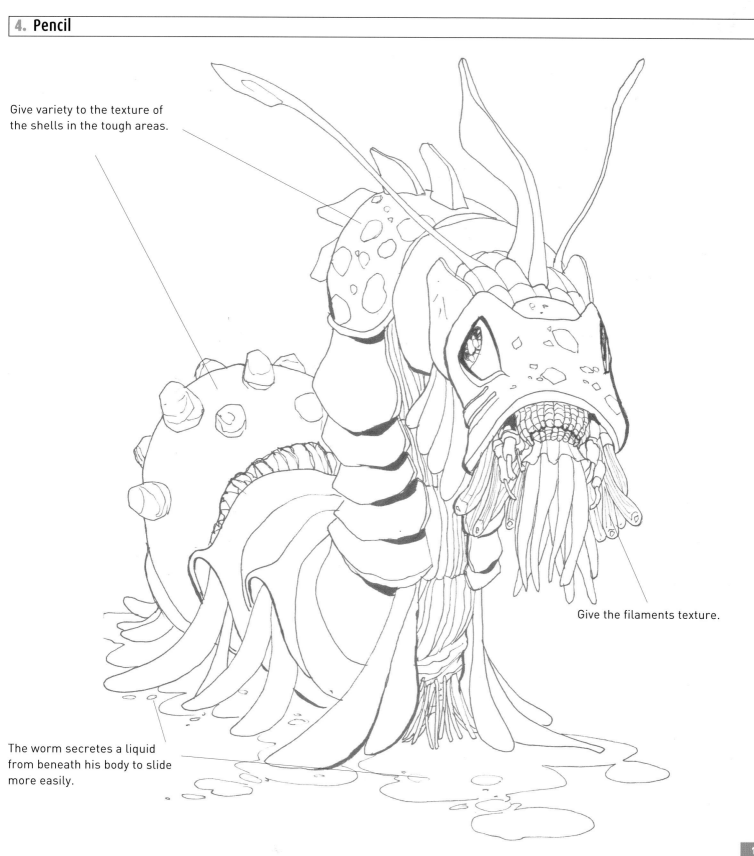

Give variety to the texture of the shells in the tough areas.

Give the filaments texture.

The worm secretes a liquid from beneath his body to slide more easily.

Source of light

Give a rough and stony appearance to the spikes on the shell.

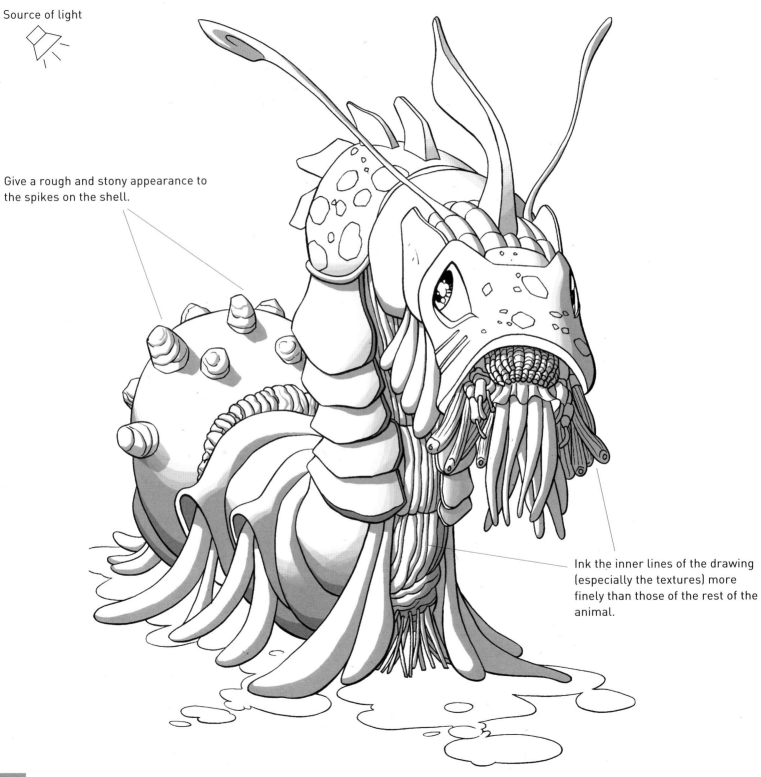

Ink the inner lines of the drawing (especially the textures) more finely than those of the rest of the animal.

6. Color

With color differentiate the fleshy parts from the armor.

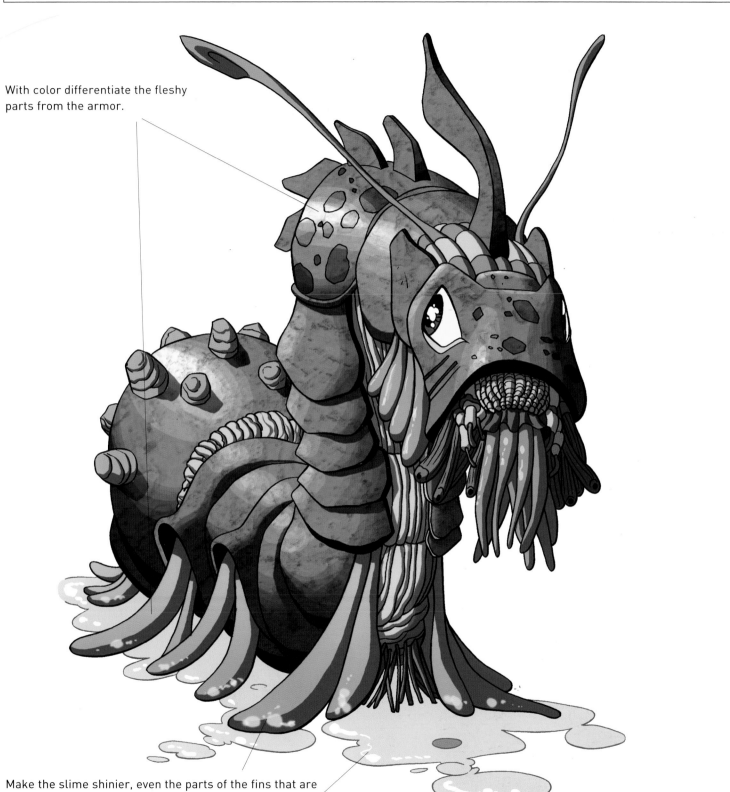

Make the slime shinier, even the parts of the fins that are in contact with the ground and slime.

WEREWOLF

The werewolf is a man that can turn into a wolf; that is why he is also known as wolf man. His natural form is that of a human, but when there is a full moon he takes on the appearance of a wolf.

We will start, therefore, with human anatomy and then add elements of the wolf. As it is a four-legged animal, we will draw the character slightly curved and turn the legs into animal legs, especially from the knees down to the feet.

A heavily built wolf man has a big chest and small hips. So we will draw a wide back, some voluminous shoulders, and a thin waist. The posture should show the wild side of this creature, with the head bent down, and the claws and teeth displayed.

Sketch a posture that shows tension and that he is ready to attack.

The feet form a different angle compared to a human; draw an extra joint to help you with the sketch.

2. Volume

Add volume to the snout, which protrudes from the sphere that is the head.

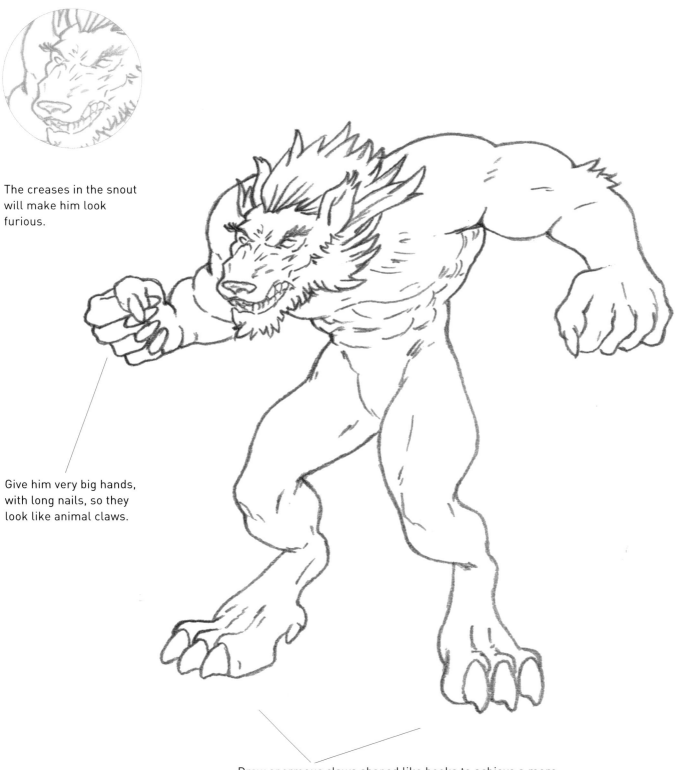

The creases in the snout will make him look furious.

Give him very big hands, with long nails, so they look like animal claws.

Draw enormous claws shaped like hooks to achieve a more aggressive appearance.

Tribal beads, pendants, leather bracelets or necklace of teeth, show that the creature spends a lot of his time in wolf form.

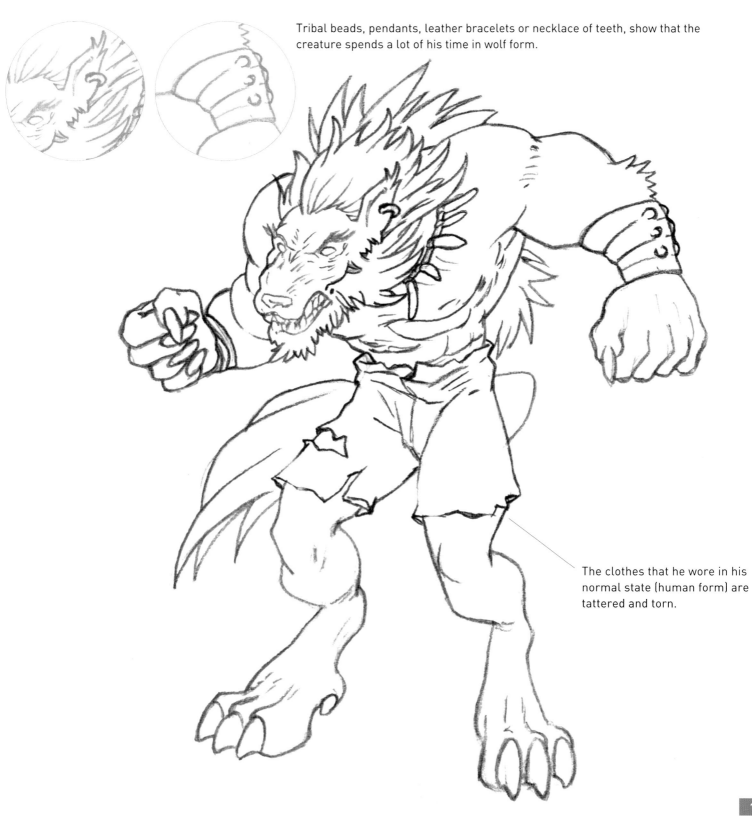

The clothes that he wore in his normal state (human form) are tattered and torn.

Use long, wavy strokes for the strands of hair and continuous shadow lines for the body.

Differentiate with shadow the mat of head hair from that of the back, which is behind.

Source of light

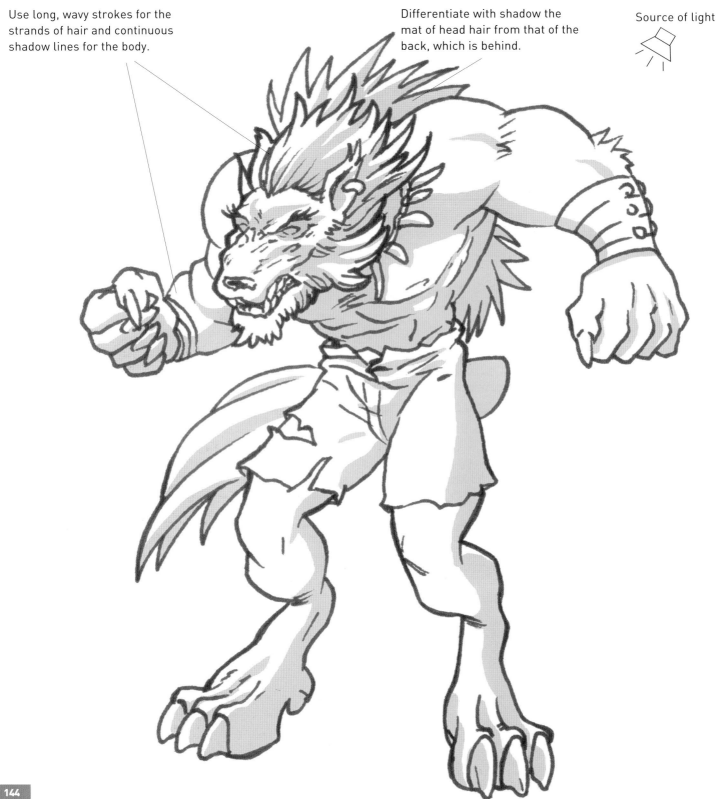

Use similar tones for the body as for the strands of hair, and do the same with the shadows of the darker areas so there is not too much contrast with the other parts of the figure.

Use earthy colors for the accessories and the clothes.

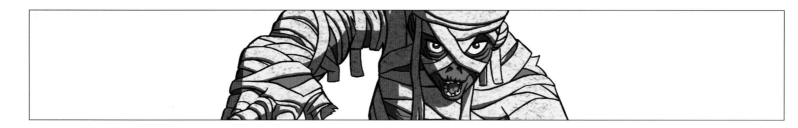

MUMMY

The origin of mummies goes back to ancient Egypt, which had the custom of embalming and mummifying important people (i.e., conserving the body to avoid rotting, whether naturally or by artificial means).

After the famous excavations from the nineteenth century, lots of tales and superstitions regarding mummies spread, which inspired literary, fantasy, and horror stories. The mummy, then, is a very common character in the horror genre, and no less in Manga. They are often accompanied by pyramids, excavations, and archaeological relics, which means some research is required to give the story and the character a bit of historical accuracy.

Mummies are generally accompanied by a sarcophagus, where they sleep. The bandages are an essential element, so we must take care with them. Since they tend to be a bit clumsy when walking, they sometimes start losing bandages and even parts of their bodies, due to their gradual but constant deterioration.

1. Shape

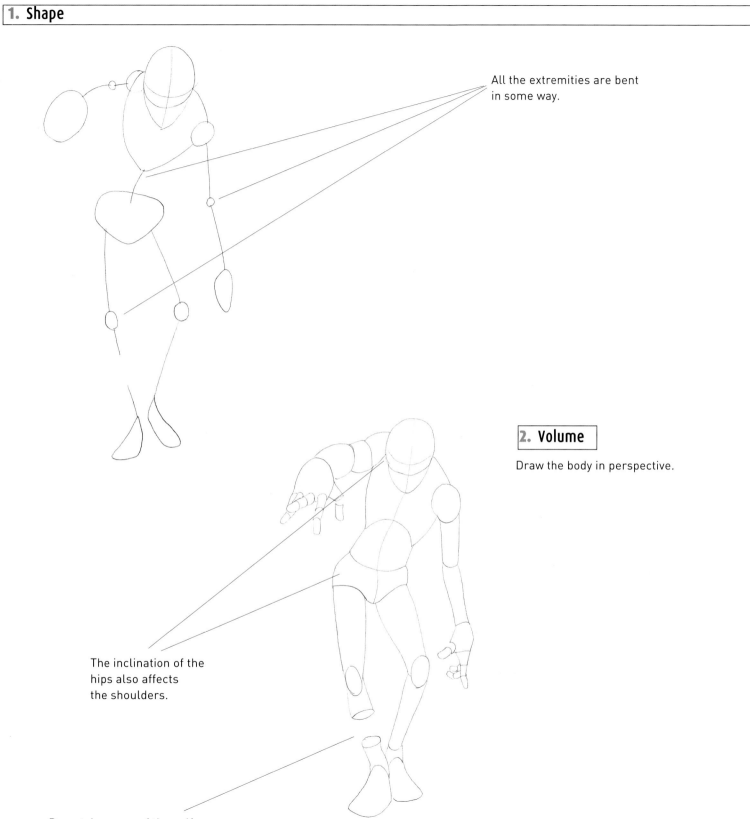

All the extremities are bent in some way.

2. Volume

Draw the body in perspective.

The inclination of the hips also affects the shoulders.

Do not draw any of the calf.

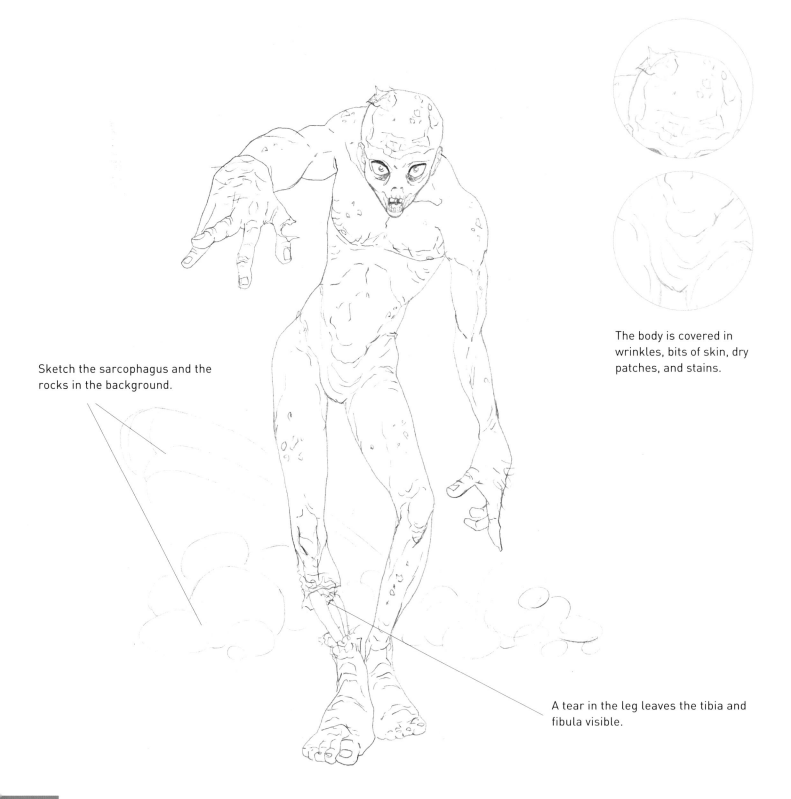

The body is covered in wrinkles, bits of skin, dry patches, and stains.

Sketch the sarcophagus and the rocks in the background.

A tear in the leg leaves the tibia and fibula visible.

Cover the mummy with an old-looking bandage, respecting the volume of the figure.

Leave a few bits of the bandage loose and torn to show how time has wasted them away.

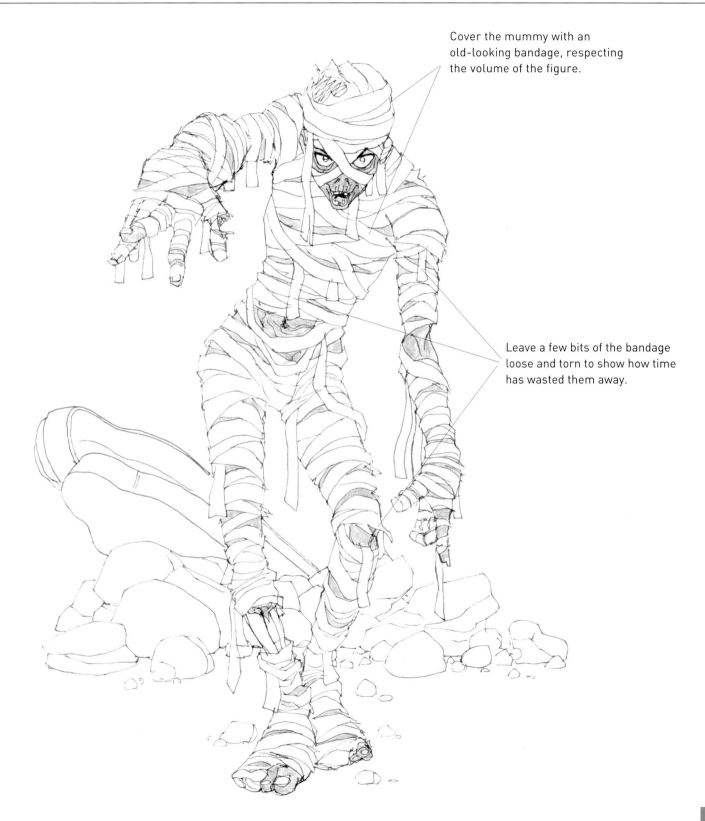

Do not use flat shadows. Adapt them to the volume of the body, as the bandages create small protrusions.

Source of light

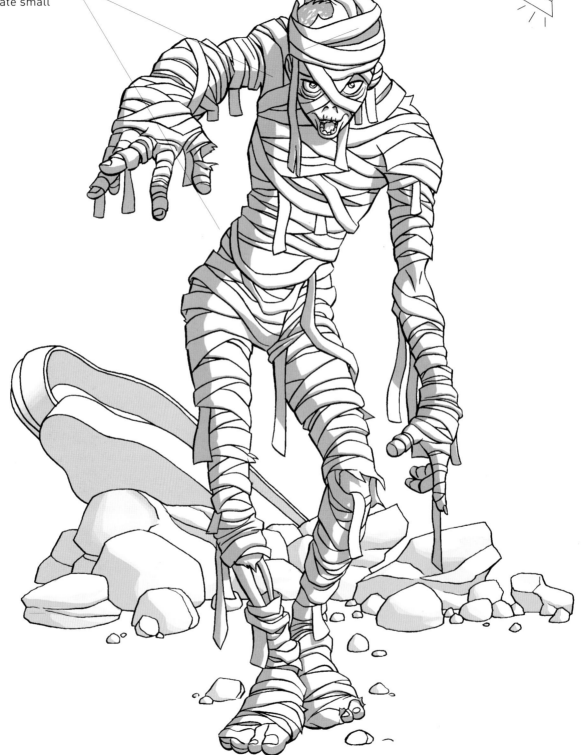

Earthy colors dominate to make the character look old and dusty.

Separate the planes by reinforcing the intensity of the shadows and the colors in the foreground, and toning down those in the background.

MONSTER FROM THE DEEP

In many stories of sea monsters, the beasts are portrayed as massive and uncontrollable, in other words, truly frightening beings. Although in Manga they often play important parts, they are not normally main characters in a story.

In spite of their dangerous appearance, we will give our character a friendly touch and a peaceful personality, playful and crafty.

This monster from the deep has certain physical characteristics that allow it to live in aquatic environments, i.e., long lateral fins to move quickly under the sea, a dorsal fin, and a large tail used like a rudder. The head and the back are protected against possible attacks by resistant armor plating.

1. Shape

Sketch the body and the head with two circles, and the fins and tail using curved lines.

2. Volume

Draw the body in perspective.

The dorsal fin and the lower fins create a triangular composition, which overlaps the circular composition formed by the animal's body and tail.

First we draw him
without his protective
plating.

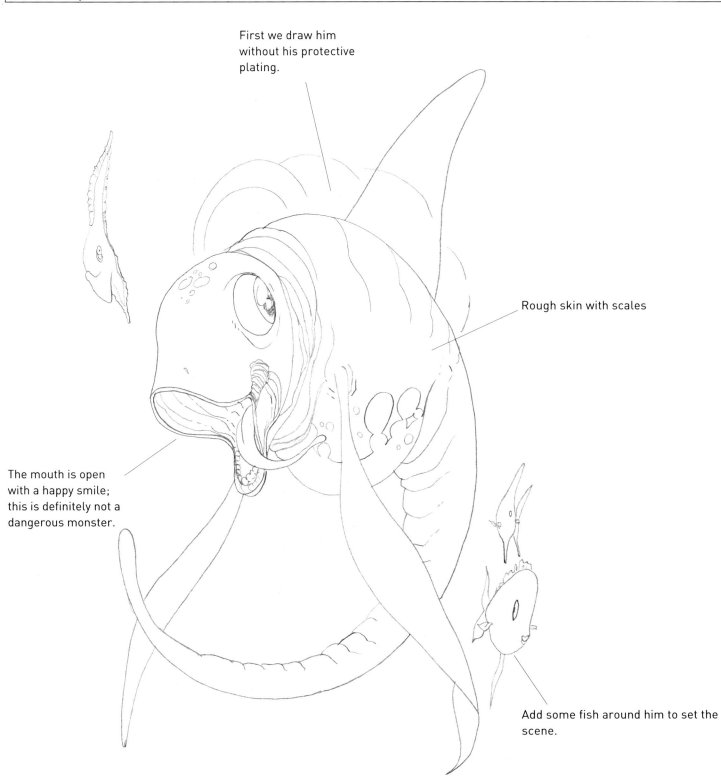

Rough skin with scales

The mouth is open
with a happy smile;
this is definitely not a
dangerous monster.

Add some fish around him to set the
scene.

Do not forget about the bubbles to
show he is in the water.

Cover his back with a shell.

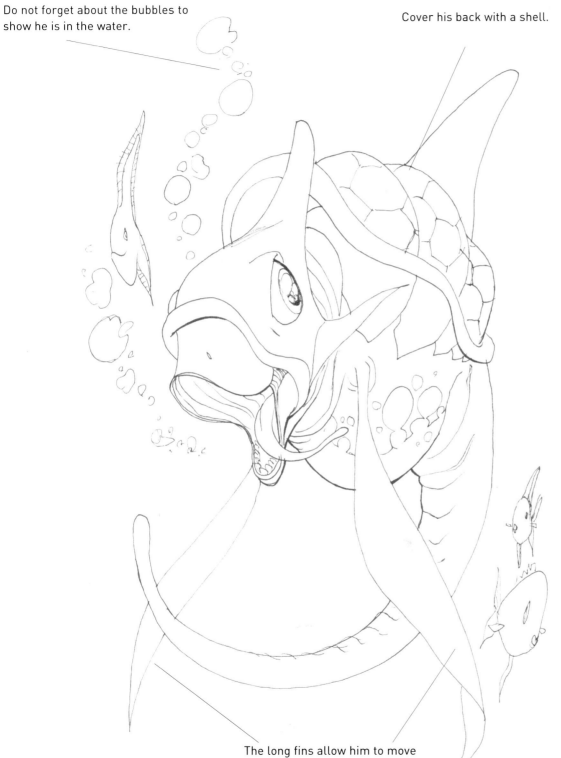

The long fins allow him to move
smoothly through the sea depths.

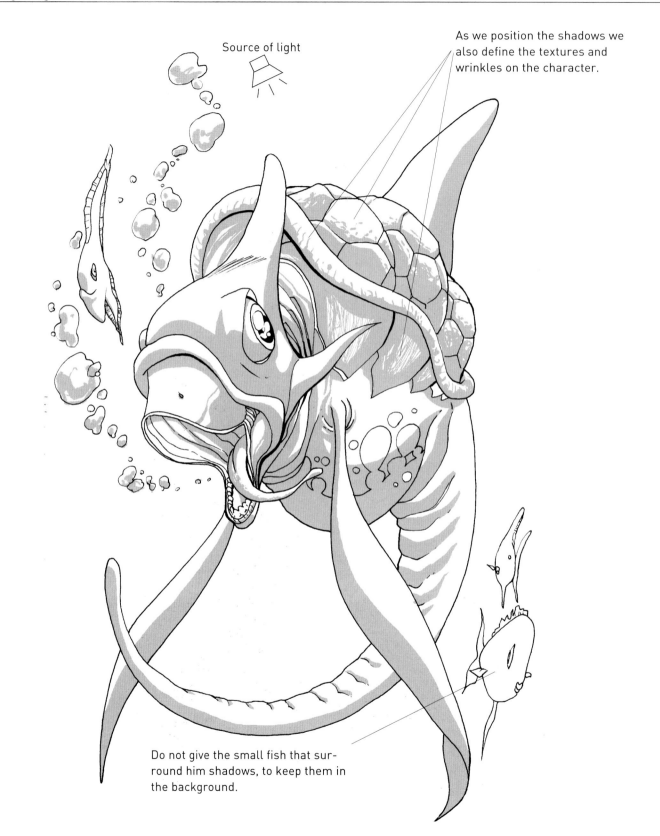

Source of light

As we position the shadows we also define the textures and wrinkles on the character.

Do not give the small fish that sur-round him shadows, to keep them in the background.

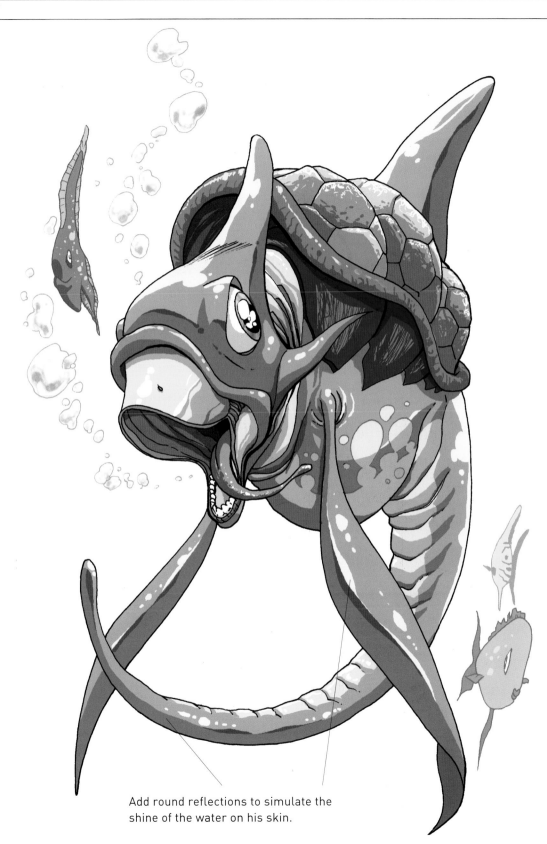

Add round reflections to simulate the shine of the water on his skin.

VAMPIRE

Vampires are creatures of fantasy that live by night and feed on blood that they suck from human victims.

They are very popular, charismatic monsters and appear as the villain and the main character in many stories.

The vampire is wrapped up in the glamour and romanticism of a cultured and passionate aristocrat condemned to live in darkness. He is powerful and formidable. He is also, however, a creature tormented by his curse.

Vampires are very versatile characters and appear in all types of stories. They appear either as the monster inspired by the cliché of the living dead and the figure of Dracula, with a medieval appearance, or a character in a present-day environment with a "vampirish" nature.

His appearance may vary, but he is often portrayed as medieval nobility or young, attractive, and sinister. The vampire that we are going to draw is more like the classical model. Using an elegant posture, we will portray a distinguished character belonging to a powerful nobility.

1. Shape

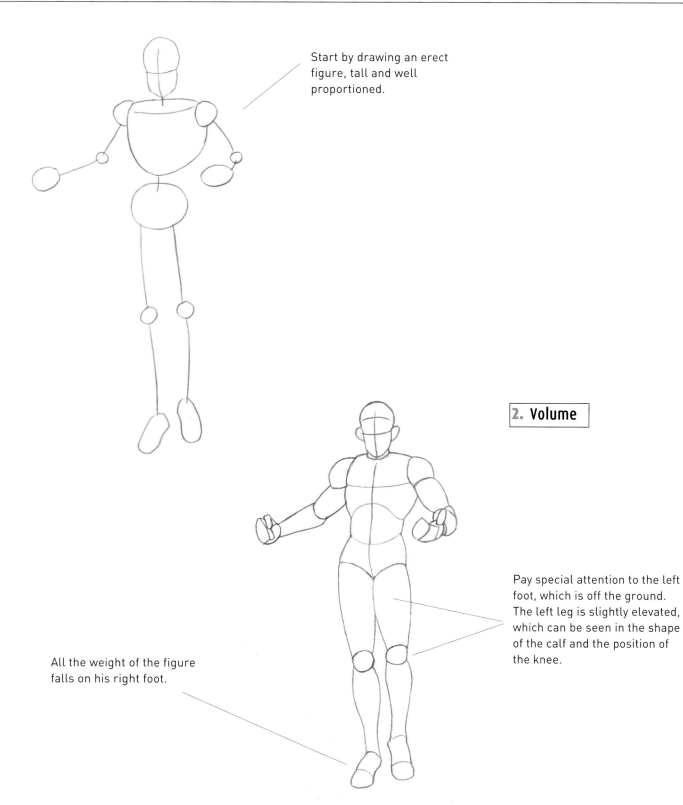

Start by drawing an erect figure, tall and well proportioned.

Pay special attention to the left foot, which is off the ground. The left leg is slightly elevated, which can be seen in the shape of the calf and the position of the knee.

All the weight of the figure falls on his right foot.

The eyes and the facial expression reflect evil intelligence.

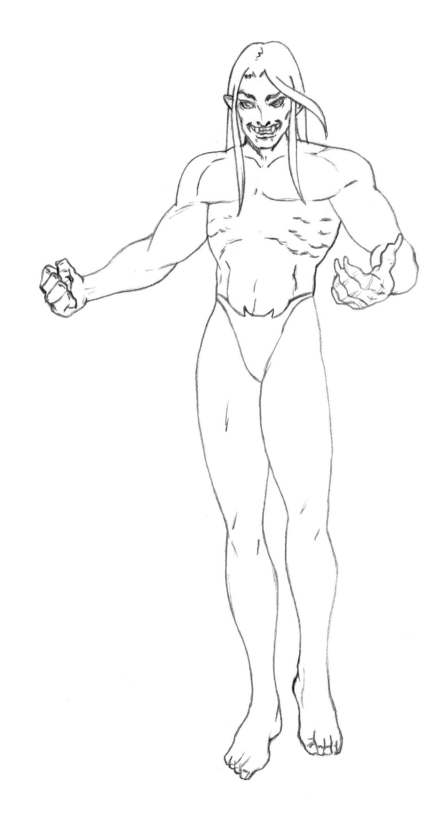

Although he has an athletic and graceful appearance, the bony hands give away the fact that he is the living dead.

The classical vampire often wears antiquated clothes. Draw a suit that an aristocrat would have worn in another era, but do not make it ostentatious or pompous.

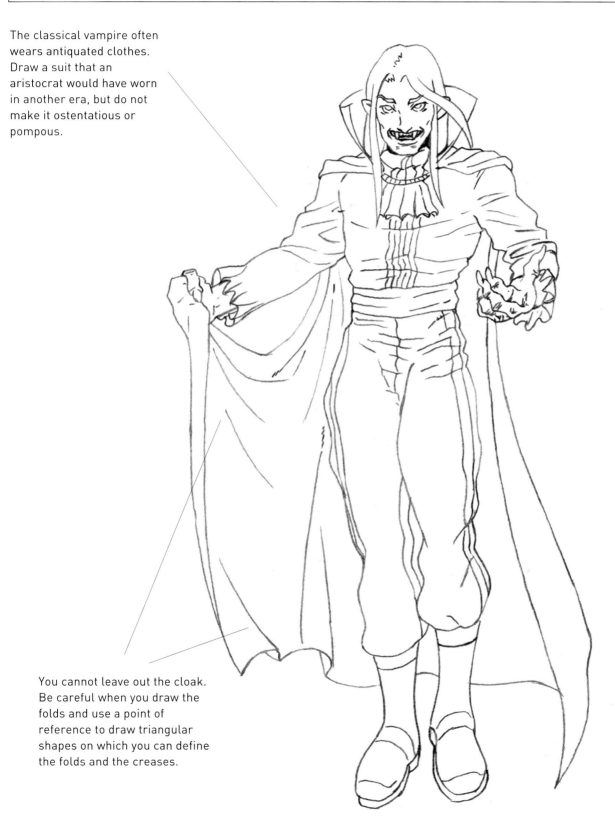

You cannot leave out the cloak. Be careful when you draw the folds and use a point of reference to draw triangular shapes on which you can define the folds and the creases.

Break up the shadow of
the shirt with shapes
that help you draw the
folds and the creases.

Source of light

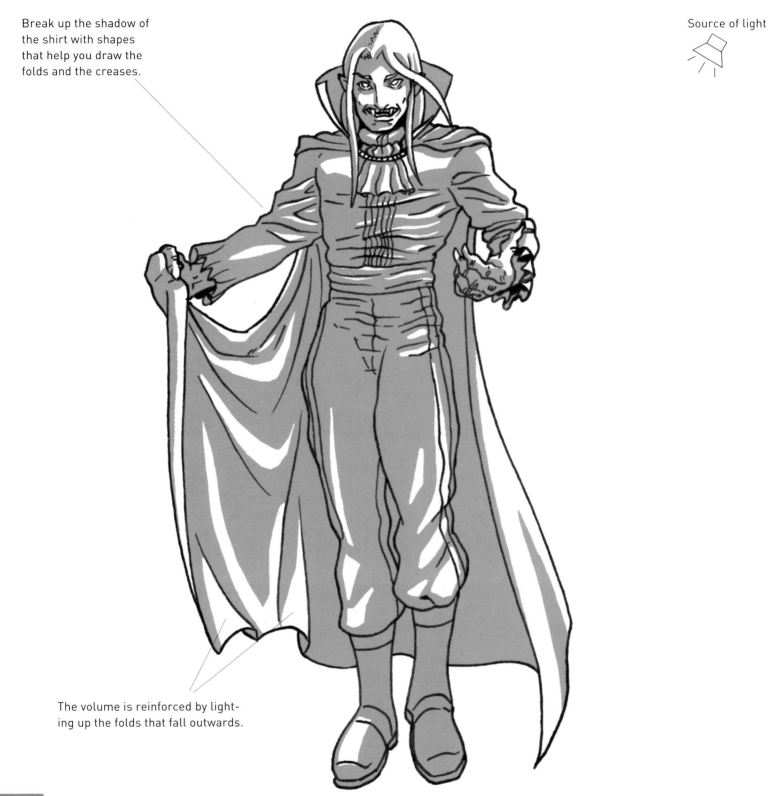

The volume is reinforced by light-
ing up the folds that fall outwards.

The hard features of the vampire are emphasized by the contrast of color and darker outlines.

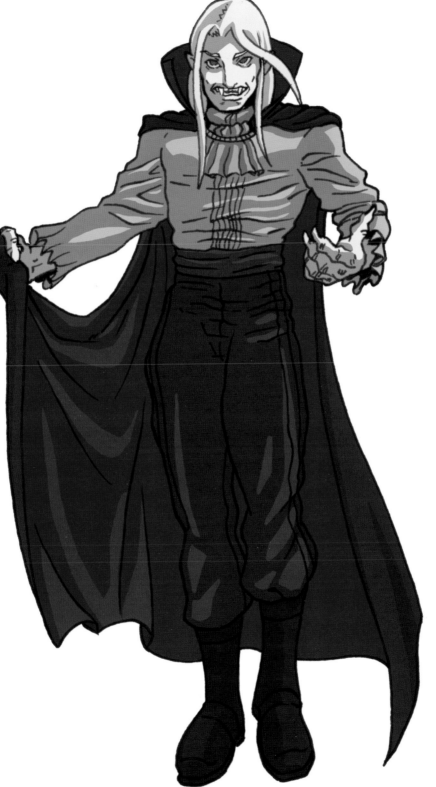

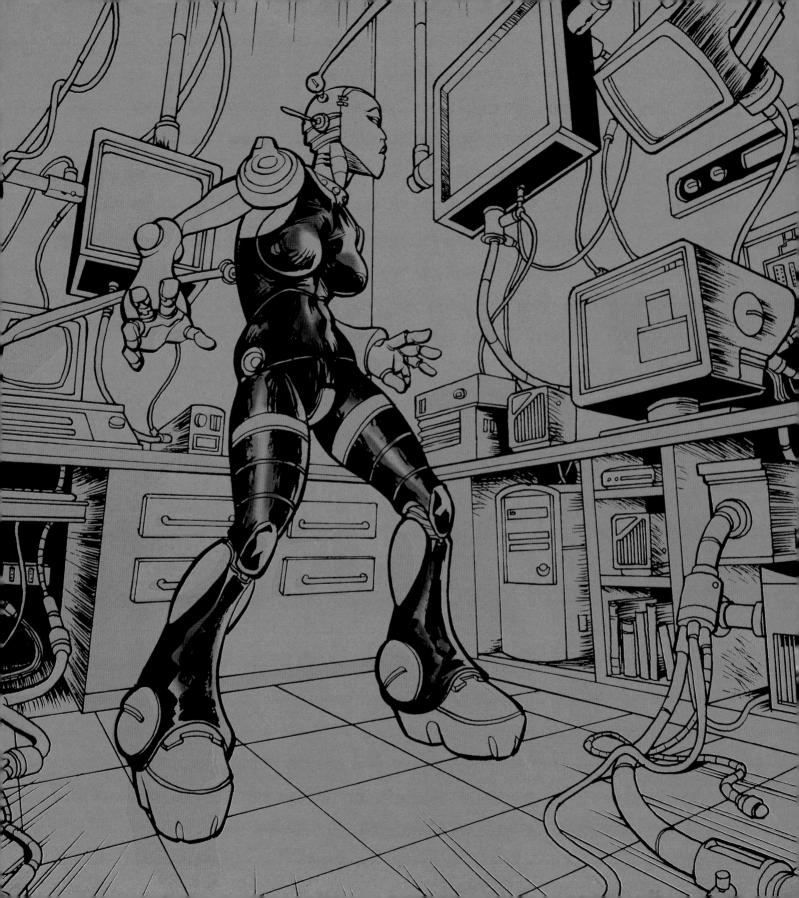

SCIENCE FICTION

DEMON

Demons are the incarnation of evil in their tireless battle against good. It is true that they are also small friendly demons, portrayed as friendly and fun characters in genres, which are humoristic and more relaxed that those of horror. They are very popular in Manga, where they appear as much as the main characters as secondary ones.

Since it is an evil character, the expression should correspond with the evil personality. Do not forget he is associated with hell, the flames, the evil, etc., so we will create an infernal background.

In the creation of evil characters, demons always seem very attractive and easy to cast for the part.

We will draw him with an arrogant attitude and one of superiority, since demons are not exactly known for their excessive friendliness; more for inflicting fear on whoever comes near them or gets in the way of their evil plans.

We will draw the figure totally erect, with two enormous wings unfolded in the shape of brackets.

2. Volume

The volumes are wider in the upper half of the body and get narrower as we go down.

The muscles, in general, are pronounced and voluminous.

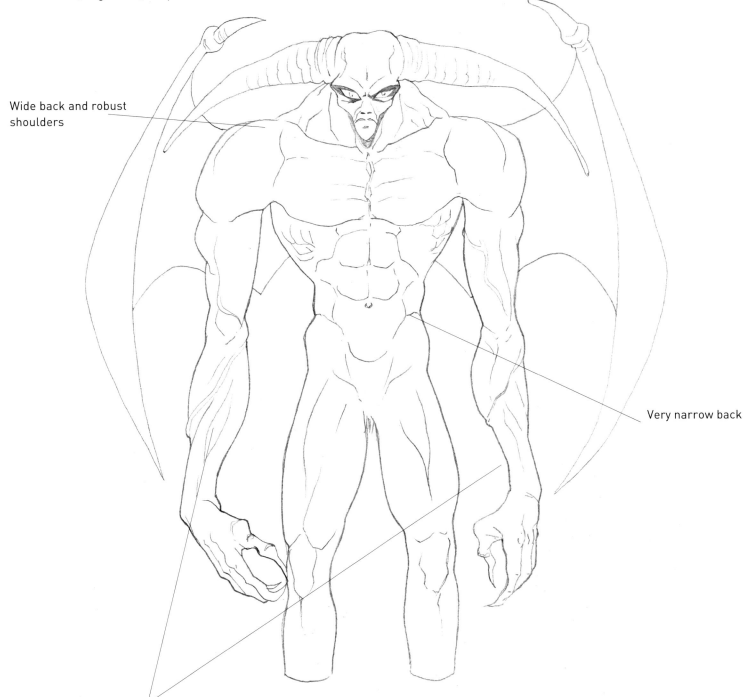

Wide back and robust shoulders

Very narrow back

Exaggerate the length of the arms (excessively long).

Bat wings

Make the expression on the face cold and sinister.

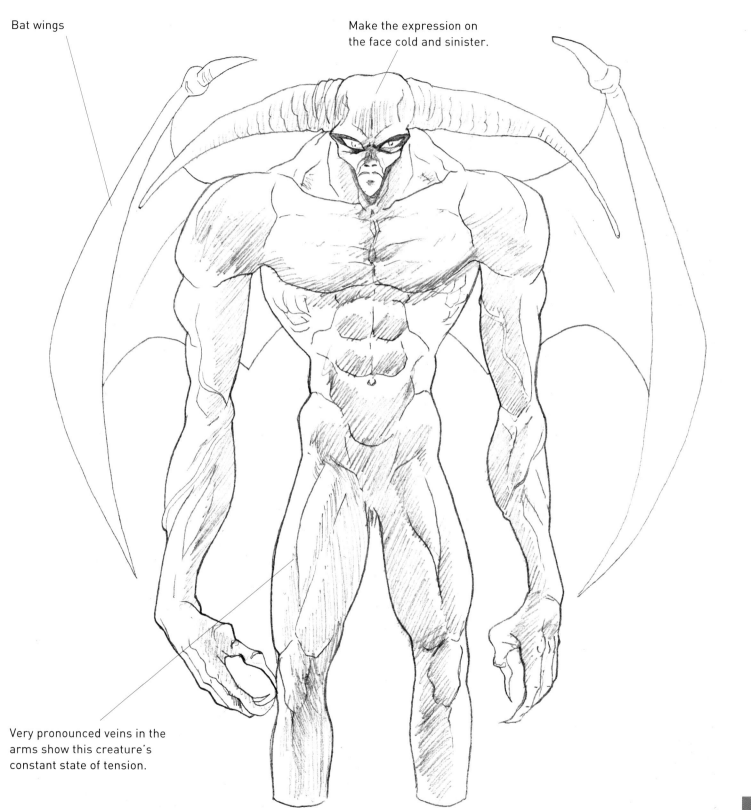

Very pronounced veins in the arms show this creature's constant state of tension.

We will draw the creature against
the light, so the shadows, which
we will mark directly in black line,
will contrast.

Source of light

Light from
behind

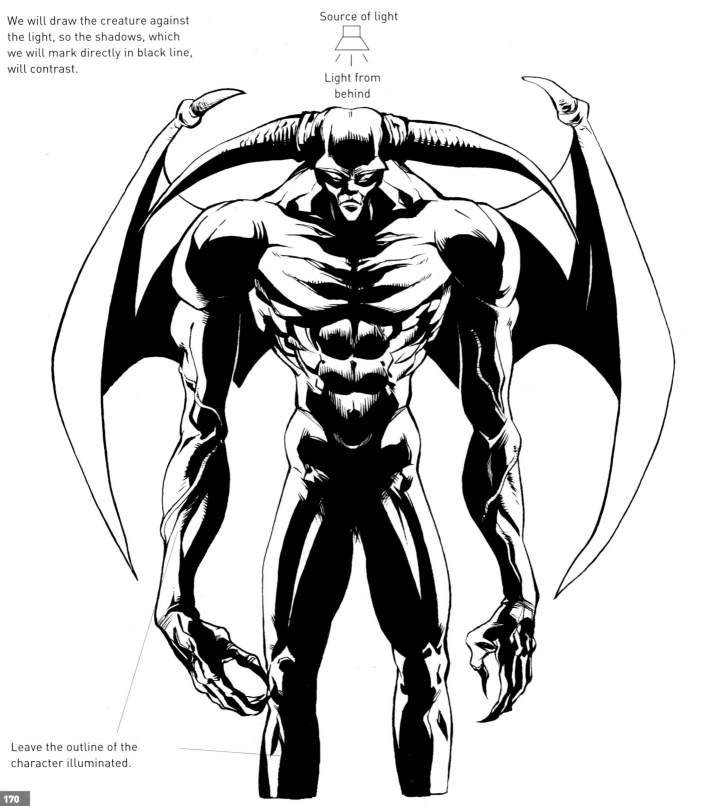

Leave the outline of the
character illuminated.

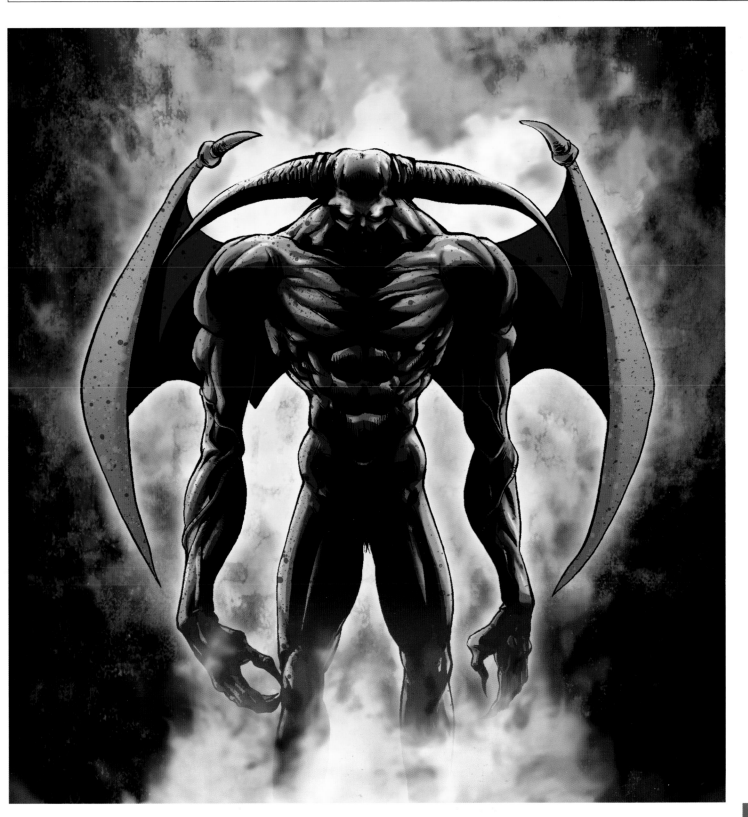

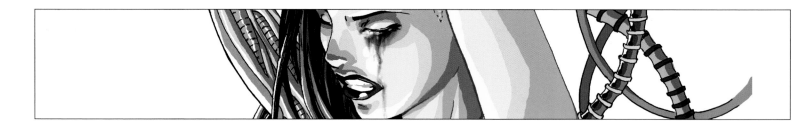

BIONIC GIRL

Our character is a young girl with artificial implants. After suffering a serious accident, she was fitted with a bionic arm, assisted breathing apparatus, and various prostheses and neuronal microchips to relieve her constant pain and migraines.

To start with, due to having so many artificial implants, the girl feels a certain rejection and tries to take out all the cables and tubes that do not form part of her body.

It is common to find characters in science fiction Mangas with artificial body parts, whether to improve an initial physical condition, or for medical reasons or amputations.

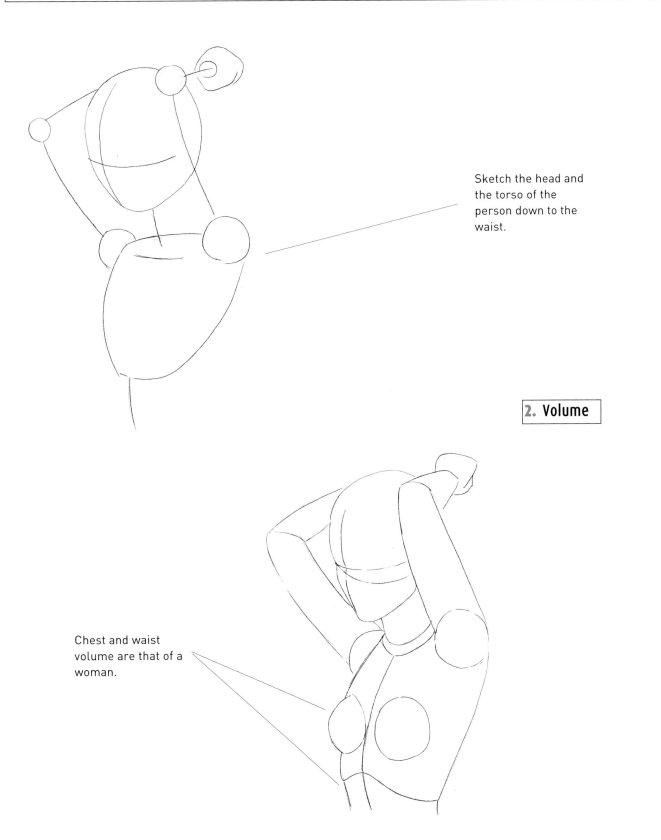

Sketch the head and the torso of the person down to the waist.

2. Volume

Chest and waist volume are that of a woman.

Expression of suffering on the face

The forearm is drawn with perspective, so it is partially covered by the rest of the arm.

Half of the head is shaved to insert cables and cerebral implants.

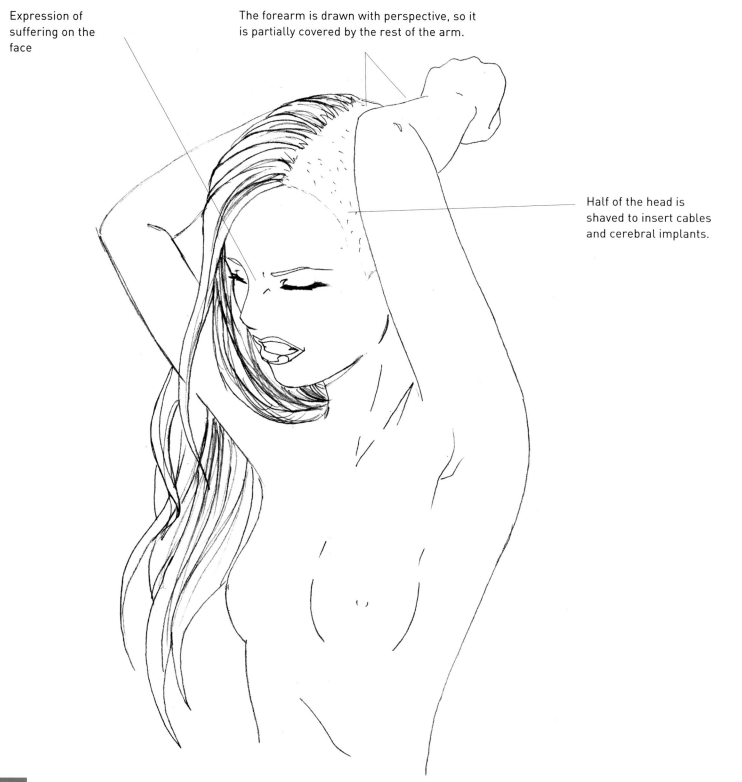

Improved bionic arm

She has various cables connected to her body, which make her feel weighed down and trapped.

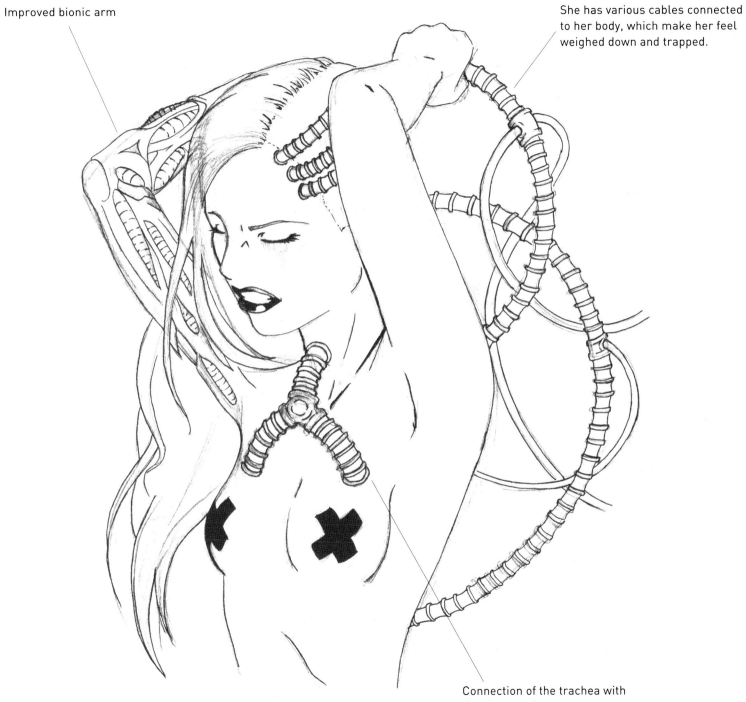

Connection of the trachea with the chest cavity

Low-angle lighting adds drama and the sense of anxiety to the scene.

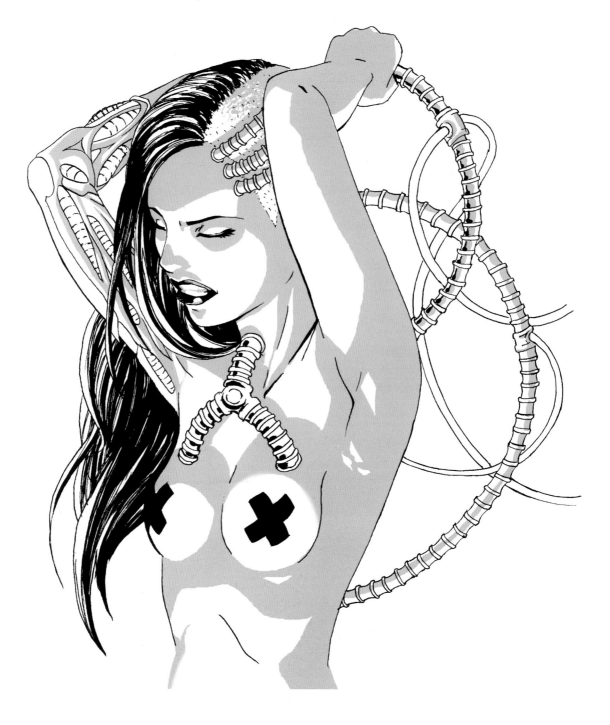

Source of light

The girl feels trapped by her
non-human side.

Cold colors indicate the presence
of artificial mechanisms.

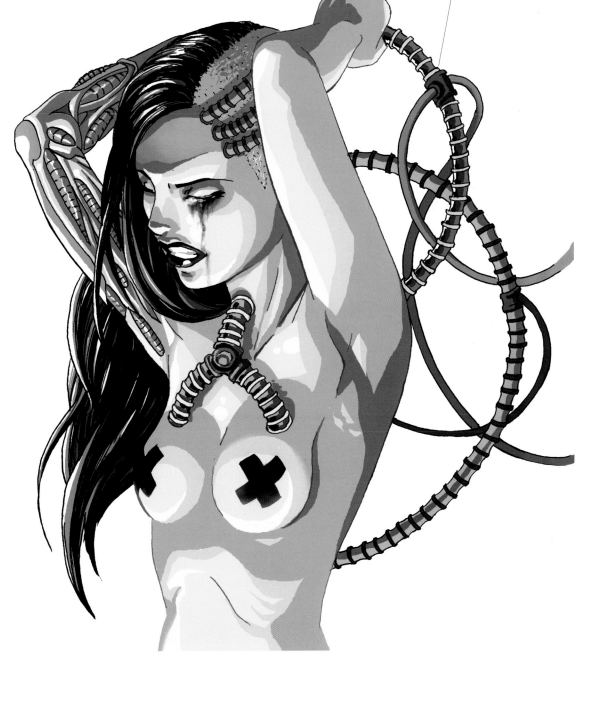

CYBERPET

The following character is a pet, which is a little peculiar. Its aggressive and violent appearance would make people want to flee from it rather than stroke it. However, it only appears dangerous; in fact, its mission is to protect and watch out for the safety of its master, in this case a little girl, without causing, on its own initiative, any violent action.

The drawing has to be dynamic and stylized. Together with this "nice" animal, we will draw its master: an innocent-looking girl in contrast with the fearful appearance of her pet. To lessen the aggressive impact the character has, we will color in the illustration with very vivid tones of fuchsia.

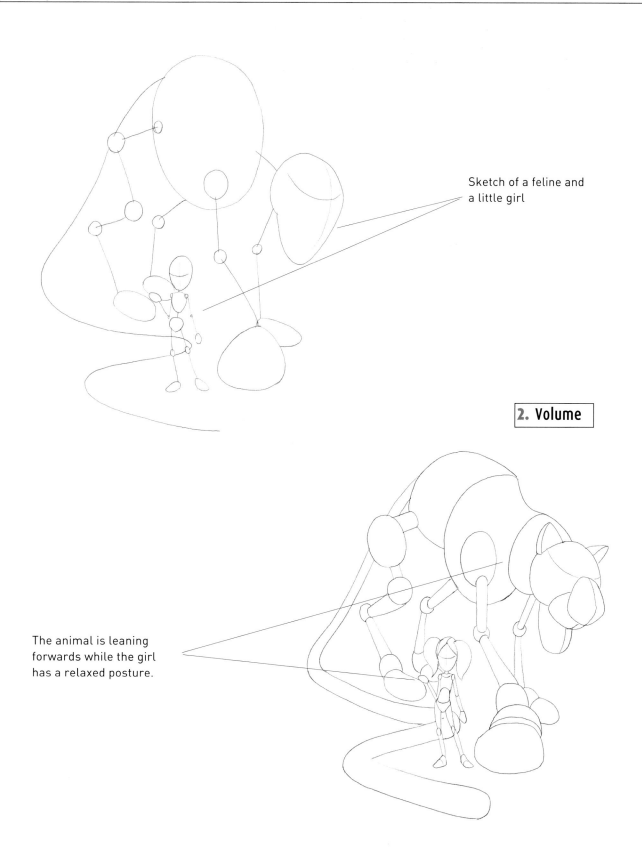

Sketch of a feline and
a little girl

2. Volume

The animal is leaning
forwards while the girl
has a relaxed posture.

The main framework of
this robot is supported
on long, flexible legs
thanks to well-designed
joints.

Give the animal
a slightly aggressive
expression in contrast
with the girl's affable
face.

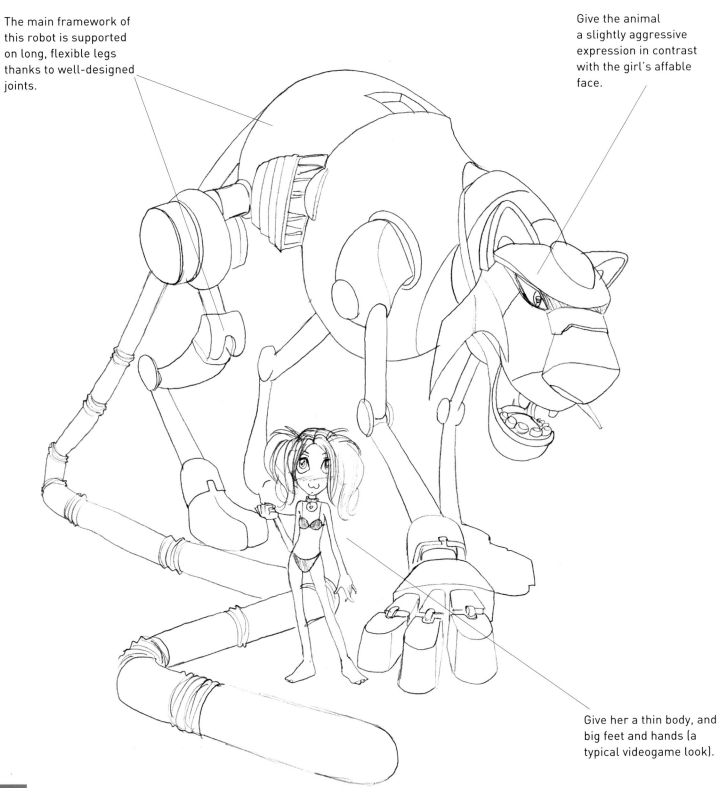

Give her a thin body, and
big feet and hands (a
typical videogame look).

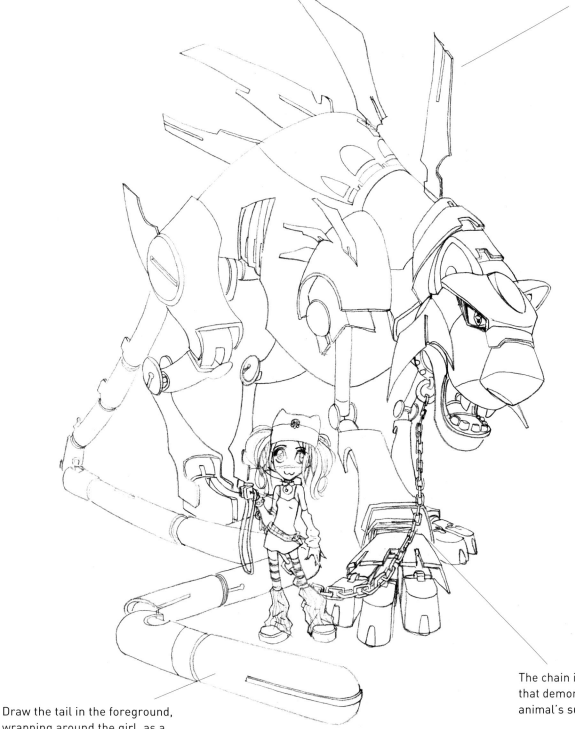

Dorsal fins and deltoids enhance the aggressive appearance.

The chain is a detail that demonstrates the animal's submission.

Draw the tail in the foreground, wrapping around the girl, as a protective gesture.

Source of light

Color the girl's clothes in black to differentiate the two planes of the drawing.

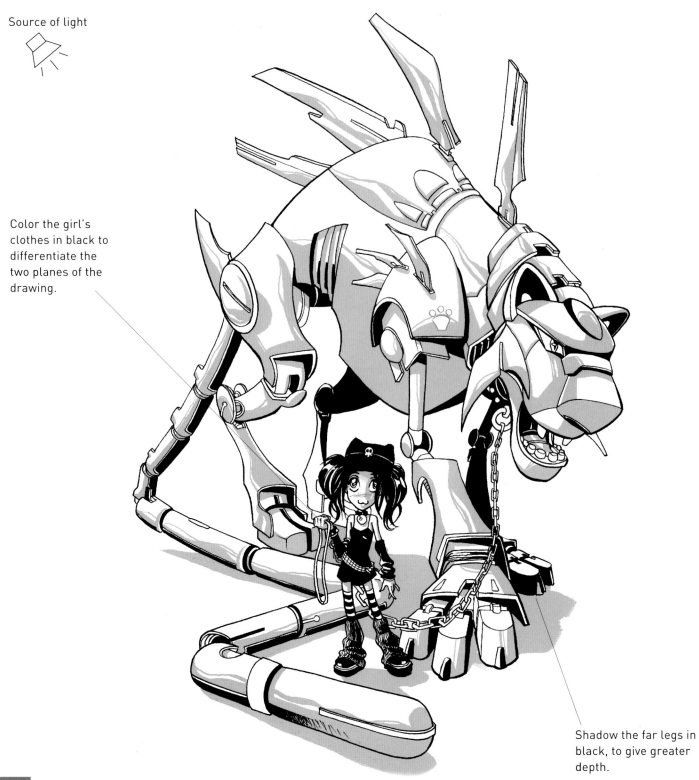

Shadow the far legs in black, to give greater depth.

Tones of pink will soften the cyberpet.

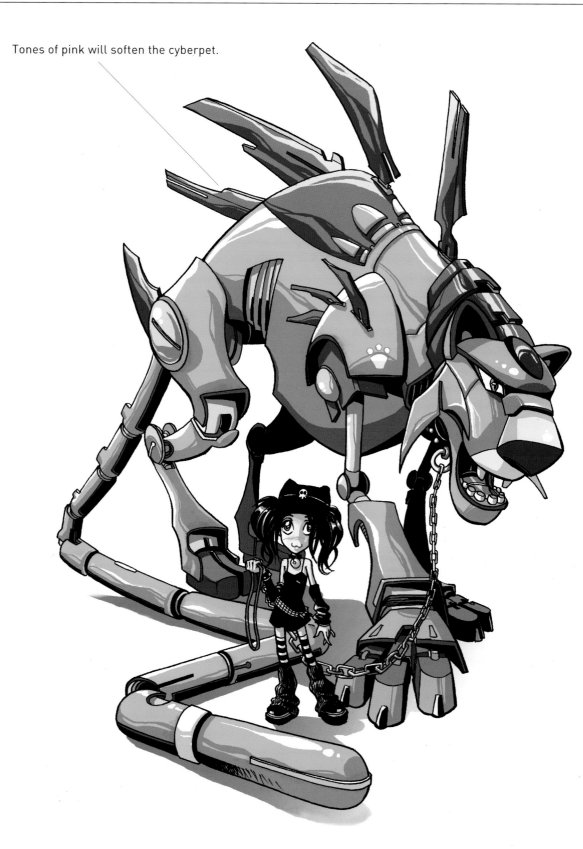

ANDROID

This character is a humanoid robot with amazing physical capabilities, used in missions infiltrating enemy territory. It stands out among other things for athletic physique, incredible stamina, and excellent tactical skills.

Our android appears in the illustration in full action, dismantling a secret biodroid laboratory. The alarms have just been set off so it is in a state of alertness with all senses and systems calculating an escape. It is a very dynamic character and, despite not being in movement, does not appear rigid.

1. Shape

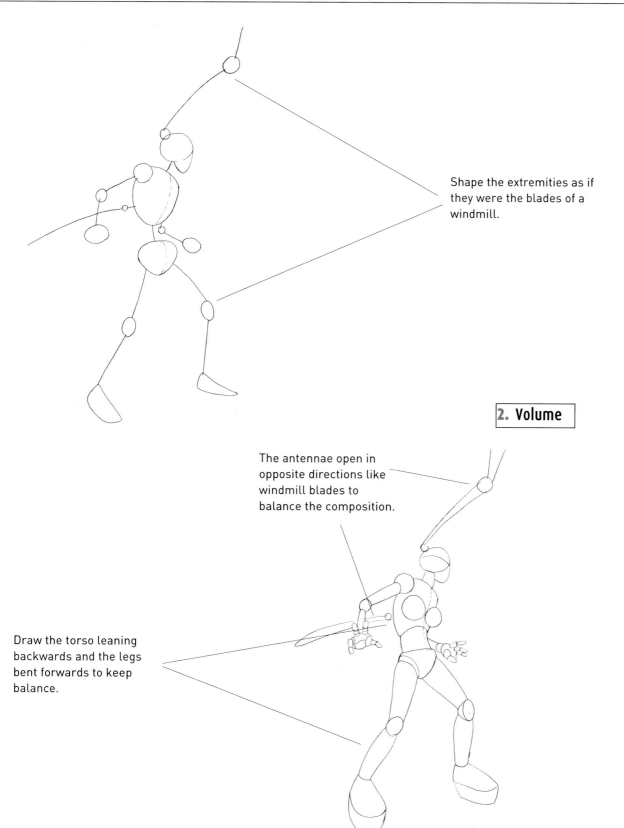

Shape the extremities as if they were the blades of a windmill.

2. Volume

The antennae open in opposite directions like windmill blades to balance the composition.

Draw the torso leaning backwards and the legs bent forwards to keep balance.

Expression of unease and fear on the face

The feet appear bigger than normal due to the perspective of the ant's-eye view.

Powerful legs and a generally athletic structure

The suit reinforces
the general anatomy.

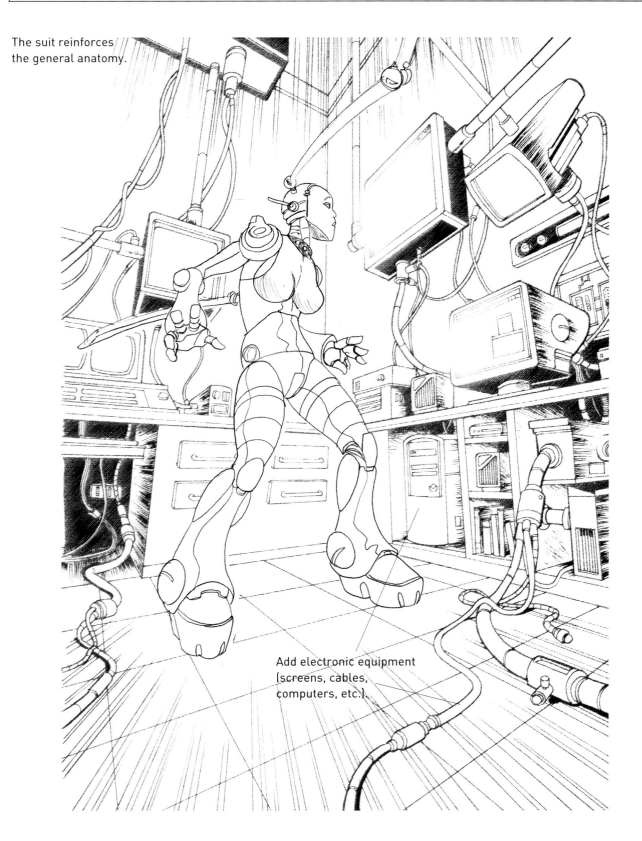

Add electronic equipment
(screens, cables,
computers, etc.).

The use of black ink on the character makes her come out from the scene.

Source of light

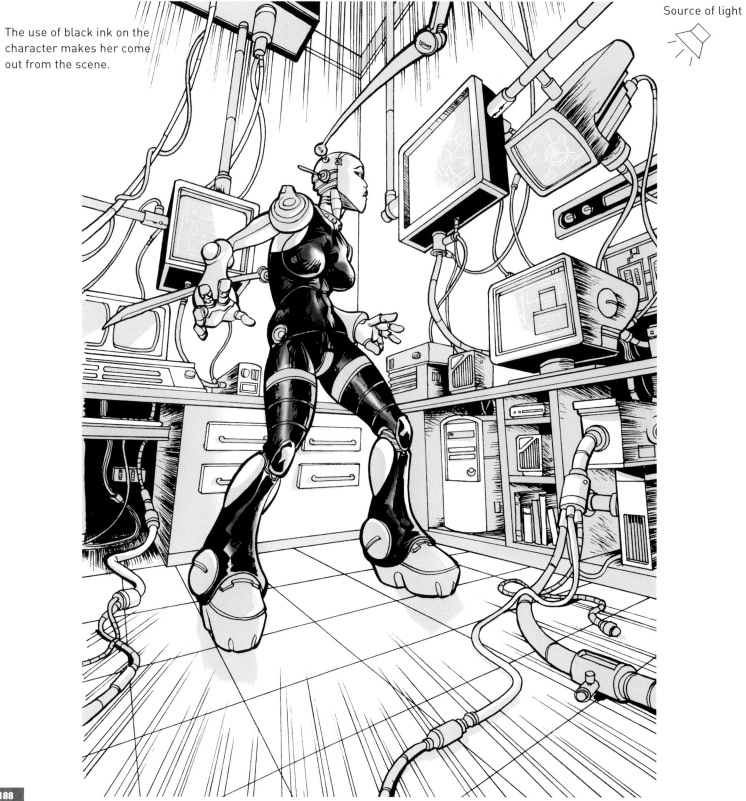

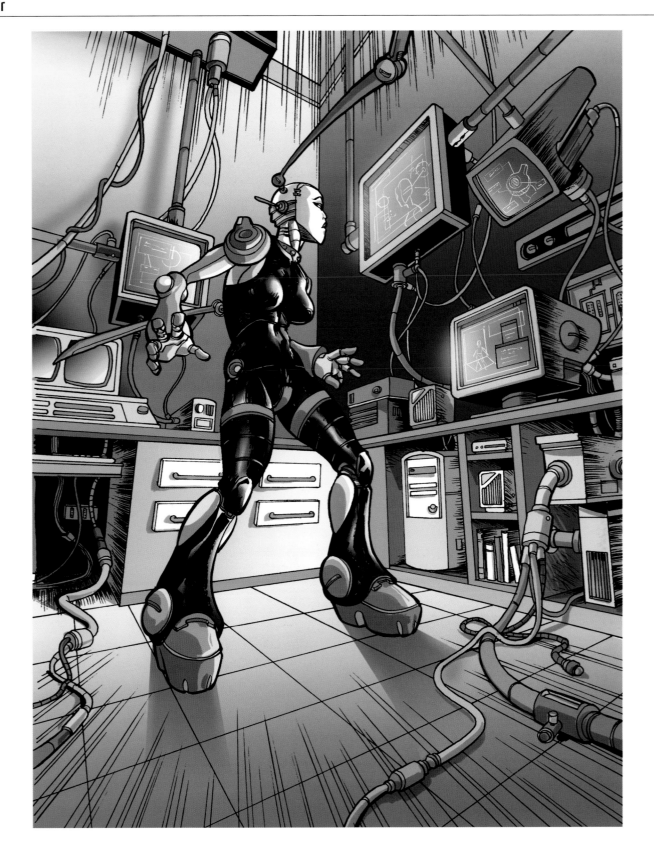

COMBAT MECHA

A mecha (short for "mechanical") generally refers to a giant robot, although it can be also to any mechanical machine, such as a spaceship, car, etc. In this case, it is a war robot, trained to combat the threats of invasion from other planets.

Since this type of robot is manned, it needs an expert pilot (especially in missions that require great skill), although it also works on automatic pilot. The mecha must have an imposing appearance to terrorize its enemies; it is approximately 150 feet high and, despite being equipped with internal arms, often resorts to wielding its laser sword.

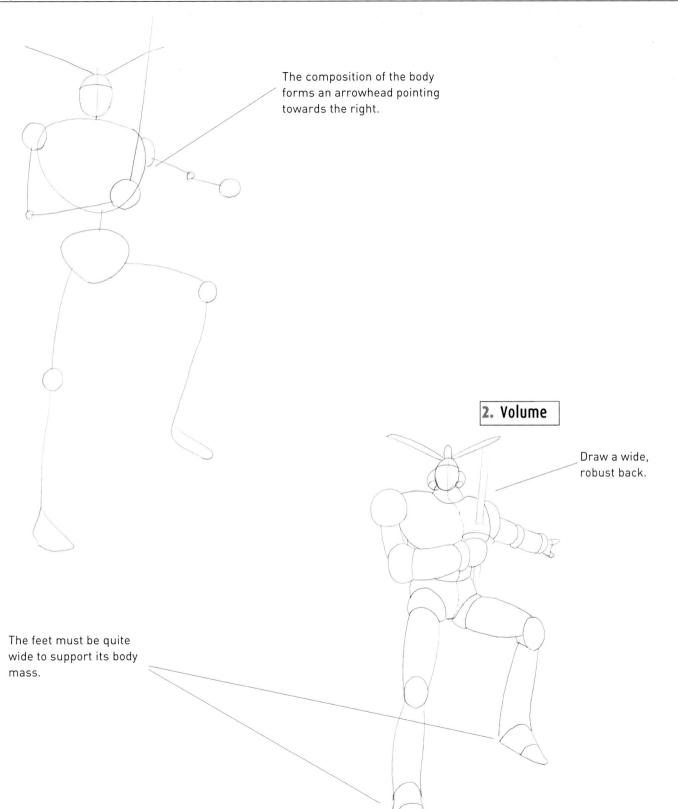

The composition of the body forms an arrowhead pointing towards the right.

2. Volume

Draw a wide, robust back.

The feet must be quite wide to support its body mass.

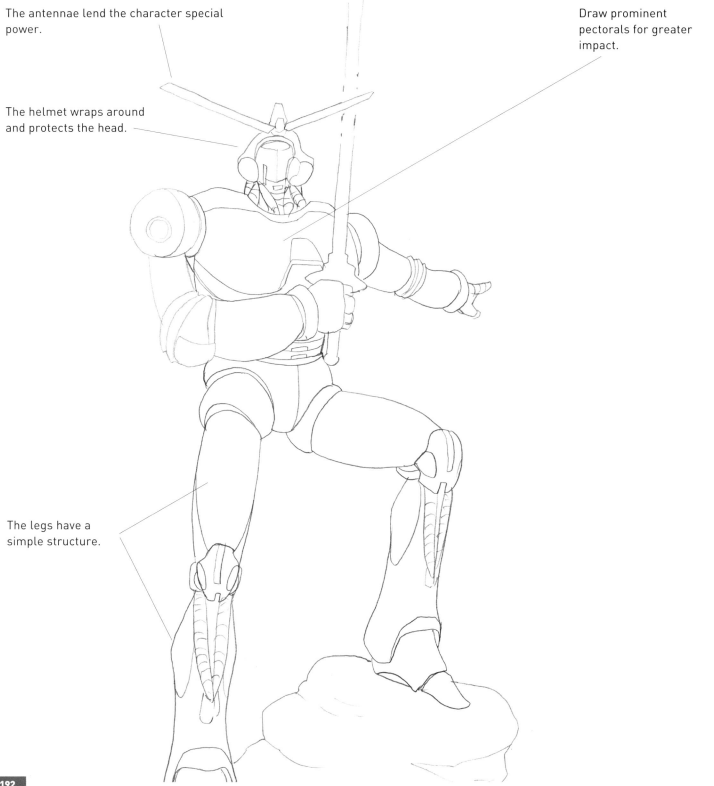

The antennae lend the character special power.

Draw prominent pectorals for greater impact.

The helmet wraps around and protects the head.

The legs have a simple structure.

Make the armor robust
and spectacular.

Add the
laser sword.

Steel whips come out
from the base of the
hilt.

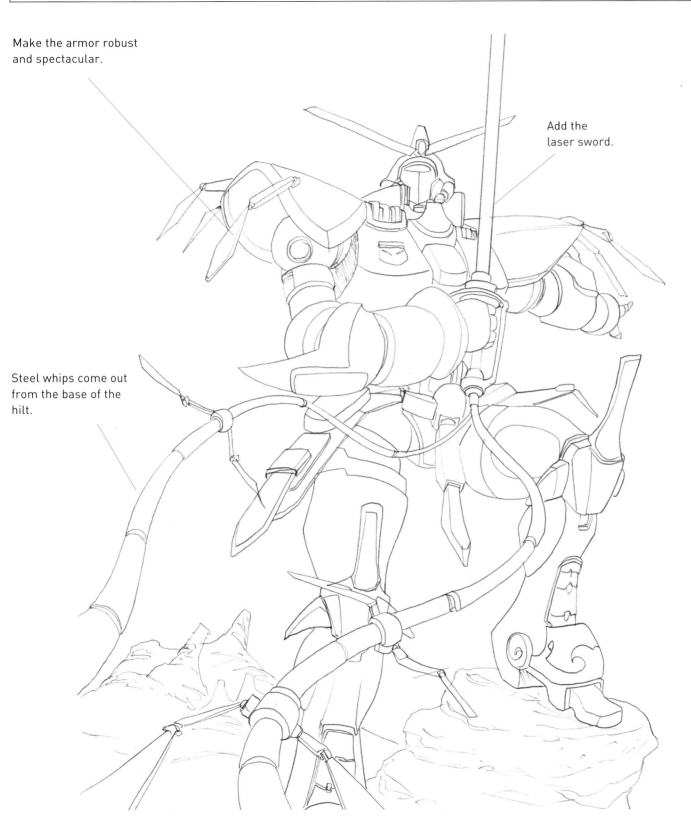

Source of light

Make the outline lines slightly thicker than those on the inside.

Reinforce the line thickness of the objects placed in the foreground.

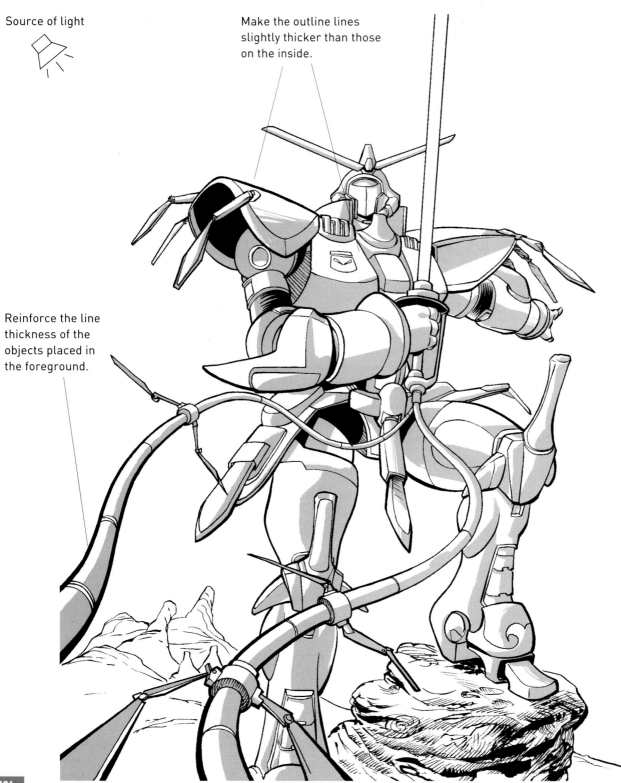

Use color to match the background and the character so that they are integrated into the drawing.

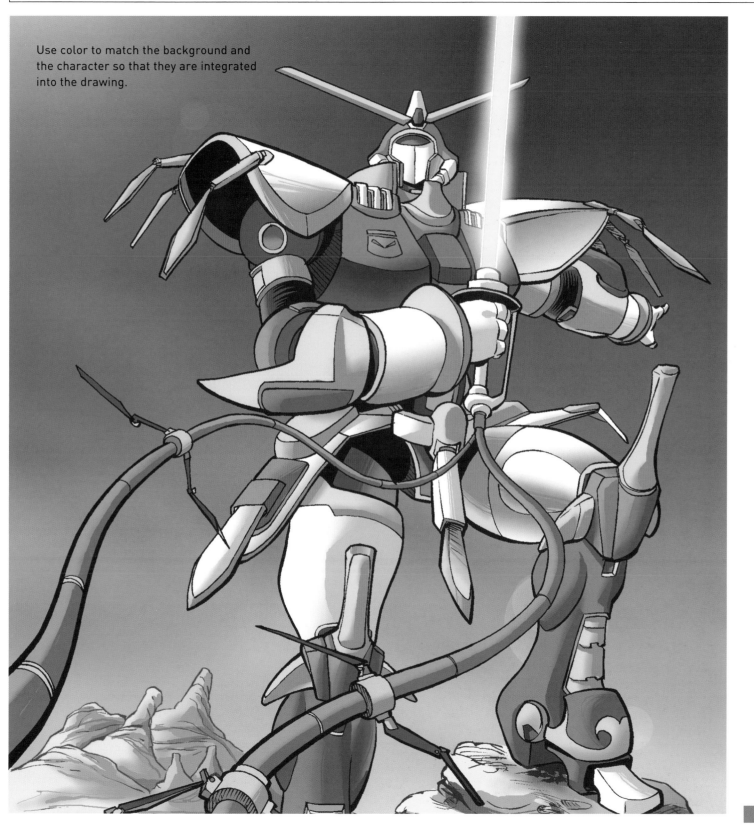

OCTOPUS

This mechanical marine character is a Mecha created for scientific purposes—for the investigation and conservation of the ocean. It should not appear aggressive, as its mission is neither to enter into combat with nor intimidate its opponent. Its anatomy is similar to that of an octopus, and it is equipped with strong paddles on its extremities to move around in the ocean depths. It is made from nonpolluting, recycled materials that minimize any sort of environmental impact. It does not appear aggressive to other marine life and passes by unnoticed.

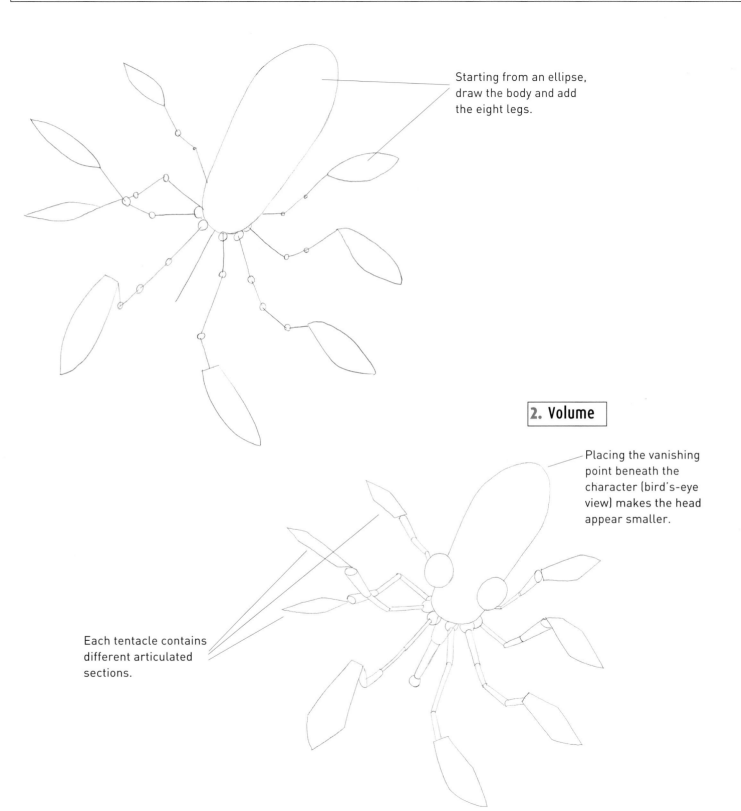

1. Shape

Starting from an ellipse, draw the body and add the eight legs.

2. Volume

Placing the vanishing point beneath the character (bird's-eye view) makes the head appear smaller.

Each tentacle contains different articulated sections.

Draw big, bright eyes that stand out.

The inside of the head contains a magnetized liquid.

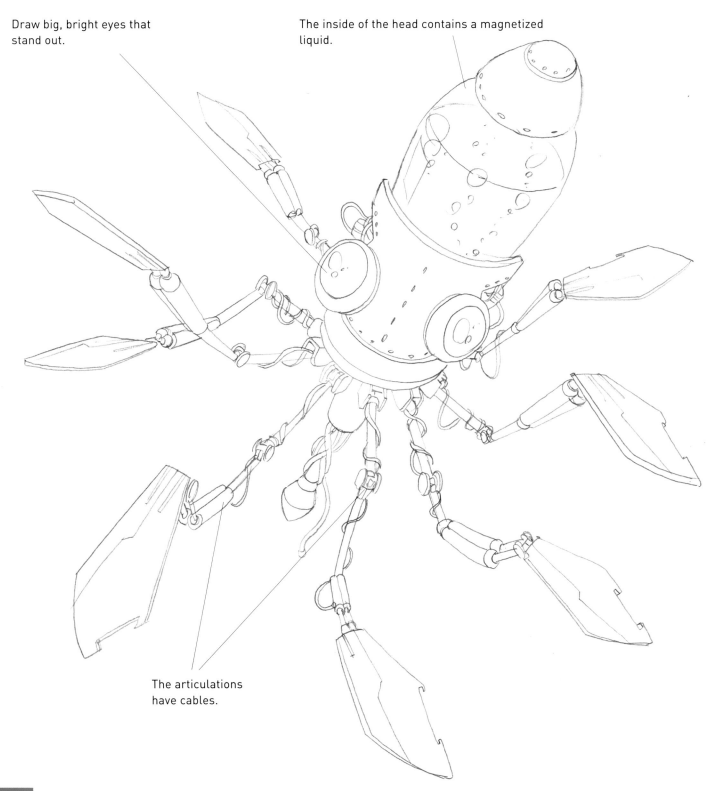

The articulations have cables.

The entire structure is covered in an insulating material.

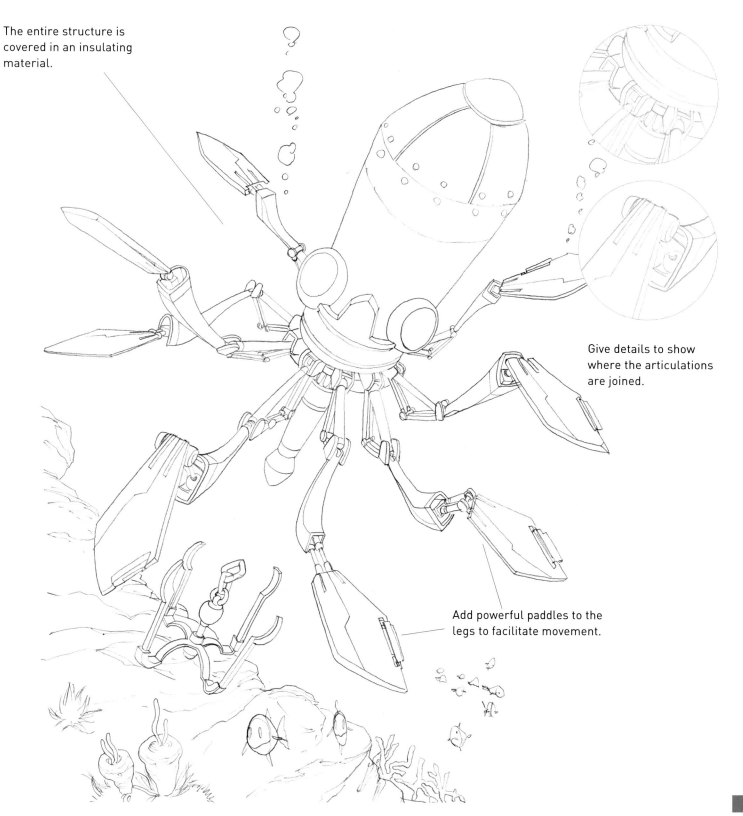

Give details to show where the articulations are joined.

Add powerful paddles to the legs to facilitate movement.

Source of light

The light source comes from the ocean surface.

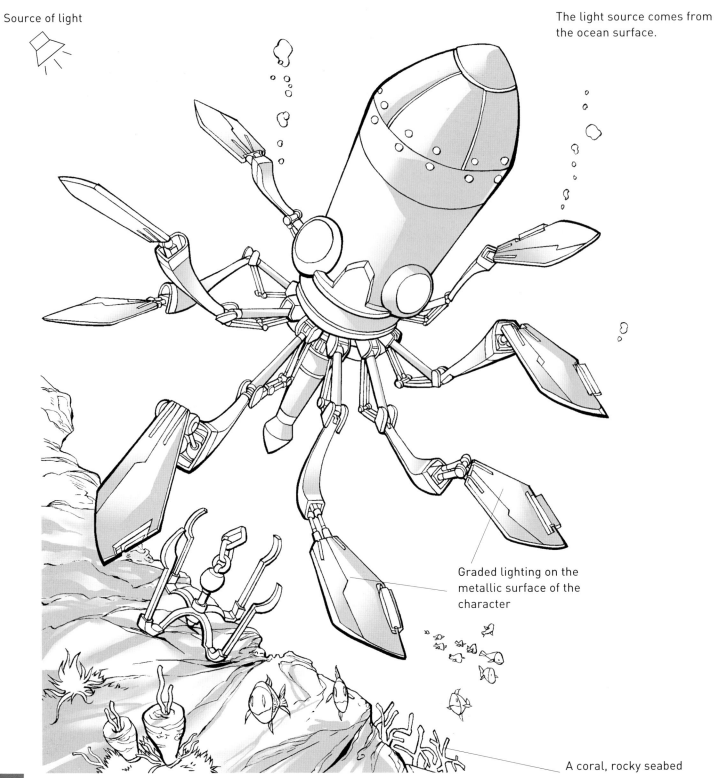

Graded lighting on the metallic surface of the character

A coral, rocky seabed

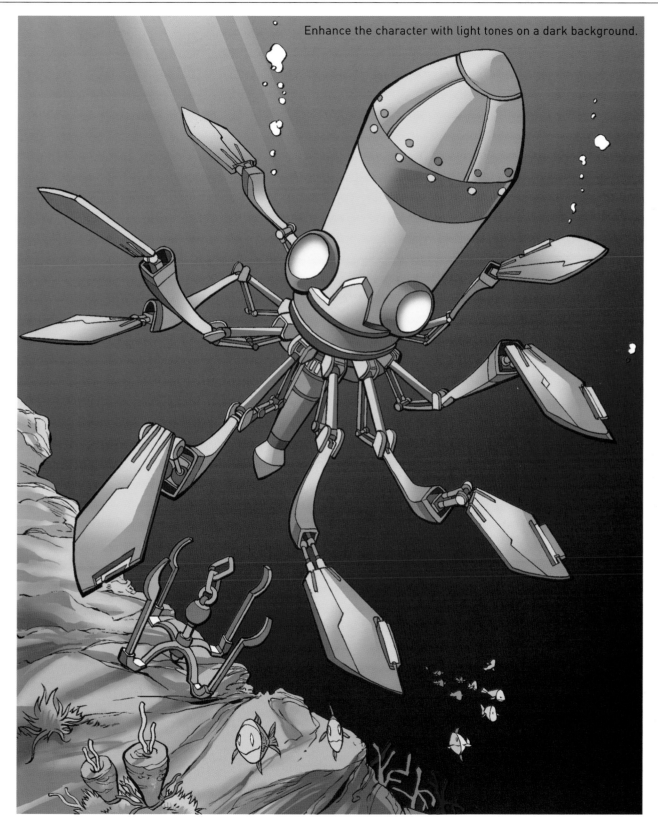

Enhance the character with light tones on a dark background.

STAR PILOT

This battle spaceship pilot is a very self-confident character, with an air of superiority, but without being arrogant; he is just good at what he does. He would fit perfectly in a Mecha or space adventure Manga.

The design of the suit must be original, i.e., visually striking and attractive. However, the fighter that he is piloting must be a modern, light, and maneuverable ship. To draw it we will have to pay special attention to the proportions and employ all our knowledge about perspective.

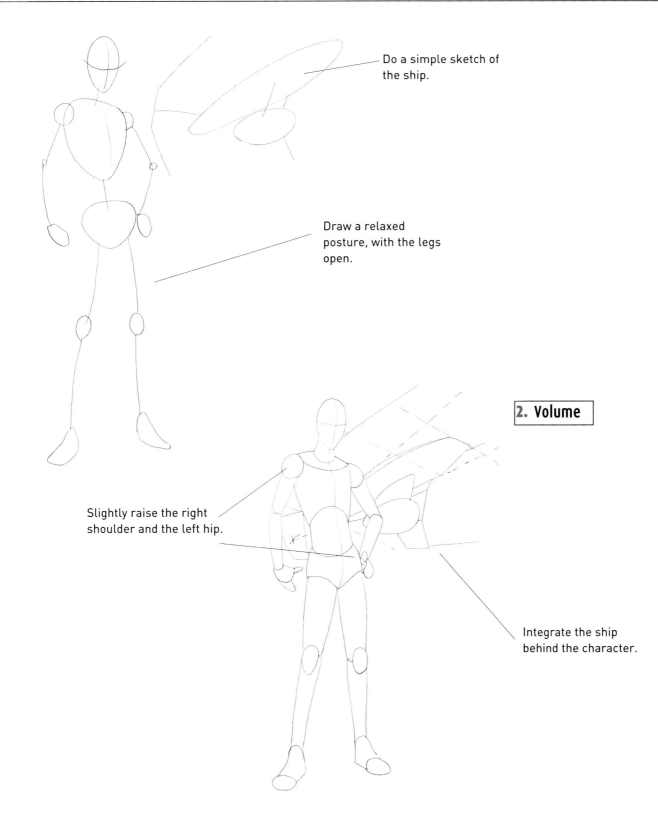

Do a simple sketch of the ship.

Draw a relaxed posture, with the legs open.

2. Volume

Slightly raise the right shoulder and the left hip.

Integrate the ship behind the character.

Well-developed, muscular, and athletic body

The wind blows the character's hair.

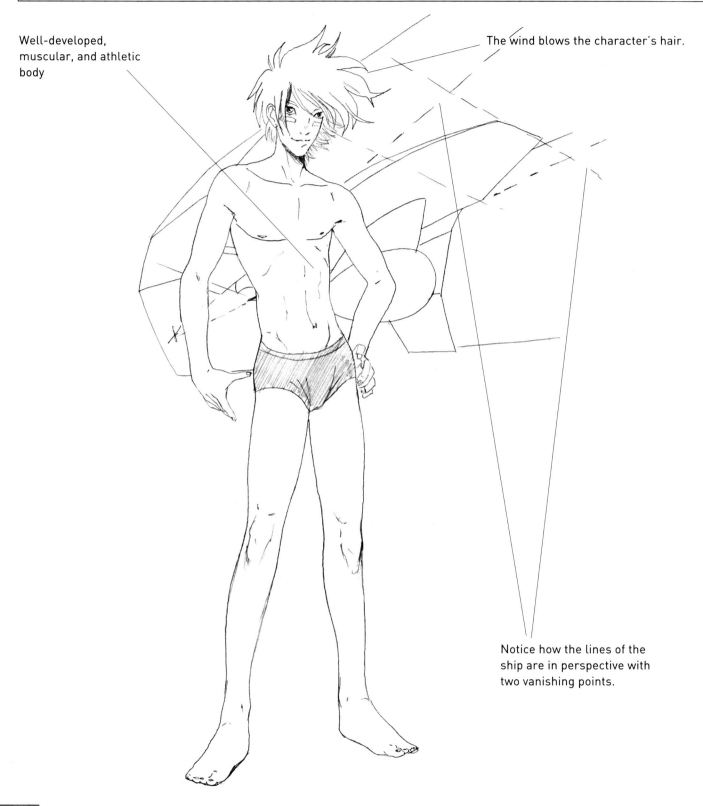

Notice how the lines of the ship are in perspective with two vanishing points.

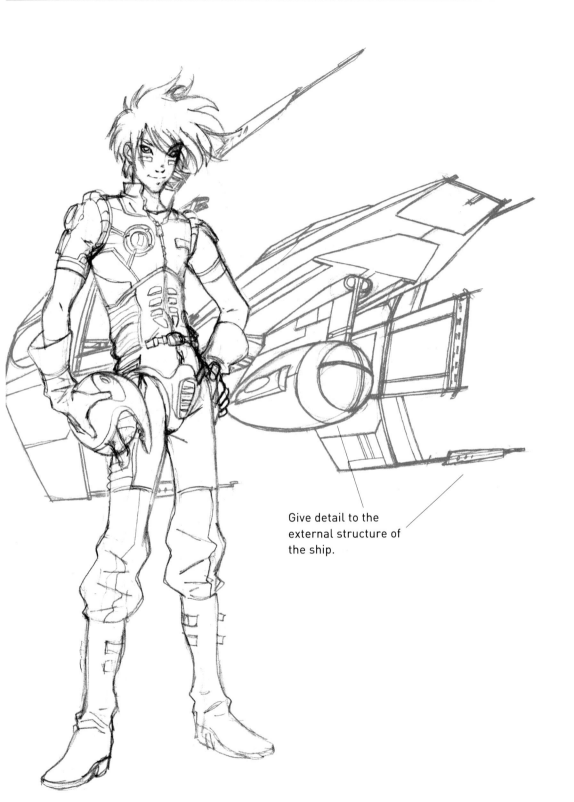

Give detail to the external structure of the ship.

Detail the pilot's uniform with insignias, protection, and decorations.

Source of light

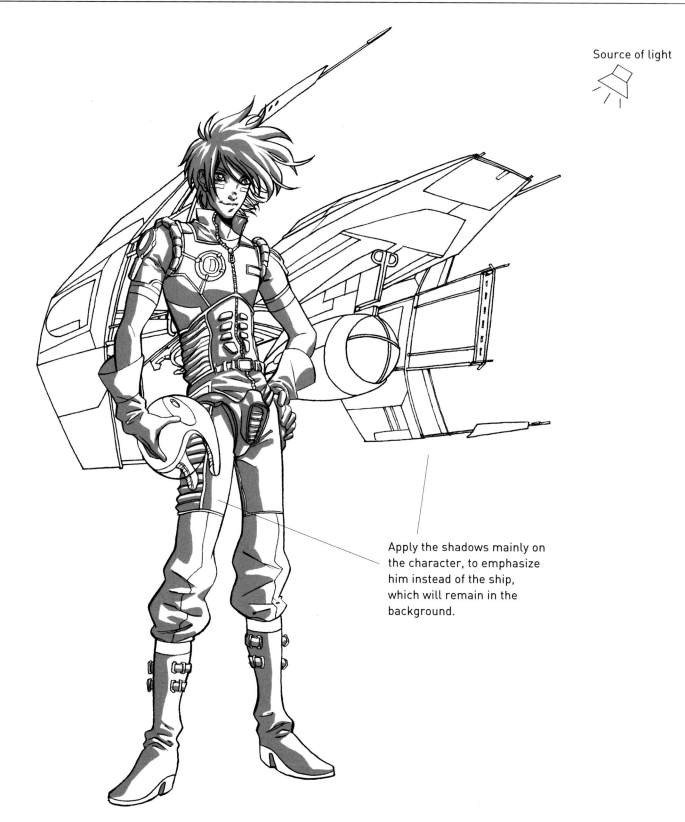

Apply the shadows mainly on the character, to emphasize him instead of the ship, which will remain in the background.

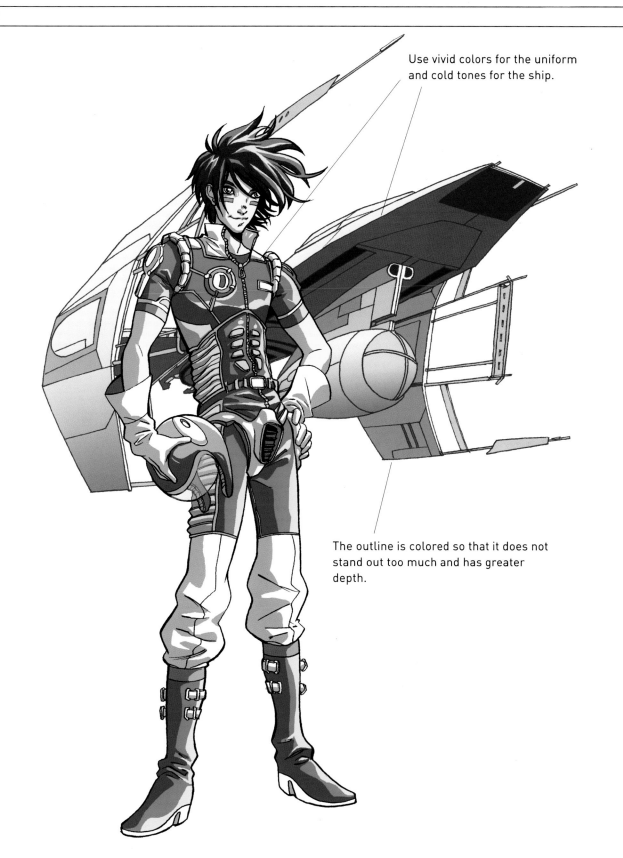

Use vivid colors for the uniform and cold tones for the ship.

The outline is colored so that it does not stand out too much and has greater depth.

PRINCESS NEBULA

This character comes from a galaxy that is different from our own; she is a princess that belongs to a race of winged beings, with a slender body and fragile appearance, who lives in harmony with the nature of her planet.

There must be a richness to the adornments and fabric of her clothes due to her social standing. The vivid colors of her clothes indicate the cheerful and happy character of these charismatic beings.

Finally, to improve the atmosphere of the scene, we will add a little fauna and flora in the background.

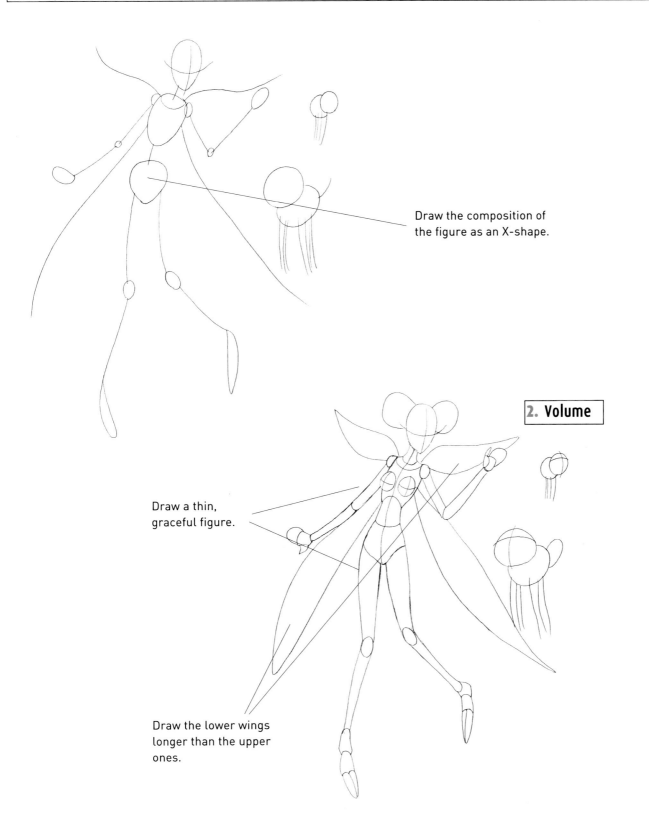

Draw the composition of the figure as an X-shape.

2. Volume

Draw a thin, graceful figure.

Draw the lower wings longer than the upper ones.

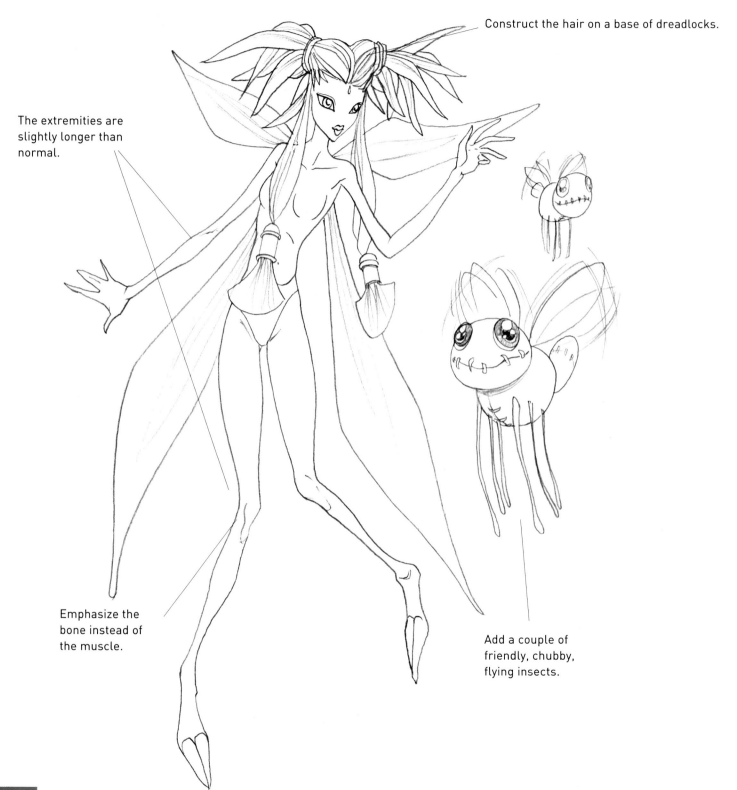

Construct the hair on a base of dreadlocks.

The extremities are slightly longer than normal.

Emphasize the bone instead of the muscle.

Add a couple of friendly, chubby, flying insects.

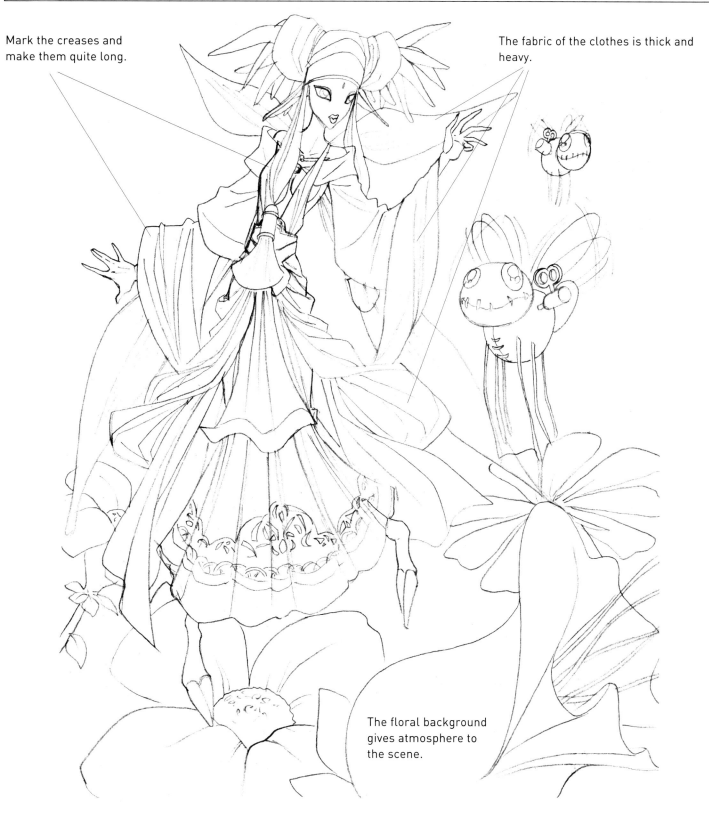

Mark the creases and make them quite long.

The fabric of the clothes is thick and heavy.

The floral background gives atmosphere to the scene.

Source of light

Indicate the shadow in the large folds of the clothes.

Pay attention to the points of tension from where the creases start.

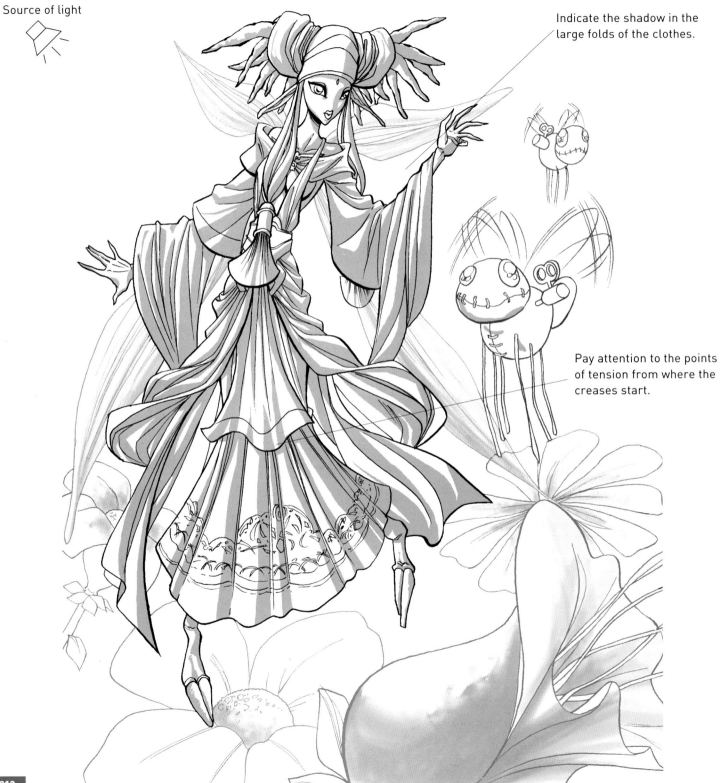

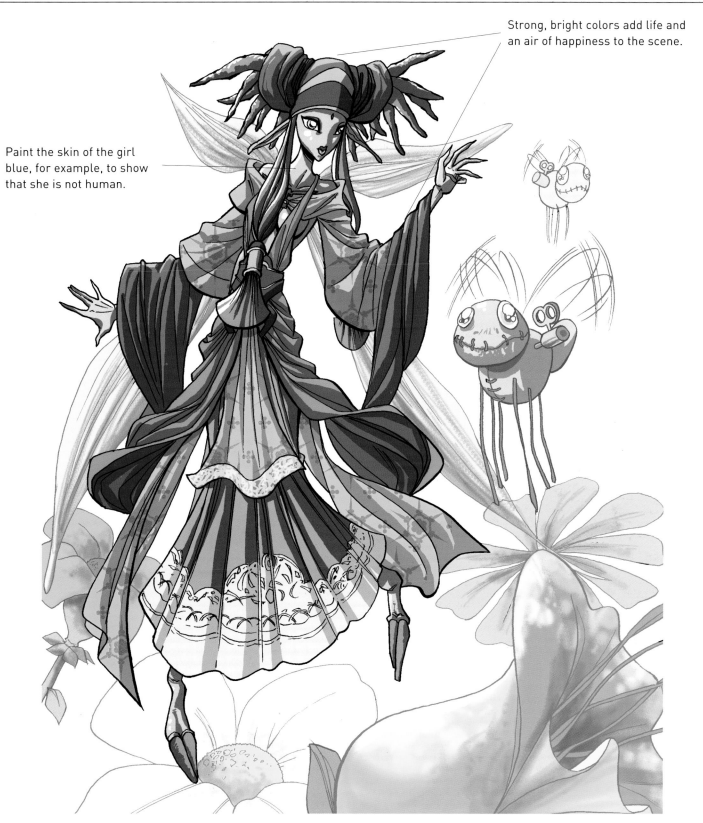

Strong, bright colors add life and an air of happiness to the scene.

Paint the skin of the girl blue, for example, to show that she is not human.

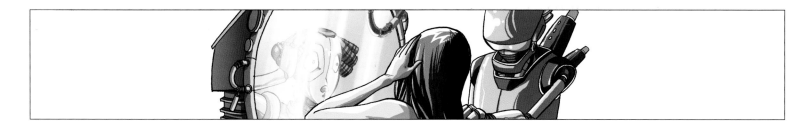

REFLECTIONS

What happens when you discover what you really are is what you desperately tried to deny? The following illustration shows the moment in which a young girl (whose external appearance is human) sees her robotic image reflected in the mirror and must therefore accept her condition as machine and her nonbiological nature.

In the drawing we will highlight, above all, the contrast between the human aspect of the girl who is looking at herself in the mirror and the mechanical reflection. The face of the character portrays intense shock and uneasiness on looking in the mirror, as she cannot believe what she is seeing.

1. Shape

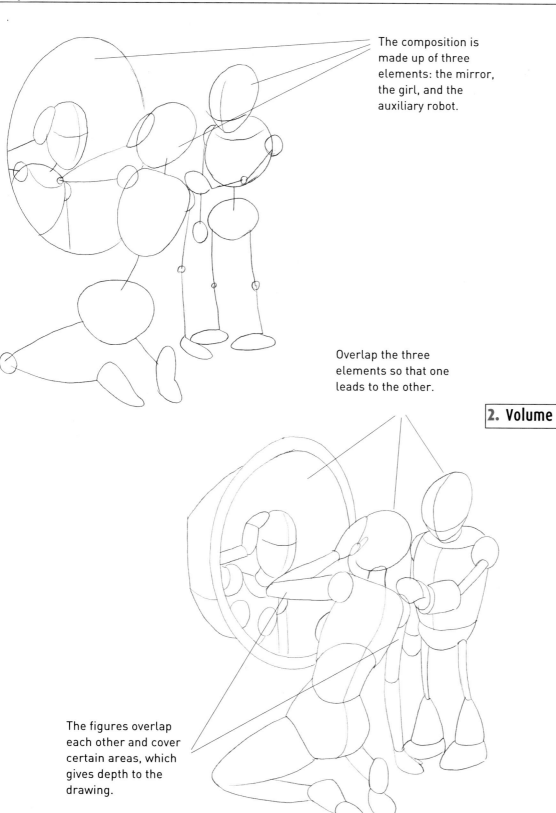

The composition is made up of three elements: the mirror, the girl, and the auxiliary robot.

Overlap the three elements so that one leads to the other.

2. Volume

The figures overlap each other and cover certain areas, which gives depth to the drawing.

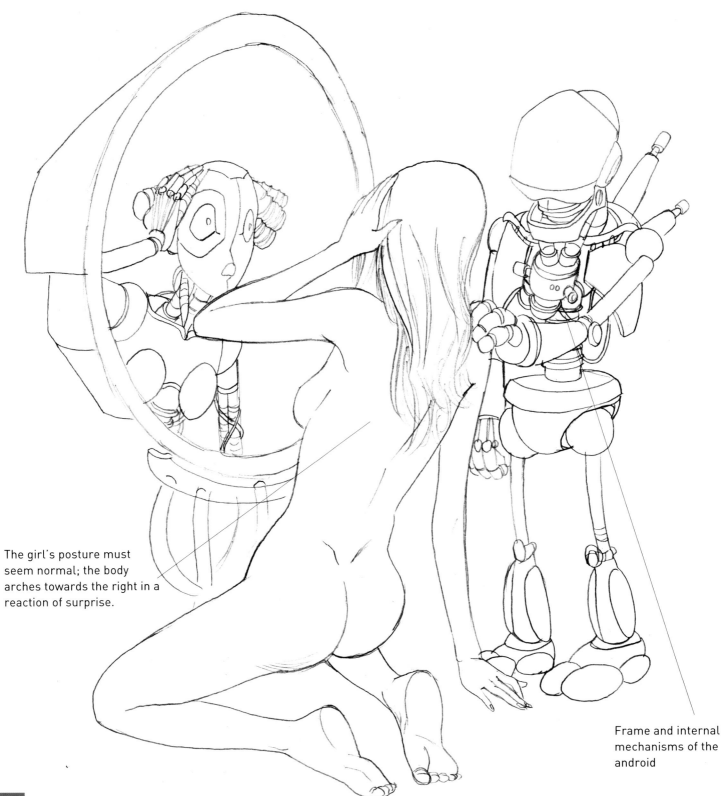

The girl's posture must seem normal; the body arches towards the right in a reaction of surprise.

Frame and internal mechanisms of the android

We detail all the elements that make up the mirror, giving it a mechanical appearance.

Design a simple and geometric shape for the robot (because it is a secondary element it should not stand out too much).

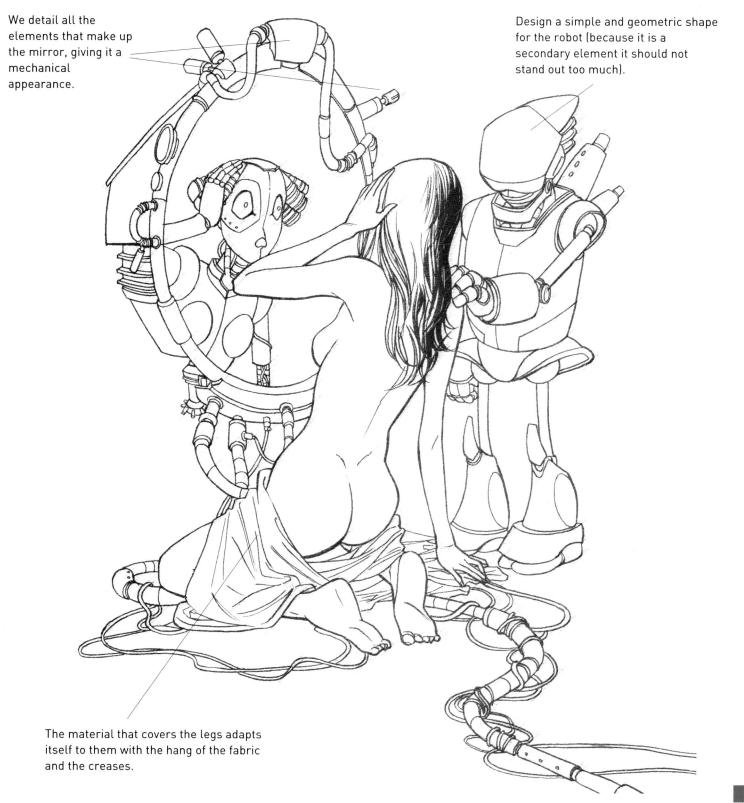

The material that covers the legs adapts itself to them with the hang of the fabric and the creases.

Source of light

The light coming from the mirror produces a contrast to the lighting of the characters, with some heavy shadows.

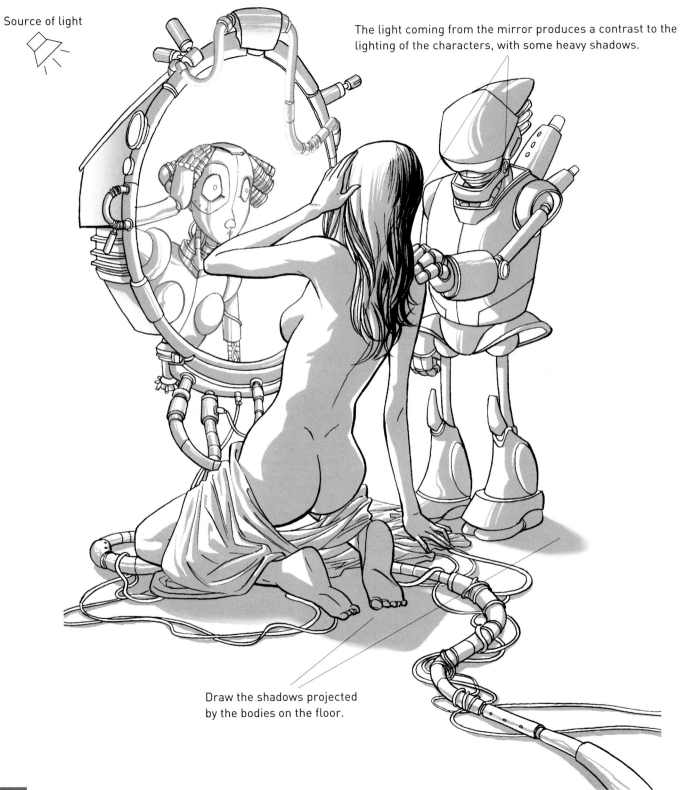

Draw the shadows projected by the bodies on the floor.

The green tones of the light that comes from the mirror will also affect the colors of the characters' shadows.

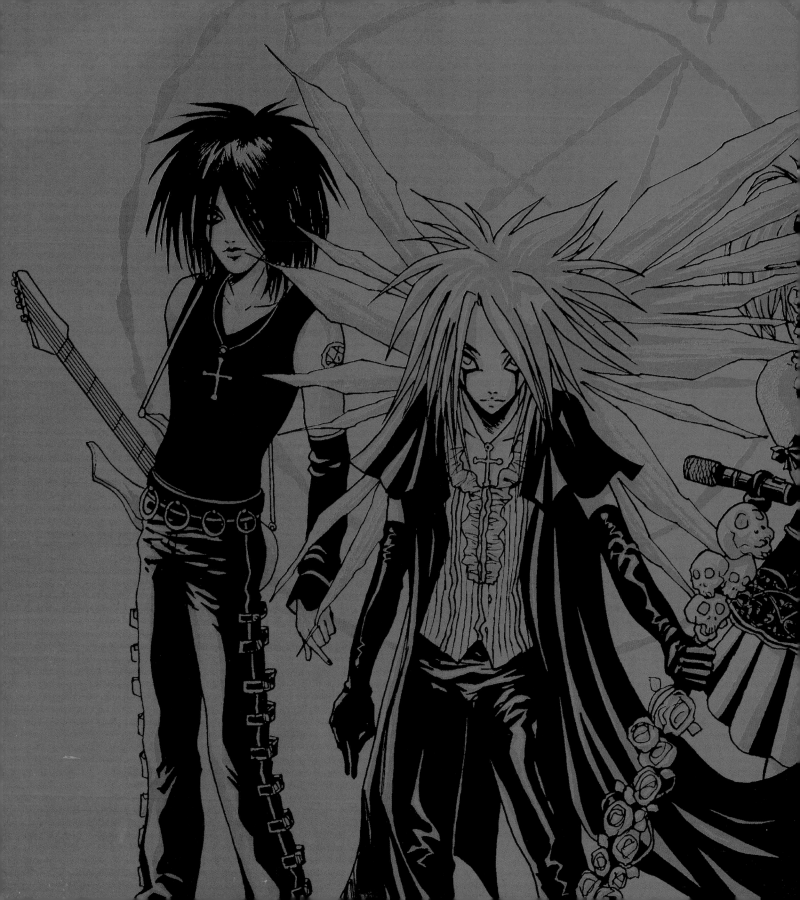

MUSIC

HIP-HOP

POP

J-ROCK

PARA PARA

TRADITIONAL

GOTHIC

CHILDREN'S MUSIC

KITSCH-POP

VISUAL ROCK

HIP-HOP

Hip-hop is a popular cultural movement, which emerged in the United States in the 1980s. It is characterized by a young, urban, and modern style of music. Many of its influences come from the street fashion of the big North American cities, especially suburban areas. The spirit of hip-hop fans today is very similar to that of its origins: the street and the youngsters from the neighborhoods with resentment against the system.

The lyrics of the songs are often aggressive and address social issues, although now that it is more commercial some of the original spirit has been lost.

The hip-hop singer has to stay close to the people in the street, and dress like them. The clothes are baggy and sporty, and it is common to use caps, chains, and rings.

The composition of this drawing should show a figure with a strong or defiant attitude, since the rhythms in hip-hop are full of energy.

1. Shape

The figure is moving, legs apart and arms raised behind the head.

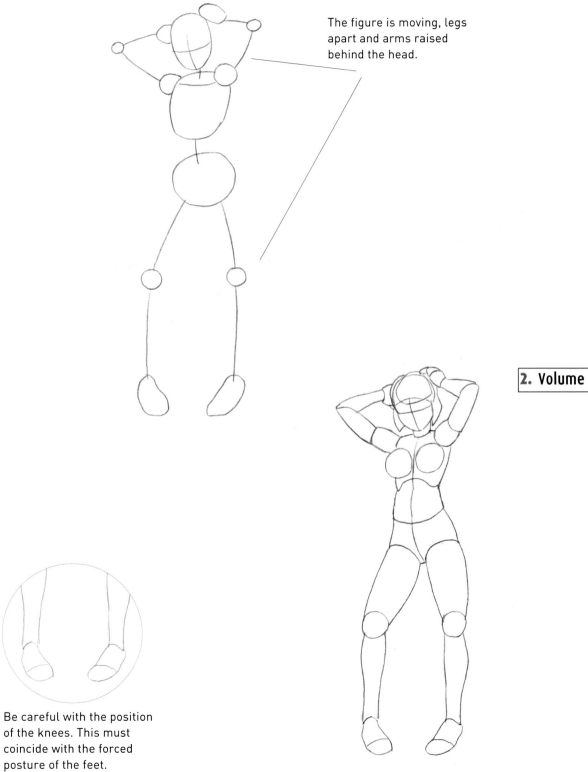

2. Volume

Be careful with the position of the knees. This must coincide with the forced posture of the feet.

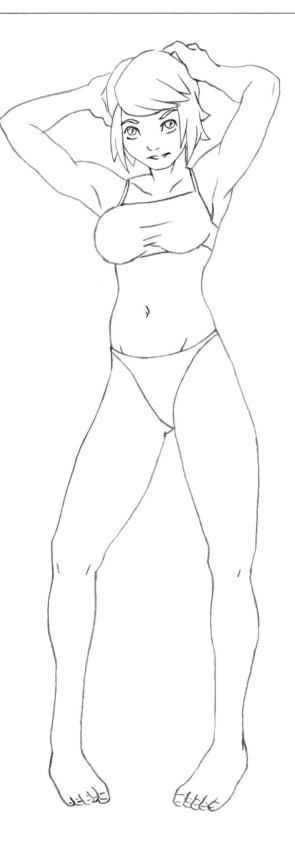

A hard and defiant look... attitude is everything in the street.

The way the leg is turned shows the inside of the thigh and marks the position of the hips.

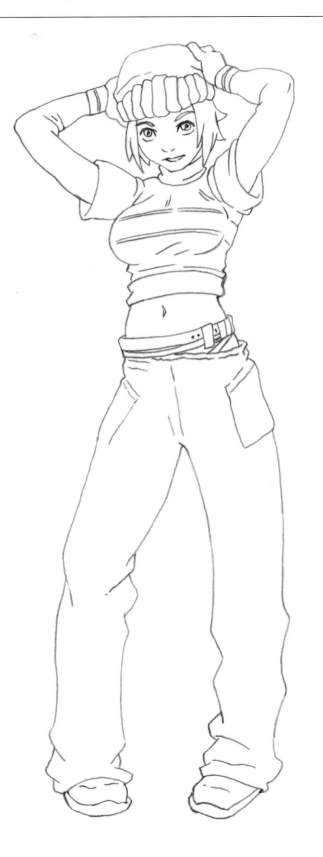

Make the clothes sporty and baggy, to allow the figure to move freely. Don't forget the accessories: caps and sweatbands.

The clothes overlap each other, but the area around the belly button can be seen; the trousers, worn low, half reveal a g-string; the belt lends movement to the figure.

Source of light

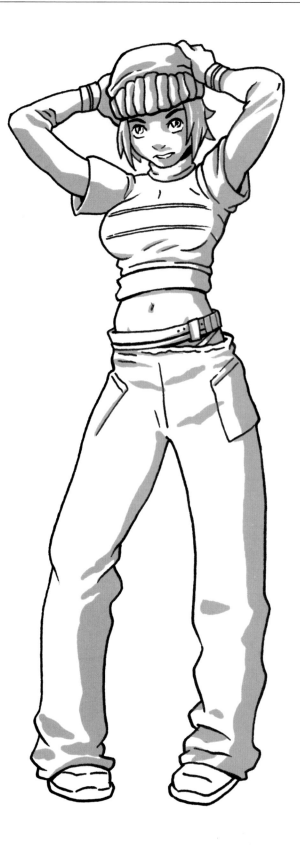

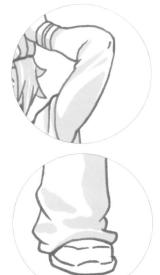

The volume of the creases is better defined by the shading; shadow lines create stress wrinkles and creases where the clothes gather together.

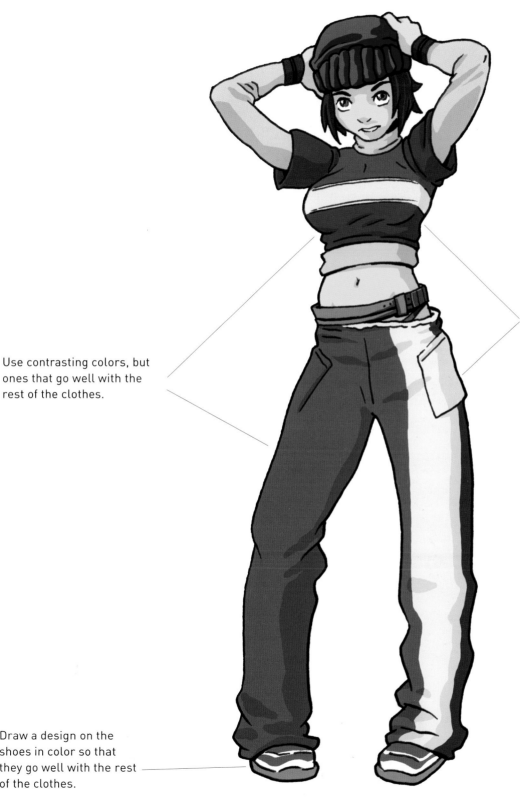

Use contrasting colors, but ones that go well with the rest of the clothes.

For sports clothing, adding strips of color or differentiating the items of clothing and the seams using several colors, creates a good effect.

Draw a design on the shoes in color so that they go well with the rest of the clothes.

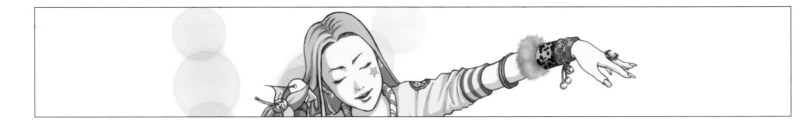

POP

J-Pop is the name of a Japanese music style inspired by pop but is noticeably different and so should be considered as a different genre.

The image of both male and female singers (especially young girls) is extremely particular and is studied in detail for these stars to be a bombshell among their fans. The marketing has created a peculiar phenomenon in which the artists' figures have become more important than their musical talent. So much so that a character is created that fans can admire and whose life they can follow avidly. These artists are called "idol singers." They are a product of Japanese marketing, which creates new fashions at an astounding pace, and so must take great pains not to go out of fashion within a couple of years (or even a couple of months). The clothes of the "idols" follow a "fantasy" style and are labels fashionable among young Japanese. The look on-stage is very well finished, as is the choreography and the visual spectacle.

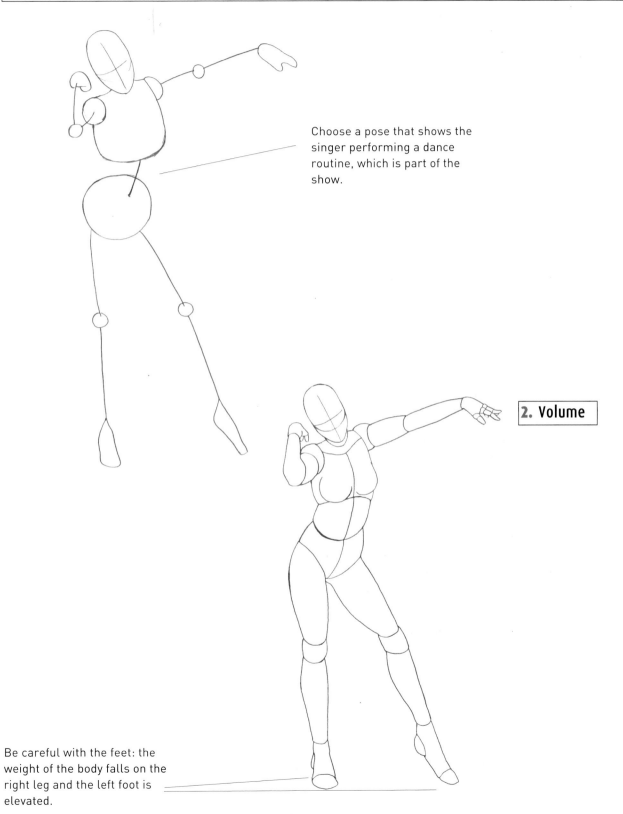

1. Shape

Choose a pose that shows the singer performing a dance routine, which is part of the show.

2. Volume

Be careful with the feet: the weight of the body falls on the right leg and the left foot is elevated.

229

Since she is a Japanese teenager, her outline should not have too many curves. It should be fairly discreet.

The hips are turned so the pose looks more sexy.

Draw one foot from the front (frontal) and the other from the side.

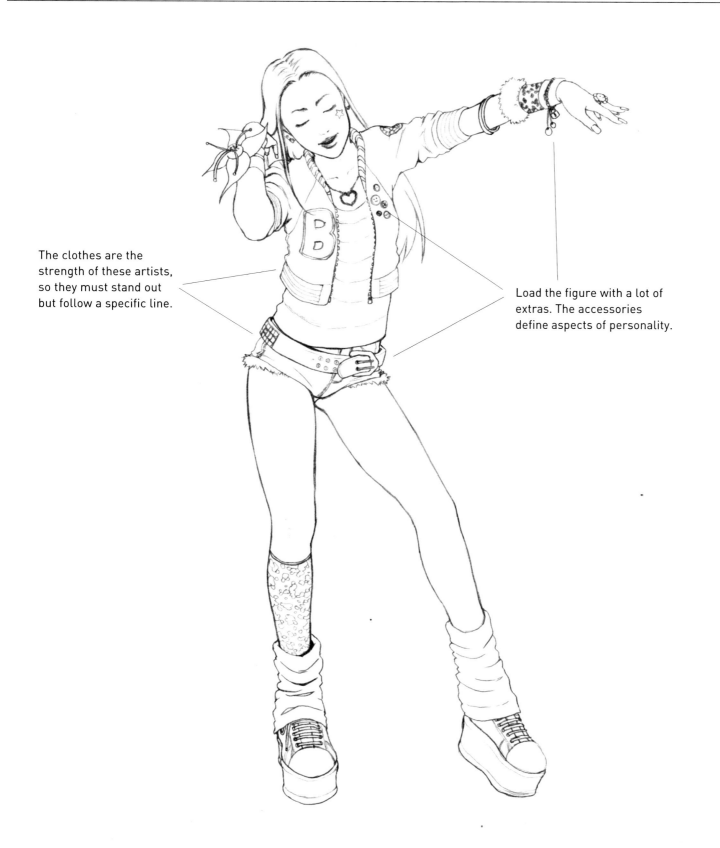

The clothes are the strength of these artists, so they must stand out but follow a specific line.

Load the figure with a lot of extras. The accessories define aspects of personality.

Source of light

Source of light

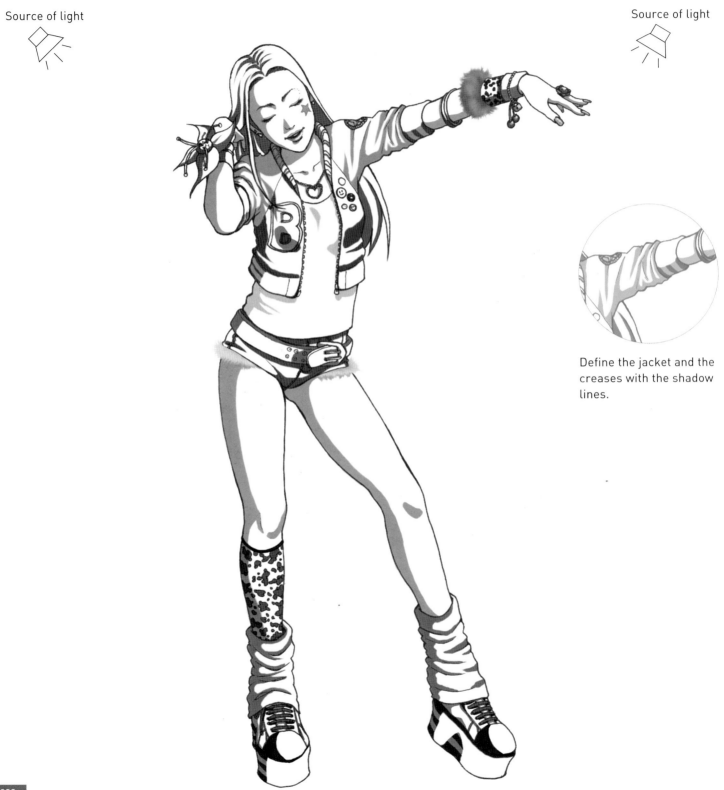

Define the jacket and the creases with the shadow lines.

6. Color

The colors are soft and
should match.

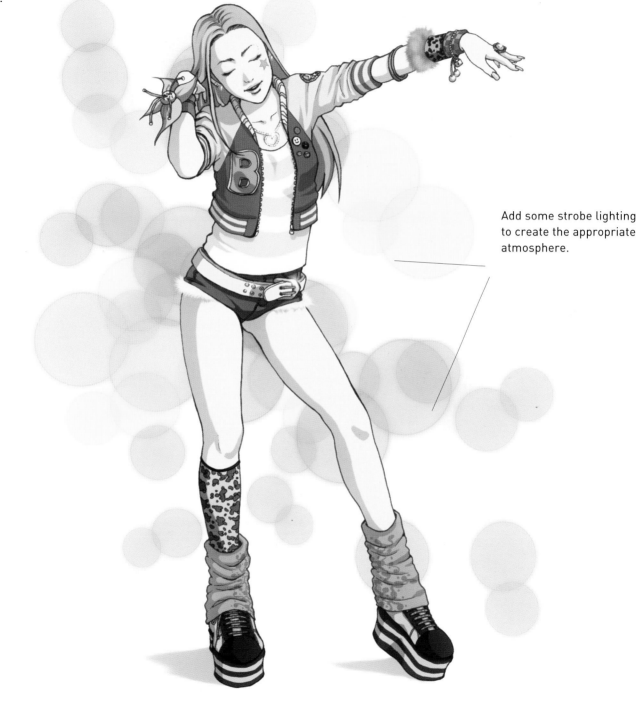

Add some strobe lighting
to create the appropriate
atmosphere.

J-ROCK

As with J-Pop, J-Rock is the Japanese artists' own version of Western rock. In this case, the marketing and image are equally important. There is, however, more room for originality and the artists have more freedom to develop their own individual style. In fact the most popular singers are those who combine the good looks of a fashion model with quite a personalized way of dressing and acting.

In this music style more veteran artists can be found, with stronger characters. Rock is a question of attitude, and so artists always try to appear rebellious and nonconformist. Within J-Rock there are several styles, as much musically as aesthetically, and the clothes and the hairstyles often show which genre they belong to. It could be more classic, a Western style, or glam (dressing up like the singers from the early days of Western rock and punk) combined with a gothic and sinister look.

Draw the character standing up fairly straight, but with the back slightly curved and the hips pushed forward.

2. Volume

Draw a posture that appears bold and shows a nonconformist attitude, looking forward defiantly.

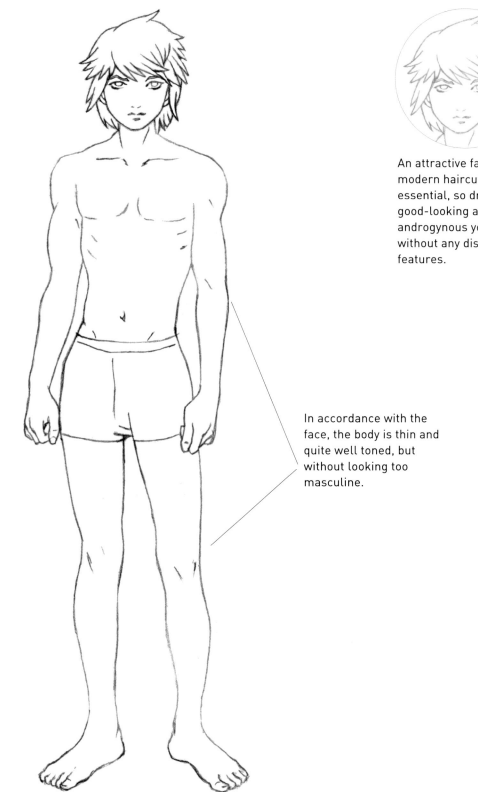

An attractive face and modern haircut are essential, so draw a good-looking and androgynous young boy, without any distinctive features.

In accordance with the face, the body is thin and quite well toned, but without looking too masculine.

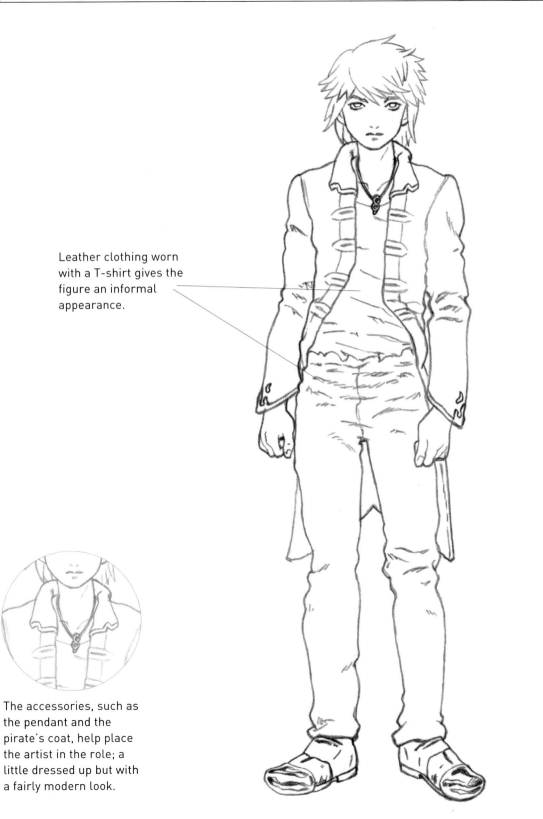

Leather clothing worn with a T-shirt gives the figure an informal appearance.

The accessories, such as the pendant and the pirate's coat, help place the artist in the role; a little dressed up but with a fairly modern look.

source of light

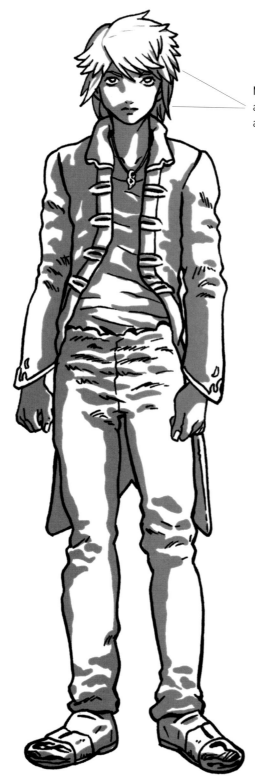

Make the haircut defined and distinguish various areas using shadows.

Differentiate the level of shading on the part of the T-shirt covered by the coat.

6. Color

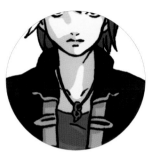

The dark browns of the leather contrast with the light color of the singer's skin.

Draw the trousers with undulating forms so they appear thick and coarse.

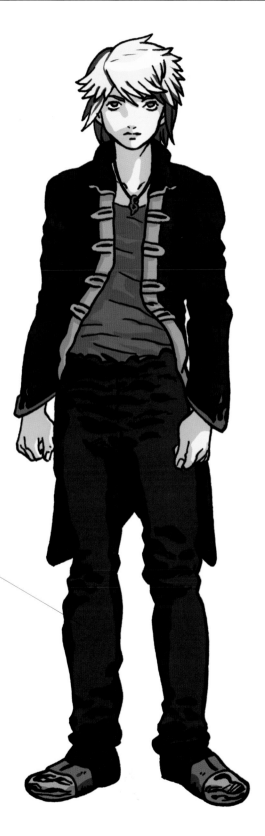

PARA PARA

Para Para is a type of music that emerged in the 1970s, with the disco boom, that falls into the panorama of dance pop. This more modern and electronic style combines with a retro style, developing an aesthetic whose main aim is to stand out. This genre of music is associated with the fashion phenomena of the "gongals." These are young Japanese who take fashions to their extremes and make them their way of life: girls wearing makeup and dressed over-the-top with bright colors, combining school uniforms with all sorts of striking accessories, or dresses and miniskirts. The other element that must be included is the enormous platform shoes.

The haircuts, are a return to the Western disco look like so many of the accessories worn in the 1970s and the 1980s. The postures of the character that we are going to draw show a certain innocence and a particular exuberance. The dancing is expressive and fun, and the character's involvement is intense.

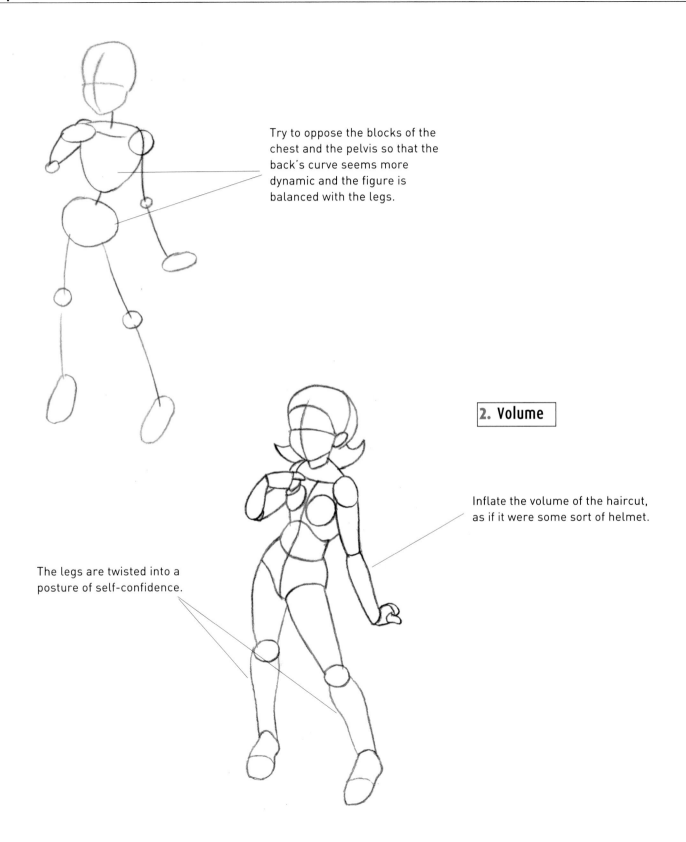

Try to oppose the blocks of the chest and the pelvis so that the back's curve seems more dynamic and the figure is balanced with the legs.

2. Volume

Inflate the volume of the haircut, as if it were some sort of helmet.

The legs are twisted into a posture of self-confidence.

The roundness of the face and its childlike aspect contrast with the makeup and the extra-long eyelashes.

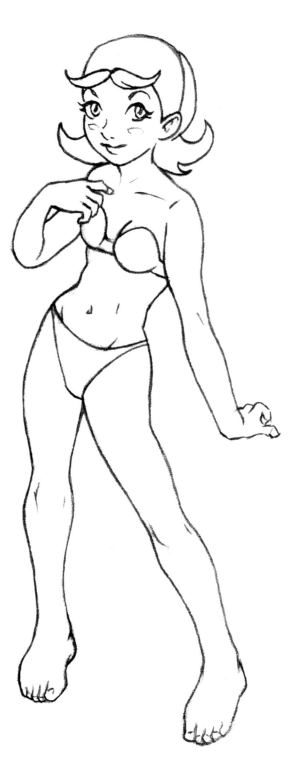

Draw the hand towards the back, with the fingers bent as if they are holding something; later you will add a microphone.

The haircut, the headband, the gloves... are the elements that identify this girl as a parapara music lover.

Draw the microphone and adjust the form of the fingers so that they look natural.

The miniskirt and the platforms are essential.

Source of light

Source of light

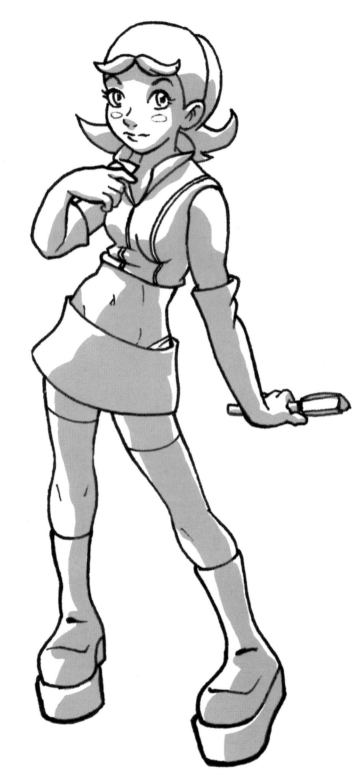

The lighting plays a fundamental role. We want to re-create the atmosphere of a disco with lots of lights, which come from above and both sides. The shadows will concentrate in intense blocks on the inside of the figure.

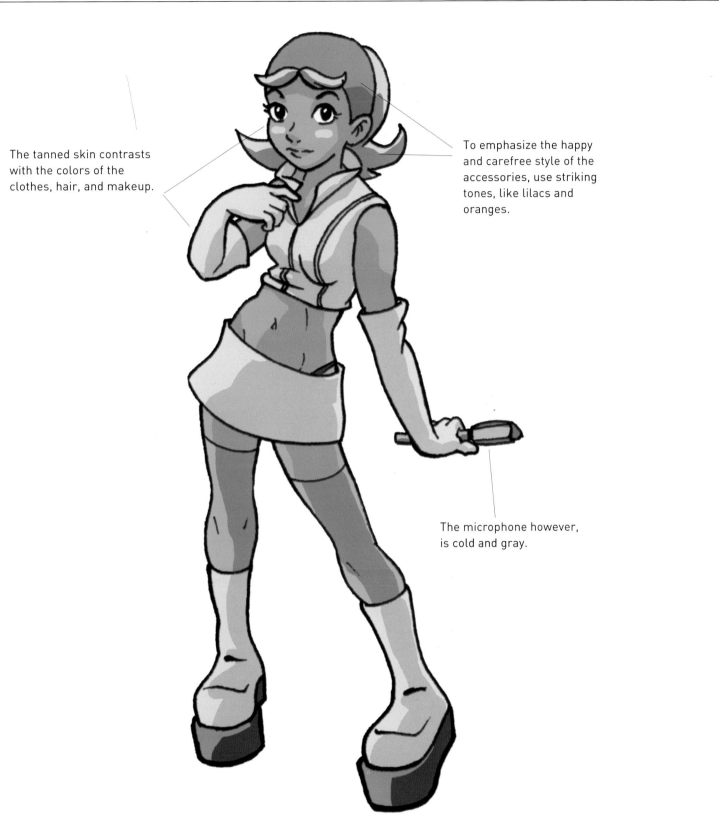

The tanned skin contrasts with the colors of the clothes, hair, and makeup.

To emphasize the happy and carefree style of the accessories, use striking tones, like lilacs and oranges.

The microphone however, is cold and gray.

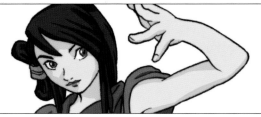

TRADITIONAL

In Japan today's fast and furious way of life and the technology cult live alongside tradition. It is very common to see people dressed in a kimono. This is not only for special occasions but as a clothing option like any other. In music circles, the use of the kimono combines with a more modern aesthetic, or as is logical, in the preservation of old customs and when performing with classical instruments. Two of the best-known Japanese instruments are the shamisen and the koto. The shamisen is a three-string lute and consists of a round base and a long neck. The koto is a type of Japanese zither used a lot in traditional chamber music, whether as a soloist instrument or in small groups, and it looks like an elongated box.

The kimono is a long item of clothing, which forms bulky folds. Care must be taken with the posture the figure is drawn in so as not to make it too difficult to draw the folds. After drawing some sketches of the figure with both instruments, we opted for the koto, as it is simpler.

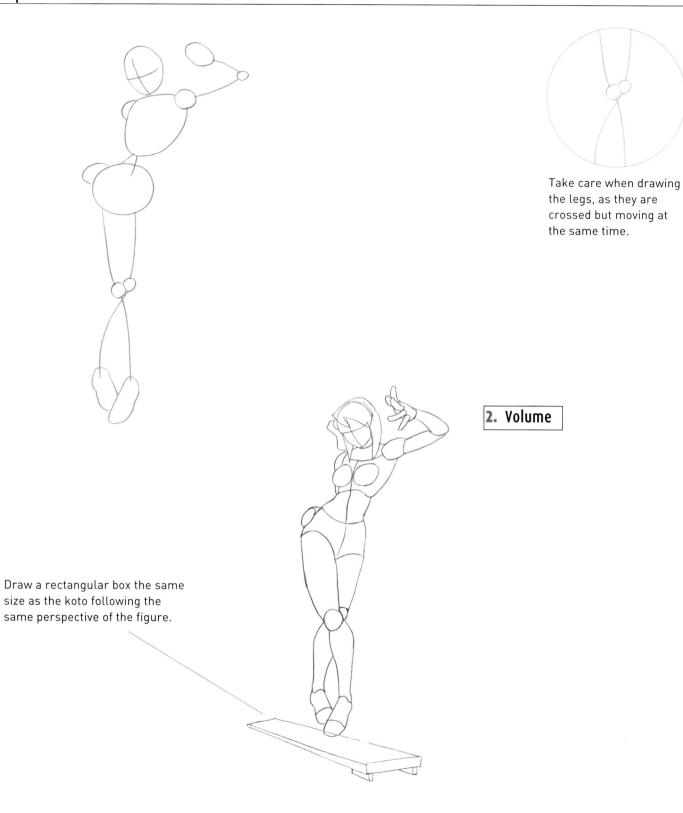

Take care when drawing the legs, as they are crossed but moving at the same time.

2. Volume

Draw a rectangular box the same size as the koto following the same perspective of the figure.

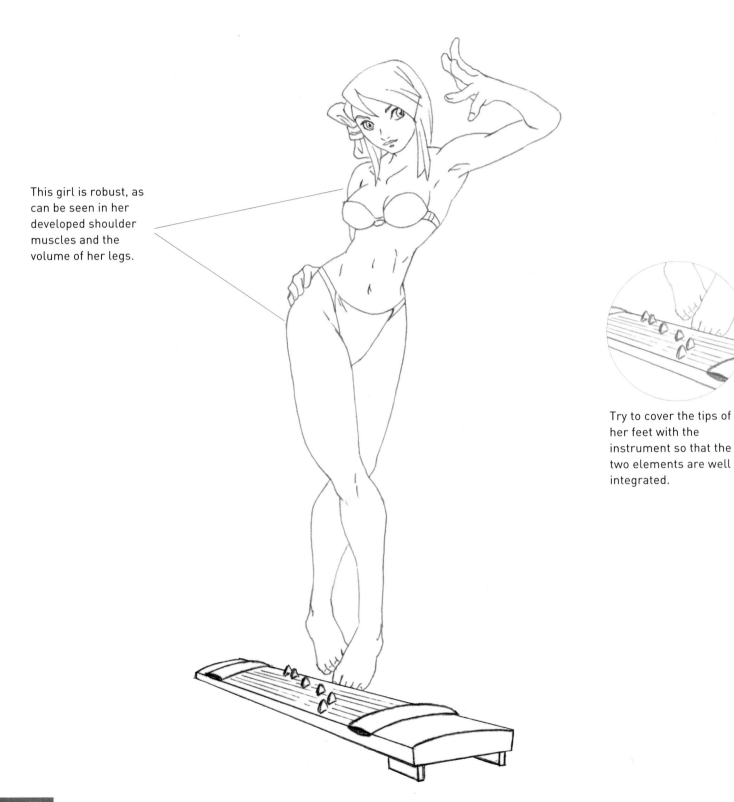

This girl is robust, as can be seen in her developed shoulder muscles and the volume of her legs.

Try to cover the tips of her feet with the instrument so that the two elements are well integrated.

The haircut has a traditional aspect: it is tied back and an elaborate bow is worn in it.

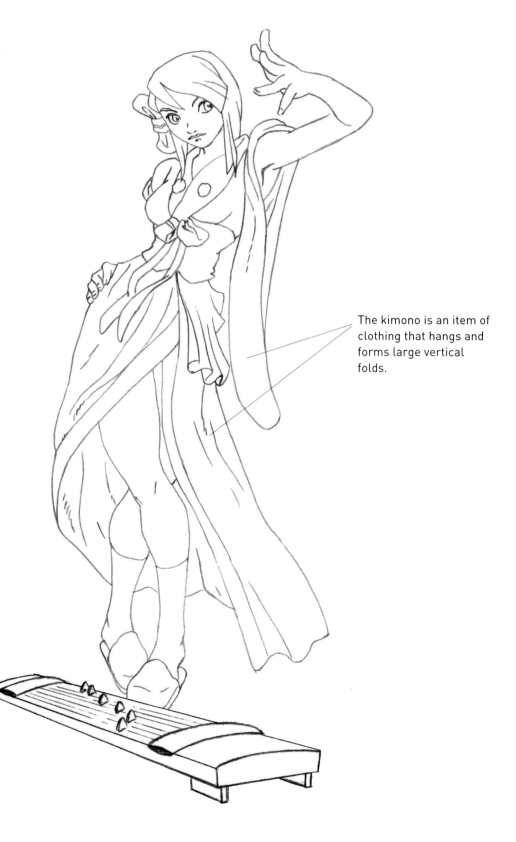

The kimono is an item of clothing that hangs and forms large vertical folds.

Source of light

The flat form of Manga is better defined with a constant shadow.

The leg that sticks out from beneath the skirt of the kimono shows the light contrast.

6. Color

The colors of the kimono and the instrument are sober, discreet, and match.

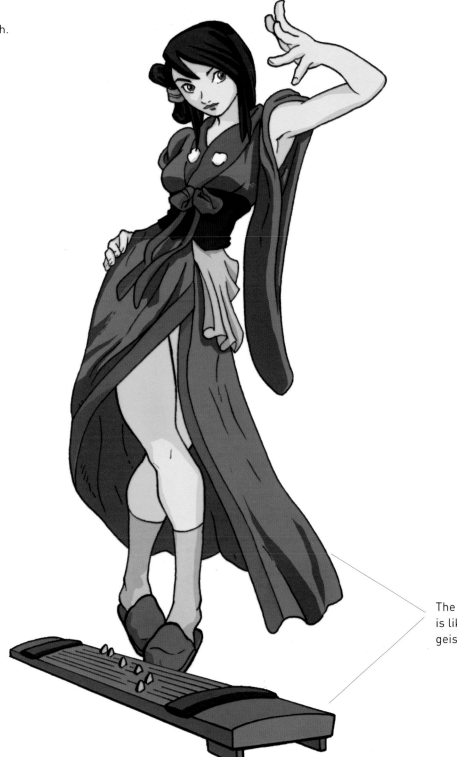

The light skin and red lipstick is like the makeup of the geishas.

GOTHIC

The height of electronic music, this style is both gothic and dark in its origins, and was adopted by the Japanese in the 1980s. Today it comes from many different sources and is often fused with different styles of rock.

This style is also marked by a specific visual aesthetic, where dark colors, bloodred and, above all, black dominate. It is related to the phenomena "gothic Lolita" that we have already mentioned in the Manga girls section.

These girls dress in elaborate gothic and baroque style with dresses similar, in many cases, to porcelain dolls. Apart from dark clothing, the accessories are also important. These are always made of silver, such as bracelets, pendants, rings, etc.

1. Shape

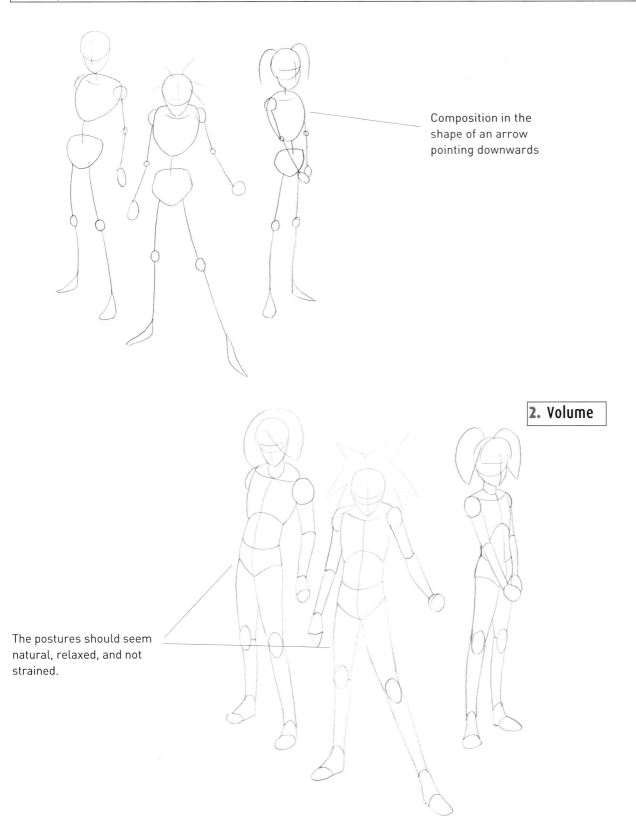

Composition in the shape of an arrow pointing downwards

2. Volume

The postures should seem natural, relaxed, and not strained.

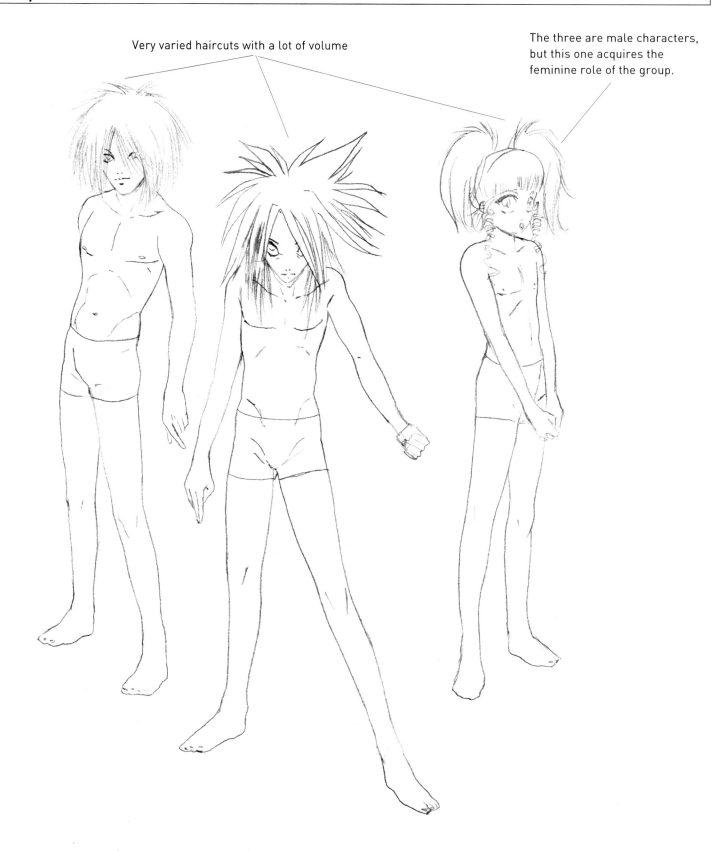

Very varied haircuts with a lot of volume

The three are male characters, but this one acquires the feminine role of the group.

Fairly tight-fitting clothes

Add some wings to the singer.

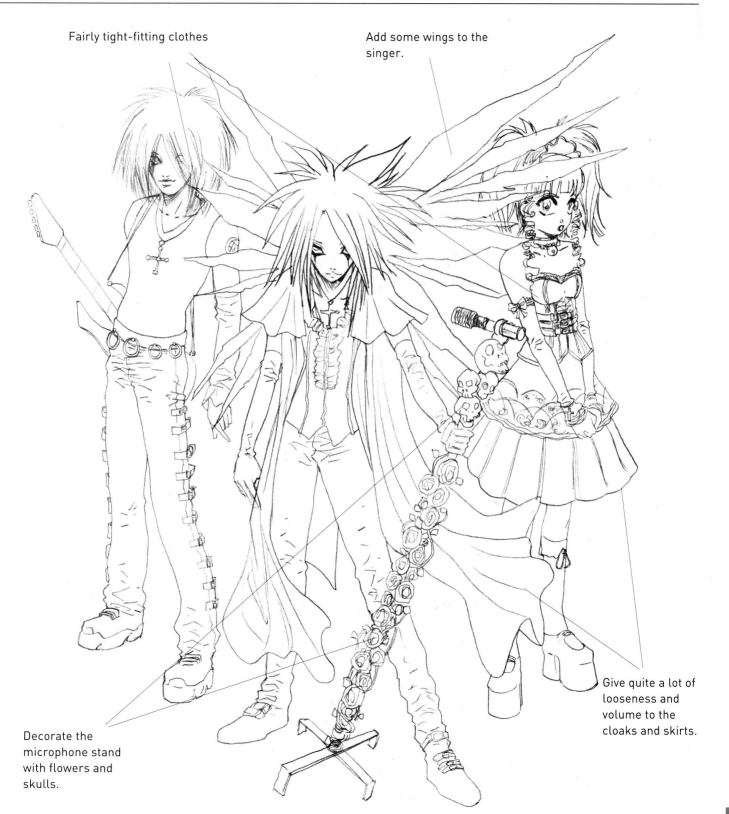

Give quite a lot of looseness and volume to the cloaks and skirts.

Decorate the microphone stand with flowers and skulls.

Source of light

This is the domain of large quantities of dark black ink that help the dark and sinister aspect of the illustration.

The shine of the latex and the leather helps to give volume to the clothes.

6. Color

We add shades of red and blue to the range of blacks.

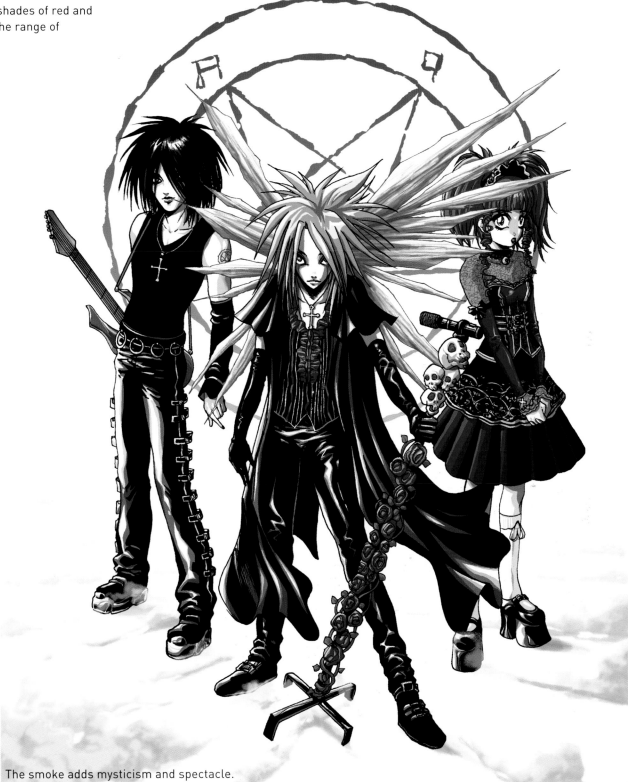

The smoke adds mysticism and spectacle.

CHILDREN'S MUSIC

When it comes to composing music we must not forget the youngest, since the public appreciates something that appeals to everyone. An infinite number of groups was born in this genre; writing light and fun lyrics and presenting a friendly and colorful image. They look for fun and attract the attention of the youngest of children. In most cases the group members are often adolescent children who perform dance routines that encourage their fans to dance to the rhythm of the music.

These groups often collaborate on the sound tracks for cartoon series and many end up famous as a result. Despite being a product aimed at a young audience, at their concerts it is not uncommon to see a large number of adults singing or humming along to the songs. In the end they become popular with lots of people of all ages.

1. Shape

The characters are in a row, which makes the drawing more vertical.

The diagonal formed by the arms makes the posture dynamic.

2. Volume

To create balance in volume locate a chubby character at the top and one at the bottom.

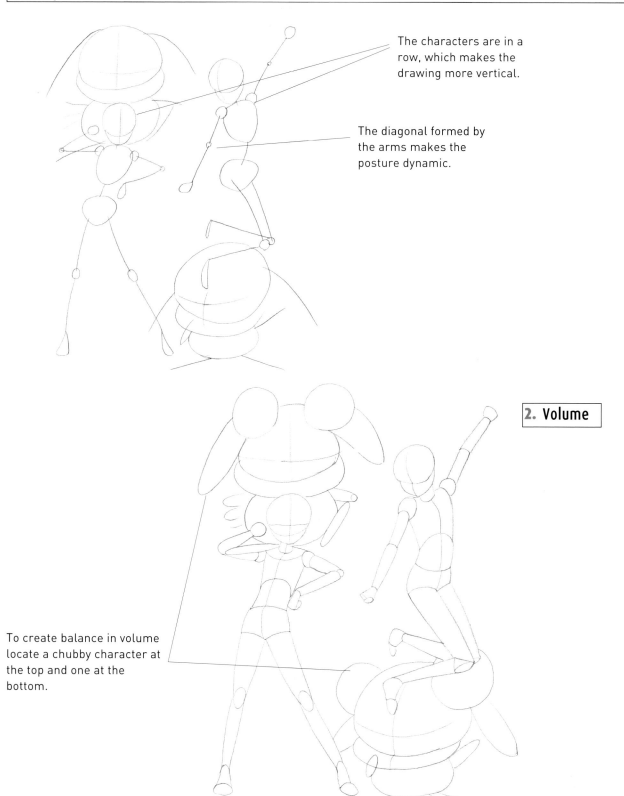

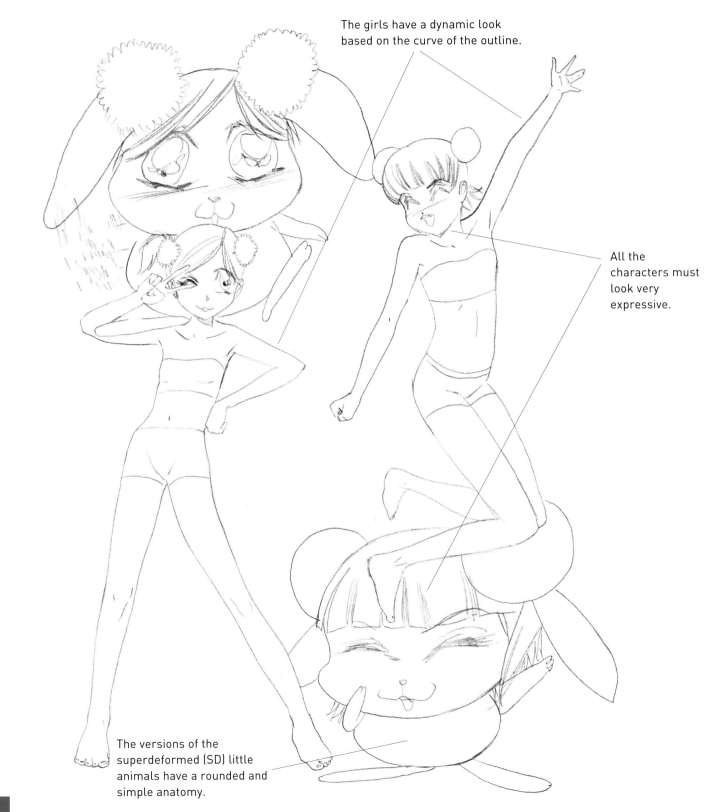

The girls have a dynamic look based on the curve of the outline.

All the characters must look very expressive.

The versions of the superdeformed (SD) little animals have a rounded and simple anatomy.

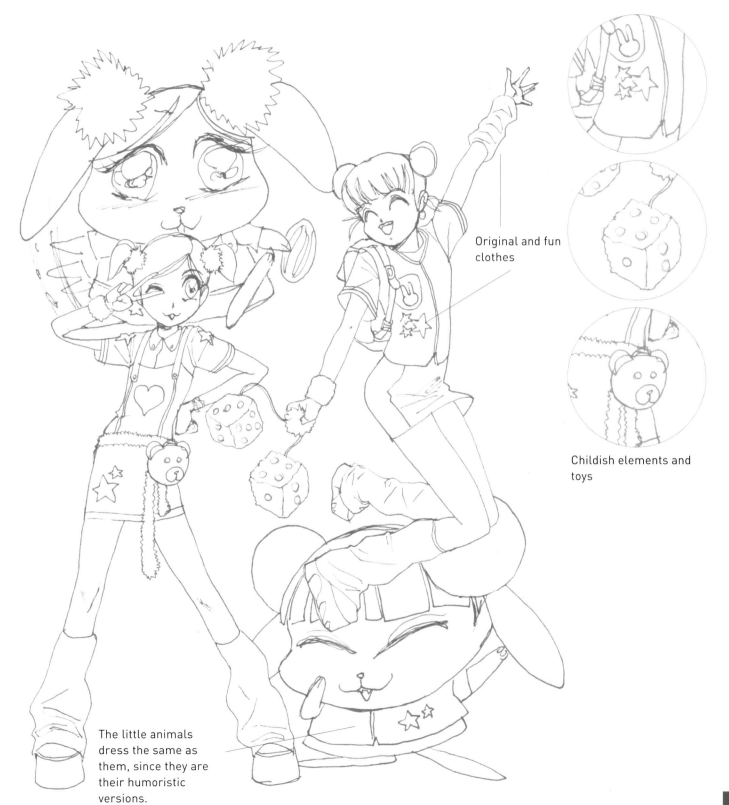

Original and fun clothes

Childish elements and toys

The little animals dress the same as them, since they are their humoristic versions.

The outline of the eye should be well defined to make it more expressive.

There is hardly any black ink, since the lighting is based on lots of color to give the drawing more life.

Source of light

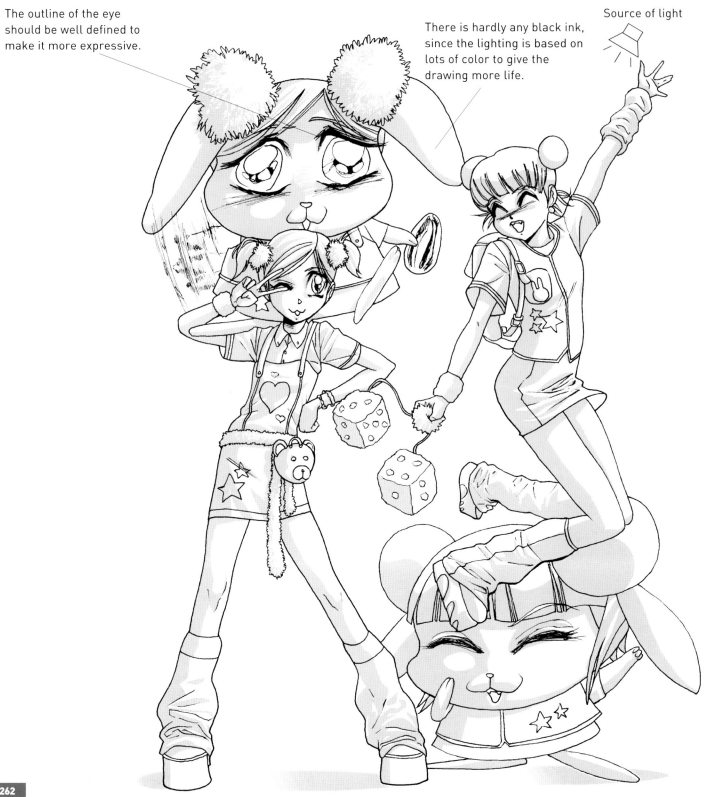

Use the same colors for the
clothes of all of them, as they
are uniforms.

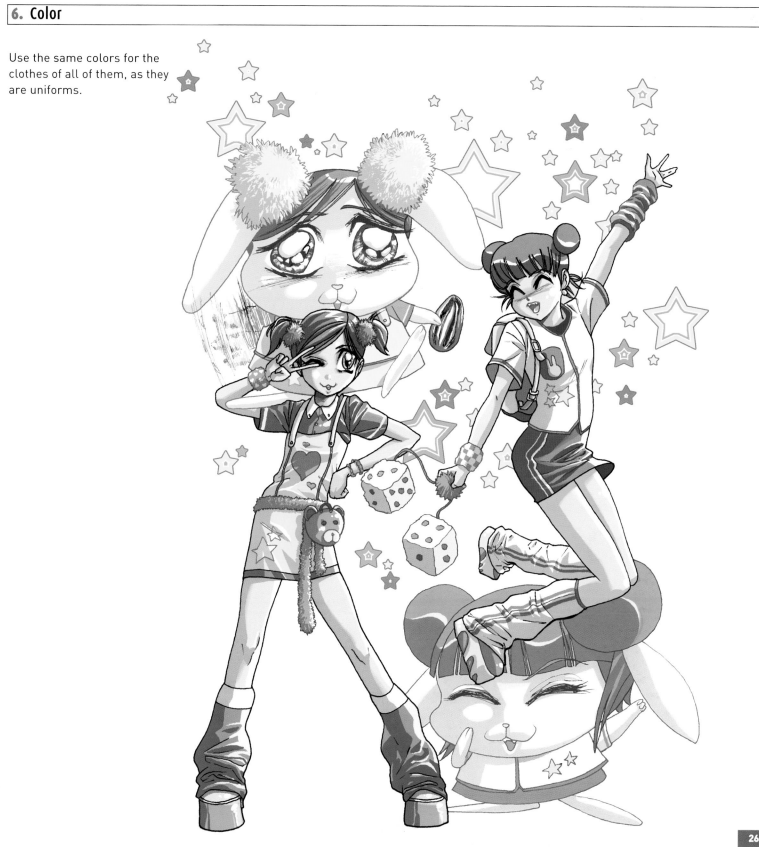

KITSCH-POP

There is a source of Japanese pop that is more outlandish and striking, especially regarding the aesthetics. Kitsch-pop singers do not necessarily stand out for their voices or artistic qualities. The most important thing is the aesthetic appearance and originality of dress. Vivid and happy colors dominate, since the songs, in the majority of cases, spread a message of happiness and optimism.

For the artist it is fun to do these types of designs because it means looking for maximum originality and something completely different when it comes to creating the characters' clothes or their bodies. A good strategy is to combine different elements that have no relation without worrying about the result being over-the-top or extravagant.

The character is sitting down, with the body in an M-shape.

2. Volume

The main character is leaning on one volume, a sofa, and holding another volume, a doll.

The posture will make the drawing compact.

We will sketch in what will later
be the wings and the back of the
sofa.

There is an
expression of
indifference and
superiority in
the girl.

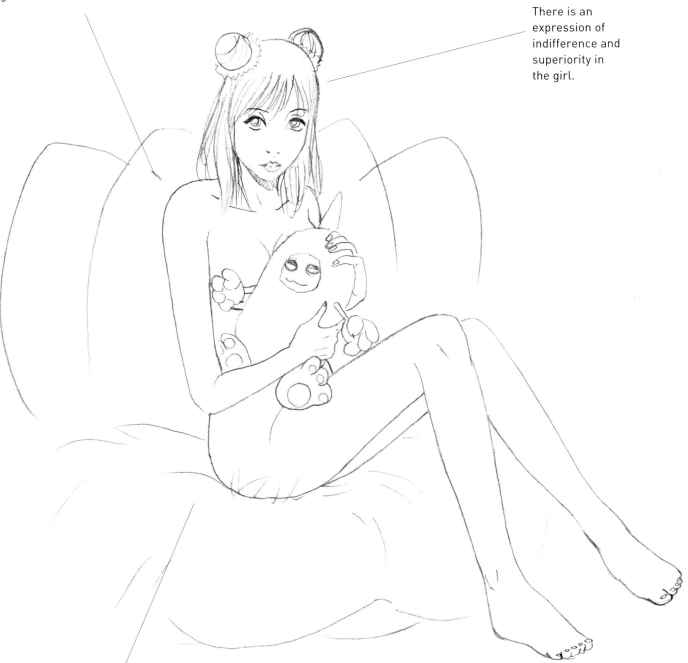

Curved lines in the anatomy
strengthen the femininity of the
character.

We combine different elements of clothing, even though they lack a relation.

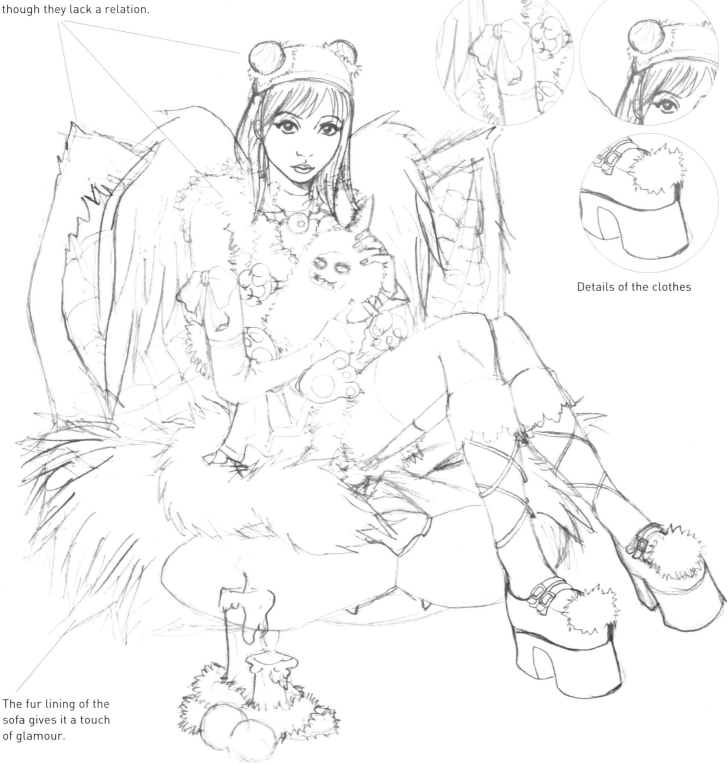

Details of the clothes

The fur lining of the sofa gives it a touch of glamour.

Ink in the ends of the hair,
giving them a "fiery" finish,
as if they were flames.

Source of light

Add the textures and make the
finishing touches to the small
details more polished.

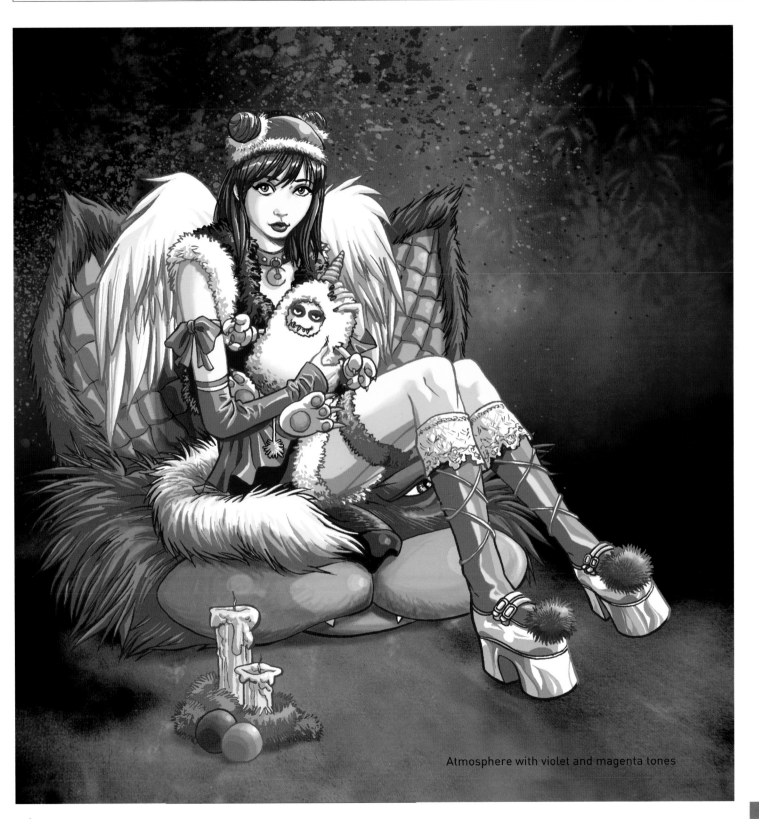

Atmosphere with violet and magenta tones

VISUAL ROCK

This type of rock music encompasses different styles of music: heavy, punk, rock hardcore, electronic music, metal, shades of pop, etc. All of these share the importance that they give to the aesthetic and visual aspect. Take great care with their compositions, dedicating equal effort to attaining the most striking and innovative aspect possible.

Due to the large amount of rock groups that exist in Japan, musicians are obliged to look for different formulas to stand out in the market and distinguish themselves from the rest. On the whole they tend to be all-male groups, although one of the members may acquire the feminine role. This is reflected, obviously, in their attire, in the haircuts, and in the makeup.

Sometimes with a more sinister aesthetic, others more punky, on occasion happier and more colorful, the important thing is to make a strong visual impact on the public and attract its attention so that people listen to their music.

1. Shape

Draw each of the characters in a different size to create depth.

2. Volume

Draw one character over another, in a way that some part of the body is covered (thereby giving more depth to the drawing).

The composition of the drawing means that each character leads us to another in a closed circle.

Very thin bodies, almost scraggy, although the muscles must be well defined.

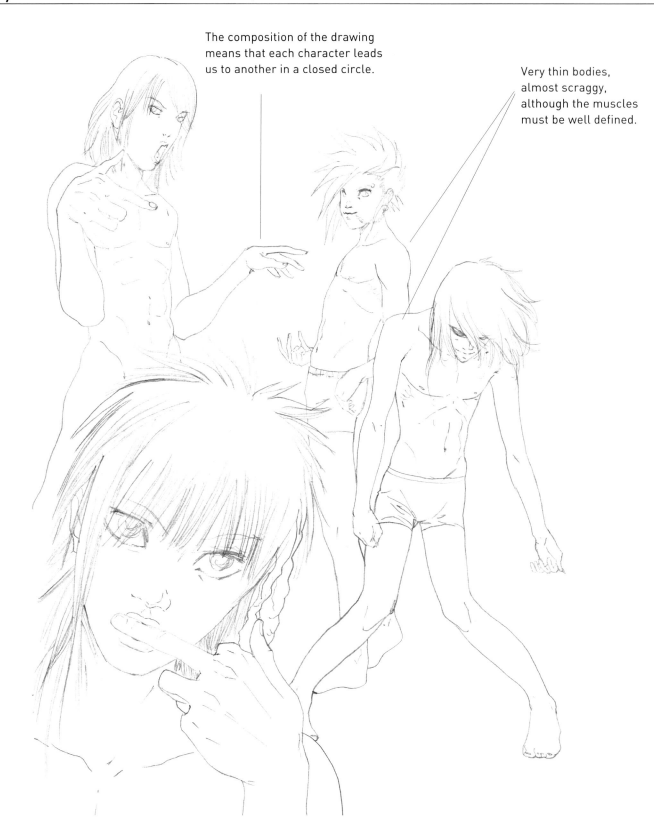

Different haircuts for each character

The clothes must also be varied, with certain punk influences.

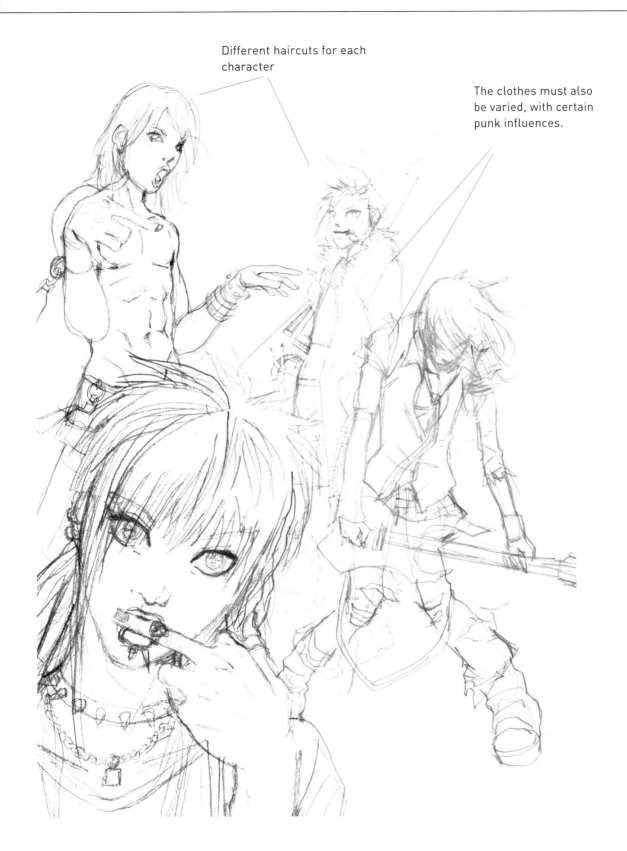

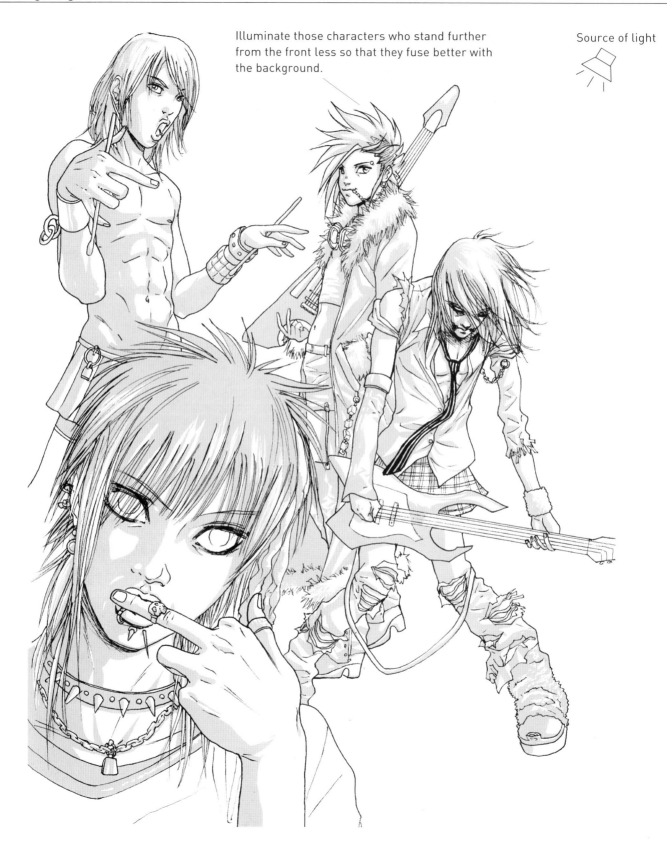

Illuminate those characters who stand further from the front less so that they fuse better with the background.

Source of light

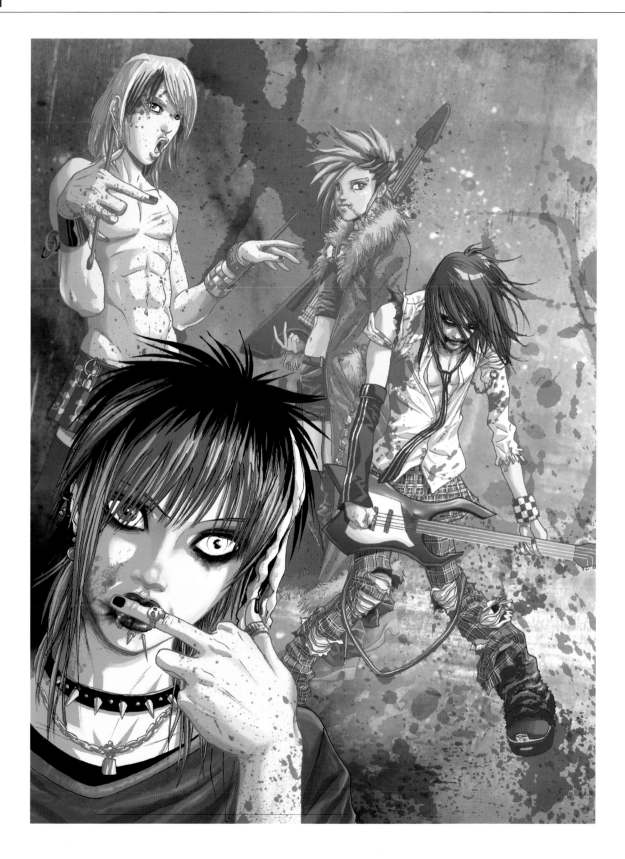

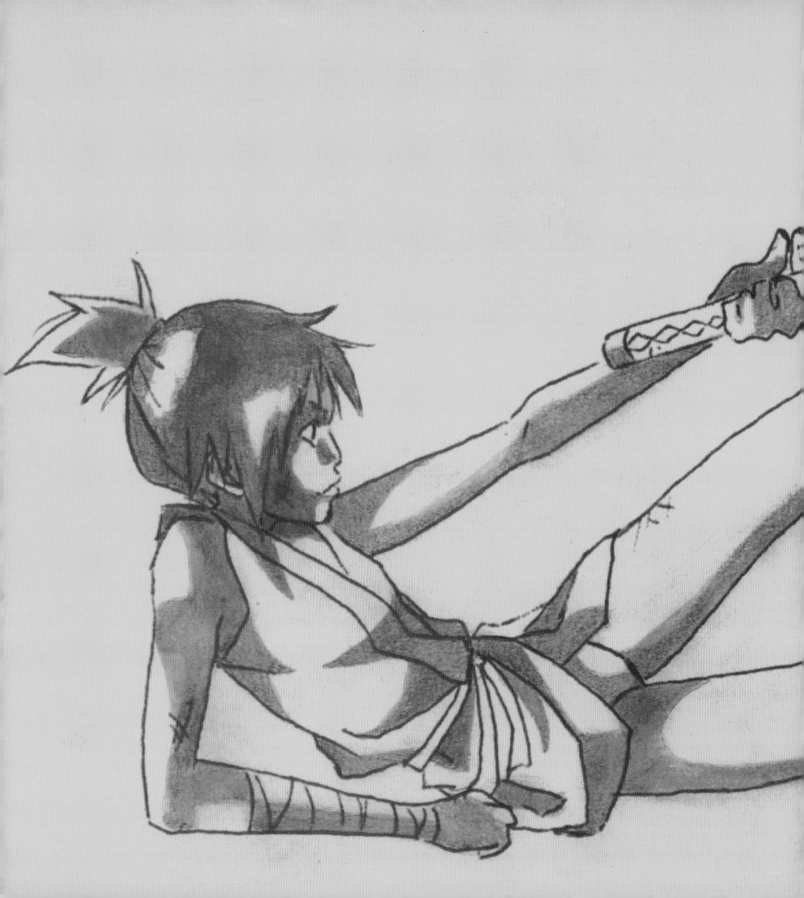

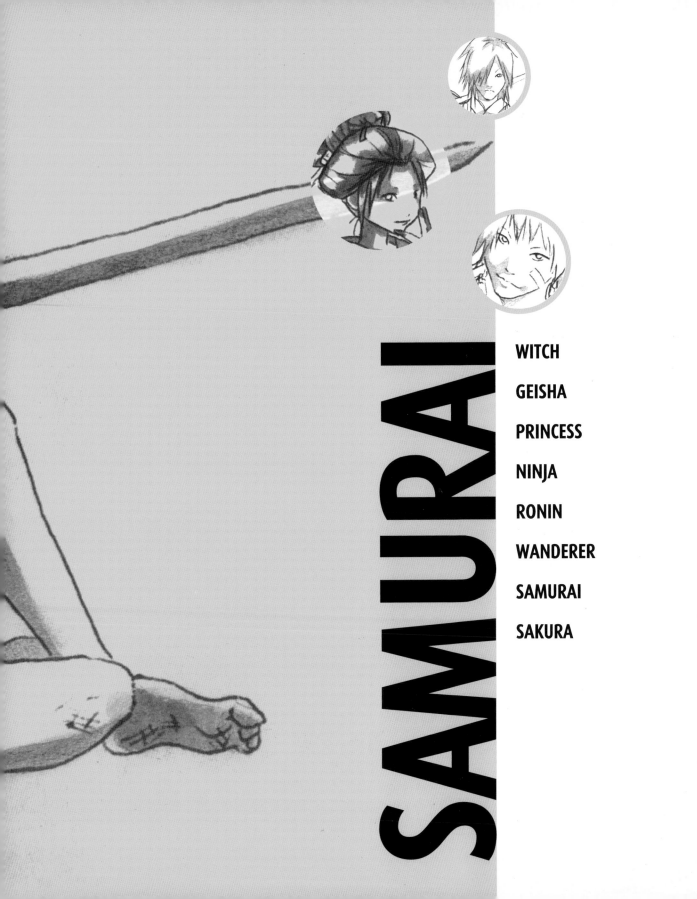

SAMURAI

WITCH

In Manga as in Eastern films (mainly Japanese and Chinese), war stories feature an abundance of mystical and enigmatic characters who use spells and magical powers to get what they want. The character in the following exercise is a former Shintoist monk who has turned into a sorcerer who uses ancestral magical practices.

This type of witch or sorcerer is somewhere between a warrior monk and the classic witch from medieval European mythology. He combines hand-to-hand-combat martial arts with the practice of sorcery. This gives him a certain supernatural advantage in combat. These are very attractive characters because of their varied repertoire in combat and because the origin of their powers is unknown.

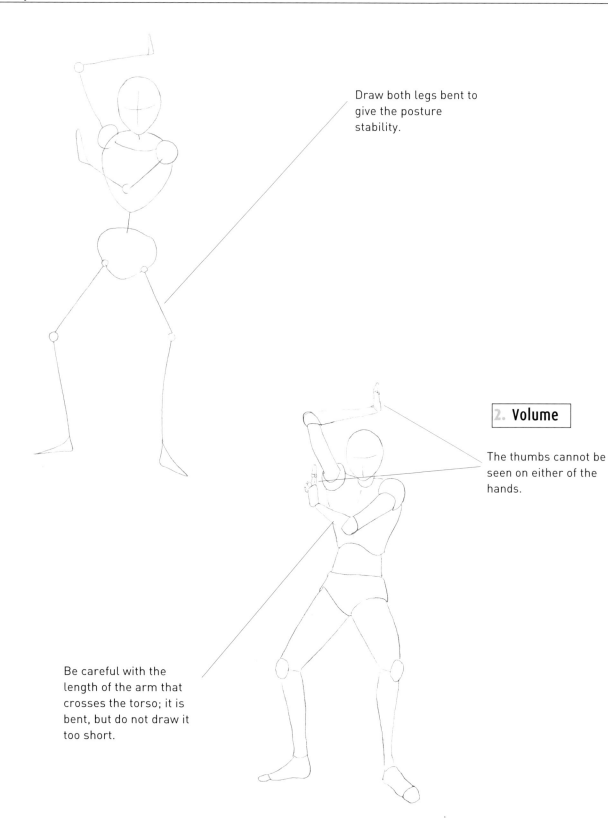

Draw both legs bent to give the posture stability.

2. Volume

The thumbs cannot be seen on either of the hands.

Be careful with the length of the arm that crosses the torso; it is bent, but do not draw it too short.

The chest muscle is
stretched when the arm
is raised and links with
the deltoid muscle.

Draw the strands of hair
slightly separated and flowing
in the same direction as the
movement.

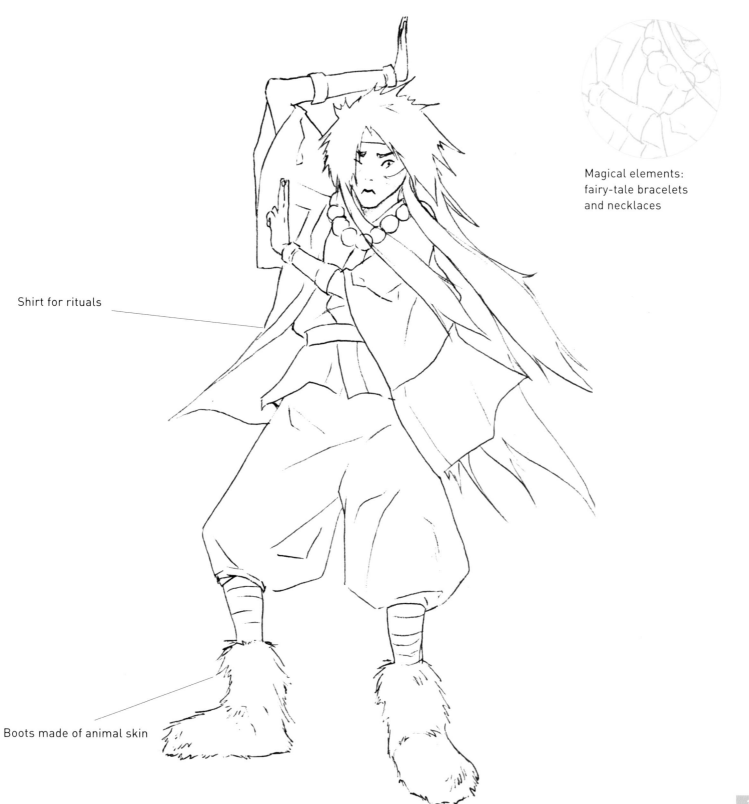

Magical elements:
fairy-tale bracelets
and necklaces

Shirt for rituals

Boots made of animal skin

281

Source of light

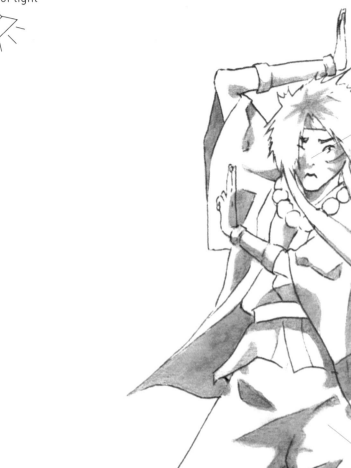

Remember the shadows that are projected, for example, those that the strands of hair cast on the face.

To give more of a sense of volume, use shading to indicate creases in the trousers.

Use very saturated and vivid colors so the character stands out.

Painting the character's face white with elements of red and black transmits a stronger expression.

Give each item of clothing a different design to show more depth.

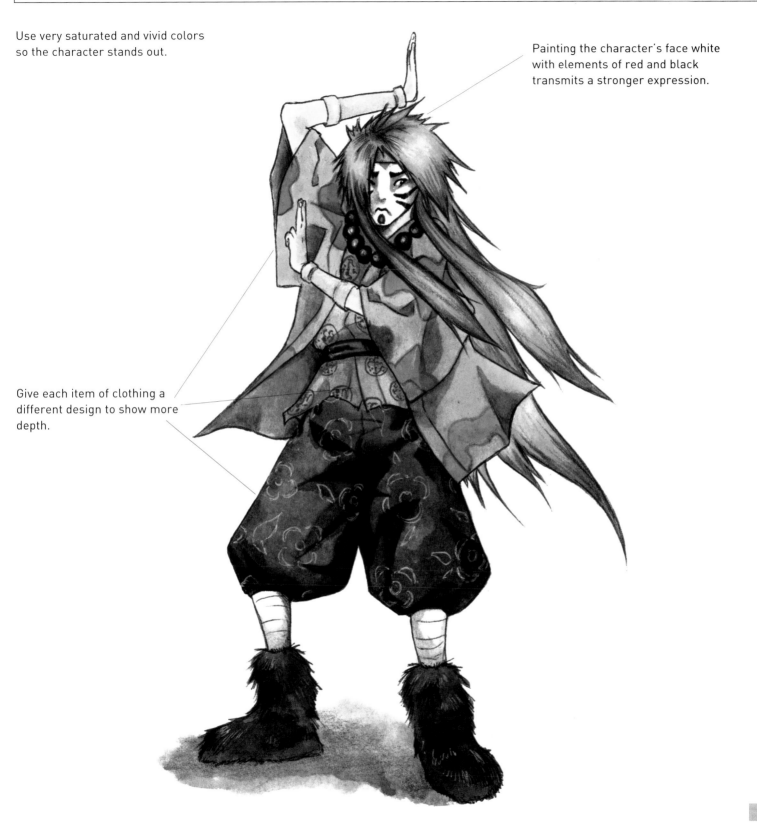

GEISHA

Japanese geishas are girls who are educated to perform dance, music, and the tea ceremony. They are contracted to liven up certain parties. Their education and refinement are exquisite, and they stand out in various artistic fields and areas of protocol.

This exercise demonstrates how to create a young and beautiful geisha, with an air of elegance and an exotic appearance.

The geisha's strong personality transforms her into a very charismatic character who an be useful in any Manga story. The makeup that she wears is eye-catching, and the accessories and beautiful fabrics in which she dresses make her extremely attractive.

Since she is delicate and fragile, we will draw her with a very feminine expression, flirtatious and mischievous, that matches her seductiveness and shyness.

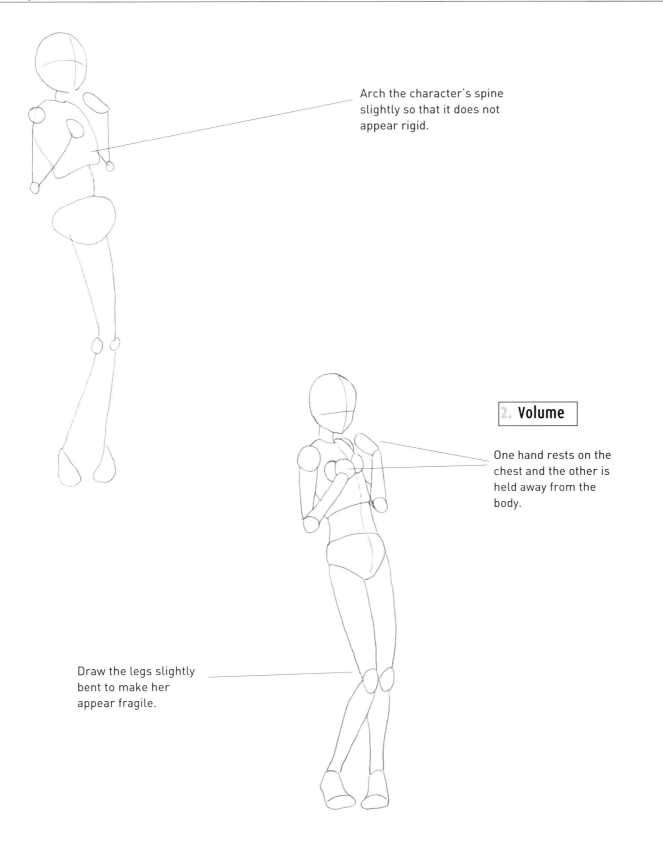

Arch the character's spine slightly so that it does not appear rigid.

2. Volume

One hand rests on the chest and the other is held away from the body.

Draw the legs slightly bent to make her appear fragile.

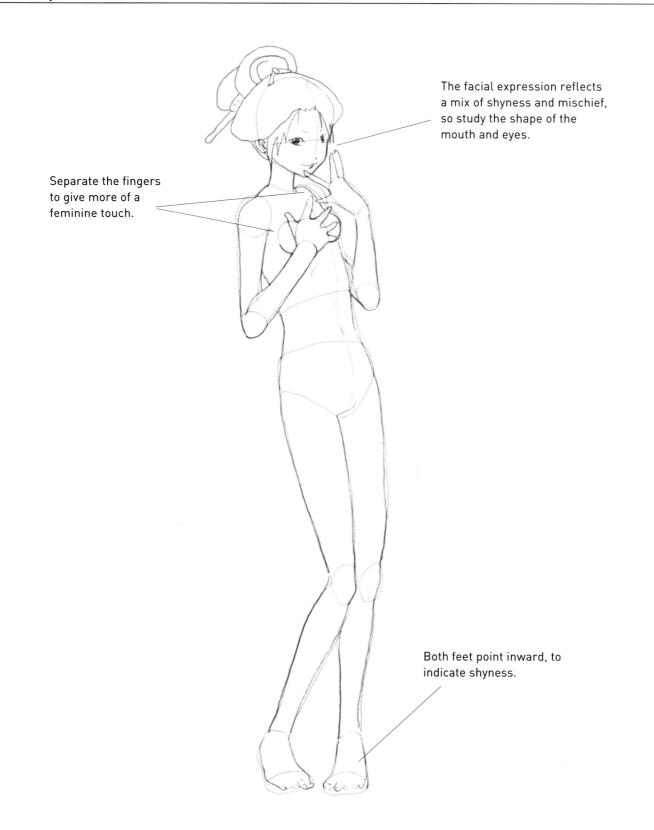

The facial expression reflects a mix of shyness and mischief, so study the shape of the mouth and eyes.

Separate the fingers to give more of a feminine touch.

Both feet point inward, to indicate shyness.

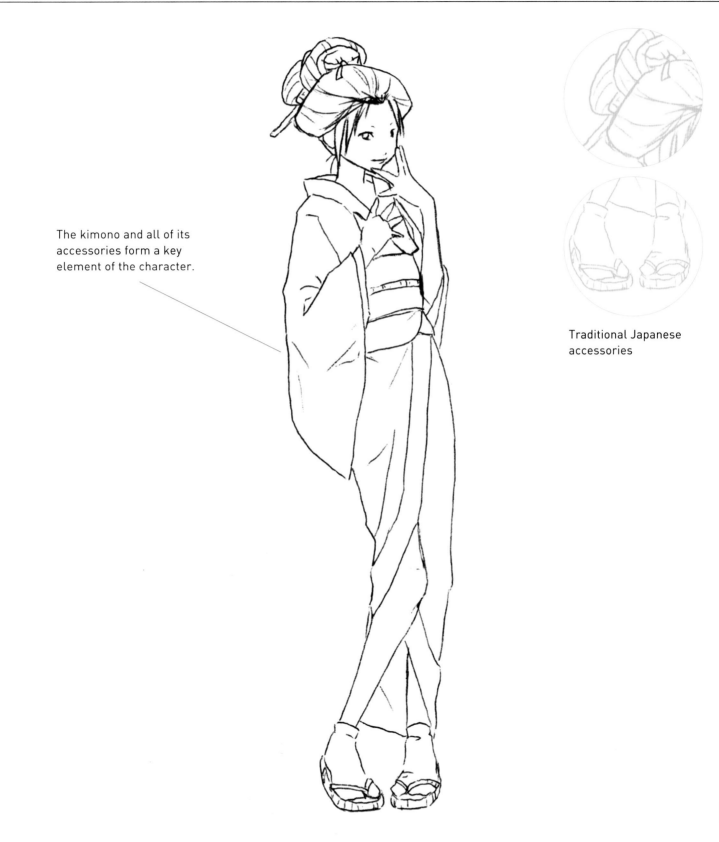

The kimono and all of its accessories form a key element of the character.

Traditional Japanese accessories

Source of light

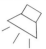

The shadows contour
the creases that the
material forms.

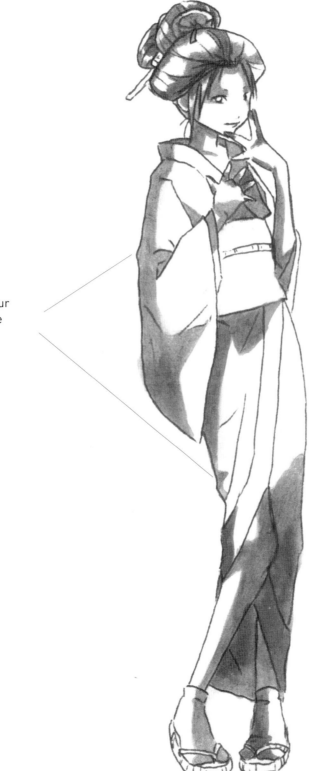

Add a parasol to lend an exotic touch and make the drawing more colorful.

White makeup on the face, which contrasts with the rosy cheeks, is essential.

Work with the motifs of the design on the kimono using natural, curved lines and avoiding straight lines.

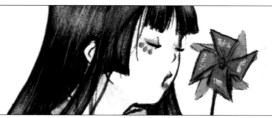

PRINCESS

Because she is the daughter of the emperor, everyone is constantly giving the princess attention and paying her compliments. This treatment has turned her into a spoiled girl who always gets her own way.

Childish, happy, and wide-eyed, she rebels against palace discipline. She is a great virtuoso in the arts and is known for her big heart and sincere consideration for the people around her.

She is very attractive and always wears beautiful kimonos and sophisticated clothes. We will draw her with long, neatly arranged hair. It is not tied back, as though to capture a relaxed moment from her everyday life.

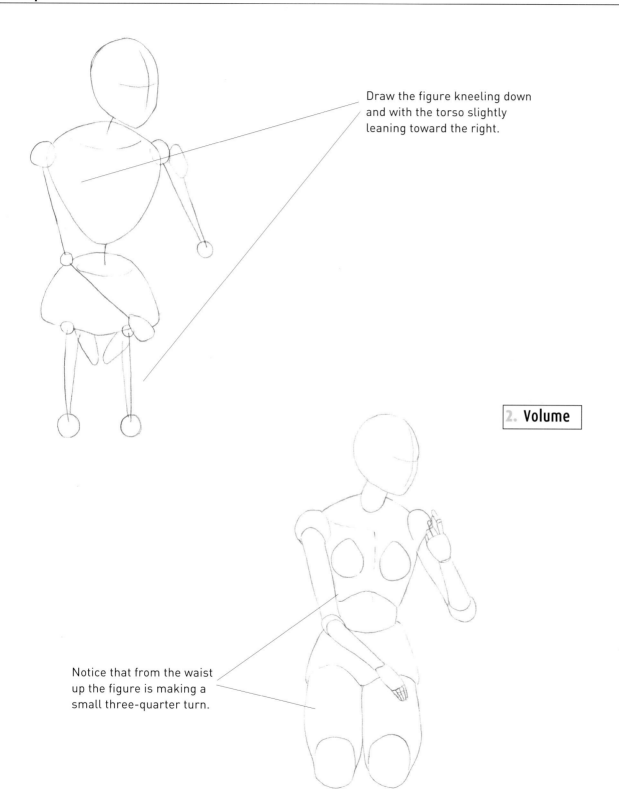

Draw the figure kneeling down and with the torso slightly leaning toward the right.

2. Volume

Notice that from the waist up the figure is making a small three-quarter turn.

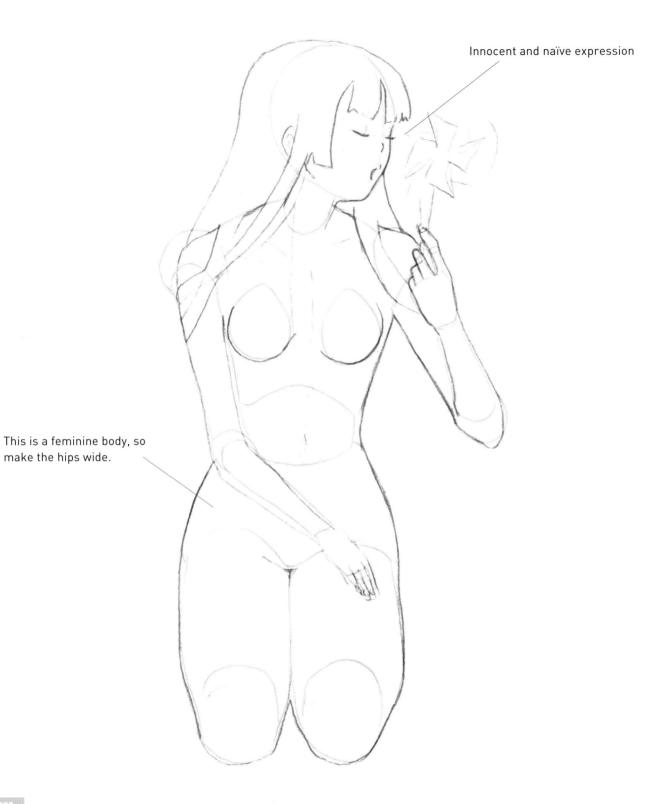

Innocent and naïve expression

This is a feminine body, so make the hips wide.

Cover the girl's body with a kimono made up of various layers.

The space taken up by the body increases because the clothes are thick and baggy.

The creases in the material are small and well defined.

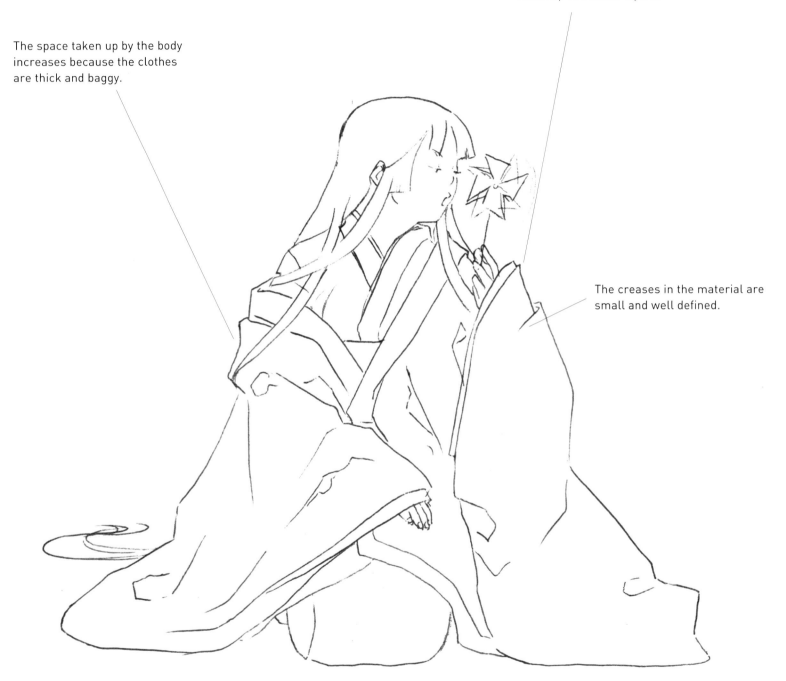

Source of light

Do not define the blades of the pinwheel too much in order to achieve the effect of motion.

The shading on the kimono is elongated and well defined.

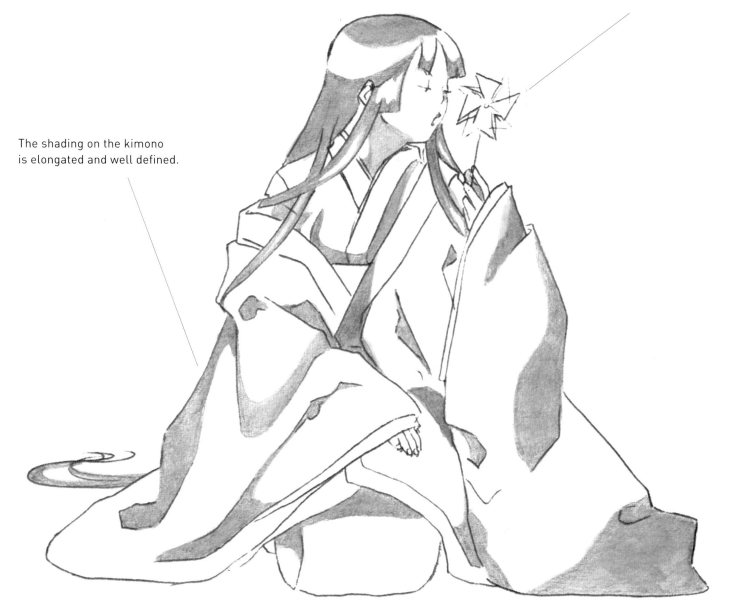

Use light and cold colors that contrast with other more vivid and warm ones such as the red.

A design with different colorful flower motifs

A small shadow projected on the ground

NINJA

Our ninja is a formidable fighter, equally adept at hand-to-hand combat and the handling of the metal weaponry. Thanks to her cat-like speed and agility, she is difficult to catch.

She belongs to a clan of ninja assassins, and is therefore capable of moving through the shadows without anyone noticing her presence. Trained from childhood, she has carried out all sorts of missions for whoever contracts her services—anything from a simple escort mission to robbery, deception, and cold-blooded assassination.

She is a cold woman, relentless and very dangerous, both inside and outside of her role as a ninja. She seldom lets anyone see her face.

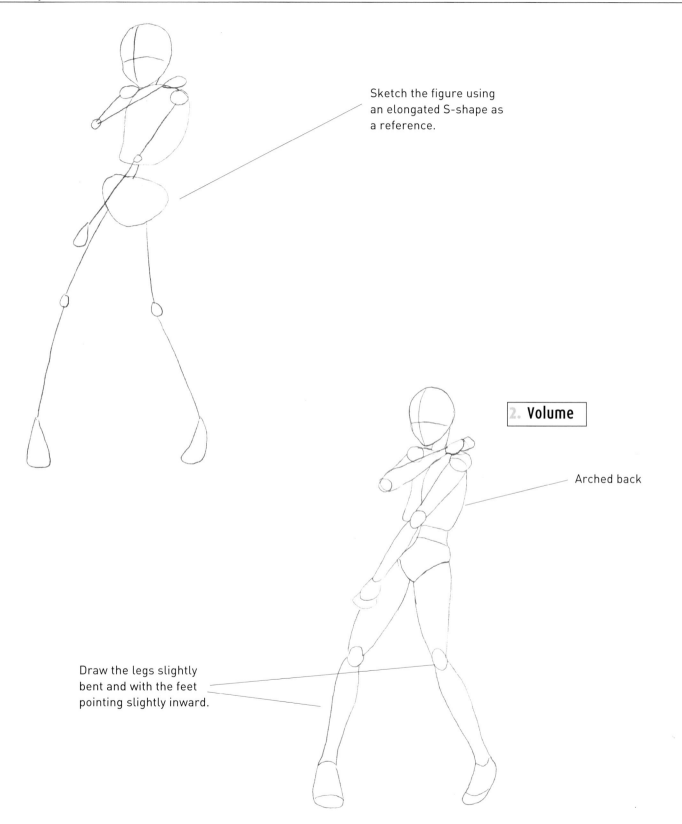

1. Shape

Sketch the figure using
an elongated S-shape as
a reference.

2. Volume

Arched back

Draw the legs slightly
bent and with the feet
pointing slightly inward.

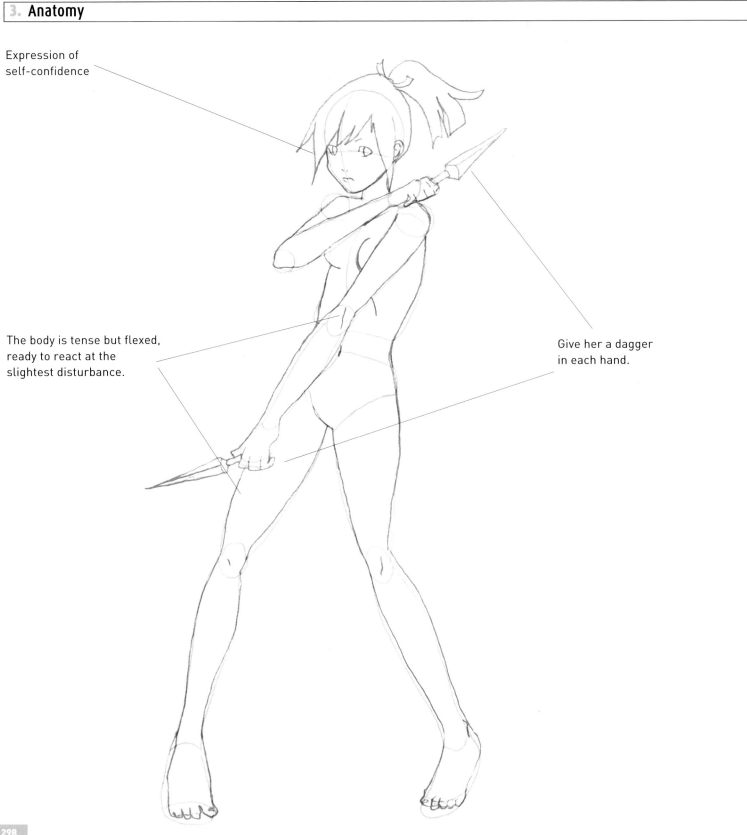

Expression of self-confidence

The body is tense but flexed, ready to react at the slightest disturbance.

Give her a dagger in each hand.

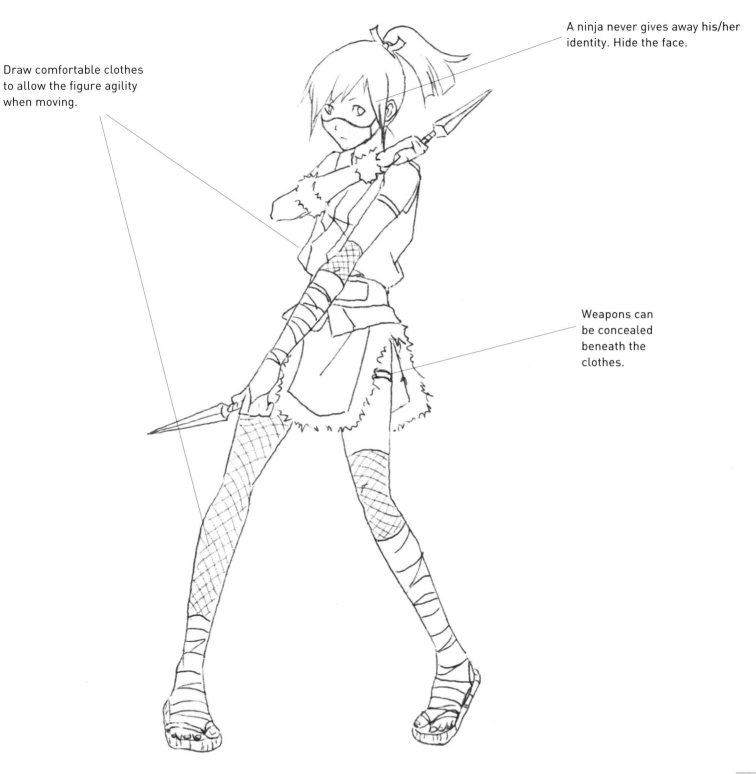

A ninja never gives away his/her identity. Hide the face.

Draw comfortable clothes to allow the figure agility when moving.

Weapons can be concealed beneath the clothes.

Source of light

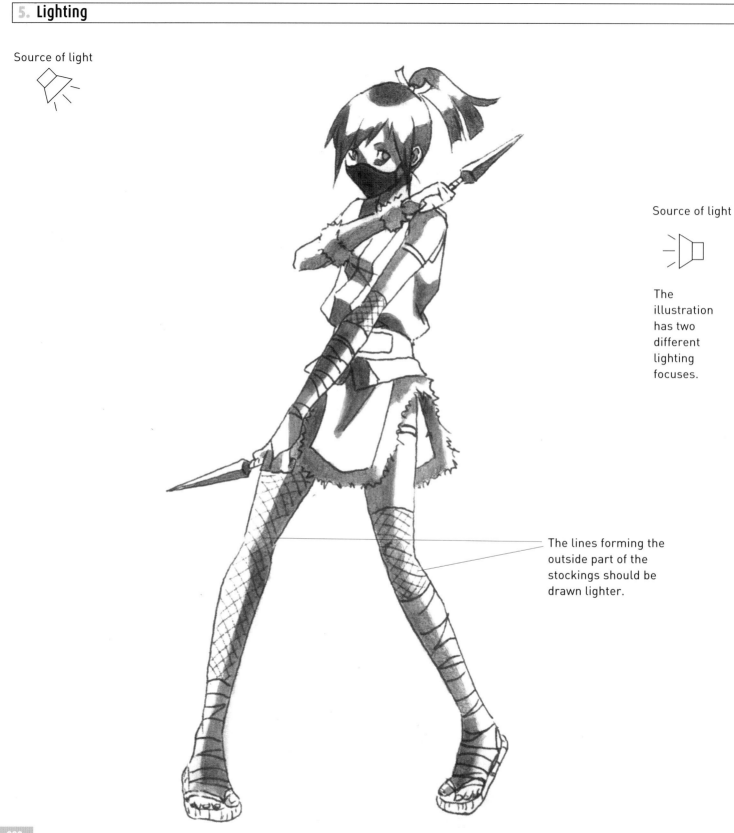

Source of light

The
illustration
has two
different
lighting
focuses.

The lines forming the
outside part of the
stockings should be
drawn lighter.

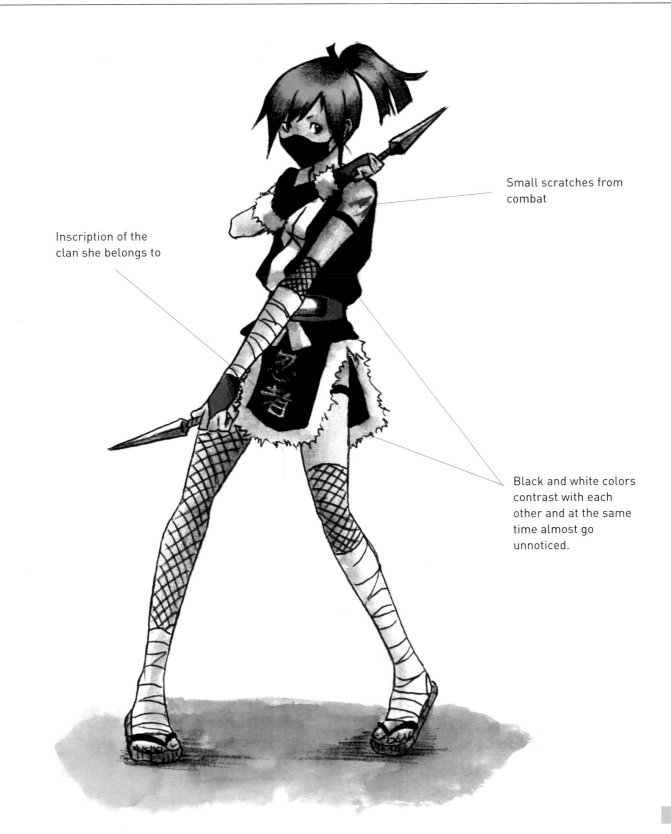

Inscription of the
clan she belongs to

Small scratches from
combat

Black and white colors
contrast with each
other and at the same
time almost go
unnoticed.

RONIN

A hired assassin and bodyguard, this character gives his services to the highest bidder. He is a kind of sword-wielding mercenary, with a strong and sarcastic personality. He fully understands what he does and does not regret his actions. Although he does not inspire much confidence to start with, he ends up gaining the main character's trust with his quick-witted, sarcastic humor.

After his appearance as a child with an air of naivety, he becomes a formidable warrior, agile and quick as the wind. His enemies put their trust in him when they meet him, and then are annihilated before they even realize what is happening.

He is small and thin, and his sword appears too big for his stature, but he handles it as if it were a small dagger. We will dress him in comfortable, light clothes to allow him to move with agility.

He is lying down on one side.

The weight falls on the character's right shoulder.

2. Volume

The head is slightly large in relation to the body, as the character is young.

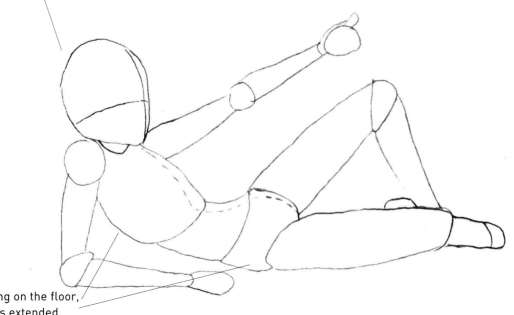

The hip is resting on the floor, and the sword is extended.

The right foot goes behind the left leg.

Serene and confident expression

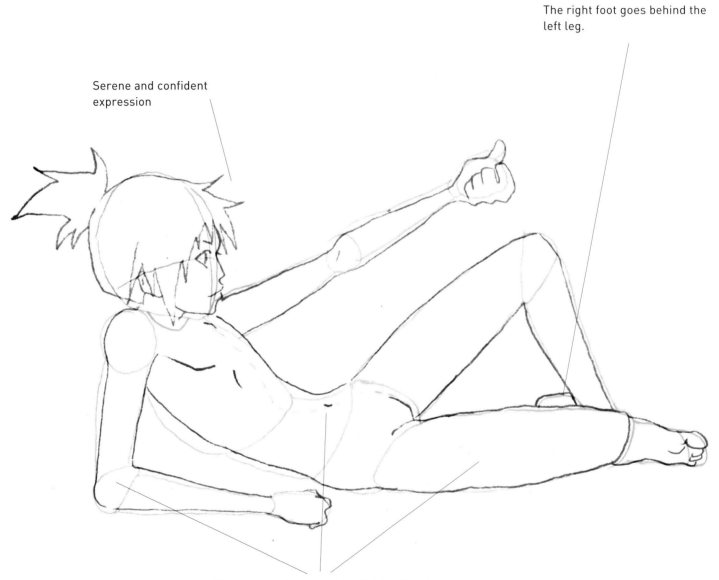

The anatomy in general is slight, without too much muscular development; the character has great agility and moves very quickly.

Add the sword out of proportion with the size of the character; this creates the false impression that he handles it awkwardly.

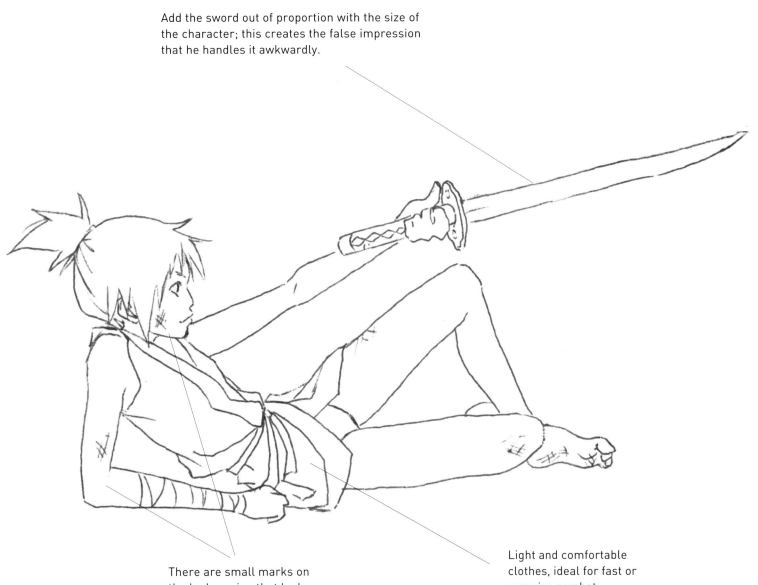

There are small marks on the body, a sign that he has been involved in a skirmish.

Light and comfortable clothes, ideal for fast or surprise combat

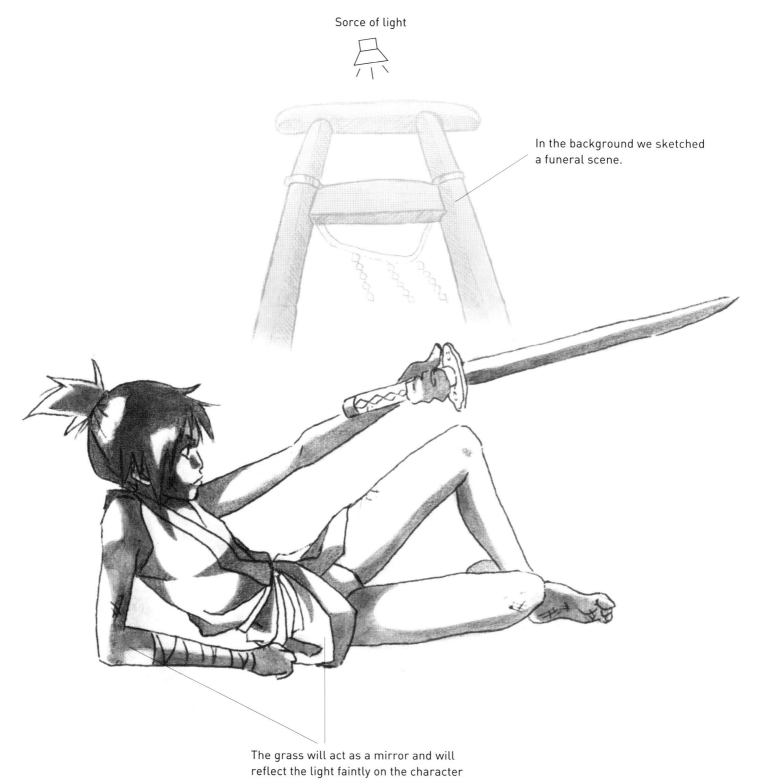

Sorce of light

In the background we sketched a funeral scene.

The grass will act as a mirror and will reflect the light faintly on the character (a shimmering effect).

Blur the color of the background so that it looks softer and not as saturated as the character's hue, to achieve a clear separation between the planes of depth.

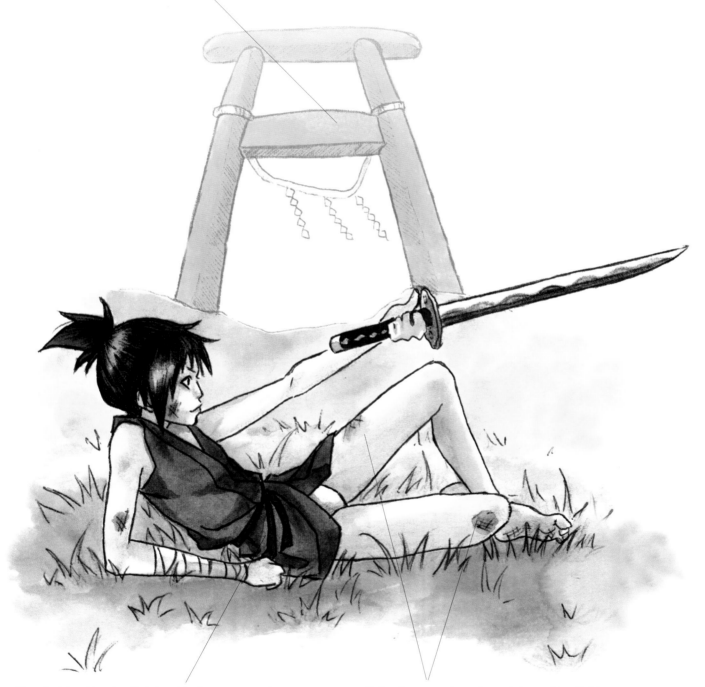

The clothing blends slightly with the grass so that the warrior can go unnoticed.

Color the wounds and scratches with a light reddish hue.

WANDERER

This character is a nomad who goes through life traveling from one place to another, without any particular direction. He could easily be the main character in a story. He seems a bit arrogant and presumptuous at first, but he gradually reveals his big heart, and the reader begins to warm to him.

He is very skilled with the sword and is always prepared to unsheathe it if the situation requires. When he is not doing some kind of escort work to earn a living, he performs small theatrical monologues with his old mask and beloved nomadic cat.

He is athletic and agile, as well as a bit vain and concerned about his appearance. He often causes quite a commotion among the young girls in the villages he visits. Despite his boastfulness, he is good-natured and kind, always ready to help people with problems.

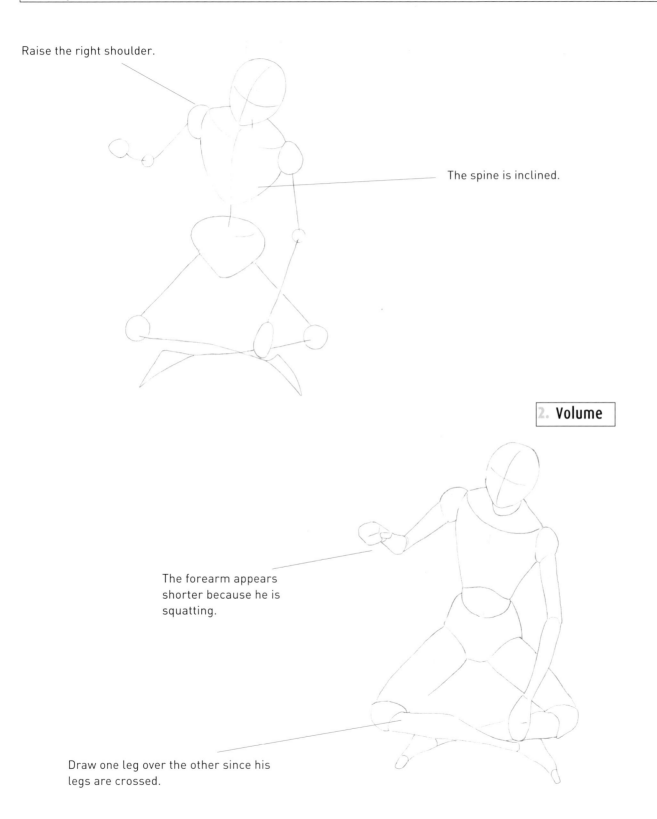

1. Shape

Raise the right shoulder.

The spine is inclined.

2. Volume

The forearm appears shorter because he is squatting.

Draw one leg over the other since his legs are crossed.

To create more of an impact, the character should be looking at the spectator.

Rest the sword on the shoulder.

First draw the hair with broad strokes and a simple shape, then add the strands.

Highlight the abdominal muscles.

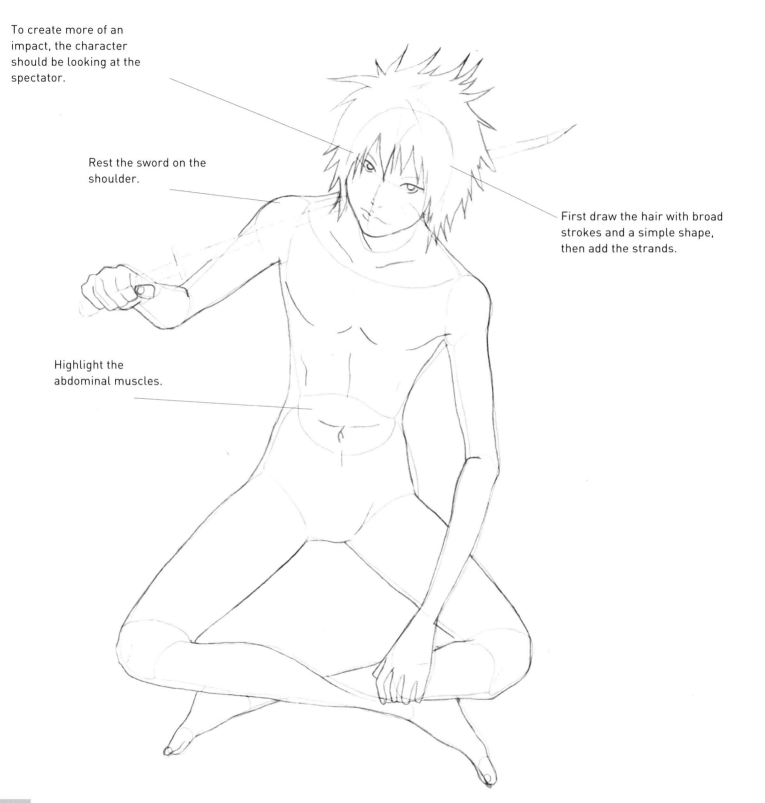

A large part of the character's charisma is the result of the small details, such as the cat that accompanies him, his hips, and his mask.

The tip of the sword is piercing a Chinese lantern.

The torso, with the tight bandages, contrasts with the wide, thick skirt.

Finish the skirt with tassels.

Source of light

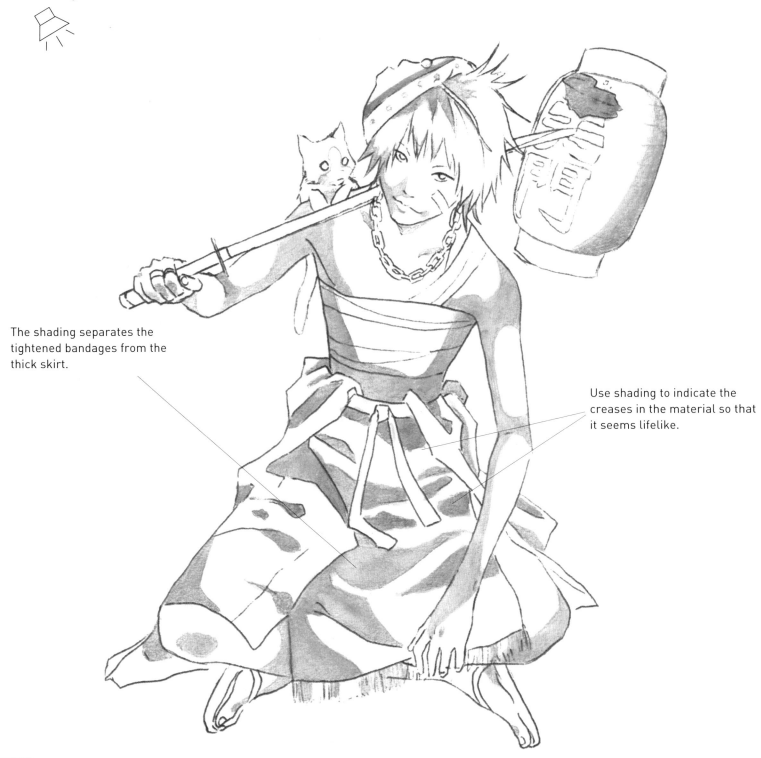

The shading separates the tightened bandages from the thick skirt.

Use shading to indicate the creases in the material so that it seems lifelike.

Use vivid colors (red, blue, green) that contrast
with the character's pale skin.

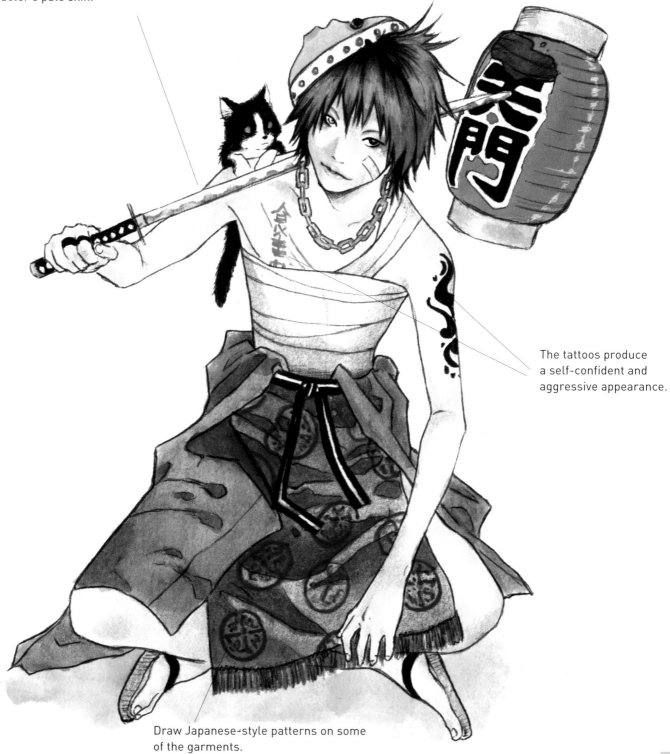

The tattoos produce
a self-confident and
aggressive appearance.

Draw Japanese-style patterns on some
of the garments.

SAMURAI

Under the old Japanese feudal system, the samurai were members of a lower class of the nobility formed by soldiers who were at the service of the feudal lords.

We will draw a high-ranking samurai, very skilled in the combat arts. He always has his sword with him and transmits enormous confidence in himself and his knowledge. He has a cold and distant expresion; his face arouses fear and respect, and he is, without doubt, an enemy who must never be underestimated. He could easily be the inseparable companion of the main character, loyal and always ready to offer help and friendship.

He wears magnificent armor, and the colors of his clothes reinforce the effect of coldness.

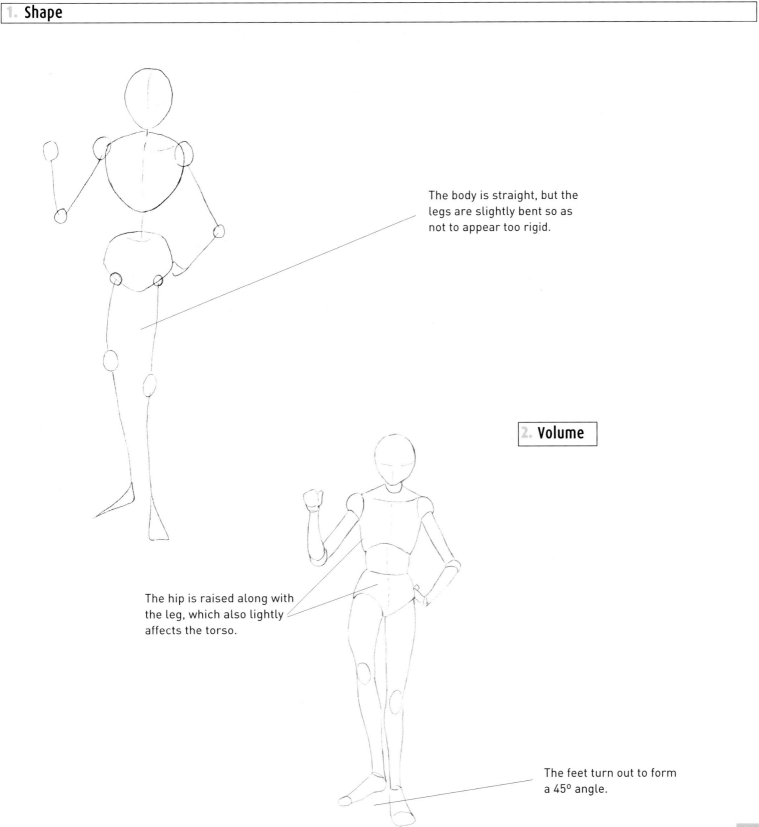

The body is straight, but the legs are slightly bent so as not to appear too rigid.

2. Volume

The hip is raised along with the leg, which also lightly affects the torso.

The feet turn out to form a 45° angle.

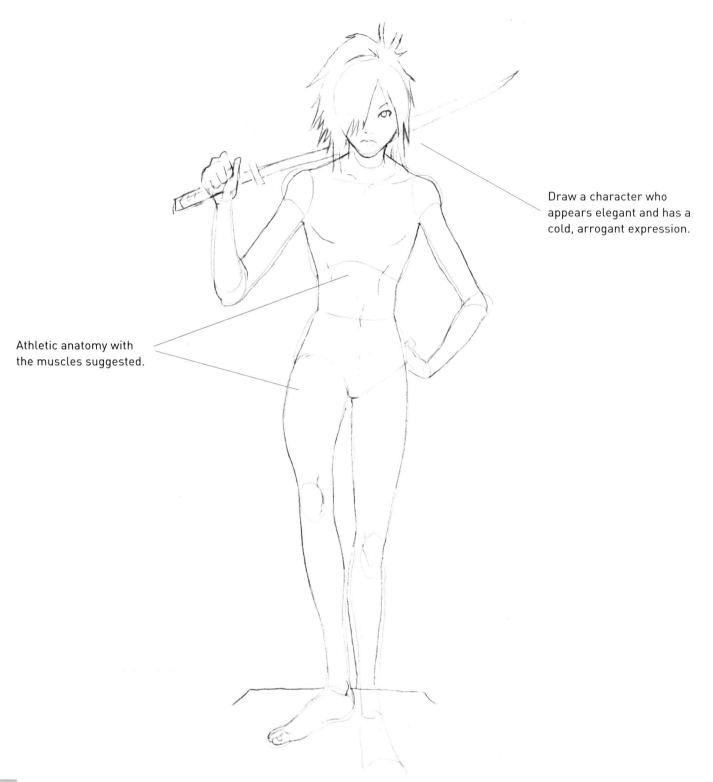

Draw a character who appears elegant and has a cold, arrogant expression.

Athletic anatomy with the muscles suggested.

Work with the details and ornaments of the armor.

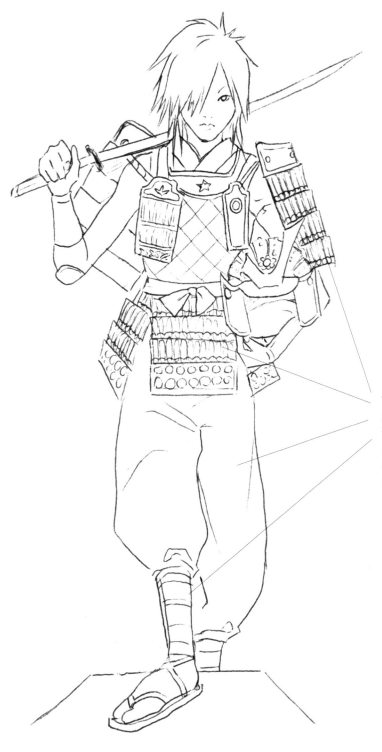

The clothing and the accessories are fundamental to the character, so some advance research is essential.

Source of light

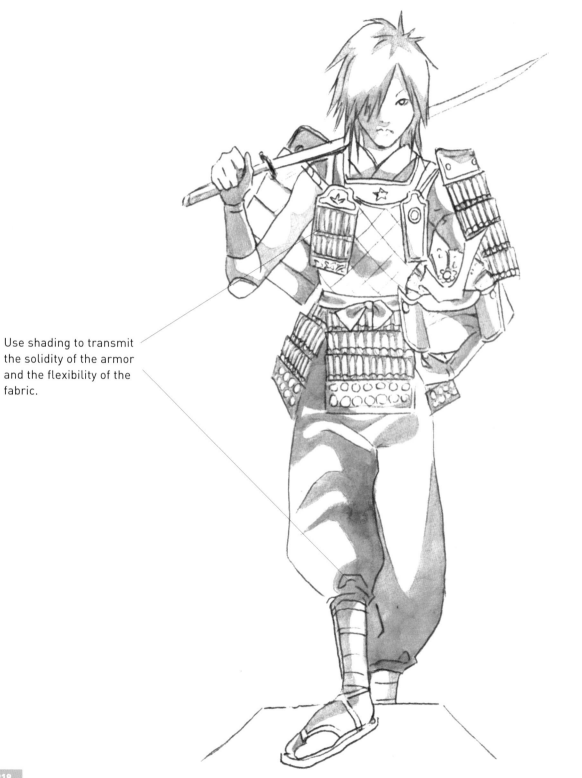

Use shading to transmit the solidity of the armor and the flexibility of the fabric.

Texture of the chain mail

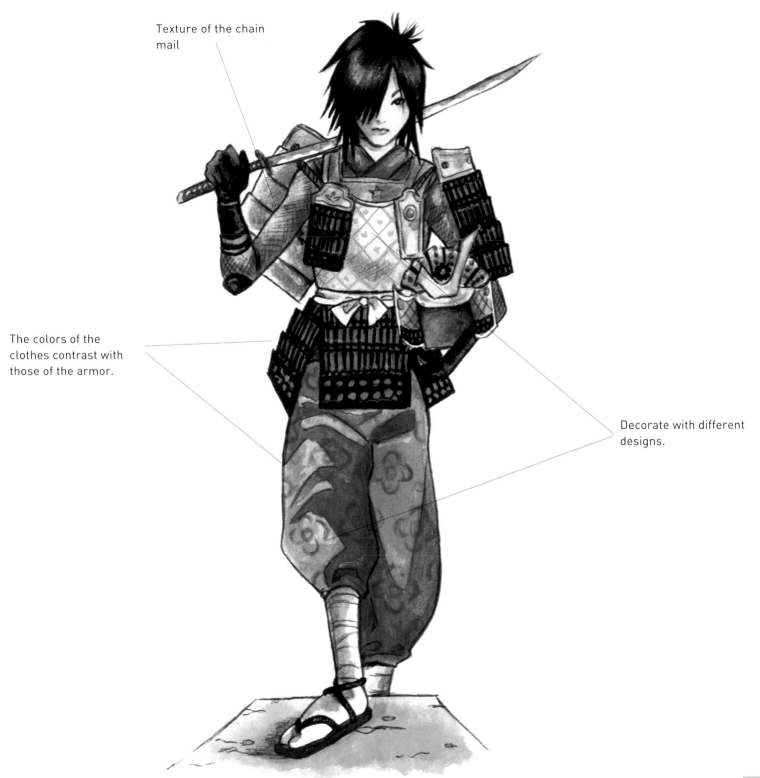

The colors of the clothes contrast with those of the armor.

Decorate with different designs.

SAKURA

This character is a samurai who has already reached a supreme level in sword handling and can fuse her body and spirit with her surroundings.

She is extremely serene and tranquil. She is aware of her great power and controls it at will, without needing to make any sort of display of doing this.

We draw her as good-natured, perfectly at peace, and balanced. This effect of serenity will be reinforced using cherry-tree flowers ("sakura"), which fall onto her back. This is a resource used widely in Manga and other comics.

1. Shape

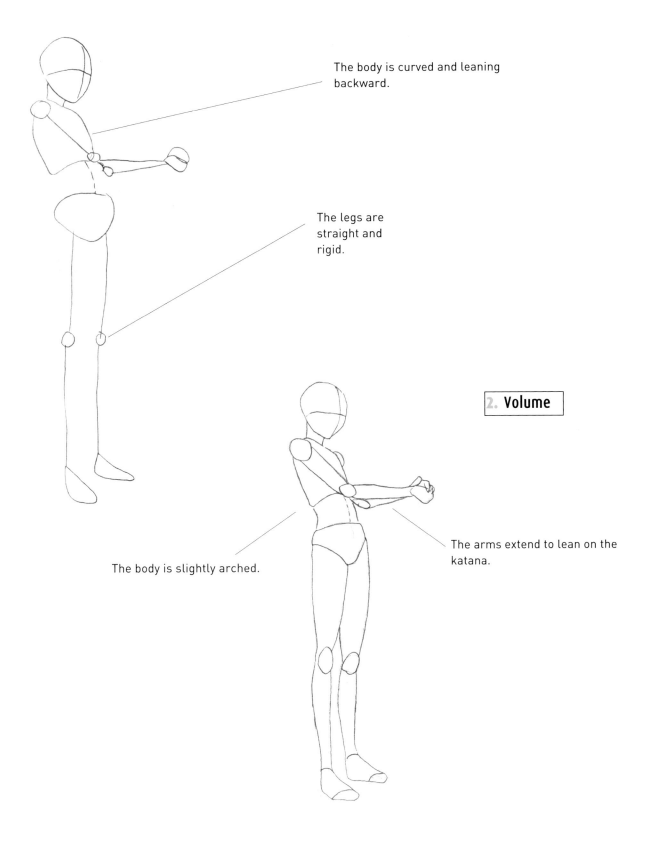

The body is curved and leaning backward.

The legs are straight and rigid.

2. Volume

The arms extend to lean on the katana.

The body is slightly arched.

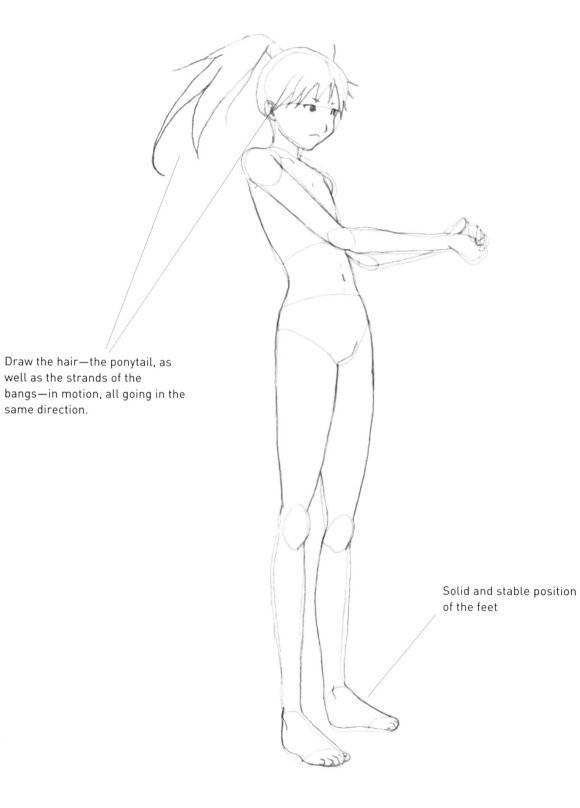

Draw the hair—the ponytail, as well as the strands of the bangs—in motion, all going in the same direction.

Solid and stable position of the feet

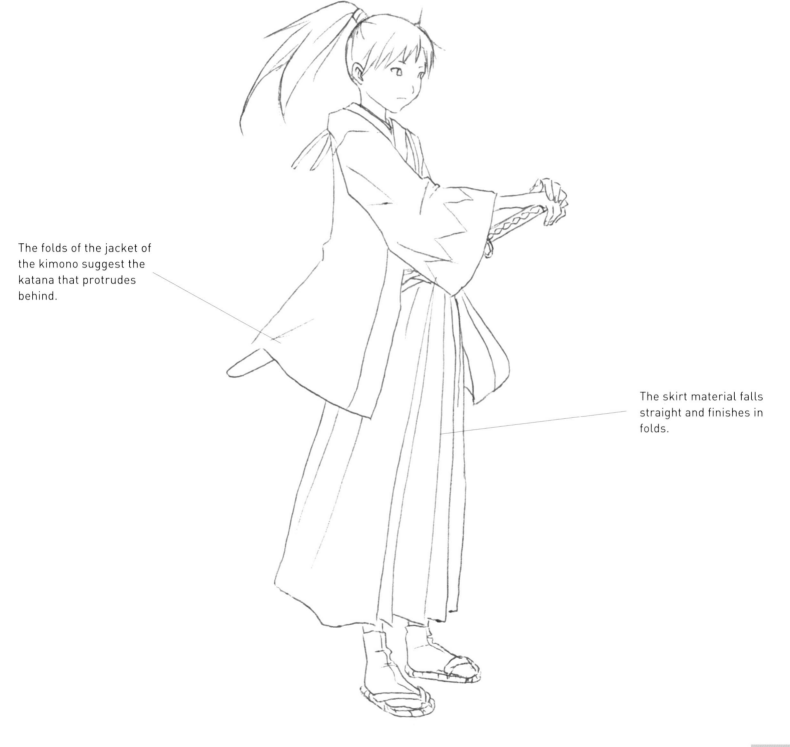

The folds of the jacket of the kimono suggest the katana that protrudes behind.

The skirt material falls straight and finishes in folds.

Jagged reflections

source of light

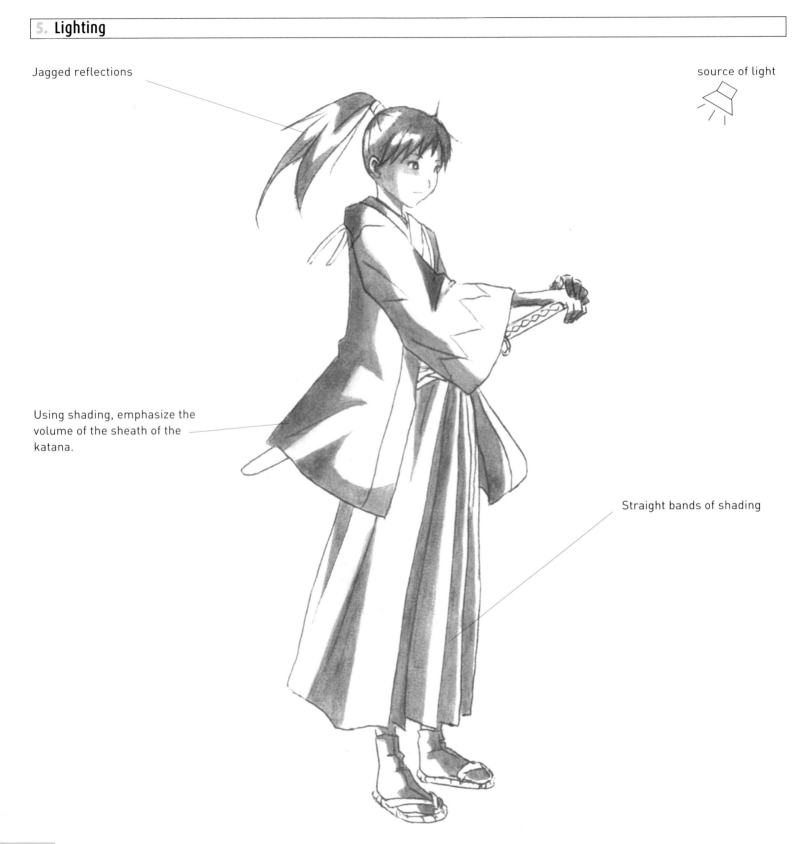

Using shading, emphasize the
volume of the sheath of the
katana.

Straight bands of shading

The cherry-tree petals in the background give a melancholic feel to the illustration.

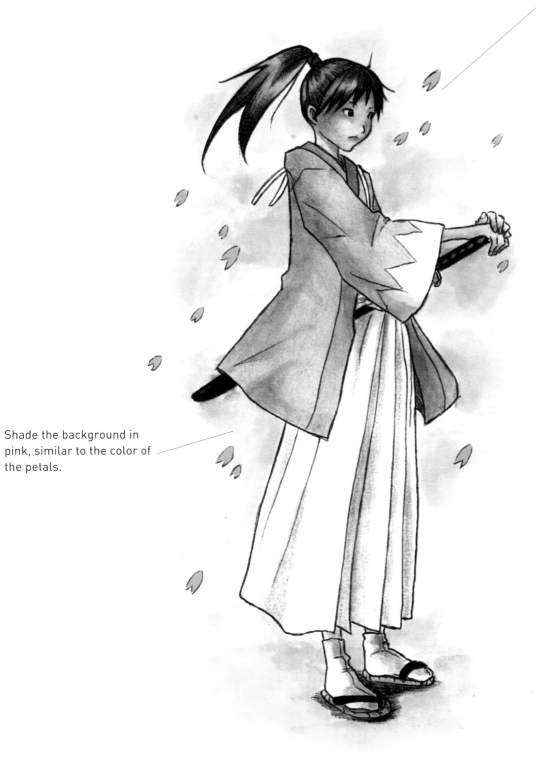

Shade the background in pink, similar to the color of the petals.

DRAWING MANGA DIGITALLY

THE DIGITAL STUDIO
Peripherals, applications, and materials

Here we will describe some of the most common peripherals that can be found in the studio of any graphic artist; these allow the artist to control, at any moment, each of the actions that make up the creative process.

The computer

This is the main tool for carrying out the creative work. Today, the use of the computer is such a widely spread practice that, for the graphic artist, it has become an essential instrument. It is essential because it is so easy to use, creating is so much faster, and it can provide elements that by hand were unthinkable to produce. A good computer can definitely solve a lot of problems and make tedious tasks much easier.

The scanner

The scanner has been one of the key pieces in the revolution of digital art as it is the most important tool when digitizing drawings or photographs that we can then work with on the computer. The main question that we must bear in mind when buying a scanner is the resolution that it offers. The quality it will give digitalized images is resolution (the higher the resolution the better the quality). In the market there are lots of models, as well as different prices and qualities.

The printer

For the artist the printer has come to represent the easiest way to check the state of the work at any time. It is also undoubtedly the fastest tool to correct and check aspects of the illustration that are not noticed on the screen.

The digitizing pad

The digitizing pad is essential for drawing and applying color with complete freedom; it allows you to considerably surpass the possibilities offered by the mouse. With the optical pencil, you can control important functions such as the pressure and flow of ink. Of course, it also enables you to create images as if they were being created by hand.

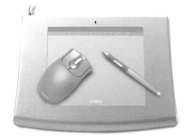

The software

A lot of programs can be used to produce your creations, but, without a doubted, Photoshop stands out from the rest. In addition to many other image-handling features, this impressive Adobe application allows us to create and execute drawings in a professional way. There are, however, other programs—for example, Freehand and Corel Draw—that can help you perform different tasks such as creating logos and title pages.

Mac or PC, the eternal question

When buying a computer, you will probably have doubts about which processor to choose, how much RAM you will need, which monitor is better suited to your needs and so forth. But, the eternal question for designers, illustrators, and artists is which operating system—Mac or PC—allows your creativity to flourish. The answer is tricky because whichever you choose, you will always find something that doesn't work the way you want it to. In any case, when it comes to digital art, the same work can be done with the Mac as with the PC because both can run the same programs. So the decision can be made according to which platform is used most. From that point of view, the Mac is favored more among artists, and has been since computers first started being used in this field.

FIRST STEPS
Types of drawings

Before digitizing the images to be able to handle them with the appropriate software (in our case, Adobe Photoshop), it is a good idea to bear in mind certain aspects that affect the drawings, like the type of illustration you want to create, the state it is in, etc. That way when you are working with your chosen program the work is as smooth as possible. Normally with drawing and paint applications like Photoshop you will be able to work with any type of original when applying color, retouching or adding other elements, but, of course, the result will depend on the original. For example, if the aim is, with Photoshop, to create a full-color illustration and at the end the ink has to be perfect, it is important to work from an original, which has been perfectly passed to ink.

Outline sketches. You can digitize this type of original to carry out the first color tests. You can also draw directly with Photoshop with the help of a graphic pad and, in this way, apply color, effects, and texture quickly.

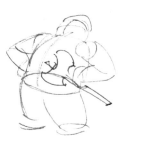 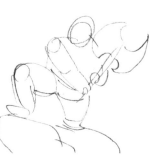

Pencil sketch. The pencil sketch is the quickest alternative to first study the color. If the sketch is clean from lines and stains, it is possible to change it to obtain a line, which is similar to what we would do in ink. If this is not the case you can always retouch it with Photoshop.

Gray lines. Normally these are drawn by hand to study the shadows and the lighting of the illustration. In any case, although it can be done with Photoshop (starting with the original in black and white or pencil), it is more common to scan in order to add colors from the program, change the tones, etc.

Ink line. The original, passed to black ink without any grays. It is without any doubt the better option to paint, quickly and easily, with Photoshop or any other program. If the lines of the drawing are closed, we can fill the base of color extremely quickly. With Photoshop, we can also save the ink so that it does not spoil.

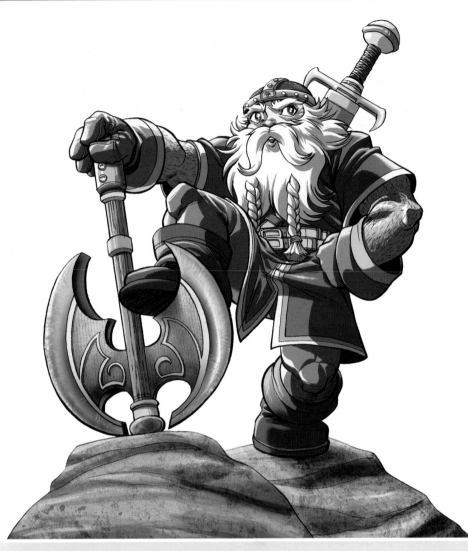

Drawing with Wacom; the easiest way

Although working with a computer has meant, for the graphic artist, an advance in every sense, the way in which we can work with the mouse is still a little limited in illustration programs, especially regarding important drawing options like the brushstroke, the pressure of the airbrush, etc. This is why the digitizing pads are so successful among artists. Working with these tools is the most similar way to drawing by hand.

With the digitizing pad and the associated pencils, it is possible to paint, draw, and sketch with unlimited artistic possibilities, unparalleled to using the mouse. In this section, the models by Wacom has most to offer in the market and can be adapted best to all needs and demands.

Stroke applied with mouse (above) and with digitizing pad (below); a notable difference in pressure exists between the two strokes.

DIGITIZING THE DRAWINGS
How to scan an image

Scanning an image is relatively easy, but the results may vary considerably if we do not do it correctly. Before capturing an image, it is necessary to determine a series of parameters in the scanner's program. Obviously this will vary depending on the make of the scanner, but one thing that is universal are the specifications that we have to introduce in this program so that the image is digitized correctly.
These specifications are as follows:

1. IMAGE TYPE

The name that will determine the picture that we want to introduce. It could be one of three types:

Image in black and white: all images that are based on black and white lines (i.e., no grays, blurs, etc.). Ideal for originals that have been passed to ink

Image in grayscale: the resulting image will be composed of different levels of gray. This is the option that we will choose for the pencil sketches as it captures all the shades.

Image in color: the image made up of colors, whether a photograph or drawing. Indicated for originals painted by hand that we want to modify with Photoshop.

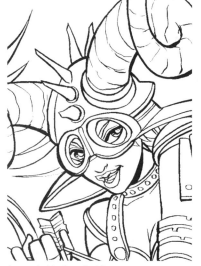
Image in black and white

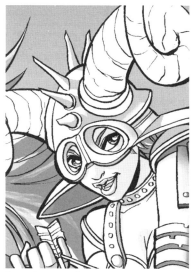
Image in grayscale

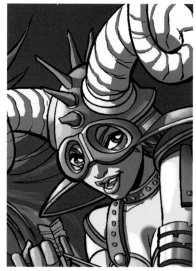
Image in color

2. RESOLUTION OF THE IMAGE

This parameter determines the quality of the final image. It is, therefore, synonymous with quality. The resolution is measured in pixels per inch (ppp or dpi). The more pixels an image has, the better the quality, and the bigger the size. It helps to calculate the appropriate resolution for each piece of work since it is the parameter that has most influence over the final size of the image and the margin available to us to handle it. In this sense, the optimum resolution that is in total balance with the final quality and size is 300 dpi. This resolution is best to scan originals in black and white, in grayscale, or in color. However, for images in black and white, it is always a good idea to apply a higher resolution (between 600 and 800 dpi), since this type of image, with no grays or colors, does not need to be linked.

3. SIZE OF THE IMAGE

The last of the three parameters that we have to establish in a scanner to digitize correctly has to be the measurements that we want our drawing to have. This factor is very important, because it is connected with the final size that will be obtained. It is determined by where our work is going to be reproduced. When we scan an image, we have to apply the exact final measurements of the work. Changing the size after digitizing will mean a loss of quality.

4. SAVING THE IMAGE

Once the image has been scanned, save it in the computer or in any other digital information file hardware to be able to handle it afterwards with the appropriate program.

Bitmap and vector graphics

Bitmap image

Vector image

The photographs, drawings, graphics, and other static images must be converted to a format that the computer can manipulate and present. Among these formats are bitmap graphics and vector graphics.

The Bitmap graphics store, manipulate, and represent the images as rows and columns of small points called pixels. The bitmap images are the electronic medium used most to save and work with unbroken tone representations, like photographs or digital paints, as they can show subtle differences in shadows and color. The bitmap images depend on the resolution since they contain a fixed number of pixels. They can, therefore, lose detail and show irregular borders if the screen size is modified or they are printed in a resolution inferior to that which they have been created for.

Vector graphics are digital creations that are constructed from sequences of mathematical equations and give graphical representations as a result. An example is the graphics obtained with programs like Freehand or Flash, which occupy very little space in the hard drive and can be enlarged without a loss of quality.

The main difference between a bitmap and vector is the way in which they can be modified. A bitmap loses definition when the dimensions are changed, whereas vectors can be modified (for example to increase their size) without losing resolution.

PHOTOSHOP TOOLS

The work area

For the graphic artist, the work area that Adobe Photoshop presents compared with other graphic editing programs means a complete revolution for creativity. With the complete range of drawing, paint, and retouch tools, Photoshop helps to effectively complete any task of image editing such as drawing, coloring, composing photo montages, writing text, creating textures and fusions, applying filters, and a long list of possibilities that all make this program the most powerful of its kind and within reach of professionals and artists. The work area consists of the following components:

Menu bar
It contains menus to carry out tasks. The menus are organized by topic. For example, the type menu contains commands to work with text.

Options bar
Allows the user to change the specifications of the tool selected in the main tools box.

Title bar
Shows the title of the document, the color mode of the image, and the zoom relation.

Rules
These are activated or deactivated in the view menu.

Palette area
Allows the user to organize the palettes in the work area.

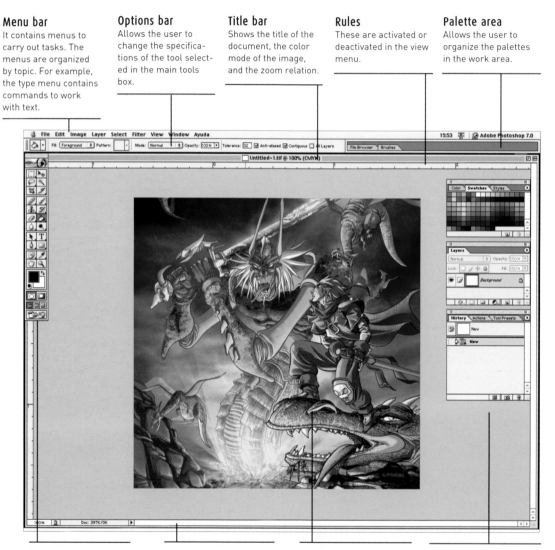

Tools box
This box contains the tools to create and edit images.

Information bar
The first quantity indicates the file size, and the second the file size with layers.

Work area
The place where we create our work. The area can be modified in size and resolution, image size, and canvas size.

Palettes
The palettes help to supervise and modify images. The palettes appear, by default, set into groups.

The tools box

The tools box appears on the left of the screen the first time that you start up Photoshop. Some of the more important tools, like the drawing, paint, or retouch ones (among others) can be modified from the tools section of the options bar. These include tools that allow the user to insert text, select, paint, draw, show, edit, move, register, and see images. Other tools from this box allow the user to change the foreground and background colors, etc. The main tools consist of the following:

Selection frames

Selection links

Crop tool

Healing brush and patch

Clone stamp tool

Background and magic eraser

Sharpen, smudge, and blur

Direct and pattern selection

Line

Notes and audio annotation

Visual tools: zoom and hand

Default colors: white and black

Quick mask mode

Switch colors

Magic wand

Create sector

Pencil and brush

History brush

Gradient and paint bucket

Sponge, burns, and dodge

Text tools

Drawing

Eyedropper, color sample and measure

Arrow to switch colors

Color frontal

Background color

Change of illustration window

Change to Adobe Image Ready

The palettes

The groups of palettes that Photoshop offers (Window menu), especially designed for each activity that the program facilitates, can be reorganized according to the demands of each user. Normally, we will not work with all the windows activated, so when we need the options of a specific palette, the best thing to do is activate and deactivate them. However, thanks to the grouping option, we can create groups of palettes (bearing in mind, for example, which we use most) and thereby adapt them to suit our needs.

Layers Window

Paths Window

Browser Window

Navigator Window

History Window

Preset tool Window

Samples Window

Styles Window

Color Window

Brushes Window

Information Window

CREATE NEW IMAGES
Beginning to work with Photoshop

After learning each of the most important work elements that are available to you in Photoshop, now is the time to start to work with images. For this, Photoshop offers different ways of creating a first image.
We can start from an empty file (File/New) where we will specify (as if we were scanning an image) the dimensions, the resolution, and the mode of the new file. We can also scan an image, like we have seen previously (File/Import).

Document title

Resulting size

New

Name: Untitled-1

OK

Image Size: 10K

Cancel

Preset Sizes: Custom

We can choose from a series of preset sizes

Width: 233 pixels

Height: 43 pixels

Measuring units
Image quality

Resolution: 300 pixels/cm

Color mode

Mode: Grayscale

We can choose one of these three options to define the background of the Document

Contents
● White
○ Background Color
○ Transparent

Archivo/Nuevo

Another option to start using images is to open images (File/Open) obtained by different mediums, such as scanners, digital cameras, or others, and which are already saved in the computer.

File	Edit	Image	Layer
New...			⌘N
Open...			⌘O
Browse...			⇧⌘O
Open Recent			▶
Close			⌘W
Close All			⌥⌘W
Save			⌘S
Save As...			⇧⌘S
Save for Web...			⌥⇧⌘S
Revert			
Place...			

File/Open

RGB vs CMYK, which color mode to choose for painting?

RGB is the color system or space that scanners, digital cameras, monitors, televisions, etc., and all devices that use light, work in. CMYK, however, is the system derived from the needs of the four-chrome offset print. It describes the colors based on the inks and actual printing systems available for offset, and not the content of colored light. That is why there are few colors available to represent reality.

Photoshop allows the user to work with RGB or CMYK files. From the Image/Mode menu we can change an RGB image to a CMYK one, or vice versa. But when is it better to use one mode or the other? Normally, when the image is for the Internet, multimedia, or any medium in which the hardware is a light device, we will always use RGB mode. We choose CMYK mode when our file is printed in any of the four-chrome printing systems common to graphic arts.

COLOR IN A DRAWING

First steps

The process followed to color in a drawing by computer coincides in some aspects with the way in which an illustration is painted manually. To draw by hand it is always advisable to save a copy of the profile and paint on a copy test in which the profile has been reproduced in another color. This avoids the line being eliminated when the paint is applied.

In the same way, when we use Adobe Photoshop to pass a drawing in black and white to a striking full-color illustration, and we apply colors over the profile of a drawing, this drawing deteriorates and the effect does not look very professional. So, before painting, we should create a copy of the profile to keep it in a safe place, just as when we scanned it at the beginning, to be able to use it as many times as we want.

The picture that we are going to paint is a good example of the possibilities that Photoshop offers.

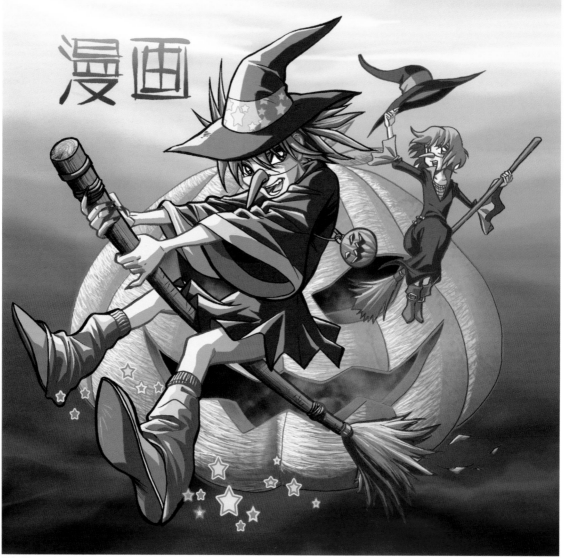

This illustration has been painted and manipulated with Adobe Photoshop.

To start with, it is important to clarify that we are going to use an original to paint the picture, from which has been perfectly passed to ink (we can paint sketches but we will look at this later on). This is obviously not the only technique to carry out this task, but it is the one used most by illustrators. If the lines of the drawing are closed, as in the example, it will be easier and faster to apply the color base, the effects, etc. If the artist does not use closed lines it does not matter because Photoshop offers various ways to close the drawings.

To scan the image, choose the black and white mode; that way you will be able to capture all the intensity of the profile and have a pure line. The resolution chosen for the drawing must be, as a minimum, 300 pixels per inch. This will guarantee an optimum quality and an image size, that is comfortable to handle in the program. Once the drawing has been digitized and saved in your computer, you can start the work with Adobe.

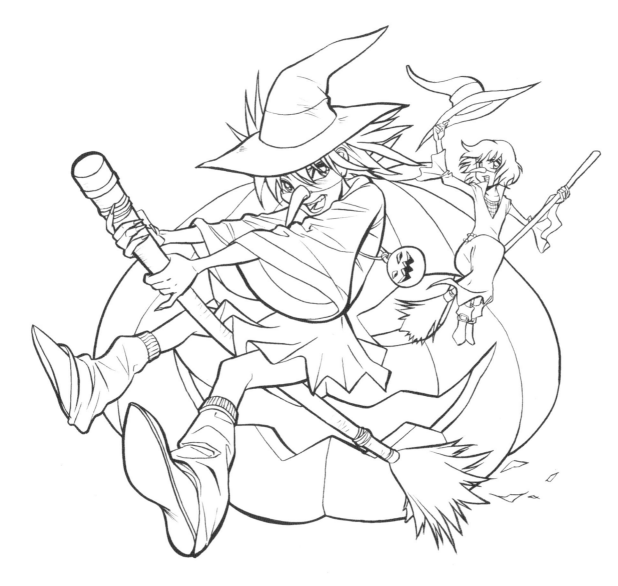

We will start with a drawing passed to ink, scanned in black and white, and at a resolution of 300 dpi.

Prepare the drawing through channels

To paint this picture we used version 7.0 of Adobe Photoshop.

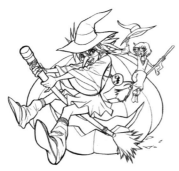

1. The image in bitmap

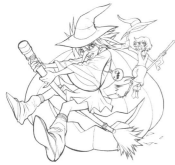

2. The image in grayscale

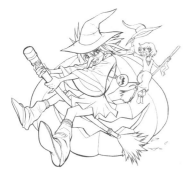

3. The new alfa channel

1. Once the image is scanned, open it from Adobe Photoshop. Select open (File menu/Open). Activate the layers window and that of the channels (Window menu/Channels/Layers).
As you will see there is only one layer (background) and one channel (bitmap), and it is impossible to paint on the drawing, because the image mode only allows you to work in black and white.

2. The following step, before converting the image to color, is to pass it to the grayscale mode. Activate the option grayscale (Image menu/Mode/Grayscale). This option is essential since you cannot pass an image in bitmap to color before converting it to grayscale.
In the option size factor, activate the default option, 1. The size factor determines how much the image will be reduced. For example, to reduce an image in greyscale by 50%, you have to introduce 2 in the size factor.
When converting the image to grayscale, the line of the drawing ceases to have the harshness it had in the bitmap option.

3. Now, save a copy of the profile in a secure place where it cannot be damaged. From the channels window and with the gray channel activated, drag the channel toward the new channel icon. A new one will be created called gray copy. This will be the reserve of the profile and will act as a selection. This means that when you activate this channel (also called alfa) the edges of the profile selection will be displayed (as you create more channels these will be numbered).

1a. Layers window

1b. Channels window in bitmap mode

2a. The channels window, in grayscale mode

2b. The size factor menu, when converting the bitmap option to the grayscale mode

3a. Drag the gray channel toward the new channel icon to create a duplicate of the original profile.

3b. The new channel created from the profile is a selection that can be used again.

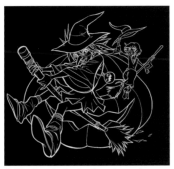

4. The inverted selection channel

5. The RGB color channels

4. The new channel that you have created can be used later to load the selection of the profile and fill it with color. This will avoid it deteriorating as you are painting it or carrying out different operations on the picture. However, the alfa channel that you have obtained is now the same as the original (in positive). So, when you show the selection, it will offer it to you in reverse. This means that the white parts of the channel are the selection and the black ones the mask. To avoid this invert the channel (Image menu/Adjust/Invert) thereby having the selection of the profile with exactly the same parts as the original drawing.

5. To finish this section you just need to convert the drawing to color. You can choose between the two most important modes: RGB or CMYK. Remember that if your drawing is for the Internet you must save it in RGB mode, but if it is to be printed it must be in CMYK mode. For the moment we will work in RGB mode to be able to access one of the filters from the filter menu, which in CMYK mode will not be visible.

4. Layers window

4. The image converted to RGB plus the alfa selection channel that will allow you to have the profile of the original later on without it being spoiled

The channels, information, and selection all in one

The channels offer information about the number of color channels created in the image mode. For example an RGB image has four default channels: one for red, green, and blue, as well as a channel used to modify the image. The color information channels are created automatically when a new image is opened.

Also, the channels window offers the possibility of saving all the selections that we want to keep and later apply them again to the image, thereby manipulating, isolating, and protecting specific parts. These selections are called alfa channels and are the easiest way to preserve selections in order not to have to create them again, and to be able to reuse them as many times as is necessary in the illustration. To save an alfa channel, all you need to do is create a selection with the tools, and in the select menu choose save selection. To load the saved selection, from the same select menu you will have to activate the option load selection.

Start to paint the base of the illustration

1. Profile

2. Effects

3. Color Base

4. Background

Position scheme of the layers. Each one has its information separate from the others.

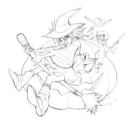

Profile of the drawing

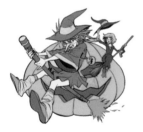

Flat color base

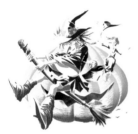

Lighting and shadow effects

Color background

1. When coloring the illustration, we will consider each of the elements it is composed of separately. To do that we must work with the layers, in which we will place each stage of the illustration independently. So, if we want to add a background, we will do so on the background layer, while the color base of the picture will be on top. The effects of the lighting and shadows will go on the color base; the profile of the drawing on top of all the others so it is not damaged, and so on until all the necessary layers have been created.

2. The first thing that we will do is erase the content of the background layer, as later on we will use it to create a color background. In the layers window, click on the name of the background layer to activate it. Select all the document (Select menu/All) and erase the content.

3. The next step is to create a new layer for the color base (Layer menu/New Layer). Do not forget to give the layers names (for example, color base) thereby working in a more ordered fashion. Now, on this same layer, load the profile of the drawing to then be able to paint it. Select black from the color selector option (click the foreground color in the tools window) and fill in the selection in black (Edit menu/Fill). The result must be the profile of the original drawing in black.

2. Background layer. Delete the content to be able to add color background, a gradient, etc.

3a. The gray channel copy is the copy of the profile of the drawing that we can convert to selection.

3b. Select menu/Load selection

3c. In load selection you can activate the copy of the original drawing.

3d. The color selector

4. Samples window. Create a library of color to store all your colors

5a. Color selector window. From the window we can create colors quickly.

5b. Color selector from the tools bar. Create the foreground or background colors using different composition systems.

4. To apply the lighting and shadow effects on the drawing, we created another new layer that we will call effects (Layer menu/New layer). That way we will be able to locate it. Having a layer separate with the effects allows you to independently control how the light falls on the drawing without modifying the color base of the original drawing. If you want you can create other layers to define new effects or to apply other textures on the drawing.

5. To finish the preparation of the drawing before starting to paint, place the profile of the drawing over the layers that you have already created. This keeps it separate from the rest of the illustration and avoids damage when we fill it with color. Create a new layer and call it profile (Layer menu/New layer). Load the selection of the drawing (Select menu/Load selection) and fill in the resulting selection in black (Edit menu/Fill). The result should be the profile of the drawing in black.

3e. The color base layer, with the profile loaded in the load select menu

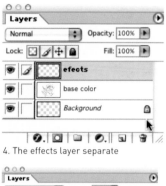

4. The effects layer separate

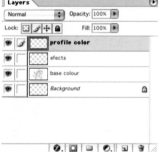

5. Final state of the layers

The actions automate the more boring processes

Preparing the drawing after scanning it is perhaps the most monotonous and repetitive painting process of Photoshop. A good way of solving this is to use the actions, a resource of the program that automates the most common processes. An action is a series of commands that are executed on a file or a batch of files. For example, you can create an action to prepare the drawing once it is scanned, convert from bitmap to cmyk, save the channel of the selection, create the layers to define the base, the effects, and the profile, load the selection in the layers and fill them in with the color that you want, save the drawing, etc.

Now, you can apply the action created to one or several drawings automatically. Most of the operations with commands and tools can be recorded in actions. The actions can include stoppages that let you carry out tasks that cannot be saved (for example, using a tool to paint). They can also plan mode controls that allow you to introduce values in the dialogue box while an action is being executed.

The tool box appears on the left side of the screen when starting up Photoshop. The most important tools, such as the drawing, painting, and retouching tools, can be modified using the options bar pertaining to each one. These include the tools used to insert text, select, paint, draw, show, edit, move, write, and see images. Other tools allow foreground and background colors to be changed, the possibility of working in different modes, etc. The main tool box consists of the following tools:

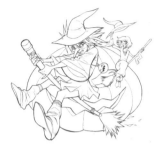

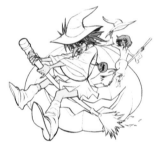

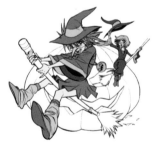

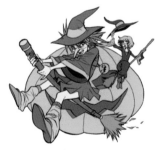

With the paint bucket tool, apply color to the drawing progressively.

1. To start, select a foreground color in the tools window using the color selector. Start with the skin of the characters. Now, select the paint bucket tool and click on the different areas that you wish to fill. As you will see, if the parts that compose the drawing are completely outlined, the paint will be applied to those as you advance. If this does not happen because the style of the drawing necessitates that you keep some areas open, you can close them with the brush tool. Apply an outline to close the drawing using the same color that you want to use for the fill, and then fill again with the paint bucket.

2. To apply the color logically, you must keep in mind aspects such as the lighting, the style of the drawing, etc., because proper use of color affects the final appearance of the illustration. Take the time needed to select the appropriate tones. Do not apply the lighting effects until you have completely finished filling in all the outlined areas.

3. Repeat the operation with the paint bucket to fill in each of the parts of the drawing that need the color base. Remember that painting with the paint bucket lets you advance through the drawing quickly and easily.

1a. Color selector. Select the colors to be applied to the foreground or background.

1b. Paint bucket

1c. Brush tool

1d. Brush tool

1e. Close an outline with the brush using the same color that you used to fill in the shape.

1f. Fill in with the paint bucket by clicking.

Apply lighting and shadow effects

As you go through this manual you will see that the lighting effects can be applied to an illustration in different ways. However, whenever you want to give your drawings a less artificial appearance, it is best to apply the shadows and lighting manually using the tools offered by Photoshop, such as the paint brush, the magic wand, the lasso, etc.

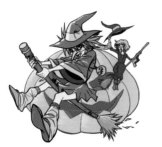

1. Once all the areas of the drawing have been painted, we can select, with the magic wand in any layer (with the option all layers from the activated magic wand tool). This is possible because the wand lets you easily select areas of a drawing that have been closed or are of the same color.

2a. Click with the magic wand on the color that you want to select.

2b. The selection of the drawing lets you reserve this area from the rest to apply only on the selected zone; for example, the lighting and shadow effects.

2c. With the adjacent option deactivated, when you click on a color, all the parts of the drawing that have that color are automatically selected.

1. Having the color base in a separate layer from the others, make the job of applying the lighting and shadow effects much easier. This is because one of the tools used, the magic wand, allows us to select all the closed areas, or all of a color that has been previously defined, to be able to apply the effects on the corresponding layer.

2. The first step to create the lighting effects is to create a new layer to work with independently. If you want, you can create two layers, one for the shadows and the other for the lighting.
Now, to define the areas where you will apply the effects, use the magic wand, which lets you select closed areas or areas of the same color. In the options bar of this tool, change the values according to your needs when selecting each area of the drawing.

With these buttons you can specify if you want to create a new selection, add to an existing one (add), take away from a selection, or intersect selections.

To define a soft border in selection, select softened. If the option is deactivated, the border of the selection will have a hard or jagged appearance.

Para definir un borde suave a la selección, escoge Suavizado. Si la opción está desactivada, el borde de la selección presentará un aspecto duro o dentado

1. Magic wand tool

2a. The effects layer

2b. You can create as many layers as is needed

Use this function to select areas from any layer. The magic wand tool on the other hand will only select the layers from the active layer.

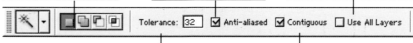

In Tolerance, you can enter a value in pixels, between 0 and 255. If it is a low value, you will be able to select colors very similar to the pixel you have clicked on. If you enter a high value, you will be able to select a wider range of colors.

To select only the color you have clicked on, select adjacent. With the option deactivated, all the objects that use the same color are selected

Appearance of the illustration step by step with the lighting effects. After selecting the areas and selecting the appropriate colors, apply with the brush the lighting and shadows in the corresponding layers. Give it a realistic touch with the underexpose and overexpose tools.

3. With the area of the drawing selected and on the corresponding layer (for example, that of the lights), select a light color in the color selector. If you are looking for a tone that complements the one you have (for example you want to apply light on skin), first select the color with the eyedropper tool and then look in the color selector (clicking on the color box of the tools window) for the lightest color. Now select the brush and apply the lines. Change the options of this tool if you want the line to look different. Notice that the paint does not escape outside of the selected area because the area is still selected. You can also create your own colors from the Color selector window.

4. To apply the shadows, do so on a new layer and repeat the previous steps. Select with the magic wand (to reserve), select a color (with the eyedropper), in the color selector look for the darkest tone, and apply the strokes (with the brush). If you want the shadows to have a hard appearance, select a brush with hard edges. If on the other hand you want the shadows to be blurred, use a soft brush. Also it is interesting to change the thickness of the brushes to obtain other strokes. Do not forget to vary the opacity options (in the brush options) if you want your shadows to have more or less intensity.

5. If you want to highlight an area where you have already applied shadows or lighting even more, you can do so easily with the underexpose tools (for the shadows), or overexpose (for the lighting). These tools give a more realistic touch to the lighting effects of the drawing.

3a. Color selector. Select colors to apply to the foreground or background.

3b. Brush tool

3c. Color selector window, where you can create colors

4. Appearance of the soft brushes (left) and the hard ones (right)

5a. Underexpose tool. Use this tool to apply shadows on the areas that already have color.

5b. Overexpose tool. Use this to apply lighting on areas that already have color.

Create a color background

In the background layer of the drawing (that which is situated behind the rest) we can insert any element, from a flat color background to a graded one and even various montages or textures among others.
In our case we apply a graded color background and with the paint brush tool we draw some lines that we will previously blur to create the effect of movement.

1. Create a color gradient

2. Apply strokes with the brush

3. Blur the movement

4. Distort zigzag filter

1. Activate the background layer. Select the gradient tool and, using two different colors, create a linear gradient.

2. Now, select the brush tool and in the options window choose a thickness of brush to blur. Also select an opacity between 70% and 80% and, in the color selector, a light color (foreground) for the lighting and another dark one (background) for the shadows. Apply the strokes with the brush with the two colors, trying not to make it too uniform. You can change from the foreground color to the background one (and vice versa) with the X key. This lets you apply the strokes with the two colors simultaneously. If you want, you can also apply other colors and experiment with other brushes and opacities.

3. To finish, you can apply a filter to blur the movement (Filter menu/Blur/Motion blur) of this same layer. This filter creates a blurred effect in the strokes and also corrects the areas where the applied paint has not integrated very well. In other words it will unite all the tones with the graded background.

4. Experiment with other filters to achieve different effects in the background (see page 356). As you will see, the result can change dramatically according to the filter that you select.

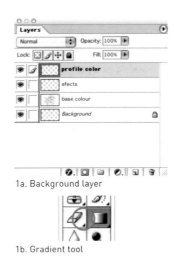
1a. Background layer

1b. Gradient tool

2a. Brush tool

2b. Brushes window

3. Blur filter

Paint the profile in color

A good idea to finish the illustration with something different is to paint the profile of the drawing in various tones of color. This lets us, for example, separate the different planes of the drawing, as well as distinguish the characters even more. Since we have saved the profile from the beginning as a selection, we can carry out this operation simply, loading the selection on a layer and painting over it with the brush.

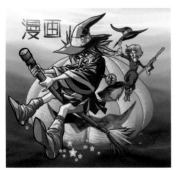

1a. Illustration finished with the profile in black

1b. The black profile of a drawing

2a. Load the selection of a drawing.

2b. Paint over the profile with the brush tool.

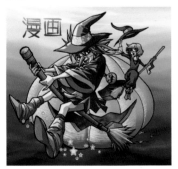

2c. Illustration finished after applying different color profiles

1. To start the exercise, create a new layer where you can apply the colors to the line (Layer menu/New Layer). Now, recover the profile of the original drawing. Select load selection (Select menu/Load selection). In the menu that appears select the gray copy channel, the one you duplicated when preparing the illustration to paint it. The result is the empty drawing selection.

2. With the profile of the selection active, select an initial color to start the painting. In the tools window, click on the foreground color box, and in the color selector, choose an initial color. Now, activate the brush tool. With the options of this tool, use a brush with a hard and not too thick edge. Try to have the opacity and the brush flow at 100% to capture the intensity of the color to the maximum. Place the cursor on the selection and start to paint. As you will see, the strokes of the brush are only visible in the areas of the profile and not in the rest.

3. If you prefer, you can create new layers and place different color profiles independently. Remember that if you have the selection active, you can use the current layer or in others that you create. The advantage of having the different states of the profile colored in independent layers is that you can always select each one of them and modify, for example, the color when you want.

1a. New layer

1b. The gray channel copy is the reserve of the profile of the drawing.

1c. Load select menu.

1d. In load selection you can activate the reserve of the original drawing.

Soften the hardness of the line

When scanning a drawing with the option in black and white (which best captures the intensity of the line of an ink drawing), the result that we obtain in Photoshop after converting from the bitmap to color is a line with a jagged or hard appearance. To avoid this, the best thing to do is convert the scanned drawing into vectors. This process is called vectoring, and the most suitable program to carry out this transformation is Adobe Streamline.

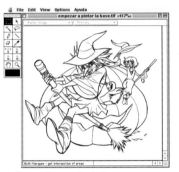

1. Streamline work window

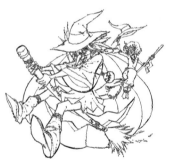

2. On converting the image the points of the line will be generated.

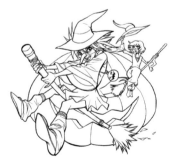

3. The open drawing with Photoshop has a softer appearance.

1. Scan the drawing in black and white. You can define a value above 300 dpi resolution, since the resulting image is that which you will use to vector (for example, 600 or 800 dpi would be fine).

2.. Once the drawing is digitized, open the Adobe Streamline program and, with this, the scanned drawing (File menu/Open). If, for example, you have an area open or parts that you want to delete from the drawing, you can use the small Streamline tools box, which has a pencil (to add lines) and an eraser (to erase imperfections). Double click on the selected tool if you want to change the brush thickness options.

3. After retouching the image, convert it to lined (File menu/Convert). On executing this action, Streamline vectors the drawing, i.e., it converts the drawing from bitmap to vectors.
Save the result (File menu/Save art as). Do not forget to give it a different name from the scanned image and a format compatible with Photoshop (for example, Illustrator EPS) to be able to open it easily after.

4.. Open in Photoshop the resulting vectored document. As you will see, before showing the drawing, you will have to specify what type of image you want, the size, and the resolution. Select color image (RGB or CMYK), the final size, and 300 dpi resolution. On obtaining the image, look at the soft appearance that the line gives. Now, repeat the steps of the previous sections before coloring.

1. The program Adobe Streamline is ideal for converting digitalized images to vectors and to be able to paint with applications such as Freehand or Illustrator.

2a. File Menu/Convert

2b. Options to save the Adobe Streamline vectored image

3. After vectoring the image, when opening it with Photoshop you have to define which type of image you want, the final size, and the resolution.

The illustration step by step

To carry out this illustration, Fernando Casaus started with a drawing, which was later traced in ink. Once this was digitized and prepared to paint, he worked the color and the different effects through layers, using different techniques and tools, like the pencil to retouch the line profile, the paint bucket to give the color base, the brush for the lighting and shadow effects, or the gradient tool to create the lighting effects. Finally, he placed in the background a page of a comic from the same series that he got from the layer options to integrate it into the drawing.

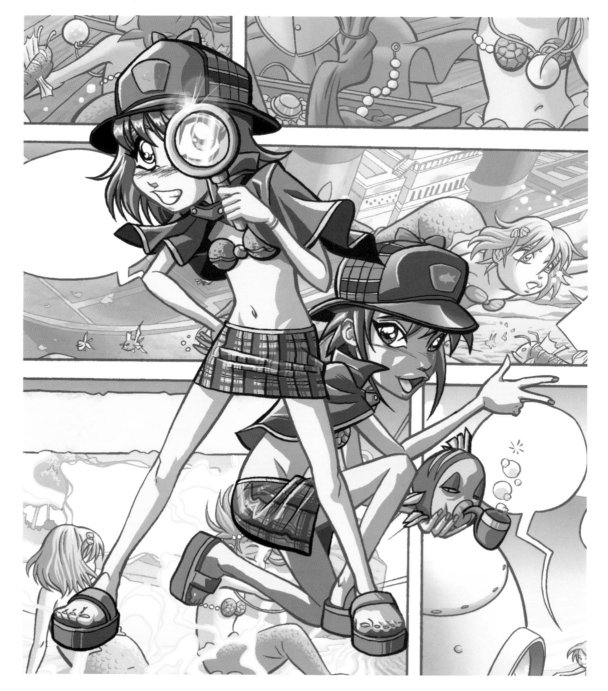

Color in a drawing

1. The color base

2. The lighting

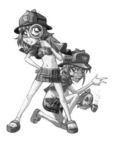

3. The shadows

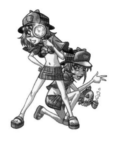

4. The color profile

5. The integrated background

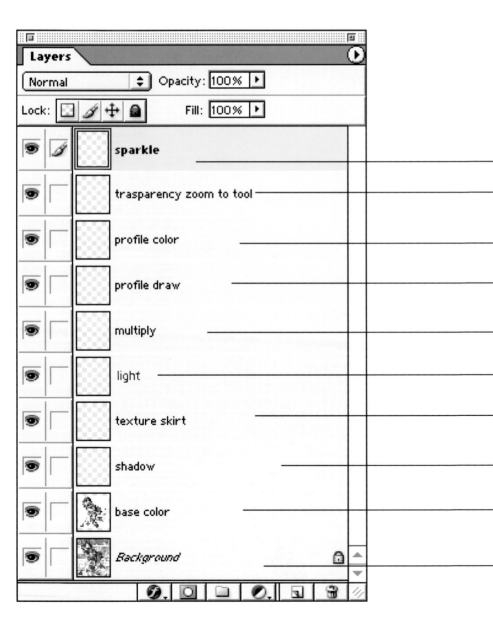

Layers

Normal Opacity: 100%

Lock: 🔲 ✏ ✛ 🔒 Fill: 100%

sparkle — With the airbrush tool some white sparkles have been created to make the magnifying glass stand out.

trasparency zoom to tool — In the magnifying glass a transparent gradient has been created to produce a glass effect.

profile color — The profiles have been painted from the selection loaded from the original profile.

profile draw — The layer with the profile of the original drawing loaded

multiply — In this layer more shadows have been applied and they have been located in multiple mode to integrate the color with the base.

light — In the lighting layer some shine has been drawn with the brush tool.

texture skirt — The textures of the skirts have been done by hand with the brush, using different colors.

shadow — The shadows have been applied over this layer using the brush and darker colors.

base color — Over the original profile the base has been filled in with the paint bucket.

Background — The background layer contains a fragment of a comic page reduced to 50%.

APPLYING SHADOWS
Creating shadows

A good way to integrate the characters of an illustration into the background, or simply give them projection, is to create shadows behind them. There are various ways of creating this effect in Photoshop, but undoubtedly one of the quickest and most efficient is to use the drop shadow function (Layers menu/Layer style/Drop shadow), with which you can control how the shadow is projected on the objects.

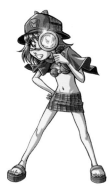

1. The base layer

2. The duplicated layer and with solid color

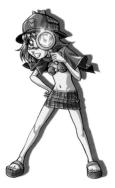

3. The shadow projected

1. To be able to create a shadow behind a character, the background must be transparent. If you can, create a background layer (two clicks on the background in the layers window). Now, select with the magic wand all the white or color areas of the illustration that are not transparent (to select various areas press on caps lock) and delete them.

2. Make a duplicate of the resulting layer (Layers menu/Duplicate layer). Select the layer again (click on the layer in the layers window, keeping the Alt key pressed and you will obtain the selection) and color in with a solid color. Like the duplicated layer it will have been placed on top of the original. Vary the order dragging it down in the layers window.

3. Choose the drop shadow function (Layers menu/Layer style/Drop shadow). Depending on the shadow that you want to apply, use the opacity values, size, and angle to add more or less shadow on the character. Notice that as you vary one of these values on the illustration, they are shown. This allows you to control very important aspects such as the direction of the lighting at any moment.

1. On the layer click with the magic wand to eliminate the white or color background.

2a. Create a new layer and fill it in.

2b. Change the order of the new layer.

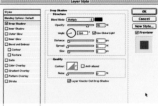

3a. Layer style/Drop shadow

3b. Apply the shadow.

352

Vary the shape of the shadows

From the projected shadows that you created previously, you can transform them to give the drawing a shadow in perspective. To carry out this operation, you need to create a layer from the shadow effects and then change it with the functions that the transform option offers you, such as skew, rotate, increase, or perspective. The creation of this type of shadow effects is fundamental when we integrate characters in the background.

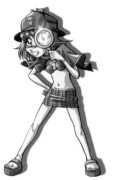

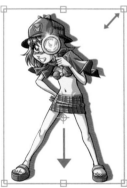

1. The layer with the shadow

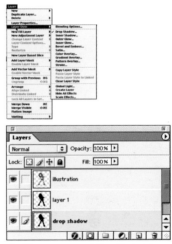

2. Move the central selector to control where to apply the transformation.

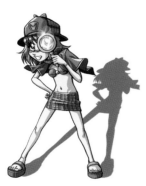

3. The shadow projected in perspective

4. The first step is to convert the shadow effects into a layer. With the shadow layer activated create a layer (Layers menu/Layer style/Create layer). Since this function creates two layers (one with the solid color and the other with the layer) delete or deactivate that which is not shadow.

5. To be able to project the resulting shadow in perspective, you can use one of the options from the transform function (Edit menu/Transform), such as, for example, Skew or Perspective.
Before stretching from any of the controllers that appear when you activate this function, try to position the central axis (the point which appears in the center) that will allow you to set the transformation. To move the central axis simply drag it to the point that you consider suitable to carry out the transformation.
Now, stretch from the main points to achieve the desired transformation.

1a. The shadow layer

1b. When you convert the effects into layer, two layers are created. Delete or deactivate the layer that is not shadow.

2. Edit menu/Transform

MONTAGES AND COLLAGES
Add photographs to the illustration

Once the illustration has been finished you can improve its appearance if you make the most of the enormous potential that the layers offer. The aim of this exercise is to add two photographs, one of the sky, the other of the sea, and integrate them into the original drawing.

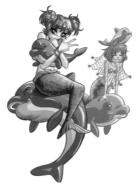

1. The original image

2. Photographs

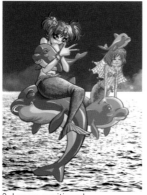

3. Layers positioned

1. The easiest way to create layers is copy and paste (Edit menu/Copy/Paste).
Open the images that you want to integrate, copy them, and paste them into the original document. The layers pasted will be put on top of the drawing layer.
When you click on the name of the layer, it will be selected in color and will indicate that it is the active layer, so that all the actions that we do will only have an effect on this layer.

2. The images that you have pasted have been put on top of the original drawing, so you will have to change the order of the layers. With the layer of the drawing activated, drag it until it is over the others. The drawing layer will become the first.

3. Now is the time to move the images in the document and put them in the correct place.
To move the elements from an active layer we will use the move tool.
Activate the layer that you want to move (click on it in the layers window) and with the move tool, move the layer and repeat the operation for the others.

1a. Layer with the original drawing

1b. The active layer is that of the sky.

2 Position the drawing layer on top of the sea layer.

3. Move tool

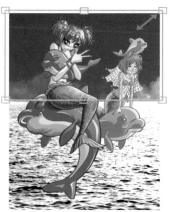

4. The handles or selectors let you enlarge or shrink the image.

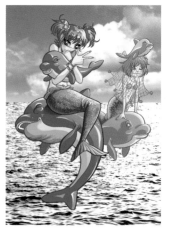

5a. With the layer selected you can change the colors.

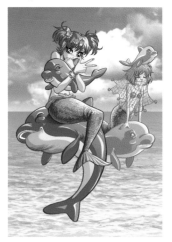

5b. Like the sky, the sea layer has also been colored.

4. Transformations can be done, like enlarge and shrink, rotate or distort, to adapt the layers that, for example, are with another size.

To shrink or enlarge a layer, activate the layer that you want to transform. Choose scale (Edit menu/Transform/Scale). Stretch from the selection controllers to shrink or enlarge the image and adapt it to the desired size.

5. With the adapted layers in position and sized, now carry out color adjustments to integrate the illustration with the photographs.

It is possible to change the general tones of a photograph with the color balance controls.

Activate the layer that you want to color and choose which color balance you want to give it (Image menu/Adjust/Color balance).

Move the bars of the different tones, and the colors of the drawing will progressively change.

Repeat the operation with other layers. If you are using shadows, medium tones, or lighting you will be able to modify the range of the tones in which you want to focus the changes.

Select preserve light to prevent changing the lighting values of the image as you change the color. This option maintains the tone balance of the image. Drag a regulator toward the color that you want to increase in the image and away from it when you want to decrease it.

4. Edit menu/Transform

5a. The color balance command changes the overall mix of the colors of an image to achieve generalized color corrections.

5b. Activated sea layer

5c. Activated sky layer

To add more realism to the scene and integrate the different layers in the colored drawing, you can create new layers, which, since they are transparent compared with the others, let you draw effects or add other elements needed to give the drawing more impact.

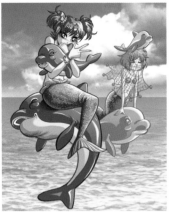

6a. Create a new layer.

6. In a new layer add some spatter effects to integrate the drawing in the sea. Create a new layer (Layer menu/New/ Layer).
On the layer that you have just created, draw with the brush tool different lines that simulate the spatter. To do this modify the options of the brush tool, changing the opacity and selecting a blur brush.
You can use, for example, the white to draw the spatter effects or, if you prefer, different grades of opacity in the options bar.

6a. Layer menu/New/Layer

6b. New layer

6c. Brush tool

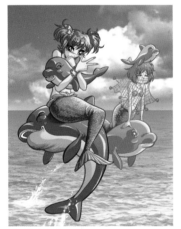

6b. Finished montage

6d. We can change the options of the brush to achieve the desired effect.

Regarding the layers; unlimited possibilities

The layers let you work with a stage of the illustration without modifying the rest and thereby improving the organization of the work. The layers function as if they were sheets of acetates piled one on top of the other, so in the areas where there is no image you can see the image below. Likewise, the layers can change order, be hidden to see any state, graduate the opacity, or change the properties. Also, with the special functions like the fill adjust layer and the layer effects, you can create sophisticated effects on the images.

CHANGE THE COLORS
Add photographs to the illustration

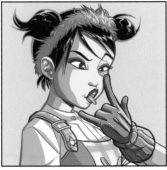

1. Original image. Select the face and the background with the magic wand.

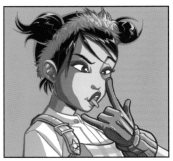

2. When moving the values, the colors change.

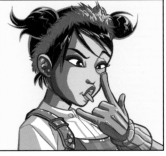

3. Totally changed image

1. You can change the colors of a drawing, which has already been painted, very easily. Simply select the area of color that you want to change.

Click with the magic wand. If you keep the shift key depressed you will be able to select more than one area at a time.

2. Now, with the selected area, select the tone and the saturation (Image menu/Adjustments/Saturation tone).

Move the tone bar and the colors of the drawing will progressively change.

If you move the saturation bar, you will achieve more or less vivid colors, whereas if you move the lighting bar the result will be lighter or darker.

3. If you want to change the general tone of the illustration, you can do so without selecting anything. When you move the tone and saturation values, the changes are applied to the entire drawing. So, you can have the same illustration with different colors through minimal effort.

1. Tools bar

2. Hue and saturation window

COLOR A SKETCH
Like retouching and painting first drawings

Aunque la forma más fácil para pintar un dibujo con **Photoshop** es a partir de una ilustración a tinta, también es posible retocar y colorear aquellos dibujos que en una primera fase se consideran bocetos, es decir, dibujados a lápiz, rotulador o con otras técnicas.

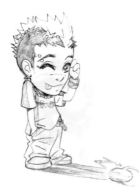

1. The original sketch

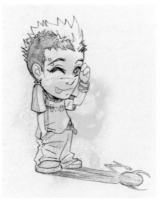

2. The resulting image with the joined layers

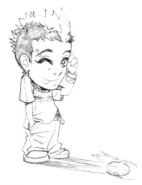

3. Final result

1. Although the easiest way to paint a drawing with Photoshop is from an ink illustration, it is also possible to retouch and color those drawings considered in the first stage to be sketches, i.e., drawn by pencil, felt tip or other techniques.

The first step is to digitize the drawing that we are going to color. The cleaner it is and the better finish it has the better; but if this is not the case, as in the example, you will be able to solve it following some simple steps that we will explain later.

If the illustration is drawn in pencil, before scanning it you will have to select the option grayscale so that it captures all the intensity of the lines. The suitable resolution to obtain an optimum quality is 300 dpi.

2. Once you have the drawing in Photoshop, delete the color background that has appeared in the drawing or the gray areas from the pencil to leave the drawing completely clean.

Create a new layer. With the eyedropper, click on the darkest shade that you want to delete. With the color obtained, fill the new layer (Edit menu/Fill/Foreground color). The following step is to select the darken mode in the fusion modes of the layers window (Layer menu/Join layers). Join the two layers. The result will be the image drawn in the background that you want to delete.

3. To finish, select Image menu/Adjustments/Replace color, to delete the excess, and move the lighting to the maximum to achieve a sharp black and white image, ready to start painting.

1. The scanned image

2a. Create a new layer

2b. Eyedropper tool

2c. The joined layers

3. Replace color.

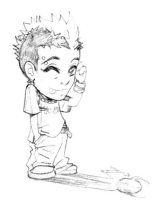

4. The layer with the profile

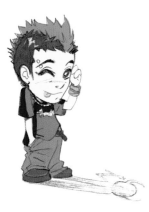

5. The base color layer

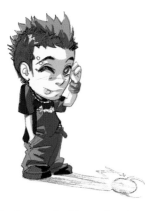

6. The final result with the effects layer

4. With the drawing already prepared, start to paint the sketch with layers, i.e., one for the color, another for the effects (lighting and shadows), and a last one to maintain the profile of the line created at the start. Each of them has to have the multiple fusion mode to keep the transparency (see page XX).

Create a new layer for the color base (Layer menu/New layer) and call it base color. Now, create two more layers, one called effects and the other profile. The latter, as it has been created under the two previous ones, should be moved and put on top of the others so it is the first (If you cannot drag the layer because it is blocked, double click on it in the layers window and it will unblock).

5. Use the brush tool to start painting the illustration. Select a brush size, give it grades of opacity, and with the color that you have selected start to paint on the base layer. As the profile layer is transparent, the colors that you apply on this layer, will let you see at any moment the original drawing. Repeat the operation with the layer that corresponds to the effects to define the areas of light and shadows. If you want to apply effects of white light you will have to create another new layer, but this time in the normal fusion mode, because if you paint with white on a layer in multiple mode, this color will not be seen.

4a. Transparent profile layer

4b. Three new layers

5a. Paint the base color layer

5b. Brush tool

5c. Brush tool options

5d. Finally, define the effects.

PAINT MODES

Easy and impressive shadows and lights

The fusion and paint modes help us control the influence that a paint or layer tool has over the values of the image. When visualizing the effects of a fusion mode, it is useful to consider the following colors:
The base color is the original color of the image.
The fusion color is the color applied with the paint or edit tool.
The resulting color is the color obtained from the fusion.

You can access the options of the paint modes with any paint tool, or from the layers window itself.

Example of altered color with the paint bucket and the link fusion mode

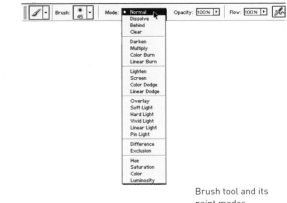

Brush tool and its paint modes

But, how can you apply the paint modes to the illustration? Very easily. For example, you can create lighting and shadows with the link and multiple modes. To do this use the brush tool with a thick diffusion (for example 35 pixels) and an opacity of 50%.
The color that you apply to these effects could be the same that you used to fill the base of the picture.

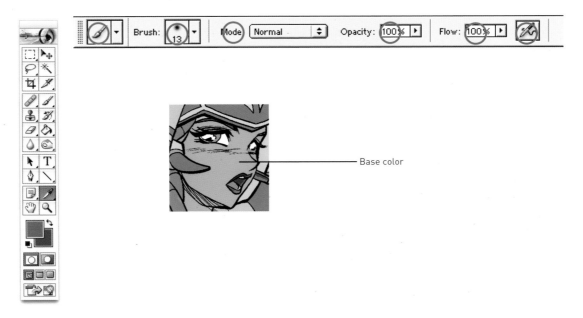

Base color

Lighting/Brush tool/Link mode

Creating lighting is very simple. Select the brush tool with a thick diffusion and an opacity of 50% and apply it to the selected areas.

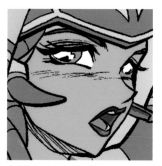

1. Original image

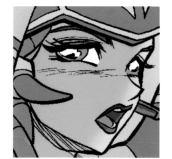

2. With the brush tool and the link mode apply a line with the same base color.

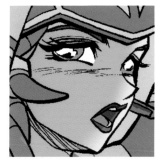

3. A second line with the same options lightens up the color even more.

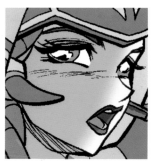

4. By progressively applying the link mode you will achieve white.

Shadows/Brush tool/Mulitply mode

Apply the shadows in the same way. Select the brush tool with a thick diffusion and an opacity of 50% and apply it to the selected areas.

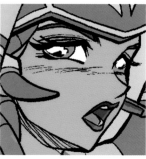

1. Original image

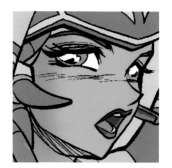

2. With the brush tool and the link mode apply a line with the same base color.

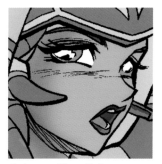

3. A second line with the same options darkens the color even more.

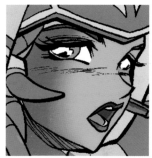

4. By progressively applying the link mode you will achieve a saturated color.

Other ways of applying lighting and shadow in the layers

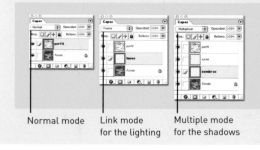

Normal mode

Link mode for the lighting

Multiple mode for the shadows

You can create the same lighting and shadow effects if you use them on a different layer. To do this just create a new layer (Layer menu/New layer) and in the fusion modes of the layers window choose link for the lighting and, in a different layer, multiple for the shadows. In both cases 60% opacity is best. Now, with the same base color and the brush tool apply on the corresponding layer until you have created the desired lighting or shadow effects.

FILTERS
Special effects

Photoshop filters are the most spectacular way of creating special effects on digitized images. Despite only functioning with RGB images in some cases, their use and combination have meant a dramatic change for the creative side of illustration. Apart from Photoshop's own filters, it is possible to add filters from other companies, whih increases possibilities. You can apply filters on the complete image, on selections and channels, etc.

Artistic filter

 Poster edges

 Watercolor

 Cutout

 Palette knife

 Sponge

 Fresco

 Color pencil

Smudge stick

 Film grain

 Dry brush

 Paint daubs

Underpainting

 Plastic wrap

Neon glow

Rough pastel

Sketch filter

 Bas relief

 Torn edges

Charcoal

 Conté crayon

Chrome

Plaster

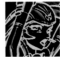 Notepaper

 Photocopy

 Halftone pattern

 Emboss

 Water paper

 Reticulation

Stamp

 Chalk and charcoal

Blur filter

Blur

 Blur more

 Motion blur

 Gaussian blur

 Radial blur

 Smart blur

Distort filter

 Polar coordinates

 Glass

 Displace

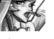 Pinch

 Spherize

 Twirl

 Wave

 Ocean ripple

 Project

 Diffuse glow

 Ripple

 Zigzag

Sharpen filter

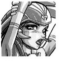 Sharpen

 Sharpen edges

 Sharpen more

 Unsharp mask

Stylize filter

 Tiles

 Glowing edges

 Diffuse

 Extrude

 Find edges

 Emboss

Solarize

Wind

Pixelate filter

 Chrystalize

 Fragment

 Recorded

 Mosaic

 Brushstroke

 Pointillize

 Color halftone

Noise filter

Add noise

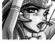

Despeckle

Median

Dust and
scratches

Texture filter

Mosaic tile

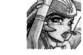

Grain

Craquelure

Patchwork

Texturizer

Stained glass

Other filter

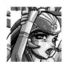

Offset

Maximum

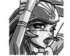

Minimum

High pass

Customize

HOW TO CREATE DRAWING PAPER

Operations with filters to create textures

When you color an illustration, the drawings stay on a white or transparent color base and lack textures that they can imitate, for example, drawing paper or a painter's canvas. The easiest way to achieve these effects is to use the Photoshop filters, like texturize. The problem is that the result will always be the same and very similar to what anyone else could do, so, if you want to achieve effects that are unique and have an impact, you should combine different filters from the long list that Photoshop offers, and then apply them to the already painted drawings or the new blank documents.

1a. Filter/Noise/Add noise

1b. Gaussian blur

2a. Paint daubs filter

2b. Emboss filter

1. Open a new document in grayscale. Apply the noise filter (Filter menu/ Noise/Add noise). Select between 300 and 500 in quantity and in distribution activate the Gaussian option. Now blur the whole document (Filter menu/Blur/Gaussian blur).

2. Apply the paint daubs filter (Filter menu/ Artistic/Paint daubs) and experiment sliding the cursor along the bar until you get the desired texture. Now, select the relief filter (Filter menu/Stylize/Relief).
To get a lighter texture use all levels (Image menu/Adjustments/Levels). Move the entry and exit regulators to contrast the lights and shadows. With the difference of tones, the paper will appear thicker.

3. The objective is to fill the canvas with texture, so you need to convert it into a repeated pattern. To do this select the offset option (Filter menu/Other/Offset). You can apply 50 in the vertical and horizontal fields and the option to rotate it horizontally so that all the pixels appear on the right and in the upper area.
To finish, select all the canvas and select define pattern (Edit menu/Define pattern). You can place the created texture, selecting pattern in the use option (Edit menu/Fill).

2c. Adjust levels

3a. Other filter/Offset

3b. Edit/Define pattern

3c. Fill pattern

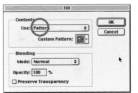

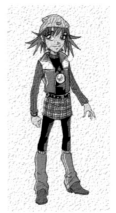

3d. Background texture

APPLY FILTERS TO CHANNELS
Completely change the illustration

The combination of different filters is perhaps the most creative way Photoshop offers to achieve spectacular (and unexpected) effects. But if you are also working with the image channels window, independently applying the filters to each of these, the results will allow you to completely change the initial handling of the illustration. For the following example, we worked from an already colored drawing, to which a sketch filter has been applied separately onto each of the color channels. Experiment on the channels with other filters and see the results.

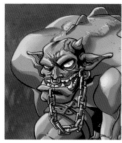
1. Original image

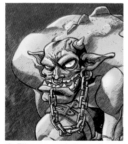
2. Filter on red channel

3. Filter on green channel

4. Filter on blue channel

1. To achieve these excellent results, open a drawing (or convert it) in RGB. Remember: if the image is in CMYK you will not be able to apply the wide variety of filters that Photoshop has.

2. Start on the red channel. Click once on the channels window and activate only this channel. Apply a sketch filter, for example, Graphic pen (Filter menus/ Sketch/Graphic pen). As you will see, the result appears in the active channel, but if you activate the global image (click on RGB) the filter has changed the general tone of the illustration.

3. Now, repeat the operation with the two remaining channels (green and blue). Click on the green channel and apply the graphic pen again.
Lastly activate the blue channel and apply the same filter again.
If you experiment with other filters you can achieve totally different effects.

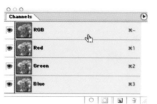
1. Channels window

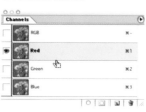
2a. Red channel activated

2b. Graphic pen filter

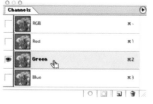
3a. Green channel activated

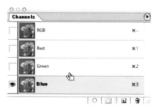
3b. Blue channel activated

PATTERNS AND TEXTURES
Add textures from the filters

A good way of optimizing the enormous potential that the filters offer is to apply them to the drawings to add textures and patterns that in some cases would be very difficult to create manually. For this you can use the Artistic, Sketch, and Texture filter, or simply experiment, combining them to suit your tastes.

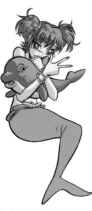

1. Colored image

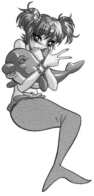

2. Texture applied

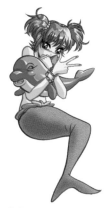

3. Created effects

1. On an already colored drawing, pick an area to apply the textures. In the example illustration the effects have been applied especially to the tail of the mermaid. Activate the color base layer, select the magic wand tool, and click on the base color where you want to apply the texture.

2. With the area selected, you can apply any of the filters from the texture menu (Filter menu/Texture/Texturize) or indeed any other, Sketch, Artistic, etc. In the example grain has been selected from texturize, to give a rough look to the tail of the mermaid. Experiment with other filters to create textures in your drawings. Do not forget that to apply certain filters the image must be in RGB mode.

3. To create shadows on the texture you must select it. Select the lasso tool and define the area you want to darken. If you do not want the result to be too hard, you can feather the selection a little (Select menu/Feather selection). This option produces an effect of blurring the selection. The bigger the radius of the feather, the more the effect applied on the selected area will be diffused.
Now, darken the selected part with the texture using the lighting controls (Image menu/Adjustments/Hue and saturation). As you will see the feather makes the edges spread the effect and integrate the effect of shadow even more.

1a. Active color base layer

1b. Magic wand tool

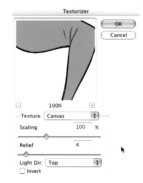

2. Texturize filter/Texturize

3a. Lasso tool

3b. Feather selection

3c. Adjustments of hue and saturation

Create mechanical patterns

Traditionally the mechanical patterns for the comic have been fundamental for adding effects. With Photoshop it is possible to imitate them from the halftone pattern filters, where more or less intensity can be given to the dots. Likewise the Artistic filter lets you define the patterns as dots, lines, or circles.

1a. 40% black background

1b. The halftone pattern obtained

1c. 20% black (left)

2. Graded gray and white background

3. Halftone pattern obtained

1. To start with you have to create the patterns in a different document to that of the drawing you want to apply them to, because the result will be completely different to what you are looking for. Create a new document in grayscale with the same dimensions as the drawing you are going to apply the resulting pattern to. Fill all the area in gray (the darkness gradient of the color will decide the density of the pattern; the grayer the denser).

2. Select the halftone artistic filter (Filter menu/Sketch/Halftone pattern). Use the controls to change the size, the contrast, and the pattern type. If the dots obtained show gray areas, you can delete them offsetting the brightness and contrast adjustments (Image menu/Adjust/Brightness and contrast).

3. You can create a similar effect with the halftone pattern filter (Filter menu/ Pixelate/Color halftone). Apply a maximum radius in the dialogue box to increase the size of the dot from the pattern.

4. If your objective is to create graded mechanical pattern textures, a gray and white graded background is better. Depending on the density required, apply the same halftone pattern or color halftone filters. The result will be a graded pattern.

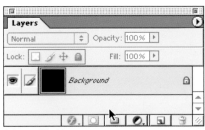

1. Layer filled in gray

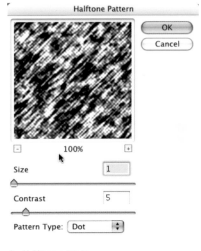

2a. Halftone pattern

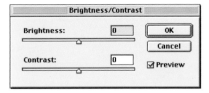

2b. Brightness and contrast

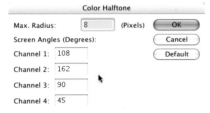

3. Color halftone

SPECIAL EFFECTS
Create a ball of fire

1a. Background layer

1b. Drawn circle

2a. Create an orange halo.

2b. Aligned layers

3. Apply the hand tool.

1. Open a new document and fill the background in black or another dark color. Now, create a new layer (Layer menu/ New layer) and draw a white circle. Use the magic wand tool to select the object created and fill the circle with white (Edit menu/Fill).

2. The next step is to create a red or orange halo around the circle. To do this duplicate the white ball layer (Layer menu/ Duplicate layer). Select the magic wand tool again and select the inside of the ball. Now enlarge the selection (Select menu/Modify/Expand). Depending on the size of the ball apply more or less pixels. Apply a feather to the selection (Select menu/Feather). The bigger the number of pixels the more the area will be diffused. Fill the selection in red or orange, depending on the appearance of fire that you want to give the circle.
In the layers window, move the white ball onto that which has the orange halo, making it the first.
The last step is to link the two layers: click on the box to the right of the eye. An icon of a small chain will appear. Now, turn the two layers into one (Layer menu/Align linked). Leave the selection (Select menu/Deselect).

3. Select the hand tool and with a reasonable size brush push from the center of the circle to the outside. Repeat the operation as many times as is necessary. To define smaller flames, choose a smaller brush and move the hand tool to the outside.

1a. The background layer

1b. Draw a circle.

2a. The duplicated layer with the expanded ball, feathered and painted

2b. After moving the white ball in the first place, link it with the second.

3. Hand tool

Create rain effect

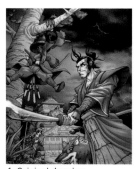

1. Original drawing

2. Add noise filter in the created layer.

3. Motion blur

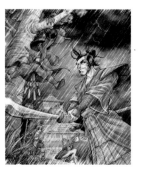

4. Final image

1. Select an already painted drawing as a background and decide where you want to create the effect. Create a new layer (Layer menu/New layer) and fill the background in black or a dark tone.

2. Apply a noise filter (Filter menu/ Noise/Add noise). In the dialogue box try to activate the monochrome and Gaussian options. The higher the quantity you apply, the more rain will appear in the drawing.

3. If you want the rain to go in one direction, apply a blur filter (Filter menu/Blur/Motion blur). You can mark out a distance of between 30 and 50 píxels, depending on the gradient of the blur.

4. With the result, clear the layer in fusion mode. Clear from the layers window. The result will be visible, because the black areas will have disappeared.

5. Lastly, in the levels dialogue box (Adjustments menu/Levels) offset the contrast values until you get the rain lines.

1a. Layer with the drawing

1b. Black layer

2. Apply the add noise filter.

3. Motion blur

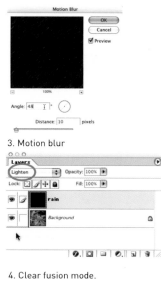

4. Clear fusion mode.

5 Change the levels.

Lightning, thunder, and flashes

1. Graded fill

2. Difference clouds

3. Adjust invert

4. Lightning effect

1. To create these effects, apply a linear graded fill of a dark color to another clear color on the layer of a document (see page XX); you can also work with the background layer. The light color that you apply will define the lightning that will appear between the two selected colors.

2. Now, apply a clouds filter to the graded background (Filter menu/Render/Difference clouds). After this step, the lightning will start to appear through the clouds.

3. Lastly, invert the image (Image menu/Adjustments/Invert) and set the levels (Image menu/Adjustments/Levels), offsetting the central values so the image of the lightning contrasts. This will slowly take shape on the background. Adjust it until suitable.

4. You can create other lightning effects if you try the other grading tools in the options menu; there are plenty of possibilities. Each will give you different variations of position, movement, etc.

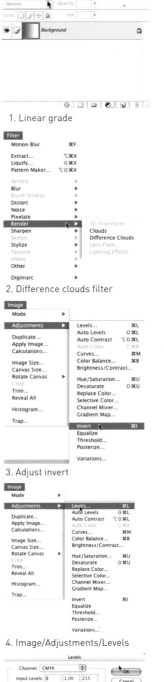

1. Linear grade

2. Difference clouds filter

3. Adjust invert

4. Image/Adjustments/Levels

4. Adjust the levels

Lens flares and lighting effects

Although the best ways to create lighting and shadow effects on an illustration is to do it manually (as you have already seen), it is also possible to do it automatically with the lighting effects and lens flare filters from the filter menu. For this always try to have the image in RGB and apply them on a layer with information.

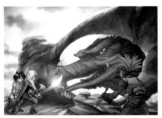

1. Lens flare of the sword

2a. Original image

2b. Lantern style

2c. RGB lights

2d. 2 o'clock spotlight

2e. Blue omni

1. The lens flare filter simulates the refraction when a bright light is shone on the lens of a camera. Apply a lens flare on a specific area of a layer that you want (Filter menu/Render/Lens flare). In the example, the sword of the character is where the lens flare comes from. You can control the size of this thanks to the brightness option, or apply a specific type of lens.

2. The lighting effects let you automatically create countless effects of this type in RGB images, combining 17 light styles, 3 light types, and 4 sets of light properties. In the effects window (Filter menu/Render/Lighting effects) you can determine the way in which the light enters the illustration through different styles, light types, intensity, etc. Experiment with your drawing to achieve spectacular automatic effects.

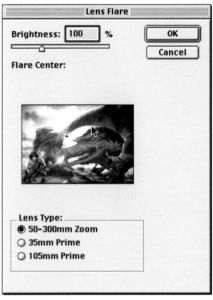

1. Filter window/Lens flare

2. Lighting effects window

Create sensation of motion

If you want a drawing to stand out for its realism, add the sensation of motion. With the blur tools and especially the motion ones, you can create the effect of a camera that captures a moving object. To do this you will need to duplicate the original layer, fill it with a solid color, and apply the motion blur filter.

1. Original image

2. Motion blur on a layer filled in a solid white

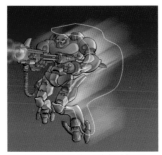

3a. Section after the original layer selected with the lasso tool

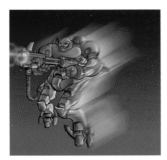

3b. Final Image

1. Select a drawing that will not look exaggerated when you apply motion. Although it is possible to blur any layer, in this specific case the object you want to apply motion to is separated from the background, i.e., in another layer. If this is not the case select, with the magic wand tool, the background color that the illustration has and delete it. Remember it is not possible to extract the background if you have not previously converted it into a layer.

2. Duplicate the layer of the character and fill in a solid color (white, for example). Now, blur it to create motion (Filter menu/Blur/Motion blur) and enter the angle and distance values in relation to the trajectory of the character. In the layers window order that of the blur under that of the main character. If the effect is too exaggerated, change the opacity settings in the layers window. You can also move the blurred layer to one side, because by default the motion filter runs the blur from left to right.

3. To give the motion more realism blur the edges of the section before the character so they are integrated with the blur layer. Activate the main layer of the character to work on it and select a large area in the section behind with the lasso tool. Apply the motion blur effect again, but this time try not to give it too much distance so that it does not look exaggerated.

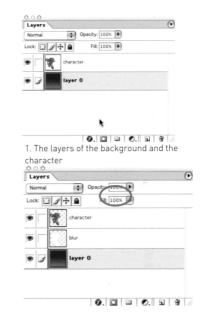

1. The layers of the background and the character

2a. Duplicate the layer of the character and put it in second place.

2b. Apply the motion blur filter.

2. Lasso tool

TYPE IN PHOTOSHOP
Insert and edit blocks of type

Thanks to Photoshop's type tools, we can create horizontal or vertical text in any part of the image. Depending on how these tools are used, they will introduce type objects or a paragraph of type. The type object is useful to insert a single word or a line of characters, like titles or logos; and the paragraph type, to introduce and apply type format such as one or more paragraphs, for example, to create speech bubbles in a comic.

1. Type tools

2. Normal type
(left) and vertical type (right)

3. Normal type mask (left) and
vertical type (right)

1. Select the type tool to create a new type object in a document. The arrow will turn into a writing cursor; click with the cursor on the place where you want the block of type to appear. When you create the type a new layer is created automatically.
If after writing the text, you want to modify it, you will have to select the same type tool.

2. If you want to create a paragraph type, select the type tool to draw out an adjustment frame on the document: press and drag to define the rectangular limit of the type; a flashing cursor will appear in the top left corner. If you keep the alt key depressed, a dialogue box will appear to define the size of the type box. It is possible to adjust the rectangular limit while you introduce a text or after creating the type layer.

3. To modify the basic type specifications, such as letter type, size, style, alignment, etc., you can do so from the type options bar, or from show character and show paragraph in the window menu. It is also possible to create horizontal or vertical type masks. The selections of type appear in the active layer and can be moved, copied, filled, and shaped like in any other selection.

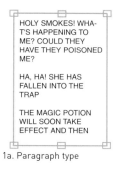

1a. Paragraph type

MANGA2

1b. Type object

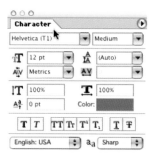

2. Size of paragraph type

3a. Window/Show character

3b. Window/Show paragraph

3c. Type options. With the text selected you can change the type of letter, the style, the size...

insert type in speech bubbles

Comics have always been drawn by hand, but when autoedit appeared, this laborious task was digitized to the point that, today, the whole process of elaborating texts is done by computer. However, to insert speech bubbles in the page of a comic the best way is to use a design program like QuarkXPress or Freehand; Photoshop also lets you carry out this task thanks to the new options that the type tool offers, as well as the character and paragraph window.

1a. The speech bubbles have been drawn separately to place them independently.

1. Lots of artists prefer to integrate the speech bubbles before inking the comic pages. However, it is better to do the drawing and the speech bubbles separately, since each line of the dialogue is different and, therefore, each bubble has its own size. For this reason, it is better to create the bubbles after writing the text, and not before. This will also allow you to insert the bubbles in a suitable place.

2. The first step is to integrate the speech bubbles that you have drawn separately into the already created drawing. After scanning them with the same resolution and size as the illustration, insert all of them into the document with the copy and paste tools. Since each bubble is in a different layer, you will be able to move them with complete freedom in the layers window. If you have to adapt the size of one of them, use the scale tool (Edit menu/Transform/Scale).

1. The layers window with the speech bubbles created

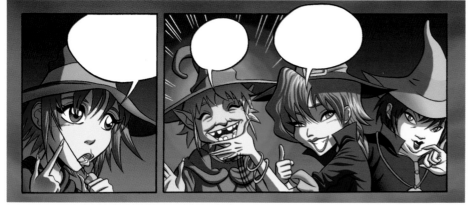

1b. Frames without text in the speech bubbles

2. Move layers tool (above) and type (below)

Frame 1 text:
HOLY SMOKES!
WHAT'S HAPPENING TO
ME? COULD THEY
HAVE POISONED
ME?

Frame 2 text:
HA HA! HE HAS FALLEN
INTO THE TRAP...

THE MAGIC POTION
WILL SOON TAKE
EFFECT AND THEN

2. Dash

3. Now, insert the bubbles from an original script in new documents. Select the type tool and place the cursor where you want the characters to appear. It is better to insert the text block for each speech bubble separately so that you can work more comfortably. Each of the texts will be inserted in an independent layer. Using the move layers tool, move them into the desired position in the frame.

4. To finish adapting the text to speech bubbles, change the letter type, the color, the size, and the interlinear from the character window (Window menu/Character). Select the layer that you want to change and with the type tool select the text to be modified.

2a. From the character window you can modify the text to adapt it to the speech bubble.

2b. Change the alignment of the blocks.

3. Frames with the text inserted in the bubbles